From one Brendan —
— as Brendan Behan inscribed a book
for me — Behind you 15 Hours G !
All the best

PRODIGALS AND GENIUSES

Brendan Lynch

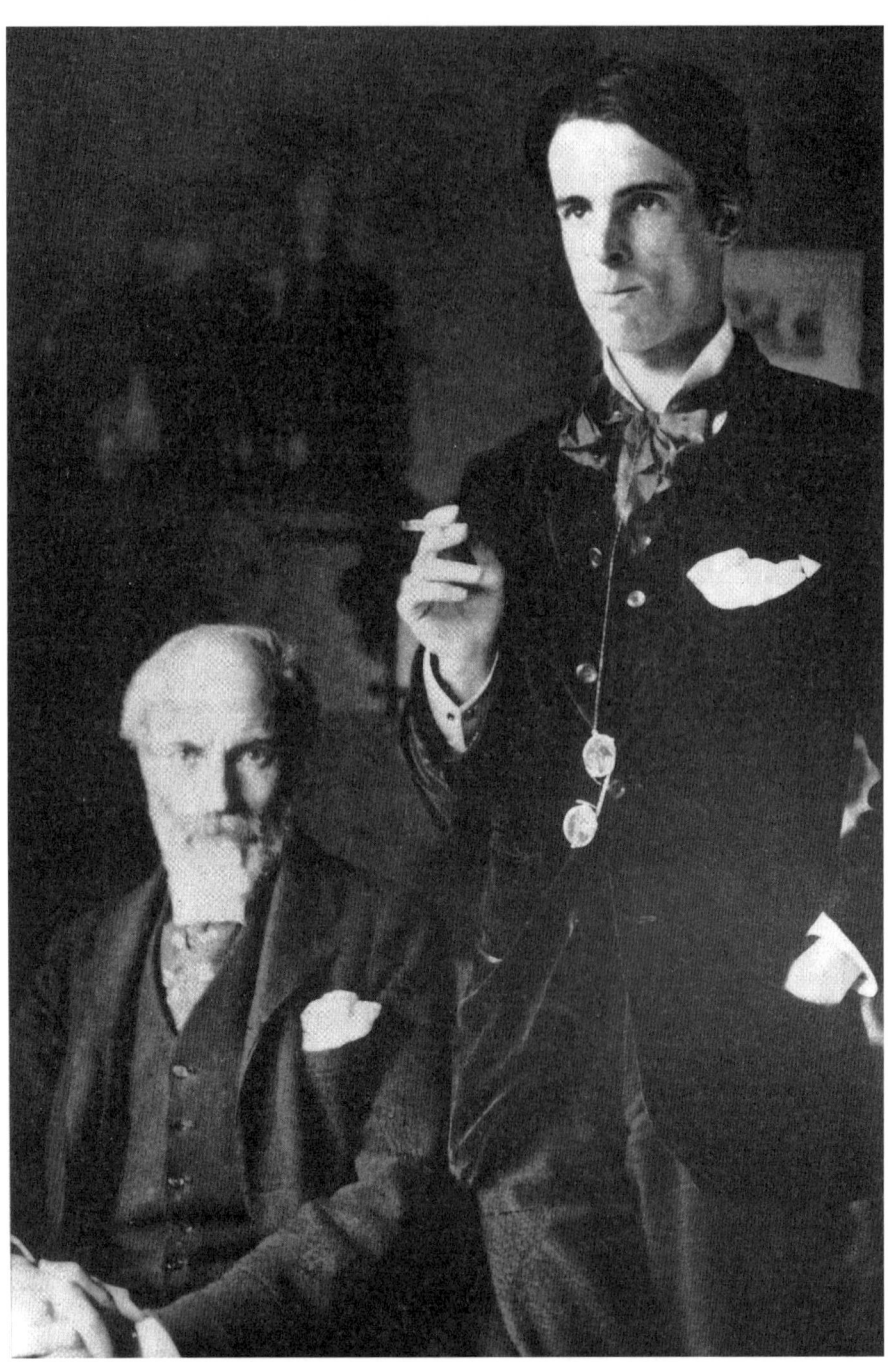

Prodigal father John Butler Yeats with his Nobel Prize-winning son, W.B. Yeats

PRODIGALS AND GENIUSES

The Writers and Artists of Dublin's Baggotonia

Brendan Lynch

The Liffey Press

Published by
The Liffey Press Ltd
Ashbrook House, 10 Main Street
Raheny, Dublin 5, Ireland
www.theliffeypress.com

© 2011 Brendan Lynch

A catalogue record of this book is
available from the British Library.

ISBN 978-1-905785-96-4 (pbk)
ISBN 978-1-908308-00-9 (hbk)

All rights reserved. No part of this publication may be reproduced or transmitted in any form or by any means, including photocopying and recording, without written permission of the publisher. Such written permission must also be obtained before any part of this publication is stored in a retrieval system of any nature. Requests for permission should be directed to The Liffey Press, Ashbrook House, 10 Main Street, Raheny, Dublin 5, Ireland.

Printed in Spain by GraphyCems.

Contents

Acknowledgements — vii
Foreword by J.P. Donleavy — xi

1. Baggotonia, Dublin's Bohemia — 1
2. Light and Shade — 13
3. The Original Bohemian – John Butler Yeats — 25
4. Brendan Behan – Housepainter to Writer — 39
5. Beatrice Behan – A Love Story — 57
6. Literary Salons and Saloons — 69
7. Laughter in Court: A Literary Libel Case — 89
8. Patrick Kavanagh – A Most Unlikely Poet — 99
9. Europe's Most Literary Waterway — 117
10. Parsons Bookshop — 129
11. Brian of the Many Masks — 145
12. Bertie Smyllie – 'The Editor' — 163
13. Pen vs. Crozier – Banned in Ireland — 175
14. The Pike – A Little Theatre by the Canal — 191
15. Baggotonia's Artists — 205
16. A Pint for a Woodcut – Harry Kernoff — 223
17. Ireland's Forgotten Writer – Ernie Gebler — 233
18. Gainor Stephen Crist – The Original Ginger Man — 241
19. The United Arts Club — 251
20. Hoddy, The Pope and Owen Walsh — 267

Bibliography — 281
Index — 293

To my long-suffering wife, Margie.

And to our late friends, Merriman School founder Con Howard, Arts Club stalwart Muriel Allison and Ken Monaghan, benign mastermind of the Joyce Cultural Centre.

About the Author

Brendan Lynch is a former racing cyclist, driver and Grand Prix reporter. A pacifist disciple of Bertrand Russell, he was imprisoned in London for Campaign for Nuclear Disarmament activities.

Brendan has written six books, including the award-winning *Green Dust* motor racing history and a memoir, *There Might Be a Drop of Rain Yet*. He has contributed to national and international media from *The Irish Times* to *The Observer*, *The Times* and *The European*. His features on Irish writers encouraged the establishment of Dublin's George Bernard Shaw Museum and the James Joyce Cultural Centre.

Len Deighton said of his last work on aviation pioneers Alcock and Brown: 'Brendan Lynch, in this excellent book, tells their story with the skill of a dedicated researcher and the talent of a popular novelist. *Yesterday We Were in America* is a very fine book.'

By the Same Author (http://brendanlynch.ie)
Green Dust: Ireland's Unique Motor Racing History
Triumph of the Red Devil: The Irish Gordon Bennett Cup Race 1903
There Might Be a Drop of Rain Yet: A Memoir
Parsons Bookshop
Yesterday We Were in America

ACKNOWLEDGEMENTS

I visited Brendan and Beatrice Behan in Herbert Street and Ballsbridge, and Kathleen and Stephen Behan in less grand Crumlin. I climbed innumerable flights of stairs to Harry Kernoff's Stamer Street studio, and also met J.P. Donleavy, Patrick and Peter Kavanagh, Peadar O'Donnell, Sean O'Sullivan, Alan Simpson and others mentioned in this book. I did not know that I was seeing history. Like Kavanagh and other Baggotonians, I often pondered a perennial problem of the 1950s, whether to spend half-a-crown on briquettes or on drink and company.

A timely celebration of Dublin's designation as a UNESCO City of Literature, *Prodigals and Geniuses* is a much-requested expansion of a previous book, *Parsons Bookshop*. I hope it provides a more comprehensive picture of Baggotonia and its writers and artists. Inevitably, it features some of the usual suspects and quotations from *Parsons*. The book is based on conversations and interviews with such 1950s figures as Beatrice Behan, Nevill Johnson, Harry Kernoff, Mary Lavin, Desmond MacNamara, John Ryan, Owen Walsh and many others, whose names are listed below. Also, on the reminiscences of Mary King and May O'Flaherty of Parsons Bookshop, and on the many works covered in the bibliography.

The book has had a long gestation and many who helped me have sadly died. We will never again see the likes of Con Howard, Ciarán MacMathúna and Sean MacRéamoinn, fellow Arts Club member Muriel Allison, Owen Walsh – and Ken Monaghan, always helpful nephew of the great James Joyce. Nor booksellers Fred Hanna and Enda Cunningham of Cathach Books, genial Vere Wynn-Jones, author and biographer Marcus Bourke, and Fáilte Ireland executive Damian O'Brien, who encouraged this and earlier books.

Particular thanks is due to Erin O'Mahony, Oireachtas Library, and the kind and professional staff of the National Library, both Printed Books and Manuscripts departments, Trinity College Library, the Gilbert Library, the Dublin Central Ilac Library, the National Gallery Library and Irene Stevenson at the *Irish Times* library. And to all the authors mentioned in the Bibliography for their painstaking research and riveting results, in particular Anthony Cronin and the late John Ryan for their first-hand accounts of Behan, Kavanagh, Flann O'Brien and company; Nevill Johnson for his poetic autobiography, *The Other Side of Six*; Antoinette Quinn for her wonderful Kavanagh biography; J.P. Donleavy for his unflagging *The History of the Ginger Man*; Vivien Igoe for her invaluable guides to both literary Dublin and the city's burial grounds; Ulick O'Connor for his biographies and engaging account of the Irish Literary Revival, and Virginia Nicholson for her comprehensive study of Bohemianism.

Salutations to the following who shared their memories: the late Muriel Allison, Leland Bardwell, the late Beatrice Behan, the late Kathleen and Stephen Behan, John Behan, Brian Bourke, the late Seamus de Burca, John Calder, Mary Caulfield, Hugh and the late Maureen Charlton, John Clarke, Peter Costello, the late Maurice Craig, Ita Daly, J.P. Donleavy, Gerard Ellis, the late Dr Garret Fitzgerald, Tom Gilligan, the late Robert Greacen, David Hanly, Dr. Peter Harbison, the late Michael Hartnett, Seamus Heaney, Aidan Higgins, the late Con and Margery Howard, the late Nevill Johnson, the late Peter Kavanagh, Peter Keogh, the late Harry and Lina Kernoff, Frances and the late Ben Kiely, the late Mary and Helen King, Thomas Kinsella, Brian Lalor, Fr. Aidan Lehane, Noel Lewis, the late James Liddy, the late Christy Little, Angel Loughrey, George MacDonnell, the late James McKenna, John McMahon, the late Ciarán MacMathúna, Peadar MacManus, the late Seán MacRéamoinn, the late Eamonn MacThomais, the late Ethel Mannin, the late David Marcus, Tom Matthews, Loretto Meagher, Vincent Meehan, Lucy and the late Ken Monaghan, Cynthia Moran Killeavy and the late Bunch Moran, Jay Murphy, Donal Nevin, Senator David Norris, John O'Brien, the late Paddy O'Brien, the late Eamonn O'Doherty, the late May O'Flaherty, the late Patsy Ronan, Patrick Pye, Liam Slattery, Tommy Smith, Camille Souter, the late Peter Stevens, Stephen Stokes, John Taylor, John de Vere White, Caroline Walsh and the late Owen Walsh.

I am most grateful to Brian Lalor, Noel Lewis, John McMahon and Peadar MacManus who read the manuscript and suggested vital corrections. Also for their consistent support to Senator David Norris, Emer and Joe

Acknowledgements

Costello TD, Joe Collins, formerly of Hodges Figgis Bookshop, Pete Hogan, writer Peter Costello, Brendan and Frances Gallagher, Adrian Kenny, Noel Lewis and Dympna O'Halloran, Colm and Maire and the late Peggy Lynch, John and Dympna McMahon, Peadar and Treasa MacManus, Loretta Meagher, Mark and Mandy Nulty, Stephen and Edward of Stokes Books, Dermot of the Secret Book Store, John and Patrick Taylor, Bob O'Cathail and Orna Donleavy, Brian O'Neill and Tony Byrne, Michael O'Reilly and Seamus Maguire, the late Dick Stynowski, An Walls, the late artist, Tony Walsh, the late Michael and Sarah Regan and their much-missed daughter, Mary Lynch.

For their technical support and expertise, I must thank Colman McMahon and Denis McCormack – and 'The Two Sisters', Bridget and Sally of Cumberland Street, on whose monitor half this book was composed. Also, the scintillating crew of Reads Print and Design Bureau, particularly, Conri Van Zyl, Anna, Brendan, Chris, Elaine, Gary, Nohema and Sean. Thanks too to Marco, Mateo, Paolo and all at Bar Italia, and David, Eileen and Steffano of Dunne and Crescenzi, who provided much-needed cheer and sustenance. To Tom Gilligan of The Duke, Frank of Davy Byrne's, Damien and Tom of Nesbitt's and Liam of The Old Stand, whose encouragement was manifested in liquid form. To Dr. Catherine Mullen, Dr. Keelan, Dr. McCann, Lisa Browne, Eamonn and Mater Hospital staff who helped me to recover!

A special thanks to the singular J.P. Donleavy for his kind Foreword. To Margie – 'The Arts Council of the Philippines' – whose hard work allowed me time to write. And, finally, to Dublin's most discerning and energetic publisher, David Givens of The Liffey Press, whose titles have made a unique contribution to our cultural and literary history. A pity he was not around when Flann O'Brien and fellow-authors needed him in the hungry 1940s . . .

QUOTATIONS AND EXTRACTS

The author and publishers are very grateful to the authors of the many books listed in the bibliography for the insights they provided into literary and artistic Dublin. We have quoted from a number of these and are thankful for permission to do so. We apologise to those for whom we were unable to trace the copyright holders, and we would be happy to correct any omissions in future editions of this book.

Quotations from poems by Patrick Kavanagh reproduced by kind permission of the Trustees of the Estate of the late Katherine B. Kavanagh through the Jonathan Williams Literary Agency, reprinted from *Collected Poems*, edited by Antoinette Quinn (Allen Lane, 2004). Quotations from poems by

Thomas Kinsella reproduced by kind permission of the poet. Quotations from poems by John Montague are reproduced by kind permission of the author and The Gallery Press.

Quotations from "A Portrait of the Artist" by Paul Durcan from *Cries of an Irish Caveman* published by Harvill, reprinted by permission of The Random House Group Ltd. Quotations from "No Flowers" by Paul Durcan from *Crazy About Women*, reproduced by permission of the National Gallery of Ireland. Quotations from poems by Brendan Kennelly reproduced with kind permission of the author and Bloodaxe Books. Permission to quote from "Unmarried Mothers" from Austin Clarke's *Collected Poems* edited by R. Dardis Clarke published by Carcanet/The Bridge Press (2007) granted by R. Dardis Clarke, 17 Oscar Square, Dublin 8.

PHOTOGRAPHS AND ILLUSTRATIONS

The author and publishers would like to thank the following for use of photographs and illustrations (page numbers in parentheses): John Cullen (236, 249); Frank Fennell Photography (143, 276); Evelyn Hofer (123); Pete Hogan (88, 144); *Irish Press* (203); *The Irish Times* (61, 75, 148, 166, 169, 173, 228, 268, 272); Harry Kernoff (77, 225, 230, 232); Brian Lalor (270); Derrick Michelson (195); Adolf Morath (101); National Gallery of Ireland (213); National Library of Ireland (4, 146); Louise Shorr, Waddington Custot Galleries (221). All other photographs are courtesy of the author or are in the public domain. The author and publishers apologise, however, for any omissions or errors which we would be happy to correct in subsequent printings of this book.

Foreword

Brendan Lynch's book evokes vibrant memories of an ancient Dublin. And could there be any other city in the world more worth speaking about? Old friends come back to life whose minds still speak from the soul. Ancient sorrows remembered to haunt, but in which a bit of bright light still glows. For without such men, we would be left lost in an empty wonderland examining our toes.

Men such as John Ryan who published in the pages of his magazine Envoy, my earliest writing, a short story entitled 'A Party On Saturday Afternoon'. And Ryan's voice could be heard loud and clear even when the Philistine and pompous pedant held full sway. And he it was who first introduced me to Desmond MacNamara, whose letters attest to his being a great correspondent, as well as one of Dublin's best Gossip Keepers. And this dear man always remaining traditionally dignified in the manner in which he conducted his life, but whom in some ways, if it were ever thought was possible to be the case in Dublin, was part of this ancient city's underground culture after the Second World War and also one of its true Bohemians.

But Mac, as he was known, always scrupulously well mannered and behaved, could, if crossed, be one of the world's greatest wielders of creative revenge. Nearly rivalling those meted out by his long and trusted friend, Brendan Behan, who had no peer in getting even with people. And this long before Behan, tongues of his shoes hanging out, was by dint of world fame welcomed into polite society. Ah, but let it be said, into which Behan would have barged anyway.

The only carp that one can have now is that in the blaze of recall one gets again inspired by reading these words which leave one wanting to race on and read more. While letting the brew of coffee boil over.

<div style="text-align: right;">
J.P. Donleavy,

July 1, 2011
</div>

An old bag of words, but mother and foster-mother of some famous sons and with no intention of letting you forget the fact. She will never tire of showing you where her James used to walk, recalling what her Sean used to say, how her Willie and George and Oscar used behave; she will breathe her George Bernard down your ear until you scream for mercy. And she will blandly forget that when she had them she used to clip their ears every time they opened their mouths. – From *Tom Corkery's Dublin*

Chapter One

BAGGOTONIA, DUBLIN'S BOHEMIA

Dublin has its own special colony of Bohemia, its 'Latin Quarter'. – Olivia Robertson

'WE'VE A LOT TO THANK THE BRITISH for,' Brendan Behan informed this author in Herbert Street one summer morning in 1958, as his rambling jacket finally surrendered a recalcitrant key.

'Personally, I don't give a fiddler's about harmony or space. I got well used to smaller joints such as Her Majesty's Strangeways and Walton suites. And all I know about architecture is Michael Scott's glassy Busáras down by the Custom House.'

He paused by the expansive eighteenth century door: 'But did you ever see such handsome houses or squares? As my bardic neighbour John Montague might say, you can feel the rhythm. Look at those railings. And the granite steps dancing in the sun, wouldn't they make your granny skip?'

'And here inside, what about that fanlight? And the stairs and those cornices up there? And my own classical reliefs, say hello to Homer and Ovid. I wonder what the previous grand residents would think of the scribblers and dawbers and chancers who have now taken over? It will all change one day again, but we'll enjoy it while we can!'

London has Fitzrovia, Paris its Left Bank, but Georgian Dublin boasts an equally atmospheric literary and artistic quarter centred on Baggot Street beside Brendan's new abode. Up to the 1990s, the wide and curving avenue was illuminated by a central strip of cherry trees whose leaves carpeted the area each autumn. Girdled by the Grand Canal, Baggot Street and parallel Leeson Street marked the hub of the unmapped village of writers, artists and

students which in the 1950s became known as Baggotonia.

Few urban enclaves encompassed such creative richness. Its inhabitants and habitués included four winners of the Nobel Prize for Literature and nearly every nineteenth and twentieth century Irish writer of note, from Oscar Wilde and George Bernard Shaw to James Joyce, Samuel Beckett, Flann O'Brien and Seamus Heaney. And a profusion of artists from Jack B. Yeats to Mainie Jellett and Camille Souter, who painted in the shadow of Francis Bacon's Baggot Street birthplace. Brendan Behan's neighbours included Liam O'Flaherty and Mary Lavin. John Banville, Maeve Binchy and Colm Toibín were later arrivals. Sculptor Des MacNamara, a Baggotonian born and bred, remarked: 'I was surrounded by prodigals and geniuses!'

A well-nourished headwater, twentieth century Baggot and Leeson Streets were fed by equally fruitful tributaries. Ghosts of the past looked over the shoulders of artists and scribes in their stuccoed and fungi-adorned garrets, reflecting like geological sediments the successive movements in both literature and art. From the nineteenth century of Charles Lever and Lady Morgan to the early twentieth century Irish Literary Revival of W.B. Yeats and Lady Gregory. From popular novelist Annie P. Smithson and George Moore's revolutionary realism to the kitchen sink drama of Behan's era. James Joyce first discussed his theory of art on the banks of the unassuming canal, which local poet Patrick Kavanagh celebrated:

> No one will speak in prose
> Who finds his way to these Parnassian islands.

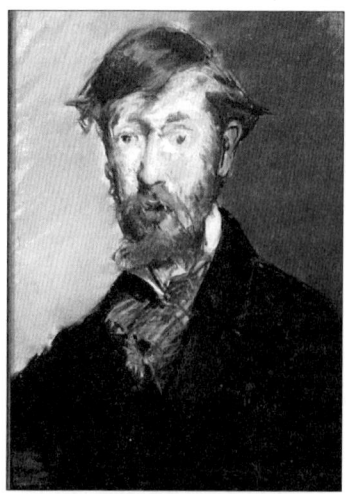
Portrait of George Moore by Manet

Paris devotee George Moore, friend of Stéphane Mallarmé and Eduard Manet, was one of the first to be enamoured of Baggotonia: 'I returned to Ely Place, pleased by the rickety lodging-house appearance of Baggot Street against the evening sky, and, for the moment forgetful of the incompatibility of dogma and literature, my thoughts melted into a meditation, the subject of which was that the sun sets nowhere so beautifully as it does from the end of Baggot Street.'

Moore regularly visited his near neighbour, playwright Edward Martyn: 'Two short flights of stairs, and we are in his room. It

never changes – the same litter from day to day, the same old and broken mahogany furniture, the same musty wallpaper, dusty manuscripts lying in heaps, and many dusty books. If one likes a man one likes his habits, and never do I go into Edward's room without admiring the old prints he tacks on the wall, or looking through the books on the great round table or admiring the little sofa between the table and the Japanese screen which Edward bought for a few shillings down on the quays – a torn ragged screen, but serviceable enough; it keeps out the draughts. On the table is a candlestick made out of white tin, designed probably by Edward himself, for it holds four candles. He prefers candles for reading, but he snuffs them when I enter and lights the gas, offers me a cigar, refills his churchwarden and closes his book.'

Baggot Street had its origins in the Viking village of Baggotrath, where muskets flashed in 1649, as Parliamentarians defeated Royalists and paved the way for Cromwell's conquest of Ireland. Starting in St. Stephen's Green, both Baggot and Leeson Streets were the main medieval roads from Dublin to the south. In the late 1700s, they framed a bustling new Dublin. Georgian society originally centred on the northside of the city. But fashion followed the Duke of Leinster southwards in 1745, when he erected the mansion on Kildare Street which now functions as the Dáil, the Irish parliament.

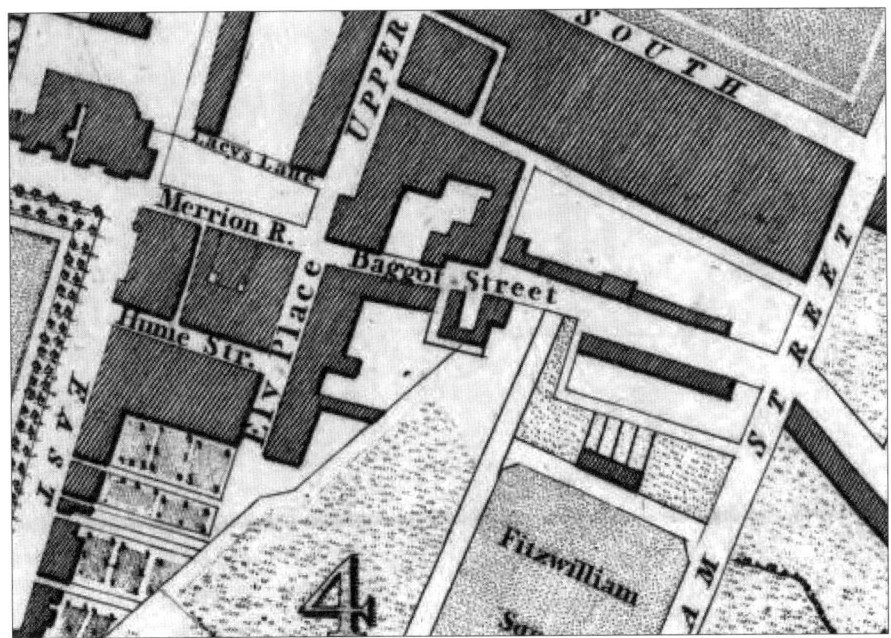

Detail, Plan of the City of Dublin (William Faden, 1797)

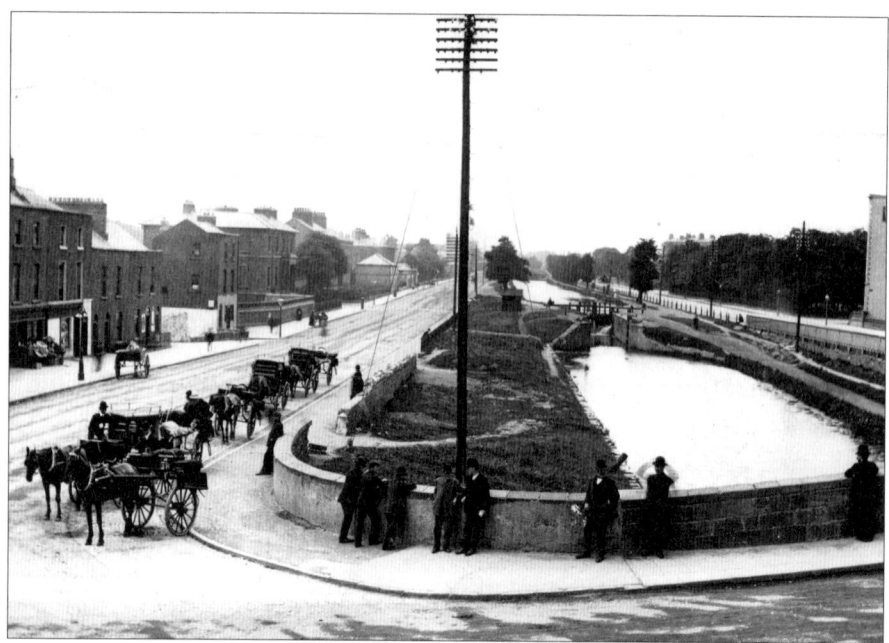

Baggot Street Bridge at the turn of the twentieth century

Uninviting swampland was transformed into a sea of glinting windows. Merrion and Fitzwilliam Squares and satellite streets rose in a symmetry of mellow brickwork, fanlight tracery and ornate railings and balconies. Novelist Barbara Fitzgerald wrote: 'The high red houses of Fitzwilliam Square were lit up by the westering sun; they glowed tranquilly in the warm light and upper windows and threw back a fiery gleam.' The clop-clop of carriage horses filled new thoroughfares; Georgian Dublin had arrived in splendour. The population trebled within a century to reach 180,000 in 1800. Dublin became the largest and most fashionable British city after London. Its private mansions complemented by such public edifices as College Green's colonnaded parliament and Gandon's green-domed Custom House and Four Courts. Public gas lighting banished darkness in 1825, electricity followed at the end of the century. The lofty swan-neck streetlamps complemented the granite-paved grandeur.

But the apotheosis was to be short-lived. Rural immigration and the transfer of Ireland's parliament to London in 1801 sparked the decline of the Anglo-Irish class. In 1841, Daniel O'Connell became the city's first Catholic Lord Mayor for 150 years. Dissension replaced security, shells and bullets shattered city landmarks and bastions of power. The country's independence in 1921 completed the process. In Georgian Dublin, only a few families survived to 1940 as owner-occupiers. The beautiful houses were divided and

rented. Actors, artists, poets, students, writers and the dispossessed moved in, bringing new colour and vitality to the quarter.

The atmosphere was infectious. A lighthouse of culture, Parsons redbrick bookshop energised Baggotonia's summit, the crest of Baggot Street canal bridge. Run by five ladies, it attracted all the local literati including Frank O'Connor and permanent resident, Patrick Kavanagh, and visitors Nelson Algren, John Berryman and Laurie Lee. Novelist Mary Lavin noted that there were often as many writers on the shop's floor as on its shelves. Olivia Robertson arrived in 1949 and observed: 'Dublin has its own special colony of Bohemia, its 'Latin Quarter'. My first act on arrival was to walk up Baggot Street, our little Chelsea, and buy an exercise book: I felt adult – a writer.'

Soon a prolific scribe herself, Olivia recorded: 'The houses are for the most part transformed into flats; and behind the flats are enticing little lanes with garages. Living over the garages are the artists, whose maisonettes, bravely painted, do indeed remind one of a Chelsea mews. A line of public houses frequented by artists keeps up Baggot Street's artistic reputation until it nears Stephen's Green, where it narrows into a gorge full of restaurants and brings one to the Country Shop, where one can eat home-grown food, buy arts and craft objects, and in the top back room find any number of artists and students.'

With a population unchanged from 400,000 in 1900, Dublin in 1950 was still the city that Joyce had known. Turf smoke incensed the air, bicycle bells rang, war-resurrected horse coaches restored a touch of old grandeur. Until buses took over, streets were illuminated by crackling armatures and the lightning flashes of discordant *Ulyssian* trams. Children swung on ropes from lamp posts. Shrines and fluttering washing added a Neapolitan dash to courtyards and backstreets. Most men doffed a hat or a cap, the bouquet of bacon and egg advertised nondescript cafes. Timekeeping was not a virtue. One could leisurely traverse the city's major streets in half a day. More than sufficient time to observe, browse, gossip and exchange opinions. A haven – for the time being – from the development and consumerism which was gathering pace in other European countries.

Tom Corkery saw the city as a loquacious old dame, with long-winded reminiscences and sentimental keepsakes strewing the drawing-room: 'A garrulous pleasure-loving provincial lady of good family, settling comfortably into middle-age, putting on too much weight in the wrong places. There is enough malice in her to keep her conversation interesting, and hospitality is for her more a pleasure than a duty. Like all provincial ladies she loves the

fuss of visitors; she will flatter them to their faces, gossip about them behind their backs, and is as much flattered as annoyed if, when they leave, they make snide remarks about her. The only unforgivable thing is to say nothing at all about her.'

The Dubliner was not unaware of his city's ambivalence towards her writers: 'An old bag of words, but mother and foster-mother of some famous sons and with no intention of letting you forget the fact. She will never tire of showing you where her James used to walk, recalling what her Sean used to say, how her Willie and George and Oscar used to behave; she will breathe her George Bernard down your ear until you scream for mercy. And she will blandly forget that when she had them she used to clip their ears every time they opened their mouths.'

'Without doubt the founding father of Bohemian Dublin,' 1950s *enfant terrible* Owen Walsh described John B. Yeats, whose Stephen's Green studio was Dublin's clearing house for artistic gossip in the early 1900s. The term Bohemian originated in mid-nineteenth century Paris, when penniless actors, artists, writers and anti-Establishment rebels gravitated towards the cheaper

'Dublin in 1950 was still the city that Joyce had known'

quarter of gypsies from Bohemia. Henry Murger popularised the life of those for whom art was a faith, rather than a trade, in his 1851 *Scenes de la Boheme* stories. Based on these, Puccini's *La Boheme* broadcast Bohemia's endearing but perilous charm to an international audience. George de Maurier's *Trilby* repeated the theme with its account of the fortunes of three artists and their Irish models.

For Bohemians, liberty and matters of the mind took precedence over appearances and material dross. They could be themselves, say what they felt. The business of living was reduced to the simplicities. *L'Artiste* recorded: 'There is in Paris a multitude of young artists, full of resolution and hope. They scorn the realities of life and they ask nothing of the world but glory. A studio in some attic or other, a few reliefs and engravings, a little paint, a canvas and some brushes, that's all their fortune. Others they lack even bread, but they have the world of the imagination, and this world is very rich.'

Bohemia was said to have been bordered on the north by cold, on the west by hunger, on the south by love and on the east by hope. This would have been an accurate description of mid-twentieth century Baggotonia. Patrick Kavanagh's first mattress was the floor, artist Isa MacNie levitated on butter boxes. The climate could not have been more inimical to creativity. Firewood or a drink? Money was scarce, pawnshops abounded. Interest in art and literature was minimal, publishers and galleries were few. Artist Noel Lewis recalled: 'Higher education was only for a fortunate few. Books were censored, the mere whiff of sex would have a work banned or a theatre picketed.'

While barefoot children shouted 'Herald a' Mail' at street corners and Georgian houses sank into dilapidation, a remarkable levity defied the rationing and censorship. J.P. Donleavy remembered a Jewish gentleman in carnation-adorned cutaway coat and striped trousers, who courteously directed traffic at the intersection of Grafton and Suffolk Streets. Unlike more self-conscious Fitzrovia, an undercurrent of wit and irony illuminated Dublin's Bohemia. Shortly after his 1949 arrival, English newcomer Nevill Johnson pulled a high stool to Doheny and Nesbitt's counter and rejoiced: 'Like the first intriguing image of a foreign land, the magic of Dublin enlarged my heart. Through its people, thonged as they were by dogma and tacitly in thrall to the hereafter, ran a maverick undertow. These folk laughed and winked like boys behind Godmaster's back. Buttressed by piety, capped and shod by wit and crafty indolence, even the poorest lived out a strange Dickensian scenario. Day to day living passed unhurried, inexpensive.'

The bare bones of a fanlight over a hungry door captivated Louis MacNeice:

> But she holds my mind
> With her seedy elegance,
> With her gentle veils of rain
> And all her ghosts that walk
> And all that hide behind
> Her Georgian facades –

All, however, was not peace and harmony in this anarchic Eden. Frank O'Connor and Sean O'Faolain were locked in constant war with the government censor. Intense jealousies and rivalries coloured the relationships of both artists and writers. Traditional painters derided modernists such as Mainie Jellett, whose supporters exhibited equal disdain. Hungry scribes envied Austin Clarke his Radio Éireann and other outlets, he equally resented the hack work necessary for survival. 'What does he do?' Constantine Fitzgibbon scorned Aidan Higgins, whose recently published *Felo de Se* was being acclaimed. Ethel Mannin reiterated: 'I loved Dublin, but oh the gossip and the backbiting and the "Mind-you-I'm-not-saying-anything" and then tearing a person's character to shreds.'

University-educated poets looked askance at Brendan Behan, whom Patrick Kavanagh detested even more vehemently. Liam O'Flaherty met Patrick one morning.

'I'm going to emigrate,' he told the novelist.

'Where?' Liam asked.

'To the fuckin' moon. So I wouldn't have to see Brendan Behan anymore. It's my only chance to die happy.'

The literati laboured under the giant shadows of the recently departed James Joyce and W.B. Yeats. But, as J.P. Donleavy noted: 'In the disparate and argumentative lot which clamoured with their polarised literary and political views, there was one unifying force. Without doubt, Joyce was a hero to all of us, even if we hadn't read everything he had written. His courage, consistency and single-minded sense of purpose were sources of great inspiration and encouragement.'

Two other key figures in the immediate post-war period were sculptor Des MacNamara and *Envoy* editor, John Ryan. Donleavy recalled: 'These two men were immense, they were the art world of Dublin. Des Mac was a little kind of magnet. He established an artistic ambience where would-be writ-

ers and artists could relax and exchange ideas. John Ryan was a fine painter and a wonderful diplomat. He was incredibly generous with his support and encouragement of so many diverse aspirants, including myself. John and Des are overdue a monument in Dublin.'

A United Arts Club member insisted: 'Kingsley Amis, a humourless dilettante, don't insult Flann O'Brien by comparing him to that yahoo!' The Club and a profusion of hostelries provided congenial debating venues for writers and such sociable artists as Harry Kernoff and Cecil Salkeld. The latter's murals, *The Triumph of Bacchus*, enlivened Davy Byrne's, outside which a handful of Joyceans unsteadily dismounted from their brougham after the first organised Bloomsday celebration in 1954. Cecil's annual retouching of *Bacchus* frequently took as long as the original work – and became itself part of Dublin lore. The artist's fecklessness saddened some observers. Elizabeth Coxhead, however, noted that 'in a city so lavishly endowed it can, perhaps, afford the waste.'

Thomas Kinsella, author of *Baggot Street Deserta*, was an early Baggotonian:

> The window is wide
> On a crawling arch of stars, and the night
> Reacts faintly to the mathematic
> Passion of a cello sonata
> Plotting the quiet of my attic...
> My quarter inch of cigarette
> Goes flaring down to Baggot Street.

Conflicting tides of industry and indolence impelled the daylight tide up and down the thoroughfare. Jack B. Yeats on his constitutional, baby-faced Flann O'Brien gliding southwards with his *Irish Times* column. Poet Patrick Kavanagh, who viewed the world as a parish, growling, 'What news, foreign or domestic?' before hiding in a doorway to avoid Brendan Behan or Frank O'Connor. 'My kingdom for a horse!' Rouged Micheál MacLiammóir paused on his

Francis Bacon was born in Lower Baggot Street

thespian path from Harcourt Terrace to salute the birthplace of kindred spirit Francis Bacon at 63 Lower Baggot Street. Though it has never been acknowledged, Bacon's work undoubtedly reflected his childhood during Ireland's Troubles, when he and his family spent sleepless nights in fear of being killed or burned out.

Reviving the street's Cuala Press publishing tradition, Dolmen Press founder Liam Miller lived at 94 Lower Baggot Street. Opposite Lampshades inviting lounge, whose regulars included theatre director Jim Fitzgerald and Gainor Crist, the American model for J.P. Donleavy's *The Ginger Man*. The bar became the unofficial headquarters of the avant-garde Pike Theatre, first to stage Brendan Behan's *The Quare Fellow* and the Irish premiere of Beckett's *Waiting for Godot*. Here in January 1955, after only a few weeks' courtship, Brendan proposed to Cecil Salkeld's daughter, Beatrice.

Des MacNamara sampled Lampshades after moving to a mews in Fitzwilliam Place, close to Paul Henry's former studio in Merrion Row: 'Entered by two archways, it was really remote from the world. Beside me was a junkshop whose owner sold African masks and Infant of Prague statues and who kept dozens of chickens which were more than a match for my frisky cats. The laneways which ran behind the Georgian houses contributed to the magic of the area. And every spring the high stone walls were coloured with gleeful outpourings of chrysanthemums and other airmailed wild flowers.'

Former Arts Club Vice-President, cartoonist Isa MacNie, lived around the corner on Baggot Street. Another cat-lover, Isa slept on a bed propped up by butter boxes which she constantly moved to avoid the falling plaster. Her neighbour was the equally eccentric jazz musician and former prisoner, George Desmond Hodnett. Baggotonians even had their own local hospital, conveniently situated between Mooney's and Searson's pubs. Here, Liam Miller, Patrick Kavanagh and Brendan Behan frequently recovered from their exertions, and pioneer Atlantic aviator James Fitzmaurice died in 1965. Behind the hospital were the studios of artists James le Jeune and Paddy Collins.

Close to composer Edward Bunting's former residence, Guinness heir and traditional music lover Garech Browne founded Claddagh Records in his Quinns Lane mews. Though Liam O'Flaherty complained of finding the recordist drunk, Patrick Kavanagh successfully recorded his own poetry for Claddagh and posterity. Samuel Beckett supervised Jack MacGowran's recording of 'End of Day', with Edward Beckett on flute and John Beckett on harmonium. Music had also featured in the early life of Beckett's friend

James Joyce, whose singing was encouraged by John McCormack. While staying on Shelbourne Road, Joyce borrowed money to pay the deposit on a piano. Before the instrument was repossessed, the 22-year-old practised sufficiently to win a bronze medal for singing at the May 1904 Feis Ceoil. The judge, 'Funiculi-Funicula' composer Luigi Denza, would have awarded a gold medal, had Joyce been able to play an additional piece of music on sight.

Victorian Pembroke Road's leafy continuation of Baggot Street featured the home of aviatrix Lady Mary Heath. Her escape from a Connemara-forced landing with Oliver St John Gogarty occasioned a rare note of congratulations from James Joyce. But it was poet Patrick Kavanagh who made Pemroke Road really famous:

> On Pembroke Road look out for my ghost
> Dishevelled with shoes untied.

A familiar sight from 1943 until 1958, he loped along in a belted gabardine, down-brimmed hat and horn-rimmed glasses, muttering to himself and kicking at imaginary obstacles. He chatted to everyone. From the local beauties and the children behind the railings of Miss Meredith's private school, where Maeve Binchy taught, to the house-proud wives who vainly remonstrated with him for his rural habit of spitting.

Peter Kavanagh remembered the cavernous first floor flat which he shared with Patrick before going to America: 'The rooms were very large and each had a fireplace with marble mantle. The ceilings were ten feet. In each room were two six foot windows that leaked cold air. Wooden shutters were on each of the windows but even when closed tight failed to stop a strong breeze which blew through the rooms.'

Peter overlooked the apartment's Bohemian squalor. Ash overflowed from the grate, tea leaves and empty sardine and soup tins filled the bath. A battered sofa listed in a sea of newspapers, books and yellowing typescripts. Patrick's bed was a mattress on the floor, which was occasionally elevated by bricks. But, like Baudelaire, the poet felt apart from his fellow-scribes in their equally unkempt flats and mews houses: 'Now, part of my poverty-stricken upbringing was my belief in respectability – a steady job, decency. The bohemian rascals living it up in basements horrfied me. If I had joined them and endured them they'd have taken me to their bosoms. But I couldn't do it. Instinctively I realised that they were embittered people worshipping the poor man's poet. Their left-wingery was defeat.'

Patrick's near neighbour was watercolourist Bunch Moran, whose third-floor room faced the sun and the Dublin mountains. Bunch scared many a fellow-artist off her favourite canal patch, but she met her match in Kavanagh: 'I loved his poetry but he talked so much to himself as he walked along, that I was always afraid to ask him to pose. And, of course, I made a terrible mistake the first time I met him. I informed him that one of my earliest shows had been opened by Cecil Salkeld. I'd forgotten that Cecil was the father-in-law of Patrick's arch-enemy, Brendan Behan!'

Composer Sir Charles Villiers Stanford was born around the corner in Herbert Street in 1852. Nothing more dramatically marked the contrast the century had wrought than the raucous arrival in the street of Brendan Francis Behan. Late of less fashionable Russell Street and various prisons, he moved into number fifteen with his new wife Beatrice in 1955. A few doors away, John and Madeleine Montague and guest Doris Lessing shuddered at the rebel's antics:

> The pubs shut: a released bull,
> Behan shoulders up the street,
> Topples into our basement, roaring 'John!'

This was the start of Brendan's most successful decade, from the triumphs of *The Quare Fellow* and *The Hostage* to his *Irish Press* column and the publication of *Borstal Boy*. His fellow-tenants were typical of the Georgian house occupants of the 1950s: 'There were elderly ladies of a loyalist nature from Ballsbridge, and pensioners from the Indian Army. There were former ladies of the Sweep, two Mayo chaps off a building job on Wet Time, a deported American and a couple of African medical students, a man that sold pigs the day before yesterday, a well-known builder and a publican, equally well known in his own shop, myself and Packy from Scarriff.'

Though Baggot Street was Baggotonia's main artery, the adjoining thoroughfares and laneways boasted an equal array of talent. And little theatres. John Montague insisted that one could not drop a load of coal into a local basement without disturbing an avant-garde play. And there was no shortage of real life theatricals. From kidnapping and the political murder of James Joyce's friends to enforced exile for Joyce and many other writers.

Chapter Two

LIGHT AND SHADE

Our virtues, all, are withered everyone!
Our music vanished, and our skill to sing!
– James Stephens

'STATELY, PLUMP BUCK MULLIGAN CAME from the stairhead . . .' Literary plots which reverberated throughout the world exalt the elegant streets and squares which stretch westwards from Baggotonia's Grand Canal. Among the quarter's habitués were the authors of such works as *Ulysses*, *The Importance of Being Earnest*, *Esther Waters*, *The Playboy of the Western World*, *The Informer*, *The Crock of Gold*, *Pygmalion* and *Waiting for Godot*.

But dramas of hunger, disillusion, exile and death overshadowed the lives of their creators. Orphan novelist-to-be James Stephens stole bread from the Stephen's Green ducks. Oscar Wilde was scarred for life by the loss of his first two great loves. Oliver St. John Gogarty, Buck Mulligan in *Ulysses*, was kidnapped by political opponents. John Millington Synge died at the tragically early age of 38. Two of James Joyce's closest friends, George Clancy and Francis Sheehy Skeffington, were shot. Another, Tom Kettle, perished on the Somme.

Many scribes relished the space and light of a Georgian mansion room, others preferred the independence of the smaller mews. Novelist Elizabeth Bowen was privileged to be born in 1899 in a spacious Herbert Place house, which featured evenings of piano music and Victorian song. She retained fond memories of her childhood Georgian quarter: 'Some days, a pinkish suncharged gauze hung even over the houses that were in shadow; sunlight marked with its blades the intersection of streets and dissolved over the mews that I saw through archways. On such days, Dublin seemed to seal up sunshine as an unopened orange seals up juice. The most implacable buildings were lanced

with light; the glass half-moons over the darkest front door glowed with sun that, let in by a staircase window, fell like a cascade down flights of stairs.'

Elizabeth's family church was the landmark Peppercannister, St. Stephen's, whose organ music competed with the cascades of the nearby canal. Beside it, Thomas Kinsella published poems under his own Peppercannister imprint.

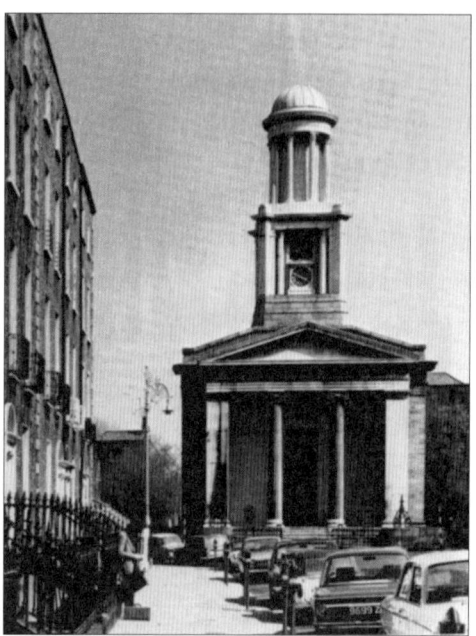

St. Stephen's Church, better known as the Peppercannister

He faced the artists' haven of Upper Mount Street, where the walls of Anne Yeats's flat shimmered with the paintings of her uncle, Jack B. Yeats. The latter's funeral service at the Peppercannister in March 1957 witnessed one of Irish religion's casual cruelties. Lord Longford of the Gate Theatre read the lesson. Gallery owner Victor Waddington, novelist Terence de Vere White and poet Thomas MacGreevy were pallbearers. Taoiseach Eamon de Valera and cabinet members paced up and down in the exterior cold; the Catholic church did not allow its members to enter Anglican establishments in those days.

Architectural critic Maurice Craig wrote his classic account of *Dublin, 1660-1860* in a sunny room overlooking Merrion Square. But not all writers and artists could afford Fitzwilliam or Merrion Square airiness. Nevill Johnson whitewashed an uninhabitable mews off Hatch Street, where George Bernard Shaw had once lived: 'I made a ceiling, and the round brick windows I covered with expanded wooden garden trellis to which I pinned varnished tracing paper. In the very centre of the floor, I installed a cast-iron coke burning stove and round it placed five or six tapering wooden butter boxes collected from the grocer. Inverted they served well as seats.'

Sculptor John Behan replicated Nevill's modest living in Herbert Lane, around the corner from writers John Banville and Leland Bardwell: 'We might have been dwarfed by the grander houses, but the lane was a happy close-knit mix of workshops, garages and small businesses. And, despite their size, the mews buildings housed many families. I had my own work-

shop in the yard and it was from there that I set out for my first exhibition in the old Project Gallery. Many interesting people lived nearby, such as artists Michael Kane, Eddie Mooney, Leslie MacWeeney and poet Hayden Murphy. And at the bottom of the lane, we had Brendan Behan and those marvellous revues in the little Pike.'

The Pike was only one of John Montague's favourite theatre clubs. Madame Bannard Cogley managed her Studio Theatre at 43 Upper Mount Street. Merrion Square hosted Liam Miller's Lantern, where Seamus Heaney made his Dublin poetry-reading debut. Barry Cassin and Nora Lever's Thirty Seven Theatre flourished in Lower Baggot Street, Phyllis Ryan's cast members doubled as booking clerks in Ely Place's aptly-titled Pocket Theatre. Despite its equally diminutive setting, the canalside Pike became Dublin's most famous theatre. Its productions of Behan and Beckett achieved international fame, before its equally spectacular demise after prosecution for staging Tennessee Williams' allegedly indecent *The Rose Tattoo*.

> Still south I went and west and south again.
> Through Wicklow from the morning till the night,
> And far from cities, and the sights of men,
> Lived with the sunshine, and the moon's delight.

One of Irish theatre's major tragedies was the premature death of playwright John Millington Synge in 1909, which shocked John and W.B. Yeats and his many admirers. The youngest of the Irish Literary Revival's principal figures, he was the first to die. Edward Stephens visited the 38-year old playwright at the Elphis Nursing Home in Lower Mount Street, where poet Susan Mitchell also died. He was in a sunny back room with a view of his beloved hills: 'He asked me whether I had heard any blackbirds singing yet. I said that I had heard thrushes, but not yet any blackbirds. For a few minutes I chatted with him about

The premature death of John Millington Synge shocked his many admirers

home and college interests and left without understanding that I would not see him again.'

Synge's Protestant family ignored his mainly Catholic theatrical colleagues, who flanked the opposite side of his open grave at the Mount Jerome funeral.

Sir William Wilde

Merrion Square will forever be associated with playwright Oscar Wilde and his parents, Lady Jane Francesca and Sir William Wilde. They resided at the number one corner house from 1855 until 1879, across the square from the reclusive Gothic novelist, Joseph Sheridan Le Fanu, who worked from midnight until dawn on such spine-chillers as *Uncle Silas* and *In a Glass Darkly*.

Like the Joyce family's failing fortunes, the decline of the Anglo-Irish class greatly enriched literature. Born in 1821, Lady Jane was a grandniece of Dublin's other noted Gothic writer, Rev. Charles Maturin, who once remarked that Ireland 'was the only country on earth where, from the strange existing opposition of religion, politics and manners, the extreme of refinement and barbarism are united'.

The eccentricities and extravagances of both Oscar and Lady Wilde owed much to the dandified Maturin. His York Street neighbour, poet James Clarence Mangan, once observed him in 'an extraordinary double-belted and treble-caped rug of an old garment'. Maturin frequently walked with odd shoes and a red wafer pasted on his forehead, a warning that he was not to be disturbed. Acclaimed by Walter Scott and Lord Byron, his choice of subject matter reflected the ordeal of a Hugenot forebear, who had been crippled by 26 years in the Bastille. Maturin's *Melmoth the Wanderer*, and its mysterious satanic hero, influenced Balzac and Baudelaire. His habit of closing the shutters to keep out daylight was replicated by Lady Wilde for her Merrion Square salon. Oscar Wilde adopted the name Melmoth to

conceal his identity when he was released from prison, before dying in the Paris of his equally tortured ancestor.

Author, poet and wit, Lady Wilde's translations and Irish folk-tales influenced the pre-Raphaelites and W.B. Yeats. An ardent nationalist in deed as in word, before her marriage she was once caught *in flagrante delicto* with Home Rule leader Isaac Butt. She campaigned for better education for women and optimistically insisted: 'The best chance, perhaps, of domestic felicity is when all the family are Bohemians, and all clever, and all enjoy thoroughly the erratic, impulsive, reckless life of work and glory, indifferent to everything save the intense moments of popular applause.'

A young Lady Wilde

Lady Wilde's Saturday literary salon attracted Dublin's leading academics, artists, barristers, politicians and writers. One visitor remembered that Lady Wilde 'would listen to a flood of bawdy talk and lewd jests without turning a hair'. *The Atheneum* wrote that her guests included all those 'whom prudish Dublin had hitherto carefully kept apart. Hers was the first, and for a long time, the only "Bohemian" house in Dublin.'

The closed shutters and flickering candles ensured a dramatic atmosphere for the entertainment of musicians, poets and actors. Lady Jane dressed exotically, as befitted her idea of a hostess. The Comtesse de Bremont remarked on her towering head-dress and velvet gown, her long gold ear-rings, the yellow lace fichu crossed on her breast and fastened with innumerable enormous brooches, and the huge bracelets of turquoise and gold and rings on every finger.

Husband William Wilde matched his wife's erudition and eccentricity. He founded medical journals and wrote books on travel and antiquities. Knighted in 1864, the antiquarian and surgeon was appointed Surgeon Oculist to Queen Victoria and was also decorated by Sweden. Happy to be addressed as 'Chevalier', he frequently wore the uniform and Order of the Polar Star. His attire influenced Oscar's velvet dress sense as much as that of his

flamboyant mother. Literature was the family's staple diet, Oscar's favourites were the historical romances. A prodigious reader by the age of ten, he told a friend: 'I would for a wager, read a three-volume in half an hour so closely as to be able to give an accurate resume of the plot of the story; by one hour's reading I was enabled to give a fair narrative of the incidental scenes and the most pertinent dialogue.'

Tragedy, sadly, fuelled the Wilde fantasies. Two of Sir William's illegitimate daughters perished in a fire. When Oscar was twelve, he experienced his first major personal tragedy. After an illness in Merrion Square, his nine-year-old sister Isola was sent to recuperate at Edgworthstown, but 'the radiant angel of our home' died on February 23, 1867. Oscar was heartbroken and, until he left for England, regularly visited her grave. A lock of her hair was found among his few possessions when he died, in an envelope he had coloured himself with their interlinked initials. He wrote 'Requiescat' in her memory:

> Peace, peace, she cannot hear
> Lyre or sonnet,
> All my life's buried here,
> Heap earth upon it.

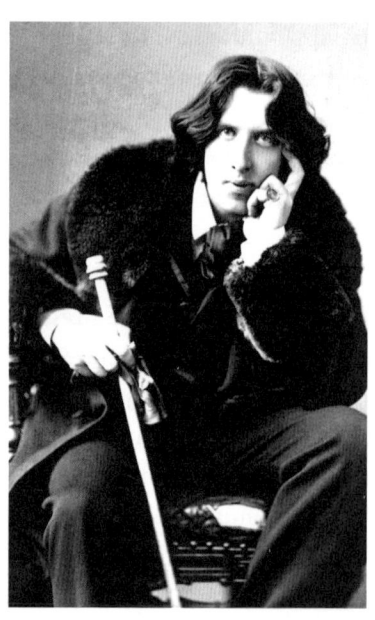

Oscar Wilde, 1882

A decade later, Oscar Wilde lost the second great love of his life. She was the beautiful Florence Balcombe, whom he met in 1875 when she was 17 and he 20. They were friends for three years, but he did not have the means to marry and she became the bride of author Bram Stoker. Years later, he wrote to Ellen Terry: 'She thinks I never loved her, thinks I forget. My God, how could I?' Oscar sent Florence a farewell note, in which he said that he was leaving Ireland. Fortune never favoured the Wildes. By the time of the playwright's premature demise in 1900 at the age of 46, all the Wildes of Merrion Square were dead as well as Oscar's young wife, Constance.

It was outside Wilde's house on June 10, 1904, that another famous literary exile, James Joyce, first encountered his future wife, Nora Barnacle. He dated

the red-haired chambermaid again six days later, the day immortalised in *Ulysses*. The following October, the impoverished pair left Ireland for Zurich and an uncertain future. He was 22, she was two years younger. Telling Padraic Colum that he could not walk on water like Jesus Christ, Joyce solicited money for his voyage. He wrote to Seamus O'Sullivan: 'As you cannot give me money, will you do this for me. Make up a parcel of 1 toothbrush and powder, 1 nail brush, 1 pair of black boots and any coat and vest you have to spare. These will be very useful. If you are not here meet me outside Davy Byrne's with the parcel at 10 past 7. I have absolutely no boots.'

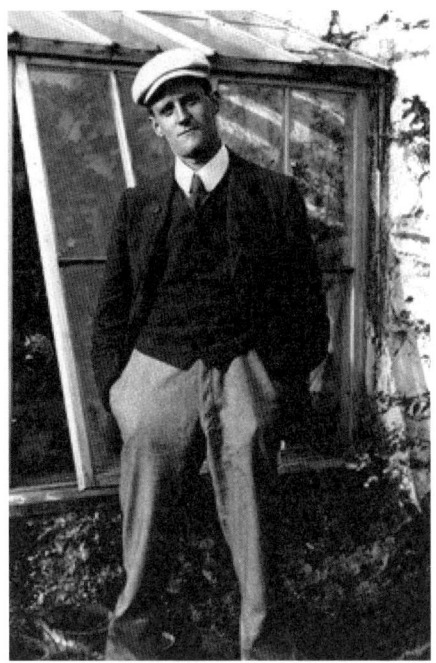
Graduate James Joyce ponders exile

Baggotonia played a key role in Joyce's development. He studied at the university established by Cardinal Newman in Buck Whaley's former mansion on Stephen's Green. While there, he first appeared in print, with his April 1900 *Fortnightly Review* feature on Henrik Ibsen's *When We Dead Awaken*. Four years later, George Russell's *Irish Homestead* published his earliest short story, 'Sisters'. Joyce first met W.B. Yeats and fellow-poet and future boon-companion, Oliver St. John Gogarty, in the environs of Kildare Street's National Library. Joyce's friend, poet Padraic Colum, worked as a clerk in the street, on which a lady harpist plays in Joyce's story, 'Two Gallants'. Colum recalled the irony that, long before he paid homage to Homer with *Ulysses*, Joyce advised him that the Greek epics were outside the tradition of European culture.

Walking to Leeson Street, novelist Lafcadio Hearn's birthplace, Joyce's literary creation, Stephen Dedalus, proclaimed his commitment to art and his decision to leave Ireland:

> I will not serve that in which I no longer believe, whether it call itself my home, my fatherland, or my church; and I will try to express myself in some mode of life or art as freely as I can and as wholly as I can, using for my defence the only arms I allow myself to use – silence, exile and cunning.

Nearby Ely Place was the scene of Joyce's last meeting in 1909 with Oliver St. John Gogarty. Having chosen the lonely path of art and exile, Joyce scorned the summer beauty of his former benefactor's garden: 'He offered me grog, wine, coffee, tea; but I took nothing. . . . To everything I said, "You have your life. Leave me to mine."'

Gogarty, ironically, soon followed him into exile, a casualty of the bitter Irish civil war. Joyce remained apolitical but he was not unaware of the inequalities which provoked the movement for Irish independence. Stephen Dedalus noted the gulf between the landed classes and the dispossessed, as he passed a Kildare Street hotel:

Oliver St John Gogarty, by William Orpen

The name of the hotel, a colourless polished wood, and its colourless front stung him like a glance of polite disdain. He stared angrily back at the softly lit drawing-room of the hotel in which he imagined the sleek lives of the patricians of Ireland housed in calm. They thought of army commissions and land agents; peasants greeted them along the roads in the country; they knew the names of certain French dishes and gave orders to jarvies in high-pitched provincial voices which pierced through their skin-tight accents.

Joyce's friends Francis Sheehy Skeffington and George Clancy were shot dead by British troops. The Galway church and hall, founded by Literary Revival co-founder Edward Martyn, were burned by Black and Tans. Gogarty, who had become a surgeon and who crammed a dozen lives into one, risked death by sheltering rebel leader Michael Collins. A successful racing cyclist and swimmer, he also rescued two men from drowning in the Liffey. He was kidnapped by republicans from Ely Place in the ensuing civil war. Unlike unarmed Protestants who were butchered in Cork, the writer escaped assassination by diving into the freezing Liffey. A month later, the republicans burnt his Galway home: 'Memories, nothing left now but memories, and in

that house was lost my mother's first portrait, painted when she was a girl of sixteen. Her first attempt in oils; books, pictures, all consumed for what?'

Embittered after his efforts for Irish independence and literature, Gogarty fled to England. Ely Place's two other prominent figures also left, George Moore and George Russell, of whom Katherine Tynan wrote: 'There is no room in him for any of the small meannesses of humanity.' Before he became disenchanted with post-Independence Ireland, Russell was a pivotal figure in Irish literature and the Cooperative Movement, and the first to publish James Joyce's stories. 'That's exactly how I feel, I have to get out of this country before it drives me mad,' he revealed the night on Appian Way he heard Frank O'Connor's latest poem:

> A patriot frenzy enduring too long
> Can hang like a stone on the heart of a man,
> And I have made Ireland too much of my song;
> I will now bid those foolish old dreams to begone.

James Stephens

Another exile was the once-starving *Crock of Gold* author, James Stephens, who lived off Fitzwilliam Square, where equally impecunious James Clarence Mangan had once worked in a solicitor's office. Before Stephens left, he optimistically described the glow of the Dublin hills, the mountain home of the Gods: 'The light around Aengus Og, the god of love, coming with Caitilin, his loved one, and the hosts of the shee, marching and dancing and leaping and tripping and singing down to Dublin, the Town of the Ford of the Hurdles, coming to liberate the Philosopher from the prison of the ignorant and the Intellect of Man from the hands of the doctors and lawyers, from the sly priests, from the professors whose mouths are gorged with sawdust, and the merchants who sell blades of grass – the awful people of the Fomor.'

'The sceptre of intelligence has passed from London to Dublin,' Edward Martyn wrote when George Moore returned to Dublin. Moore's ten years from

George Bernard Shaw, another exile

1901 in Ely Place were as eventful as the period during which he had exchanged Irish provincialism for Parisian sophistication and defied the English censor with such books as *A Modern Lover*. He completed his *Hail and Farewell* trilogy in Ely Place, but his neighbours were unimpressed with his work. The next-door Drew spinster sisters tore up their copy of *Esther Waters* and stuffed its pages through his letter box. When Moore rattled his stick along their railings in retaliation, they hired an organ-grinder to interrupt his writing.

'My race is over, betrayed, scattered, and in exile.' The Irish civil war proved more traumatic. Moore entertained distinguished guests under paintings by his Paris friends Monet, Pisarro and Manet, who had played a key role in the novelist's development, encouraging him to ignore the critics and to write with candour and courage. But literary courage was lost on the republicans, who looted and torched his Mayo home and its precious books and family pictures in 1923. With Gogarty, Joyce and Russell, Moore lived his final days far from the country whose literary reputation he had enriched. Joyce's Stephen Dedalus had not been mistaken:

> Do you know what Ireland is? Asked Stephen with cold violence. Ireland is the old sow that eats her farrow.

Samuel Beckett practised Richard le Gallienne's dictum that 'the proper writing place is a garret. There is an inspiration in skylights and chimneys'. While lecturing in Trinity College, he laboured on his early 1930s work in Clare Street, beside the former home of fellow-Francophile poet George Sigerson (where crystal-gazing W.B. Yeats once mistook a window-cleaner for a symbolic vision). Beckett described his attic: 'The ceiling and the outer wall were one, a superb surge of white, pitched at the perfect angle of farthest trajectory, pierced by a small frosted skylight, ideal for closing against the sun by day and opening by night to the stars. The bed, so low and gone in

the springs that even unfreighted the middle grazed the ground, was wedged lengthways into the cleft of the floor and ceiling.'

Beckett eventually tired of his lectureship, 'the absurdity of teaching to others what I did not know myself.' He dallied longer in the local pubs, to the chagrin of college authorities and of his family. The Dubliner looked and felt like a permanent drunk and suffered a nervous breakdown. Ireland's insularity also overwhelmed him. He knew that only his writing would save him. Like Joyce, his last view of his beloved Dublin mountains was from the rolling deck of the steamer which carried him into permanent exile. He was in good company, having been preceded by fellow-playwrights Goldsmith, Sheridan, Wilde, George Bernard Shaw and Sean O'Casey. And contemporaries Thomas MacGreevy and Liam O'Flaherty, who proclaimed that France was 'the only country where there is a profound respect for the human intellect in itself'. Ironcially, Beckett's Becquet forbears had fled religious persecution in seventeenth century France. In Paris, Beckett celebrated the publication of his Clare Street stories, *More Pricks than Kicks*. The book was promptly banned in Ireland.

Samuel Beckett headed to Paris

Another exile was Austin Clarke, outraged by religious triumphalism and hypocrisy. In *Unmarried Mothers*, he wrote:

> In the Convent of the Sacred Heart,
> The Long Room has been decorated
> Where a Bishop can dine off golden plate:
> As Oriental Potentate.
> Girls, who will never wheel a go-cart,
> Cook, sew, wash, dig, milk cows, clean stables
> And, twice a day, giving their babes
> The teat, herdlike, yield milk that cost
> Them dearly . . .

A light dimmed in Dublin with the exodus of Beckett, Clarke and so much talent. And, as Cecil Salkeld lamented: 'In three decades from 1890 to 1920,

Yeats, Wilde, Shaw, Synge, Joyce and Sean O'Casey created an Ireland no atom-bomb can destroy. Overnight, the tradition from which these men sprang, vanished; the sources from which they drew their inspiration dried up.'

It was against this unpromising background, and the moral and economic bankruptcy bequeathed by civil war bloodletting, that Irish writers from the 1920s onwards took their first faltering steps towards expression. Not only had they to contend with isolation and disillusion, they also faced what Robert Graves described as the fiercest censorship outside the Soviet Union. Irish monks had saved civilisation after the onset of the Dark Ages. Its scribes and artists would now have to replicate this feat at home against similar odds. They had a tradition of scholarship and enquiry on their side. None boasted a more fearless and analytic mind than a friend of the Wildes, who lived on Stephen's Green and was described as Dublin's original studio-philosopher and Bohemian.

Chapter Three

THE ORIGINAL BOHEMIAN – JOHN BUTLER YEATS

Everybody else wants to put fresh chains on humanity. He wants to strike them off. – George Moore

'THERE WERE BOHEMIAN CHARACTERS in this town long before Sean O'Sullivan or myself were heard of,' Owen Walsh cleaned his painting brushes one evening in 1989.

He extricated a well-thumbed tome from the listing bookshelves. 'Fresh from Parsons Bookshop, William Murphy's *The Prodigal Father*! You couldn't think of a more apt title for a biography of John Butler Yeats, the original studio philosopher,' he chuckled.

'Though he'd somersault in his New York grave to hear this, I'd say that John Butler Yeats was without doubt the founding father of Bohemian Dublin. Lady Wilde preceded him with her candle-lit salon. But there was nothing contrived about John B. He was one of that extinct breed who followed their convictions and never sold themselves for money. He realised his dreams and gave up a future in law to become an artist. His enthusiasm kept some of us later delinquents at the easel when we didn't have the money for a chop or a sod of turf. And, like myself, many a fire he married with works that weren't up to scratch!'

Owen admired the artist's enquiring spirit: 'As well as bequeathing a priceless record of the Literary Revival's key players, he established a tradition of debate, dissecting art and every other bloody subject under the sun. His friendships bridged the divides of generations and politics, from Isaac Butt to Isadora Duncan. Though he was slight in stature, he had the cour-

age of a lion. He saw off the Abbey Theatre hecklers of Synge's *Playboy* in style. And he was Action Man to the end. It took a New York blizzard to kill him at the age of 82!'

John Butler Yeats was reared far from artistic deprivation or excess. Born in 1839 near Banbridge in the north of Ireland, he was the son of Church of Ireland rector William Yeats, who was of Yorkshire origin. William was no dour Ulster bible-basher. A broadminded cleric, he risked life and reputation to visit both Catholic and Protestant victims of the 1845 cholera epidemic. The poor of his parish revered him. His writing desk concealed a medicinal bottle which enhanced his evening reading, while young John savoured his first book, *Robinson Crusoe*. John remembered his father's lifelong pursuit of truth and beauty, and the singular optimism he himself inherited: 'With a wave of his hand he made all difficulties disappear as if by magic. He made castles even in Ireland, as others did in Spain.'

The future artist sketched compulsively in his youth and, later, at college and law school. He became a member of the Philosophical Society of Trinity College, where he embraced Darwinism. Auditor of the King's Inns' Debating Society, he was chosen to deliver its 1865 annual address in front of the Lord Chancellor and Sir William Wilde, who had often welcomed him to Merrion Square. Wilde was impressed when, hardly glancing at his notes, the 25-year-old student proclaimed that the purpose of a debating society should be the attainment of truth, not the cultivation of oratory. Arguing against dogma and prejudice, he insisted that if students inculcated a spirit of enquiry 'that deep slumber which is too apt to settle upon long accepted beliefs . . . will be broken as with the sound of a trumpet'.

John was admitted to the bar in 1866. He found that the spirit of enquiry was lacking among his fellow-barristers, who wasted time waiting for rewarding cases. Friends John F. Todhunter and the Dowden brothers encouraged him to submit satirical sketches to magazine editor Thomas Hood. The Londoner immediately requested further caricatures. It was the encouragement John needed to embark on his dreams. The following year, to the shock of his new wife, Susan, and her Sligo merchant family, he decided to uproot and study art in London. Despite having only a modest income from family land, he celebrated: 'I had become consciously a man, a person, a being detached and an individual, whereas till then I had only been a cog-wheel in some mysterious machinery that might grind me to powder.'

Heatherley's Art School was the nursery of Millais, Rossetti and Sickert. Initially impressed by the Pre-Raphaelites, John decided to concentrate on portrait painting, while he continued to supply illustrations up to the 1890s to magazines such as *Good Words* and *Leisure Hour*. He worked diligently but his commercial instincts lagged behind the artistic. When Ernest Dowden, now Professor of English at Trinity College, commissioned a portrait for one hundred pounds, John wanted to do it for less. He developed the habit of continually reworking his pictures; an early commission took two years rather than the same number of months. One sitter, Mrs. Dodgson Hamilton Madden, had died by the time Yeats finally delivered her portrait – on the morning, unfortunately, that the second Mrs. Madden crossed the threshold.

A friend commented: 'It is possible that the persistent effort to give as much as Mr. Yeats wishes to give in every portrait sometimes hampers him, and one occasionally feels that some of his best results have been attained when subject and accident have compelled him to be satisfied, or at least to stop.'

Despite his obsession with art, John did not neglect his children. He read to them daily and they grew into adulthood on a rich diet of Balzac, Chaucer, Keats, Shelley and Shakespeare. Young Willie, who became better known as W.B., was particularly stirred by *The Lays of Ancient Rome* and *The Lay of the Last Minstrel*. These examples of the individual spirit in action, and his father's continual emphasis on the importance of art, influenced the future poet more than any formal education. Biographer William M. Murphy pointed out: 'It was his insistence to his children on the supremacy of the artistic over the material that encouraged the manifestation of their own unique qualities.'

In 1881, the Yeats family returned from London to the seaside village of Howth, ten miles from Dublin. Their future was precarious. Now aged 40, the unworldly artist had yet to earn a secure income. While Susan and the fishermen's wives welcomed the returning boats, he found a studio off Dublin's Stephen's Green at 44 York Street. He breakfasted here every morning with W.B., invariably reciting verse and dramatic scenes before he commenced work. W.B. absorbed his father's ability to captivate an audience with a flow of conversation. Fellow-artist Sarah Purser became a regular visitor. She praised John's work and vainly encouraged him to raise his prices. Edward Dowden felt that he had now arrived as an artist, though he cautioned: 'Yeats

has his head and shoulders around the corner. His legs are following as fast as possible.'

John moved to a new studio in 1883 at 7 St Stephen's Green, the last Irish home of *Dracula* author Bram Stoker. According to poet Katherine Tynan, everybody who was anybody in Dublin visited him there. From George Moore and George Russell to aspiring playwright John Millington Synge and poet Gerard Manley Hopkins. Katherine was enamoured of the lively studio: 'It was a delightful place, its atmosphere permeated by the personality of Mr. J. B. Yeats, the quaintest and most charming of men. Canvases were stacked everywhere around the walls.'

It was here that Yeats painted one of his best known pictures, *The Bird Market*. He focused on portraiture, though after hearing him discuss the mission of art, an American patron observed: 'Sir, your patrons would tell you that you had not to consider your mission, but your commission.' Despite his parlous finances, John usually only painted people who interested him. He conversed constantly with his sitters. According to one, he advanced on his canvas with great strides, 'putting on touches with the ardour of one who would storm a fortress, retreating as eagerly, talking enchantingly all the time, his whole nature in movement'.

William Butler Yeats by John Butler Yeats, 1900

Three of the Yeats children enrolled in Dublin's Metropolitan School of Art, the budding poet, W.B., and daughters Lily and Elizabeth, who subsequently launched the Dun Emer embroidery and handprinting enterprises. In 1885, both John and 20-year-old W.B. joined the Contemporary Club, which discussed the social, political and literary questions of the day. Based over a bookshop at the corner of College Green and Grafton Street, members included leading academics and nationalists such as Michael Davitt, Douglas Hyde and the old Fenian leader, John O'Leary. John Yeats soon established himself as one of the club's most entertaining speakers. He rarely attended without his sketchbook, in which

he recorded many of Dublin's leading figures and such visitors as pioneer socialist and poet William Morris.

The Yeats meeting with John O'Leary, who believed there could be no political revolution without a cultural revival, resulted in much more than an acclaimed portrait. It changed the course of W.B. Yeats's career and of Irish literature. Hitherto, the poet's standard diet had been Shakespeare and Blake. O'Leary introduced him to both Gaelic and recent Anglo-Irish literature and lent him books the young man had never seen before. As Yeats later acknowledged, the Contemporary Club meeting with O'Leary provided one of the sparks which ignited the Irish Literary Revival: 'From these debates, from O'Leary's conversation, and from the Irish books he lent or gave me has come all I have set my hand to since.'

Though he preferred the conviviality of Dublin, John B. Yeats decided in 1886 to once again seek his fortune in London. While their eldest son progressed towards poetry and 16-year-old Jack commenced art studies, Susan Yeats suffered the first of several strokes. The Yeats offspring inherited their artistry and independent minds from their father. W.B., nevertheless, reacted to his father's lack of drive, which he described as an infirmity which prevented him from finishing his pictures and ruined his career: 'The qualities which I thought necessary to success in art or in life seemed to him "egotism" or "selfishness" or "brutality". I had to escape this family drifting, innocent and helpless, and the need for that drew me to dominating men like Henley and Morris, and estranged me from his friends.'

Maud Gonne

The poet cultivated a wide circle of friends, including William Morris, George Bernard Shaw and Aldershot-born Maud Gonne, with whom he fell in love. His father was less enamoured with the Englishwoman, whose affair with a right-wing French politician produced two children. While W.B. progressed to publication, his father continued to prove more successful at making friends than money. He existed on rare commissions and the goodwill

of doctor and poet John Todhunter, publisher Elkin Mathews, the anarchist Sergius Stepniac and other colleagues in the Calumet conversation club.

In 1889, John once again met Oscar Wilde, whom he had known as a child. Though many so-called friends deserted the playwright when he was charged over his illegal homosexuality, the Yeats family stood by him. Before the trial, John urged W.B. to collect letters of encouragement from prominent Irish writers, which the poet delivered to Wilde's Tite Street house. W.B. also visited Lady Wilde shortly before she died.

Among John B. Yeats's many visitors was novelist G.K. Chesterton, who based a character in *The Man Who Was Thursday* on him, and 30-year-old Irish poet and singer Susan Mitchell. Describing Yeats as 'full of old wisdom and young folly', she sang to the artist twice her age as he painted. She was astounded with the family's diverse talents, and with the home in which ideas were valued above all other possessions: 'I wish I was skilful enough in words to paint for you that delightful household in Bedford Park, where first I learned what conversation meant, where Mr. Yeats, that brave head thrown back, his eyes smiling, said things that appeared to me daring, witty, full of old wisdom and young folly, but said them always with a distinction and grace that made the saying of them significant.'

While John's fortunes fluctuated, his son, Jack, held his first exhibition in 1897. The show proved a milestone for both artists. Among its visitors was Lady Gregory, who afterwards called to the family home. When she found Yeats senior sketching the Irish playwright Edward Martyn, she immediately commissioned portraits of his sons. She then invited the artist to Dublin to complete portraits of leading cultural figures George Russell, Douglas Hyde and Horace Plunkett. These commissions marked a turning point in his life.

Lady Augusta Gregory was one of John Yeats's patrons

John Butler Yeats celebrated his sixtieth birthday on March 16, 1899. But at an age when most were considering retirement, he was still seeking commissions. He completed pencil sketches of Ernest Rhys, York Powell and other English acquaintances. The growing Boer War jingoism made him think again of returning home to Ireland, a sentiment boosted by the sudden death of his wife, Susan, in January 1900. Like the spouses of many artists, Susan Yeats paid a high price for her husband's convictions. As biographer Roy Foster observed: 'Having married a law student with good connections and a solid background in the Protestant clerical establishment, she had no reason to anticipate being carried off to bohemia, and never reconciled herself to the abduction.'

Yeats was an instinctive free-thinker. By contrast, Susan reflected her conservative and religious upbringing and was a little short on affection. Had her husband practised law, she would have enjoyed a comfortable life in familiar surroundings. Instead, though she rarely complained, the self-effacing mother of six children endured frequent deprivation in a city she never loved. Her heart was always in Sligo. When she died, she was buried in unbeautiful Acton, far from her original home.

A century later, Owen Walsh observed the home-bound traffic:

'Lord save us all from artists! I suppose the mothers of Leonardo and Michelangelo were also disappointed with their impractical sons. And Mrs. Joyce had to endure not only her profligate husband, John Stanislaus, but also the wayward James. If art were better rewarded – and none of us do it for the loot – Susan Yeats would have enjoyed a happier life.

'But if you look at her family, the Pollexfens, they accumulated riches and provided employment – but what did they bequeath to posterity? Most of them looked down on John B. Yeats and derided him as a failure. But Susan Yeats and he were a supremely accomplished couple. Between them, they provided the most artistic family that Ireland has ever known. Willie, the Nobel Prize-winner, Jack the internationally respected artist, and the sisters Lily and Lolly who founded the Dun Emer and Cuala enterprises. No other parents made such an impact on Irish artistic life.'

Owen had just enjoyed a successful exhibition, which should have greatly improved his parlous finances. 'Don't mention that bloody show,' he expostulated. 'I've often had the idea for a picture I've yet to complete. An artist, like Cezanne, lugging his easel and paraphernalia up the hills. My fellow would not only be carrying the easel maker and the canvas manufacturer,

he'd also have the paints and brushes supplier on his back. And the framer, whose prices increase every other week, and the gallery owner, Mr. Forty Per Cent. After missing him a few times, I finally caught up with my exhibition organiser.

"'Congratulations Owen, amazing show," he wrung my hand. "But don't talk to me about the expense. The catalogue cost a fortune, I've never seen people drink so much wine, and of course I had to humour those so-called critics with private libations. The next problem is to extract the readies from the purchasers. Owen, you have no idea how hard it is to get cash out of people these days. Sometimes, this business could make you very cynical. But don't worry, call next week and we'll sort something out for you."

'I had to wait for a fortnight before standing in front of his expensive motorin' car one morning in Merrion Row. He gave me about a quarter of what was due to me, before racing off in a cloud of dust.'

John B. Yeats abandoned his easel for several months after his wife's death, but a surprise invitation to the 1900 Royal Hibernian Academy exhibition in Dublin encouraged him to resume painting. Inspired by the reception of his work, he submitted further pictures the following year. Elation turned to dejection as the academy refused his new efforts. But the rejection led to a dramatic and long overdue change of fortune. Impressed for many years by his dedication, Sarah Purser was so annoyed that she immediately set about organising a joint exhibition of his work and that of Jean-Francois Millet's painting companion, Nathaniel Hone.

Thanks to her forceful personality and artistic fame, Sarah was by now one of Dublin's most influential women. She acquired no fewer than forty-four paintings and portraits and John Yeats's first-ever exhibition opened on October 21, 1901 at 6 St. Stephen's Green. It was an eventful week for the Yeats family. W.B's play *Diarmuid and Grania* opened at the Gaiety Theatre the same evening and an exhibition of Jack Yeats's work was launched the following day in Merrion Row.

The exhibition was a success. William M. Murphy, recorded: 'Suddenly, John Butler Yeats was an established figure. At the age of sixty-two he had been introduced to society, like a late-arriving debutant.'

The critics were equally impressed. The *Irish Times* noted that the artist avoided the frills of his pre-Raphaelite contemporaries in order to concentrate on the character. In describing the portrait of John O'Leary as probably the finest painted by an Irish artist in recent years, the *Daily Express's* George

Coffey wrote: 'It has been said of Rembrandt that he takes a head and hangs it in the infinite, and that in relation of the head to the background there is the whole mystery of existence. It is because we find something of this quality in Mr. Yeats's best work that his paintings are so interesting to us.'

John B. could still only afford cheap Leeson Street lodgings and dropped in to friends at dinner time. But news of his exhibition reached New York lawyer John Quinn, who wrote asking if he could purchase the portraits of O'Leary and Willie Yeats. The reply was the first of many that Yeats would exchange for the next twenty years with the man who was to change the course of his life. On learning that the original works were sold, Quinn immediately commissioned new portraits of O'Leary and George Russell.

New York lawyer and Yeats patron John Quinn

The Dublin exhibition ended Yeats's London exile. His Irish return was intended to be temporary, but he was happy to remain permanently after Evelyn Gleeson invited Lily and Lolly Yeats to open her Dun Emer embroidery and printing enterprise. Walter Osborne's death facilitated an equally felicitous return to the artist's favourite studio at 7 St. Stephen's Green. Yeats could hardly have picked a more auspicious time for his homecoming. The Irish Literary Revival was in full flow; stirring talk of Home Rule filled the air. Recalling the explosion of artistic, literary and musical talent, and the cooperative farming efforts of George Russell and Sir Horace Plunkett, fellow-artist Beatrice Elvery proudly noted: 'Everyone seemed to be doing something for Ireland, and without shedding a drop of their own or anyone else's blood.'

Though W.B. Yeats would later quarrel with George Moore, John Yeats regularly visited the Literary Revival's leading novelist. While they discussed literature and art, the painter savoured Moore's gallery of modern art by Monet, Berthe Morisot, Daubigny and Tonks. Moore described Yeats as possessing the most stimulating mind he ever met and more humanity than most: 'Everybody else wants to put fresh chains on humanity. He wants to strike them off.' Describing him as a man tumbled out of some distant planet and free from the constraints of formal education, Yeats responded to Moore's direct-

John Butler Yeats in his Stephen's Green studio

ness and sincerity: 'I always feel better morally for being with him. Compared to him, I find most people humbugs, addicted to dishonest practices and thoughts.'

W.B.'s friend, Lady Gregory, invited John to Coole in 1903 to paint Douglas Hyde and to inscribe his initials on her famous beech tree. The habitually dark-clad hostess complained later that he had been one of her more trying guests: 'Space and time mean nothing to him, he goes his own way, spoiling portraits as hopefully as he begins them, and always on the verge of a great future.'

The artist himself was less than ecstatic about what appeared to be a well regimented home, but thanks to Lady Gregory's influence, further commissions followed. New sitters included Padraic Colum, Walter Starkie, Lady Gregory herself and Willie Fay of the Abbey Theatre. Yeats continued to joust with all his sitters. He wrote to John Quinn about the editor and lexicographer Father Dineen: 'It is not every day that a Protestant has a chance of buttonholing a priest, and I seized my chance to say what I was always wanting to say to Catholics.'

Lady Gregory's nephew, the collector and dealer Hugh Lane, was one of those most impressed by Yeats's 1901 exhibition. Imbued with the spirit of the Literary Revival, the show inspired him to establish a gallery of portraits of important Irish figures which he could present to the nation. Yeats was the ideal artist and by 1903 the pair agreed on terms and the standard size of the works. The artist relished the literary and artistic sitters, but he was less enamoured with such Lane nominees as the British Viceroy, Lord Dudley, and Lady Grosvenor, wife of the prominent Unionist, George Wyndham. When he initiated a Devil's Advocate discussion about Fenianism, Wyndham refused to allow her back for a second sitting.

Yeats encouraged many young artists, including Harriet Kirkwood, Clare Marsh and Mary Swanzy, who went on to study in Paris. Thanks to Hugh Lane, who subsidised his Stephen's Green studio, he made a triumphant visit to London, where his portraits were shown at the Irish Painters Guildhall exhibition. His work was now widely acclaimed – his family pictures for their intimacy and reflection, his literary sketches for their character and conviction. After making a special trip to see his pictures, American virtuoso Robert Henri insisted: 'Yeats is the greatest British portrait of the Victorian era.'

John Butler Yeats, December 1907

Yeats preferred to live in his native country. Comparing the two countries, he said: 'Ireland is like ancient Athens where all were such talkers and disputants. England is like ancient Rome with its legions and cohorts and dull business of conquering the world.' His studio continued to be a centre of discussion. He argued with visitors over the direction being taken by the Literary Revival, and lyricised on the transparency of Keats and the letters of Charles Lamb. The only notable writer Yeats did not paint was the precocious James Joyce, whom he had met briefly on Northumberland Road. Oliver St. John Gogarty claimed that on another occasion Joyce and he had tried to borrow money from the artist, which he refused, correctly surmising that they would spend it on drink. Yeats later wrote of his admiration for Joyce: 'The whole movement against Joyce and his terrible veracity, naked and unashamed, has its origins in the desire of people to live comfortably, and, that they may live comfortably to live superficially.'

The artist was commissioned by Hugh Lane to lecture at two important Dublin exhibitions. He provided his personal definition of art in his 1906 talk

on the British artist and sculptor George Watts: 'Art does not say – "Be happy, or be miserable, or be wise, or be prudent"; but it says – "Live, have it out with fortune, don't spare yourself, be no laggard or coward, have no fear."'

He insisted that, while the body decays, the spirit is always young, and he recorded his definition of life: 'We live to play; that is my slogan, under which we shall set about the real things of life, and be as busy, and in the same spirit, as is nature on a morning in spring.'

Yeats never shied away from controversy. Explaining that his allegiance was to good pictures rather than the Academy's Council, he attacked the RHA for its opposition to Hugh Lane's gallery plans. John Millington Synge was one of the new generation of writers with whom the artist became close. Yeats sprang to his friend's defence after the riots which greeted that year's Abbey Theatre staging of *The Playboy of the Western World*. Nationalist and religious extremists complained that the play's plot and characters insulted the people of the west of Ireland; some objected to the mention of a woman's underclothes. Police had to be called to keep order, which antagonised the objectors even more.

The furore made international headlines and a public debate on the play was held at the Abbey. John insisted on speaking, despite a sore throat. When he stood up and referred to Ireland as 'a land of Saints', he was greeted with loud applause by the play's opponents. This swiftly changed to catcalls when he added ' – a land of plaster saints'. After praising Synge's main character as a real vigorous and vital man, he concluded: 'Unfortunately in this country people cannot live or die except behind a curtain of deceit.' The debate's chairman hastily shouted that the artist's time was up; it was some time before he could be heard above the uproar. W.B. Yeats later mythologised the incident:

> My father upon the Abbey stage, before him a raging crowd:
> 'This land of Saints,' and then as the applause died out,
> 'Of plaster saints'; his beautiful mischievous head thrown
> back.

The 68-year-old artist's friendship with the playwright thirty years his junior was short-lived. Suffering from Hodgkin's Disease, Synge paid one of his last visits to the Stephen's Green studio. The pair joked about young Jack Yeats being a better businessman than either of them, after discovering that he had received more for his illustrations of Synge's *Manchester Guardian* articles on Connemara than the writer himself. Synge and John had much in

common, having rebelled against their common Protestant upbringing and dedicated their lives to art. Recalling his friend's love for the natives of the west of Ireland, Yeats wrote in an American obituary: 'Synge found the people too full of paganism and Christianity of high poetical vitality – an island of sinners as well as saints: also an island of poets. His plays revealed this manifold existence but because it was not the island of Carleton and priestly tradition, all Dublin, Protestant and Catholic, went mad with riot and noise.'

Those who thought Yeats was home for good were mistaken. Some of the excitement went out of the city in December 1907, when he left as unexpectedly as he had arrived. This time on the *Carmania* for distant America, with the works of Keats and *Letters of Charles Lamb* among his few possessions. Hugh Lane had organised a fund to enable him to visit Italy, but the 68-year-old artist used the money to accompany his daughter, Lily, to New York where she was to exhibit her Dun Emer work at the city's Irish Exhibition.

John Butler Yeats in New York, around 1917

Yeats's sojourn in New York was intended to be brief, but his spirit was bewitched by the city's energy, excitement and variety: 'To leave New York is to leave a huge fair where at any moment I might meet with some huge living.' As the years passed, the Yeats family became anxious. W.B. offered to pay all father's debts and bring him home. Lily wrote: 'Not only do I love him as my father but also as my greatest friend. When I think of his age and the distance he is off I cannot keep away my tears, and then the thought of the sixty years of hard struggle he has had for the money that never came! He doesn't know what a success he is, how fine his work is, what a big man he is.'

The artist, whom his daughters now called 'the Pilgim Father', parried family concerns. He enjoyed the company of former pupil Clare Marsh, who

visited New York in 1912, and of fellow-Bohemian artists and writers Robert Henri and Van Wyck Brooks. He boasted how he had walked down Broadway with dancer Isadora Duncan on his arm. Conrad Aiken featured him in some of his stories, Ezra Pound in *Cantos* and John Sloan in his 'Yeats at Petipas' painting. The exile advised his son, Jack: 'Forgive me for not coming home – I am kept here by certain things that must be done – These finished – I will come home with much happiness and be a cherished antique – and be put on my shelf and carefully dusted every morning – with a good fire – so that the temperature be right – and nothing to harm my frail porcelain.'

But John B. Yeats never returned. He remained in New York for fifteen years, sketching, illustrating, lecturing and contributing to journals such as *Harper's Weekly*. Fellow-artist John Sloan wrote: 'He's still young in spirits and attracts young people around him.' It was the final period of a migratory life: thirteen years in London, seven in Dublin, another thirteen in London, another seven in Dublin.

The artist who had known survivors of the Battle of Waterloo never lost his old fire. He annoyed an audience of Philadelphian Christians when he insisted that Puritanism was a mistake. 'The best thing in life is the game of life,' he wrote. He contracted pneumonia at the age of 82 after walking out in a blizzard. He died on February 3, 1922, the day after Sylvia Beach published James Joyce's *Ulysses*. By his bedside was the self-portrait which John Quinn had commissioned seven years previously and on which he was still working. Back in Dublin, George Russell lamented his passing: 'The most lovable of all bearing the name.'

Quinn missed Dublin's original Bohemian: 'He was an affectionate lovable man. His talk was more interesting than most books, more brilliant, more amusing. He never preached or cared to instruct or improve. He followed the gleam. Down to the end, life was still full of interest and mystery. And now that he has sunk into his dream, there ought to be no regrets.'

Chapter Four

Brendan Behan – Housepainter to Writer

Brendan was a rebel the way other kids become altar boys.
– Beatrice Behan.

'Wave to your da,' Kathleen Behan lifted the bare pudgy hand of her new black-haired son, Brendan, one spring day in 1923.

Kathleen saw the return salute through the bars of one of Kilmainham prison's high windows. And she heard her husband Stephen's unmistakeable Dublin accent: 'Jasus, Kit, throw me a tin of whatever you're feeding him, I can hear him from up here!'

That was Stephen Behan's earliest glimpse of his first son, Brendan, who would continue to make noise all his life. Through a cell window in Kilmainham, where Stephen was imprisoned during the Irish civil war. Kathleen, whose brother had written the Irish national anthem, weaned Brendan on a diet of patriotic and socialist ballads. At the age of 14, Brendan attempted to go to Spain to fight Franco. A year later, he was arrested in Liverpool with a suitcase of explosives intended to destroy the city's docks. After two years in borstal, he was imprisoned on his return to Ireland for shooting at a Garda. Altogether, Brendan spent six of his forty-one years behind prison bars.

'Brendan was a rebel the way other kids become altar boys,' his widow Beatrice explained. 'But, more importantly, he inherited a love of literature and song and his father's comic approach to events. Also a fondness for drama, as a youngster he regularly attended his uncle-in-law's Queen's Theatre. And a passion for life, which is sadly ironic in view of his early death.' It was an even

Stephen and Kathleen Behan (drawing by Liam C. Martin)

bigger irony that less than two decades after being deported for his Liverpool offensive, Brendan's anti-war comedy *The Hostage* represented Britain at the 1959 Paris Theatre Festival.

The Behan family originally inhabited a tenement house in inner city Russell Street. While Brendan attended St. Canice's CBS school, another famous Brendan, future RAF ace Brendan 'Paddy' Finucane, studied next door at O'Connell Schools. The Behans were moved to a new estate in Crumlin, when Brendan was 14 and studying housepainting at Bolton Street College. He missed being spoiled by his Granny English, who had introduced him to drink at the age of seven, and the northside's intimate streets and songs: 'Songs that were never made on paper, but grew out of the stories of the pavement, passed on from one generation to the next.'

The dapper Stephen Behan was a seminarian turned housepainter, and president of the Irish Painters and Decorators Union. Occasionally hot-tempered, he was a voracious reader and accomplished fiddle player and singer. Kathleen Behan modelled for artist Sarah Purser and, as housekeeper for Maud Gonne MacBride, she frequently cooked for W.B. Yeats. She knew nationalist leader Michael Collins, who gave her £10 one day on O'Connell Bridge when she was pregnant with Brendan.

Music, drama, literature and politics pervaded the Behan household. Books by Charles Kickham and George Bernard Shaw rubbed covers with

publications of the Thinking Man's Library and the Rationalist Press. Two priests collecting funds for Franco retreated before Stephen's colourful defence of Spanish socialists. While Kathleen vented rebel ballads and educated her childen on Irish history, Stephen introduced them to Dickens and Zola.

An inveterate pipe-smoker, Stephen countered hardship with humour and a fund of anecdotes and stories, traits his son would inherit and put to good use, together with a prodigious memory though, sadly, without fully acknowledging his father's influence. Brendan grew up closer to his mother than to his father, who dispproved of his physical force activities. Post-Independence Ireland had cured Stephen of banners and slogans. Five innocents were dismembered in a republican explosion in Coventry. Father and son argued on the November 1939 night that 16-year-old Brendan left for Liverpool with his explosives.

Brendan's two-year incarceration in Suffolk's Hollesley Bay was to lead to his acclaimed autobiography, *Borstal Boy*. The institution's annual Eisteddford included an essay competition. With colourful evocations of Yeats, O'Casey and Shaw, Brendan's entry was a sure favourite. *Borstal Boy* recorded the announcement of the essay winner:

> The Major got up and said that there was one essay he had no trouble at all in recommending for the first prize. It was about 'the sad and beautiful capital of that sad and beautiful island', and with that there was a great burst of applause, led I noticed by Shaggy Callaghan, with Jock and Joe adding their piece and Charlie, with his face lit up and his eyes near out of his jaws with excitement, clapping away like mad.

The Dubliner celebrated by singing 'An Chuilfionn' in Gaelic, to another rapturous reception. A man who always appreciated an audience, it is likely that he discovered in Hollesley what the English demanded from Irish entertainers – knowledge that he would put to good use in his plays. Brendan's borstal experience also modified his perception of the English, whom he had originally only known through legends of Black and Tan excesses. His respect for the enlightened Governor Joyce provided him with an appreciation of the English sense of fair play. He learned to play rugby, a game he had previously thought was only for the English or Irish upper orders.

Hollesley Bay also played a major role in Brendan's sexual awakening and subsequent bisexuality, a topic which could never be discussed in Ireland during the strait-jacketed forties and fifties. Brendan's mixed feelings

probably contributed to his self-destructive drinking. When Ulick O'Connor referred to Brendan's bisexuality in his biography, some of the Behan family threatened him with violence. Even Brendan's wife Beatrice loyally denied the allegations. John Montague surmised that Brendan's occasional stammer owed much to sexual conflict. Fellow-poet John Jordan suggested that the brazen-tongued public entertainer was the defensive obverse of a warm-hearted and slightly unsure friend.

Young Brendan Behan at his typewriter

One of Brendan's big sorrows was the death at sea of his borstal friend, Chewlips. Years later, Beatrice, recalled: 'When we were in London for the premiere of *The Hostage* at Joan Littlewood's theatre, Brendan brought Joan, Gerry Raffles and myself up to Hollesley Bay on a visit. He showed us the beach where he had often swum with other inmates, and the Shep pub where they sometimes enjoyed a quick drink. We went in for a drink ourselves and when we came out into the sunshine, we saw a party of inmates harvesting in the distance in their blue jeans and jackets. I will always remember how Brendan stood and looked at them for a long time. It was as if he had left a large part of his life in Hollesley Bay.'

Deported back to Ireland at the end of 1941, Brendan was imprisoned a year later for shooting at two gardaí during a demonstration. Some observers attributed his action to a hysteria which frequently overcame him; his friend Anthony Cronin noted a self-destructive edge to his capers. Brendan's life was only saved by the presence of spectators who inhibited detectives from returning fire. In danger of being shot on sight by fellow gardaí, Brendan was spared for a second time by his father. Stephen's former prison-mate, Sean T. O'Kelly, was now the Irish president. Stephen walked into Dublin to ask him to ensure that gardaí would not shoot his son. When Brendan was finally arrested, he was sentenced to fourteen years penal servitude. He recalled in *Confessions of an Irish Rebel*: 'The police told their story and, with one exception, told it without any venom, and I reflected on the sadness of Irish-

men fighting Irishmen or men fighting women or women fighting anywhere, because at heart I'm a pacifist.'

One of Brendan's left-wing friends was sculptor Desmond MacNamara. The pair met as teenagers when tugging opposite sides of a banner at a Dublin anti-Franco demonstration. Des recalled: 'Peadar O'Donnell was the man behind the rally. A novelist as well as a political activist, he encouraged Sean O'Faolain to look at the writing which had become Brendan's obsession in Mountjoy prison. Brendan's professional literary career commenced when Sean published 'I Become a Borstal Boy' in *The Bell* of June 1942.'

'PAPER – I do not have a page. Send me a parcel of paper urgently,' the 20-year old prisoner appealed to his cousin, Seamus de Burca. Thanks to O'Donnell's lobbying, Sean O'Faolain was allowed to visit Brendan in Mountjoy. The meeting with such an established writer boosted Brendan's confidence. O'Faolain in turn was impressed by the enthusiasm of the slightly fleshy mid-height Dubliner. He reassured the prisoner of his talent and agreed to consider any further stories he sent to *The Bell*.

The budding writer gradually became disenchanted with his dogmatic and inflexible republican colleagues. Adding insult to injury, they refused to stage his play, *The Landlady*, because of its characters' racy language and perceived immorality. Brendan was not the first Irish writer to suffer the painful loss of faith, with which Dr. Johnson had commiserated: 'The transition from the protection of others to our own conduct is a very awful point in human existence.' For Brendan, writing now assumed the importance of his earlier political expression. One of his fellow-prisoners was a butcher, Bernard Kirwan, who had killed his brother. On the day before he was executed, Kirwan shocked Brendan: 'Tomorrow, at ten past eight, I'll be praying for you in heaven.' Kirwan would become the central character of Brendan's anti-capital punishment comedy, *The Quare Fellow*.

Brendan was transferred to the Curragh internment camp in 1944. As the wind whistled through their huts, he honed his Irish language skills with writer Mairtin O'Cadhain, who also encouraged his literary efforts. Released unexpectedly on parole at the end of 1946, Brendan wrote constantly, while earning a living from house painting. Though he regarded country people as unredeemable yahoos, he accepted a painting commission in Kerry, where he witnessed for the first time the beauty of nature. Mesmerised one morning by the sun's rays striking the dewdrops, he commenced to write poems in Irish, including 'A Jackeen Says Goodbye to the Blaskets':

In the sun the ocean will lie like a glass.
No human sign, no boat to pass,
Only, at the world's end, the last
Golden eagle over the lonely Blasket.

On his return to Dublin, Brendan made up for lost time by frequenting pubs and shebeens like the Catacombs. J.P. Donleavy captured his Catacombs arrival in *The Ginger Man*:

A man, his hair congealed by stout and human grease, a red chest blazing from his black coat, stumpy fists rotating around his rocky skull, plunged into the room of tortured souls with a flood of song:

'Did your mother come from Jesus
 With her hair as white as snow
 And the greatest pair of titties
 The world did ever know.'

Brendan Behan at the taps

Brendan's ready wit, verbal fluency and fund of stories made him a popular drinking companion. Anthony Cronin insisted: 'You could not have a better company in a day's idleness than Brendan. He was a kaleidoscopic entertainment but he was also fecund in serious ideas.'

Brendan's new friends included *Envoy* editor John Ryan and theatre producer Alan Simpson. John introduced Brendan to former British double-agent and smuggler, Eddie Chapman, with whom he plied the Irish Sea for six months in the latter's small freighter, *Sir James*.

One person whom Brendan failed to impress was the intro-

spective Patrick Kavanagh. After a short acquaintanceship, the countryman and the townie spent the rest of their lives either avoiding or insulting each other. Brendan's nationalism, bisexuality and drunken violence were anathema to Kavanagh. The animosity was mutual. Brendan disliked the rural blow-ins who were beginning to outnumber native Dubliners. He responded to the poet's attack on the Irish language and the hairstyles of working-class fans of the new rock-and-roll:

'As Mr Kavanagh does not know any Irish, his opinion on this subject is only as valuable as mine on the subject of turnip-snagging. . . . I know enough about young Dublin workers, to know that anything they get is hard-earned and honest, whether it's a Hollywood hair-style or a suit with a velvet collar. I know they are not sufficiently interested to dictate to the gilded youth of Innishgeen what hair styles they should favour, or at what angle they should tip their cap, or how they should tie their hob-nailed boots, when they're on the way to the mission, the Dublin train or the Liverpool boat.'

The legend of Brendan the vituperative drunk mushroomed over the years. His neighbour John Montague observed: 'I was very fond of him. He seemed to me half-angel, half-beast. On the one hand a very handsome little man with delicate feet and hands and a quick intuitive mind: on the other, a beast with a crooked mouth that spat poison at people.'

McDaid's manager, Paddy O'Brien, had a better knowledge than most of the effect of drink on Brendan: 'When Brendan first came in here, he was working as a housepainter. He was only a young fellow. I had to carry him outside and lay him down after only a few drinks. I knew then that he wasn't a drinking man like, say, Patrick Kavanagh or Myles, who would never get into a rage as Brendan sometimes did. It was only shortly before he died that I heard he was diabetic. And it was that, in my opinion, as much as the drink which finally did for him.'

But a second thirst dogged Brendan's life, an equally powerful craving for recognition as a writer. His socialising, however, distracted him from composition, his drinking frequently landed him in trouble. After a month in Mountjoy prison garb for his part in a brawl, Brendan felt that he was going nowhere in Dublin. He left for Paris in the footsteps of Joyce and Beckett. It was a heady time, with Juliette Greco, Jean Paul Sartre and every playwright advertising change and existentialism. Within a short time, Brendan knew writers James Baldwin, Alexander Trocchi and Norman Mailer, who was on the point of his first major success with *The Naked and the Dead*. Quickly acquiring French, Brendan also met *Points* magazine editor, Sinbad Vail, who

saw Alfred Jarry's dissipation in his frequent drunkenness. He earned some useful francs from painting, including the sign for a non-English-speaking café owner who wanted to attract English visitors:

> Come in, you Anglo-Saxon swine
> And drink of my Algerian wine.
> 'Twill turn your eyeballs black and blue
> And damn well good enough for you.

Though Samuel Beckett had to bail him from a police station after another fight, Brendan persisted with his writing. In 1949, the Irish-language magazine *Comhair* published his poems on James Joyce and Oscar Wilde. *Points* ran his short stories 'After the Wake' and, in 1951, 'Bridewell Revisited', which would later become the first chapter of his acclaimed autobiography. *Envoy* published another poem and his story, 'A Woman of No Standing'. Brendan also wrote 'An Irish Boy Dies in Korea', about a soldier killed in the 1950-53 Korean War.

'People remember James Joyce's singing but Brendan Behan also had a fine tenor voice,' insisted broadcaster Ciarán MacMathuna. 'He was a welcome and lively addition to Radio Éireann's *Ballad Maker's Saturday Night* programme.' As well as inviting Brendan to sing on his return to Dublin, the national radio station also commissioned two short plays and talks on his youth in Russell Street and on his time in Paris. Dublin was a very class-conscious city, but despite the reservations of university literati in McDaid's and other pubs, Brendan was gradually being recognised as a writer.

His friendship with Bertie Smyllie led to his *Irish Times* debut. He put his smuggling experience to good use in *The Scarperer*, which the paper serialised in 1953. Des MacNamara insisted: 'Brendan didn't like thrillers and knew nothing about them. He got around this by compounding a mixture of recollections, lags' lore and fantasy. Short of a character or location, he would put down an account of his daily odyssey, squeezed, stretched and altered to make a further chapter. He was the kind of person who could make an epic out of buying a bus ticket. But he wrote *The Scarperer* under a pen-name, in case it would conflict with his reputation as a serious writer!'

Brendan reached a wider audience with a regular weekly column in the *Irish Press*, which was later published as *Hold Your Hour and Have Another*. But it was the success of *The Quare Fellow*, which Alan Simpson's Pike Theatre produced in 1954, which finally established his professional credentials. Amid the rave reviews, the *Evening Press* predicted: 'When he finds

himself technically, the Irish theatre will have found another and, I think, greater O'Casey.' The *Irish Independent* concurred: 'undoubtedly, the finest by a new dramatist seen in Dublin for years.' Samuel Beckett wrote to Alan Simpson: 'Remember me to the new O'Casey.'

The playwright shared Patrick Kavanagh's regard for Beckett. When a literary snob asked Brendan if he understood the playwright, when *Waiting for Godot* was playing at the Pike, he replied: 'I don't understand the composition of water but I love an ould dip.' Questioned about their contrasting messages, Brendan responded: 'When Beckett was absorbing Trinity College lectures, I was in my uncle's Queen's Theatre. That's why my plays are music hall and his are university lectures!'

As Brendan's notoriety grew, Des MacNamara decided that he should be commemorated in the city's central park: 'I conceived the idea of a sculpture of Brendan, arrayed as Rabelais and well endowed with artificial pigeon shit, which would stand on a plinth which a few of us intended to wheel into Stephen's Green under darkness. I modelled a head and improvised the plinth. But, as Brendan grew more famous and travelled, and my London forays lasted longer, the project was never completed.'

In February 1955, Brendan married Beatrice Salkeld, the quiet and beautiful daughter of artist Cecil ffrench Salkeld. She soon found that Brendan aroused strong feelings wherever he went; adulation was frequently matched by the abuse of those who only knew him from the headlines. As his fame grew, Beatrice provided him with love and much-needed stability though, sadly in the long run, she could not save him from himself and the drink. After a spell in Waterloo Road, they moved into a ground-floor apartment in Herbert Street, close to Baggot Street bridge, which witnessed the brightest and most productive stage of Brendan's short life.

Beatrice shared his triumphant 1956 return to Britain, from which he had been deported fifteen years previously. The success of John Osborne's mould-breaking *Look Back in Anger* paved the way for a new wave of British

theatre. Joan Littlewood and Gerry Raffles encouraged Brendan to rewrite *The Quare Fellow* which opened at their Theatre Royal in May 1956. The play was an instant success, and Brendan woke to find himself featured in almost every newspaper. Kenneth Tynan celebrated: 'The English hoard words like misers; the Irish spend them like sailors; and in Brendan Behan's tremendous new play language itself is out on a spree, ribald, dauntless and spoiling for a fight.'

As well as hailing the richness of Brendan's language, *The Observer's* Irving Wardle praised the play's indictment of the prison system. Brendan's protest against the death penalty encouraged the campaign then being waged for its abolition. *The Quare Fellow* transferred to the West End's Comedy Theatre to further acclaim. Harold Hobson wrote in the *Sunday Times*: 'Brendan Behan takes a place in that long line of Irishmen, from Goldsmith to Beckett, who have added honour to the drama of a nation which they have often hated.'

But it was Brendan's drunken interview on BBC television which impelled his image into almost every British home. Paddy O'Brien had always insisted that what would be an aperitif for another would be sufficient to make the writer drunk. Brendan was nervous before the interview and adjourned to the hospitality room for sustenance. When he appeared on the programme shortly afterwards, shoeless and with his shirt buttons undone, he was scarcely coherent. It was the first time anyone was seen drunk on a live show. Despite interviewer Malcolm Muggeridge's best efforts, most of Brendan's answers were inaudible. After answering many of his own questions, Muggeridge had the presence of mind to ask: 'Brendan, can you sing something for us?' Brendan concluded the interview with a wavering rendition of 'The Ould Triangle'.

The BBC switchboard was jammed with complaints, newspaper columnists went into overdrive. The following morning, a newspaper vendor grabbed Brendan's hand: 'You were great, Mr Behan. I didn't understand a word you said but I didn't know what Mr Muggeridge said either.' Many Irish people complained that Brendan had disgraced his country but his English fame could not be ignored. Brendan was finally regarded at home as a writer; a friend conveyed his sentiments: 'The university poets can now go and fuck themselves'. After recounting how the national Abbey Theatre had declined *The Quare Fellow*, Flann O'Brien celebrated in the *Irish Times*: 'There's another crowd in this country that gets out a wee book now an' again and has a whole crowd over the head of it drinking small sherries in the High bernian.

Your man just clatters a play off the typewriter and takes the whole world into his lap.'

Like Oscar Wilde and George Bernard Shaw, Brendan had to make his name in London before he was taken seriously at home. By the end of the year, the Abbey's belated production of *The Quare Fellow* attracted further superlatives. The national columnists also took note. The *Irish Press* observed: 'The Behans never come down town. They make a royal progress. Brendan, the curls low on his forehead, like a cheerful Julius Cesar bestowing the accolade of friendship on innumerable acquaintances. Beatrice, slender, like a gentle nun.'

An *Irish Times* portrait detailed the risks involved in knowing the playwright: 'There are persons of bourgeois respectability in the city of Dublin who nourish a secret unease. It is that one day they may be proceeding on their middle-class way, chatting smoothly with their employer or their bank manager, when suddenly across the street will come a loud and ebullient "View-halloo" followed by a colourful and uninhibited commentary on things in general.'

But the newspaper interest would turn out to be a double-edged sword. Brendan would have been wise to have heeded a subsequent *Irish Times* feature, which warned him against turning into another non-productive Dublin 'character'.

Mary King of Parsons Bookshop was also concerned: 'We have to remember that Brendan was weaned on alcohol. The wonder's not that he drinks so much, but that he can find the discipline to refine his column, plays and poetry. A punishment for such a gregarious person! But now that he's becoming famous, he's attracting the awful tabloids and all the wrong people who will become between him and his work. Hopefully Beatrice will save him from the dangers of the drink and the accumulating hangers-on.'

The newspapers had further headlines when a hospital ward replaced the familiar pubs in July 1956. After three weeks in Baggot Street Hospital, Brendan was diagnosed with diabetes, for which he was prescribed a daily dose of insulin. Despite this setback and his increasing weight, Brendan laboured away on *Borstal Boy*. The BBC broadcast his play *The Big House* in 1957. After a long retreat in Connemara, he finally delivered the manuscript of *Borstal Boy* to Hutchinson. At the end of the year, he realised his teenage ambition to visit Spain. Beatrice rented a house in Ibiza, where she hoped Brendan would complete a new play, *An Giall, The Hostage*. But a bar fracas led to another deportation order. Brendan's version was that the authorities

Brendan Behan at the height of his success

targeted him because he replied 'Franco's funeral', to a journalist's question about what he would most like in Spain.

While many regarded Brendan as a playboy, *The Ginger Man* author J.P. Donleavy disagreed: 'Brendan was immensely competitive and serious about his work. Some of his lesser known short stories and poems translated by Ulick O'Connor are masterpieces and he was also a fine critic. He was the first to read the manuscript of *The Ginger Man*, which he peppered with pencilled corrections and suggestions, which I pooh-poohed at the time but, when it came to rewriting, I was happy to take most of them on board.'

With Beatrice's encouragement, Brendan continued his writing. *An Giall* opened to cheers and tears in June 1958 at Dublin's Damer Hall. 'Probably the best thing he has done so far,' enthused the *Evening Press*. Its English translation, *The Hostage*, reinforced Brendan's reputation in London a few months later. Reflecting Brendan's music-hall traditions and producer Joan Littlewood's desire to entertain, additional characters and songs further enlivened the original Irish version. Endorsing Littlewood's approach, Brendan explained: 'T.S. Eliot wasn't far wrong when he said that the main problem

of the dramatist today was to keep his audience amused; and that while they were laughing their heads off, you could be up to any bloody thing behind their backs; and it was what you were doing behind their bloody backs that made your play great.'

Critics lauded the author's exuberance and humanity. Insisting that Ireland had found a dramtist that it should treasure, Harold Hobson celebrated: 'A masterpiece of magnanimity, Mr Behan's portrait of the young English soldier is magnanimous indeed. Life is what *The Hostage* is rich in. It shouts, sings, thunders, and stamps with life, and with the life of the un-selfpitying English orphan, as ever Mr Behan finds for him an epitaph that is clasically restrained and beautiful. A girl drops on her knees beside the shot body and stills the boisterous tumult of this curious rowdy play with words of staggering simplicity: "He died in a foreign country and at home he had no one." Nothing finer in this kind has been written for 2,000 years.'

The reviews quelled Brendan's artistic doubts and his diabetes concerns, but the media interest increased his speed on fame's roller-coaster. The play's debunking of fanaticism also peeved former political allies. BBC interviewer Kenneth Allsop recounted that Brendan was haunted by republican atrocities and had reiterated that only a lunatic boasted of taking a human life. Some compatriots hinted that he had sold out to the box-office, others that *The Hostage's* English translation bore no resemblance to the original Gaelic version. Brendan despaired: 'The Archbishop of Dublin says I am a Communist. I am attacked by some citizens who maintain that my poor old play is pro-British! Jesus, I've heard it all now.'

Brendan found an even vaster audience when *The Quare Fellow* opened in New York, and the unexpected bonus of a *Time* magazine interview. Further international acclaim greeted the long-gestating *Borstal Boy* which was finally published in November 1958. The first print run of 15,000 copies sold out immediately. Every major UK and Irish paper and journal published reviews, and translation rights were sold across Europe. *Time* proclaimed that Brendan had 'Gabriel's own gift of the gab, a cold eye for himself, a warm heart for others, and the narrative speed of a Tinker'.

Hailing the book as a masterpiece, the *Times Literary Supplement* praised the author's stupendous gift for language. Frank O'Connor, however, cautioned: 'If I am a little unhappy about the book, it is not because I think it can do anything but good, but because Behan is not the only young Irish writer who has been forced into violent exhibitions of nonconformity, and I

am afraid that his mannerisms may grow on him and overlay the quality in him that makes *Borstal Boy* important.'

The Behans returned home in triumph. Reporters hung on Brendan's every word, photographers were never far away, newspapers clamoured for interviews. The writer honoured the ladies of Parsons Bookshop with an early call. 'Make sure you clear a mighty big space in the window for the book,' he joked in an American accent. 'Time you displayed a few *Borstal Boys* to shake up all those clerics and philosophers who give Baggot Street such a bad reputation!'

Brendan's success finally generated a worthwhile income. Concerned about the dampness of their Herbert Street flat, Beatrice persuaded him to consider a house recommended by a relative in Anglesea Road, Ballsbridge. A Hutchinsons' cheque sealed the deal and the Behans moved into what was once an exclusively Anglo-Irish enclave. Apart from the royalties, Brendan was thrilled that his book was available to Irish readers. He was also aware that the account of an Irishman's life in British prisons would prove popular at home.

But joy soon turned to anger and frustration. Parsons Bookshop would never stock *Borstal Boy* – nor would any other Irish shop. The shipment sent by Hutchinson in December was confiscated. The Irish authorities reacted to the swear words rather than the lyricism. *Borstal Boy* was banned in Ireland. Brendan was shocked that his own people could not now read his major opus. His wife remembered his fury: 'They've banned me, Beatrice. They've banned the fucking book. They banned O'Faolain and O'Flaherty and the rest. Now it's Brendan Behan's turn.'

The Dubliner felt he still had the affection of the people who really mattered, when he was asked to switch on the Christmas lights in Parnell Street, close to his childhood home. He responded to the Censorship Board:

> My name is Brendan Behan, I'm the latest of the banned
> Although we're small in numbers, we're the best banned in
> the land,
> We're read at wakes and weddin's and in every parish hall,
> And under library counters, sure you'll have no trouble at all.

The playwright made further headlines early in 1959, but again for the wrong reasons. Charged with being drunk and disorderly in Greystones outside Dublin, he was lucky to escape with a fine after apologising for his antics. He continued his drinking in Berlin, where he was booed when he made a

speech from the stage of the Schiller Theatre after arriving drunk for the first night of *The Quare Fellow*. The critics also savaged the play. Beatrice insisted that its failure owed more to the ponderous production than to the lack of a local sense of humour. Brendan's dishevelment was another matter.

> Someday maybe, I'll go back to Paris,
> And welcome in the dawn at Chatelet
> With onion soup and rum to keep us nourished,
> Till the sun comes up on St-Germain des-Pres.

The Germans were soon forgotten as Brendan and *The Hostage* triumphed in his favourite city, Paris, in April 1959. The opening night audience gave him a rapturous reception. Resplendent in full dress suit and fully buttoned white shirt, Brendan thanked them in French for their enthusiastic welcome. Once again, he was besieged by the media and applauded in the streets of the city where Joyce and J.P. Donleavy had also been lionised.

Hutchinson commissioned *Brendan Behan's Island*, which they saw as an update of Thackeray's *Irish Sketchbook*. The book was to be illustrated by Paul Hogarth, noted for his collaborations with Graham Greene and Laurence Durrell. Despite suffering an epileptic fit shortly beforehand, Brendan embarked with Beatrice and Hogarth on their annual Connemara holiday. The artist saw the writer perform his favourite role on the crowded Aran Islands steamer: 'Brendan sang on, stopping only to make sure that everyone had a big glass of stout in his fist. The stout flowed like water. Two hours and what seemed like two thousand songs later, the boat steamed into Kilronan harbour with an inebriated cargo of singing fishermen. It was an extraordinary spectacle.'

Brendan suffered another fit, illness and drinking delayed the work. Observing that he was essentially a talker who wrote as he spoke, Hogarth's wife, Pat, suggested the use of a tape-recorder. Some commentators deplored the playwright's subsequent spoken works as not being real books. Brendan retorted: 'If the Mycenaean poets could do it, then so can I. I do not set myself up as an authority on these matters, but if Homer is to be believed, the Greeks wrote their books by improvising them in talk.'

Dr. Terence Chapman shocked Brendan in Dublin: 'Stop drinking or prepare to die soon.' He booked Brendan into Baggot Street Hospital. But, after two nights, the playwright fled to London where *The Hostage* had just opened at Wyndham's Theatre. Suitably fortified, Brendan helped a busker outside the theatre, before exchanging ad libs with the cast and regaling

Brendan Behan being asked to sing at the Jaeger House Ballroom in New York

the audience with a speech. Most of the playgoers were thrilled with this extra theatre, but the management banned him from re-entering. He suffered another alcoholic seizure and was charged with being drunk and disorderly. When Des MacNamara arrived to rescue him from a police station, the playwright and the officers were seated around a crate of pale ale: 'His hosts were enjoying his company so much, they were reluctant to release him!'

Des provided an insight into Brendan's character in his *Book of Intrusions* profile of the playwright as the garrulous nine-foot-tall female Eevill: 'She had a gregarious nature, drawing energy from others and condensing it to a white heat through her own personality. Left alone in a house, she would browse through books, newspapers, tenancy agreements, the small print on guarantee forms or copies of the *Watch Tower* left by an elderly lady in Jehovah's Witnesses. She could spend a contented day absorbing anything from the horrors of a novel by Celine to "Live Letters" in the *Daily Mirror*, and apparently derive an equal edification from both. But as the hours passed, the need to charge her batteries on other people's energy drove her out to seek a likely source.'

Brendan returned to Dublin, where he was admitted to hospital for a fortnight. He finally stopped drinking and left in good health for the New York premiere of *The Hostage* in September 1960. Appearing on a television show with Peter Ustinov, Anthony Quinn and Tennessee Williams, Brendan explained his philosophy: 'In *The Hostage*, I have nothing to sell – not religion, not a political system, not a philosophy, and certainly not a panacea for the ills of the world. I respect kindness to human beings first of all, and

kindness to animals. I don't respect the law; I have a total irreverence for anything concerned with society except that which makes the roads safer, the beer stronger, the food cheaper, and old men and women warmer in the winter and happier in the summer.'

Inevitably, Brendan again succumbed to the drink. He was lucky to escape a custodial sentence for assault on his return to Dublin in February 1961. Shabbily attired, he later called with a donation to the Sisters of Charity. A nun thought he was there for one of their free meals. 'I'm very sorry, but you're far too late for dinner,' she told him. May O'Flaherty remembered sadly: 'From that point on, he was firmly on the escalator to self-destruction.'

A friend observed Beatrice Behan's efforts to save the playwright from himself: 'Beatrice was great the way she stood by him through all his problems. She told us of her concerns about his health but, despite all the warnings, Brendan was easily led by his many friends. The resolve to stay off the drink and control his diabetes lasted for only a few heroic periods. Brendan couldn't resist the company, he blossomed in a crowd.'

Brendan thrived on the liveliness and openness of New York and once asked Beatrice if she would consider settling there, away from narrow-minded Ireland. Frank O'Connor ascribed Brendan's frequent travelling to the fact that he received abroad the acclaim that the banning of *Borstal Boy* had denied him at home: 'This left him open to the flattery of England and America and I am afraid that he vulgarised that small, pure, absolute genuine gift of his, or allowed it to be vulgarised.' After further misadventures in New York and Toronto, Brendan tape-recorded *Confessions of an Irish Rebel* and *Brendan Behan's New York*. These were his last works.

Beatrice gave birth to their daughter Blanaid in November 1963. Brendan visited them every day in the Rotunda Hospital. He trudged to Dr. Chapman for his regular insulin injection but after falling into a diabetic coma, he was once again hospitalised in Baggot Street. On his release, he resumed drinking. He made a final visit to McDaid's, where he reminisced with poet John Jordan about the 1950s. John's friend, a doctor, remarked: 'He looks like a man who has not slept for years.' After another seizure, Brendan was admitted to the Meath Hospital. 'May you be the mother of a bishop,' he thanked one of the nuns who looked after him. He died on March 20, 1964 at the age of 41.

Sean O'Casey lamented the playwright's premature death: 'Brendan was amiable and kind. He had no bitterness or venom or literary jealousy. Had he

lived another ten years he would have written more and perhaps better . . . he had so much to offer.'

The funeral of the housepainter turned writer was one of the biggest seen in his native city. Mourners thronged the windy streets, many were in tears. For most, Brendan Behan was Dublin. They could not accept that he had died. A garda stood to attention on O'Connell Bridge and saluted the coffin of the man his colleagues had hunted two decades earlier. "'Tis hard to see the craythur go so young, but, Jasus, isn't it a shame he can't see the crowds?' a shawlie wiped her eyes on Parnell Street. The Lord Mayor and Tanaiste Sean McEntee attended, and writers and friends including Christy Brown, Harry Kernoff, John B. Keane, Frank Norman, Joan Littlewood, Jacqueline Sundstrom and Carolyn Simpson. Stephen Behan held his hat by its brim, as the son he had first seen 41 years earlier from a Kilmainham prison window was lowered into the ground. There would be no more noise.

John Jordan saw Brendan as a Falstaffian character, heroic in his faults, heroic in his virtues. Flann O'Brien reiterated: 'He was a delightful rowdy, a wit, a man of action in many dangerous undertakings where he thought his duty lay, a reckless drinker, a fearsome denouncer of humbug and pretence, and sole proprietor of the biggest heart that has beaten in Ireland over the past forty years.'

Harold Pinter paid a final tribute: 'He impressed me as a man with a blazing spirit. I thought he was a fine writer. He just didn't care a damn, that was his quality – and it was his wonderful sense of freedom that made us laugh.'

The adulation continued after Brendan's death. The plaque commemorating him in St. Patrick's Cathedral park was stolen by an admirer. His bronze bust by sculptor John Behan disappeared from Glasnevin cemetery. A plaque, incorrectly worded, was placed on the site of his former Russell Street home. A seat, which mispelt the title of *An Giall*, was erected beside the nearby Royal Canal. A block of flats was named after him. Brendan would have been particularly amused with the appearance of his work on school curricula. One in the eye for those McDaid's university-poets.

Chapter Five

BEATRICE BEHAN – A LOVE STORY

Poor Beattie had her hands full. – Mary King

'I'VE A FEW BOB, LET'S GO OVER to F-France,' Brendan Behan leaned across his pint in Lampshades lounge.

Beatrice Salkeld was surprised: it was their first date. 'What for, Brendan?' she enquired.

'A t-trial marriage.' Brendan, who stammered when he was nervous, took another slurp.

Beatrice's gentle nature was deceptive. 'We'll go alright, Brendan,' she quietly replied. '*After* we're married.'

Beatrice Behan was a familiar Dublin figure, as she rode her upright black bicycle along the leafy backwaters of Ballsbridge from the 1960s until her death in 1993. She cycled as she had lived, at a cool unflurried pace. Her slim youthful face was crowned by a mop of wiry grey hair, a newspaper and a loaf of bread usually peeked out from her wicker basket. Those who did not know her could have been forgiven for thinking she was the retired district nurse.

But Beatrice was the survivor of a nine-year marriage to Ireland's most rumbustious writer, Brendan Francis Behan. It had been an unlikely partnership and a shock to all their respective friends. A shy, quiet and educated artist running off with a rough-hewn rowdy former jailbird, whose unpredictability and excessive boozing were legendary in a city famous for its drinkers. But Beatrice's shyness concealed a rare unflappability, as Brendan discovered on that Lampshades date.

The pair had first met in Beatrice's Donnybrook home, when the seventeen-year-old was doing her school homework. Her father, artist Cecil ffrench Salkeld, seldom returned from a drinking spree without bringing some interesting new acquaintances. He met Brendan in a pub where he was sheltering from the rain. Intrigued by the overalled housepainter's knowledge and vivacity, he asked him home to continue their discussion on politics and literature. Beatrice dutifully provided tea and scones and then ignored their guest, little knowing that within twelve years their names would be linked forever. 'I was well used to meeting artistic characters at that stage. We had a little cottage in Glencree, beside the woods and a stream. Many writers visited us there, including Liam O'Flaherty, Joseph Campbell, Francis Stuart and Padraic O'Conaire, who had a tent in the valley. The only people I ever considered strange were those that were not writers or artists.'

Brendan Behan soon became known as a Dublin character, admired by some, avoided by many. His stories and poetry appeared in magazines including the Irish language *Comhar*, to which the Salkelds contributed. Beatrice had several more sightings of him while attending convent school on Stephen's Green and, later, her art college on Kildare Street. But their first meeting as adults was at the Pike Theatre's premiere of *The Quare Fellow* in November 1954. They soon discovered they had mutual friends, such as Liam O'Flaherty and Harry Kernoff. Beatrice was at that time seeing another man. He could not compare to the ebullient Brendan, who lost no time in asking her out for a drink.

Despite the fact that he was now an acclaimed playwright and newspaper columnist, Beatrice's friends were appalled when she announced that she would marry Brendan. Many of them had witnessed his unpredictability and violence after drink. Some recalled the night he had broken up a party of Beatrice's fellow-art students in Anglesea Street. He had only just finished a ten-day sentence in Mountjoy for assault. Beatrice's sister, Celia, told her she was mad to even consider the idea. Cecil Salkeld, no mean imbiber himself, cautioned: 'Please be careful. I know Brendan. He has a reputation as a drinker, and you've had your share of that with me. Don't imagine for a moment that you can change him.'

The wedding victim herself explained: 'Brendan said to me once about those who complained about him, "All these people understand is my drinking". I found a completely different Brendan behind the blustering public image. A very compassionate and caring man, concerned about injustice, inequality and human suffering. He would speak to me about his childhood and

events and ideas which moved him, it was the first time I had met someone so concerned. And on top of all that, he had a great sense of humour. He was the most alive and exuberant person I ever met.'

Beatrice was 29 and Brendan 32 when they married on February 16, 1955 at Donnybrook parish church. The wedding was as unorthodox as their future life together. None of the Behan relatives was present; Brendan said that they would not all fit in the church. Having heard of his family's political record, the

Portrait of Beatrice's father, Cecil Salkeld, by Reginald Gray

priest whom Brendan first consulted asked if he was a member of the Communist Party. Celia Salkeld was the bridesmaid but the wedding priest would not allow her boyfriend, artist Reginald Gray, to be best man. He was a Protestant. 'Thanks be to Jaysus that's over. Let's go and have a few jars,' Brendan insisted, as they escaped into the crisp morning air.

After a small hotel reception, Brendan decided it was time for Beatrice to meet the Behans. As they drove through the concrete wastes of Crumlin, Brendan pointed to a lady who was stepping out briskly with a shopping bag. 'That's the ma,' he told his new wife. He shouted to his mother: 'I'm married!' She replied: 'And so am I!' Kathleen Behan at first thought her son was joking but she quickly took to his new wife. Beatrice recalled: 'Brendan's parents, Kathleen and Stephen, whom I encountered later in Stephen's Green, were a very stimulating couple. It was easy to see where Brendan had got his talent and spirit from.'

Beatrice soon experienced the hectic pace at which her new husband lived. Despite the success of *The Quare Fellow*, he was still short of money. He brought his new bride around the city by horse-cab, as he solicited funds from friends and, finally, from his cousin, Seamus de Burca. The theatre costumier recalled: 'I could never imagine Brendan married. So I had a bigger shock than most, when he rushed in – wearing an unaccustomed new

suit. Needless to say, the till was raided. And though he didn't wait to introduce me to his bride, I waved a theatrical topper as they rattled down Dame Street on their way to Paris and their future. I was delighted afterwards to meet Beatrice. Knowing of her father Cecil and poetess grandmother Blanaid, I thought that she was one of the few women around who might be able to understand and control him.'

Before the newlyweds boarded the cross-channel ferry at North Wall, they made a final halt at the Lincoln Inn pub. Brendan showed Beatrice the hotel where Nora Barnacle was working when she met James Joyce, and the office of *The Irish Homestead*, which had first published the Dublin writer. The couple heard a fiddler outside the pub, an impromptu wedding serenade. Brendan asked if he would perform his favourite, 'An Chuilfionn'. As he played, Brendan's tenor voice soared above the music and the swirl of the traffic. People stopped to listen, girls opened office windows and leaned out. Beatrice realised that her life would never be the same again.

Their holiday in the city where Oscar and Constance Wilde had also honeymooned was run at the same breathless rate. Beatrice was thrilled to see the city of so many of her own and her father's favourite artists. She was amazed to find how much at home and how well known Brendan was. Even clochards greeted him. He proudly showed his old haunts, the student restaurants and bars, and places where he had stayed such as the Hotel Louisiane. Also Colette's house, the hotel where Oscar Wilde had died and the Café Pergola where Norman Mailer bought him ham and eggs the day he sold *The Naked and the Dead*.

The Behans' first home was a garden flat at 18 Waterloo Road, where Brendan worked at the living room table on his *Irish Press* column. Beatrice remembered: 'Brendan rarely missed a deadline. When he started on *Borstal Boy*, his method was a bit more haphazard. He would type for a while, then get up and walk around the flat or maybe take up a book or even go out for a walk. When he returned, he would sit down and start working again. The *Press* was our only source of income so I did some work for the *Irish Times*, illustrating horticultural features. Brendan didn't neglect the social side and would frequently go out to a local pub at lunchtime, sometimes returning with his friends Ben Kiely, Pearse Hutchinson, John Ryan or John Jordan.'

At the end of 1955, the Behans moved to a ground-floor flat at 15 Herbert Street. Here, Beatrice discovered Brendan's fondness for animals and birds. He brought home a dying sparrow, which he put it in a box and buried near Baggot Street bridge. A neighbour thought he carried his love of animals a

Beatrice and Brendan Behan celebrating

bit too far when she saw him feeding a bottle of stout to a horse on Mespil Road. Beatrice often recalled the day when Brendan rescued an abandoned kitten, while returning with Des MacNamara from a party in Howth. As he was going up Grafton Street, a squad car screeched to a halt. The gardaí ordered Brendan to stop and demanded to know what was in his pocket. Disappointed to find only the kitten, they ordered him on his way when he demanded sardines for the animal.

Beatrice remembered: 'Our best days were in that flat, which we shared with Beamish, our cat. Whatever the previous night's excitement, Brendan was always up clattering at the typewriter by eight. Then it was over to Parsons for the *Irish Times*. When Brendan wrote, he worked very hard indeed. And for such a convivial man, that was more difficult than for others. We had great fun working together when those *Press* columns were published in book form as *Hold Your Hour and Have Another*, for which I did the drawings.'

'Despite all the work, we never had a surfeit of money. I participated in some group shows and one of our best windfalls was when my picture of Bin Day in Herbert Street was bought by an American visitor for £25 – a fortune in those days. The picture showed cats foraging around our dustbin and it was from Herbert Street that we were persuaded by Petronella O'Flanagan to bring Beamish to an exhibition in the Mansion House. Brendan was mortified when he saw Beamish dolled out with a large green bow around his neck, he had to go across the road to the Dawson Lounge to recover!'

One *Press* story reflects Brendan's joy at his new married condition. Beatrice's sketch shows him confronting a blank sheet of paper in his Remington, under the watchful eye of Beamish. 'I sat down this morning after a kipper, some mushrooms, cheese, black coffee with bread and marmalade and butter, and looked out the window, thinking of the poor. While the turf was blazing itself into a white heat of fragrant caressing warmth, I digested my breakfast and reflected on the excellence of my condition.'

'The wicked,' I thought happily, 'prosper in a wicked world.'

'But, alas, not the worst of us is free from the improving influence of a good woman. My first wife came in and said, "I thought you were doing that bit of an article today?"'

Journalist Petronella O'Flanagan had often spoken to the Behans about Carraroe in the west of Ireland, where she had seen a young Dylan Thomas holidaying. Carraroe was the heart of the Irish-speaking Gaeltacht area of Connemara. Having earlier enjoyed Kerry, Brendan was delighted when Beatrice suggested they try Carraroe for a break. Here he could work, swim and rest. Afterwards, Beatrice recalled: 'I would cook dinner over the open turf fire and then we would go to Stiofan O'Flaitheartaigh's bar, where Brendan would speak in Irish with the locals and sing the occasional song. Brendan was very proud of his Gaelic, by the way. His Irish language poems are among the best of his work and it's a shame that they haven't been more publicised.

'Loneliness', which was translated by his nephew, Colbert Kearney, is one of the most moving:

> The taste of blackberries
> After rain
> On top of the mountain.
> In the silence of prison
> Cold whistle of the train.
> The lovers' whispered laugh
> To the lonely one.

'Sing us "The Ould Triangle"!' Brendan's fame attracted many hangers-on. Beatrice was not averse to pub life; she relished meeting the pub characters who abounded in the 1950s. As Tom Corkery explained: 'In that leisurely and hospitable decade, a shrewd ball-man could borrow a two-shilling piece and entering a pub could reasonably hope, by good projection of his personality, wit, anecdotes and stock of blarney, to spend the evening as the guest of his peers. Nor was the ball-man despised for not having the readies in his own pocket; there was an unwritten law in Dublin that the boon companion, like the labourer, was worthy of his hire.'

But Beatrice became increasingly concerned that the pubs and need for an audience curtailed Brendan's will to write. The publication of *Borstal Boy* and the success of his plays introduced the additional element of the publicity circuit. Citing the physical and mental strain on her basically shy husband, Beatrice vainly appealed to the publicists to reduce their demands. Inevitably, Dublin pub tours were replaced by pub crawls in London and New York. But before being finally broken on the well-lubricated publicity treadmill, Beatrice ensured a home environment where Brendan could build on his early success. Had they not married, *The Quare Fellow* would probably have been his last, as well as his first, play. During their years together, he wrote *An Giall* and its English version, *The Hostage*. Also, *Borstal Boy*, many of his Irish poems and his books on Ireland and New York.

Mary King observed: 'Poor Beattie had her hands full. She was very brave to marry Brendan, having seen how alcohol had reduced the life of her own gifted father. I had coffee many times with her after her children had grown up. Whenever she spoke of her time with Brendan, it was always in a positive way, she never once complained about him. No one else could have managed him as successfully as she did for so long.'

The Parsons lady had no doubt about Brendan's love for Beatrice: 'Whenever he mentioned her, it was always in a most affectionate way. The two of them often visited the shop together and they were closer than many married couples we knew. Some commentators have written about what a hard time she must have had. But they ignored the affection they shared and also Beattie's influence on Brendan's career. Without her, he would have succumbed much earlier to the drink and diabetes, and with less work to show for his time. Her role in Brendan's success has yet to be properly acknowledged.'

Beatrice endured many of Brendan's drunken escapades. She tried vainly to defend him when he was arrested by French police after an incident at Orly airport in 1958. Their Dublin plane was forced to turn back after a lightning strike. Brendan refused to reboard the plane, saying that he was prepared to die for France, but not for Air France. He demanded his money back and when he was refused he was arrested after rowing with the airport manager. He made further headlines the following year when he was charged with being drunk and disorderly in Greystones. Beatrice suffered the humiliation of being called to the witness box, but thanks to her testimony he escaped with a fine. In Berlin, Ibiza, London, Hollywood, New York and Toronto, she was in the thick of further drink-fuelled confrontations.

Artist Paul Hogarth was impressed by Beatrice's determination to protect her husband, but the playwright's wife admitted that it was a demanding life. Living out of suitcases for months of the year and striving all the time to save Brendan from both himself and the hangers-on: 'I surprised myself by acquiring a new tolerance for people of all sorts. It would have been unthinkable in former days to find myself at the centre of bar-room rows, but I was prepared, as Brendan's good companion, to share his life, come what may. I had to admit that the world was hardening me a little. Incidents that once would have shocked me I now took for granted. My main concern was keeping pace with Brendan, encouraging him, advising him, loving him.'

Inevitably, the drink and diabetes caught up with Brendan. In 1959, he was hospitalised in Galway after suffering two seizures in Carraroe. Following further seizures, Beatrice hired a taxi to take him back to Dublin. Brendan insisted in stopping at pubs along the route. Dr. Terence Chapman of Baggot Street Hospital reiterated the Galway doctor's advice that if Brendan did not stop drinking, he would soon be dead. Brendan abhorred institutions as much as he did uniforms. After two days in Baggot Street Hospital, he turned up at Anglesea Road, wearing an overcoat over his pyjamas.

Beatrice Behan, a very supportive wife

Despite Beatrice's protestations, he immediately packed for London, where *The Hostage* had just started in the West End. She could not accompany him as both her mother and sister were ill. A few days later, she read that he had been arrested in Mayfair. To add to her concerns, newspapers were also writing about his alleged but non-existent affair with a young English playwright, Shelagh Delaney. But the event which caused Beatrice most anguish occurred in 1963, when she was pregnant with their first child. That was Brendan's New York affair with a young Irishwoman, whom Beatrice had regarded as just another stagestruck groupie: 'I told him I hadn't noticed girls around him when he lay in a coma, or when he was convulsed with a seizure, or when he was violently sick. "They don't come around to clear up the mess, do they?"'

If Beatrice Behan suffered the low times, including Brendan's anger at the banning of *Borstal Boy*, she also shared many rare and joyous moments with her husband. Not only the Irish first-nights of *An Giall* and *The Hostage*, but also his triumphant return to the home of the ancient enemy who had once deported him. Beatrice remembered that Brendan was almost tearful at *The*

Quare Fellow's reception when it opened in 1956 at London's Theatre Royal Stratford. A similar response and glowing reviews greeted *The Hostage*.

Beatrice's favourite memory was of what she regarded as Brendan's greatest success. She never forgot his honeymoon introduction to Paris and his joy in showing her the sights and old friends. She shared his love of the capital which had welcomed compatriots Beckett, Moore and Wilde, and favourite artists Mainie Jellett and Mary Swanzy. And Paris didn't let them down, when *The Hostage* represented Britain at the Theatre des Nations Festival. Over 1,250 packed the Sarah Bernhardt Theatre for the premiere on April 3, 1959. A red carpet greeted author and guests under the glittering chandelier. Unlike Brendan's earlier custodial caretakers, he and Beatrice were escorted up the staircase by a magnificently-uniformed guard of honour whose gold epaulettes sparkled in the light. The reaction to the play was equally fantastic. Brendan received a three-minute ovation and the cast ten curtain calls.

The playwright's widow recalled: 'The cries of "Auteur!" at the final curtain had an exciting ring. My husband, I thought, had been awarded his accolade in his favourite city. The audience turned to where he stood in the circle acknowledging their applause. He spoke in French, telling them how proud he was to have his play presented in the most civilised city in the world. Brendan's triumphal return to Paris was probably the highlight of his literary life and I was proud to share it with him.'

Beatrice's problems did not end with Brendan's death. From playing the very public role of a celebrity wife, she found herself alone and struggling with the practicalities of her new role as a widow and mother. Her husband was hardly buried when the government gave her an ultimatum about his unpaid income tax. As she was forced to rent out half her home, she remembered Brendan's complaint after *Borstal Boy* was proscribed: 'First they ban my book and then they want me to pay tax on it!'

The widowed Beatrice remained a very private person. Relieved that the hangers-on had flown, she enjoyed a small circle of friends, including Mary King and her mother-in-law, Kathleen. She confessed her ambition to resume painting to journalist Michael O'Toole, one of the few people to whom she gave an interview. She devoted her life to raising Blanaid and Paudge, the son she later had with Brendan's friend, Cathal Goulding. Co-written with Des Hickey and Gus Smith, she published her own memoir in 1974, *My Life with Brendan*.

Beatrice survived to see *Borstal Boy* unbanned and Brendan's plays re-staged many times in Dublin and abroad. Though most people retained positive memories of her husband, the misrepresentations sometimes resurfaced. Hugh Leonard frequently denigrated Brendan and all the Behans in his newspaper column. The impression of a foul-mouth was reiterated by a 1990s production of *The Hostage*. Beatrice was forced to protest: 'Some people complained about Brendan's bad language and I was saddened that a recent production of *The Hostage* featured so many swear words. These were never in the original. I know because it was I who translated it from the original Irish.'

Beatrice would rarely discuss her life with the demanding Brendan, but she insisted: 'Better off marrying a bank clerk? I'm afraid not! I married the most entertaining and most generous man I ever met and, despite the hard times, we were happy. There was never a dull moment when he was around. Though Brendan was a man who needed company, I thought that I could handle his drinking temptations. The diabetes, however, added to our problems.

'But I prefer to remember the good times, particularly in Herbert Street. The area had a wonderful artistic feel and at its heart was Parsons, a welcoming second home that we visited most days. Miss O'Flaherty and Miss King became our friends as well as our booksellers.'

The former Herbert Street resident readily confessed: 'I miss Brendan every day since his death, and his funeral showed how much he had also meant to the people of Dublin. One of my proudest moments was when the Brendan Behan flats were opened in Russell Street where he first lived as a child. He loved to help old people and he would have been very proud to have seen this senior citizens' development named after him.'

Beatrice recalled how Brendan had often brought her to Davy Byrne's, for a drink under the murals painted by her father, Cecil Salkeld. Up to the time of her death, Beatrice retouched the paintings each year. She remem-

bered: 'I was thrilled when my father painted me into that last picture by the door – I am the little girl in red running down the stairs!' Despite her turbulent marriage, the consistent Beatrice remained a little girl at heart. She died while asleep of a heart attack on March 9, 1993, and was buried beside Brendan in Dublin's Glasnevin Cemetery.

Shortly before Brendan died almost three decades earlier, he opened his eyes and murmured to Beatrice: 'You made one foolish mistake, Beatrice.'

'What was that, Brendan?' she bent down.

'You married me,' he replied.

'I saw the two days,' she told him. 'That's all that matters, Brendan.'

Brendan and Beatrice Behan's grave in Glasnevin Cemetery

Chapter Six

Literary Salons and Saloons

If you miss the Irish Times, *you miss part of the day and if you go into the Pearl Bar, you'll miss the whole bloody day!*
– Eamonn MacThomais.

For better or worse, generations of Dublin literati and artists took Oliver Goldsmith's 1773 advice to their hearts:

> Let schoolmasters puzzle their brain,
> With grammer, and nonsense and learning:
> Good liquor, I stoutly maintain,
> Gives genius a better discerning.

Drink and public houses played a vital role in their lives, offering the camaraderie of like minds and sanctuary from an inimical exterior world. If the city was famous for its disproportionate number of writers, its literary pubs were among the liveliest in Europe, particularly from the deprived 1920s to the 1970s.

Peter Keogh, who served in Lampshades, insisted: 'Without places like ours, I don't think the artists and writers would have stayed sane. They led lonely lives. Owen Walsh painted by himself all day in his apartment-studio across the road. Beatrice Behan told me of Brendan's morning hours in front of the typewriter. We offered them a meeting place they would not have had otherwise, a place where they could shed their inhibitions. I won't say they were always the best of friends. In fact they sometimes got out of hand. Haranguing each other over ideas and opinions – while the rest of us were fretting about the price of eggs and butter!'

Cyril Connolly observed the Irish pub action on a 1940s visit to the Palace Bar: 'It is as warm and friendly as an alligator tank, its inhabitants from a long process of mutual mastication, have a literary look, and are as witty, hospitable and kindly a group as can be found anywhere. The Palace Bar is perhaps the last place of its kind in Europe. A Café Literaire, where one can walk in to have an intelligent discussion with a stranger, listen to Sean O'Sullivan on the early days of James Joyce, or discuss the national problem with the giant Hemingway-esque editor of the *Irish Times*.'

The association of literature with pubs started when publishers shared premises with taverns, which also staged early book auctions. Literary salons pre-dated the Dublin literary pubs, most famously those of Sydney Lady Morgan in Kildare Street and Lady Wilde in Merrion Square. A former governess who married surgeon Thomas Charles Morgan in 1812, Lady Morgan was the daughter of Robert Owenson, a popular actor and a relative of Oliver Goldsmith. The Establishment derided her liberal opinions and support for Catholic Emancipation. But Lady Morgan's authorship of such popular books as *The Wild Irish Girl* and *Florence Macarthy* ensured her social success and she established a reputation as one of the city's most successful hostesses. Her soirees and musical evenings attracted Richard Brinsley Sheridan, Samuel Lover, Sheridan Le Fanu, Charles Maturin, Felicia Hemans and the Italian virtuoso, Nicolo Paganini. Thomas Moore was another visitor: 'He sang some of his most beautiful songs then in his most delightful manner without stopping, some of them twice over.'

> Let us have wine and women, mirth and laughter,
> Sermons and soda-water the day after.

Lady Morgan brought a Byronic association to Kildare Street. She was a confidante of Lady Caroline Lamb, who left her a miniature of Lord Byron. The poet's last lover, Contessa Guiccoli, also presented her with a locket containing a lock of Byron's hair. Sadly, the locket escaped its chain when Lady Morgan was pacing the street after a cold morning carriage ride. 'I have met with a loss which breaks my heart,' she lamented. Always elegantly dressed, Lady Morgan in her later days used a gold pen set with mother-of-pearl. But despite this extravagance, she admitted to the motivation of many a scribe: 'Our destiny in this world is such a wretched one, that I try to forget it in writing.'

Lady Jane Francesca Wilde instituted Dublin's most notable literary and political salon in Merrion Square. As many as one hundred guests usually

attended, from artist and antiquarian George Petrie, Charles Lever and Samuel Ferguson to mathematician Sir Rowan Hamilton and the Home Rule party leader, Sir Isaac Butt. It was here that John B. Yeats announced that he would renounce his legal training to become a painter. Lady Wilde attempted to replicate her salon in London to which she moved in 1879. Though she attracted such guests as Browning and Ruskin, she found that Londoners lacked the spirit of her Merrion Square visitors.

Speranza – Lady Wilde

In 1842, William Makepeace Thackeray enjoyed Dublin's Shelbourne Hotel, to which Rudyard Kipling brought a whiff of the orient during his three stays up to 1911. While sojourning there for the winter of 1883-4, George Moore progressed his novel, *A Drama in Muslin*, about mothers bringing their debutante daughters from the west of Ireland in search of husbands. From his room overlooking Stephen's Green, he corresponded with his friend Emil Zola. Fifteen years later, he and Edward Martyn were guests at a special dinner to celebrate the launch of the Irish Literary Theatre with the latter's *The Heather Field*. Moore, Lady Gregory, John Millington Synge and Douglas Hyde also attended the 1904 hotel banquet in honour of John Quinn. The New York lawyer was the benefactor of John B. Yeats and future defender of James Joyce, whose works also featured the Shelbourne.

W.B. Yeats dined there the night after being awarded the 1923 Nobel Prize. Another Moore, novelist Brian Moore, recuperated at the hotel in 1976, after collapsing during a dramatisation of one of his books at the Abbey – 'My God! Surely we weren't as bad as all that!' a member of the cast reacted. Brian's friend, Sean O'Faolain, celebrated his eightieth birthday at the hotel in February 1980.

The Shelbourne's romantic associations continued long after George Moore. It was here that Elizabeth Bowen conducted her affair with Sean

O'Faolain, and Kate and Baba in Edna O'Brien's *Girl with Green Eyes* sipped cocktails. Brendan Behan equally nervously showed the first grubby manuscript of *Borstal Boy* to Ernie Gebler's agent, Iain Hamilton of Hutchinson, who later published Ernie's young wife, Edna O'Brien. Patrick Kavanagh treated James Liddy's sister, Nora, to afternoon tea in the Shelbourne. Mirroring George Moore's western mothers, Patrick's interest was as much practical as romantic. Nora Liddy was a medical student, just the sort of person he sought to look after him in his old age.

The nineteenth century salons were succeeded by tea afternoons and evenings. The most famous were hosted by Sarah Purser, and by George Moore and Oliver St John Gogarty who lived opposite each other in Ely Place. Moore's Saturday Nights mirrored his Café Nouvelle Athenes, Paris afternoons with Manet and Degas who had each painted him. With artists Walter Osborne, Walter Sickert and John Yeats, his guests included George Russell, Lady Gregory and German scholar Kuno Meyer. Gogarty played host on Friday evenings to policical leader Michael Collins, Horace Plunkett, Tom Kettle, as well as James Stephens, Count John McCormack and painters William Orpen and Augustus John.

Sarah Purser's Second Tuesdays attracted many literati and business people to Mespil House. Nationalists mixed with Unionists, young artists met prospective patrons, George Bernard Shaw and G.K. Chesterton called. A staunch Parnellite in an equally strong Unionist society, Sarah hated humbug and was a fearless wit. After George Moore mischieviously enquired why such a clever woman as she could paint so badly, she delivered the oft-quoted put-down: 'Some men kiss and tell; Moore tells but doesn't kiss.'

Together with Oliver St. John Gogarty and the Yeats brothers,

Sarah Purser, by John Butler Yeats, 1904

Sarah herself was a regular visitor to the 1920s salon of Enid Starkie. Enid was the mother of *Raggle Taggle* author and Trinity College lecturer Walter Starkie, who introduced Samuel Beckett to Italian literature. Sean O'Faolain's later Sunday evenings featured James Plunkett, Mervyn Wall, Brian Boydell, Norah McGuinness and James Joyce's friend, Con Curran. Aidan Higgins recalled the glamour of evenings in Arland Ussher's Blackrock house attended by the Purser sisters, Paddy Collins' Spanish friend Carmen, and Terry Butler's equally exotic wife from Bologna. Despite an unfashionable lack of alcohol, Padraic Colum, Austin Clarke and other writers attended Monk Gibbon's poetry recitals in nearby Sandycove.

In the 1960s, less abstemious Mary Lavin provided Italian dishes in her Lad Lane mews for writers Tom Kilroy, Desmond Hogan, Nuala O'Faolain and teacher Maeve Binchy, who remembered the 'strong drink and liberal chat and late hours'. Schoolteachers had to be careful in those days. Maeve recalled: 'Mary Lavin had her children so well trained that not a word of this ever leaked out to the pupils. No tales were ever told that Miss Clarke and Miss Binchy might have been boisterous in civilian life.' Music enlivened Garech Browne's soirees on the opposite side of the canal, attended by

Maeve Binchy enjoyed literary evenings at Mary Lavin's mews

singer Dolly McMahon, broadcaster Ciarán MacMathuna, sculptors Eddie Maguire and Eddie Delaney, and the ubiquitous Brendan Behan.

Liam Miller's Baggot Street home also harboured Bohemian waifs. He and his wife Josephine entertained such diverse guests as Patricia Lynch and the American poets John Berryman and Pulitzer Prize winner Theodore Roethke, as well as biographer Richard Ellmann, actor Eamonn Keane, his playwright brother John, singer Ronnie Drew and photographer Cartier-Bresson. Liam's cabinets sheltered rare books and bookplates by Eric Gill and works by William Morris and Harry Clarke. John Montague remembered: 'Liam would take down a Gill and expound it with a seraphic, enigmatic, smile. He made beautiful pages of his own on those never-ending summers. Baggot Street was never deserta in those days.'

Nearby Fitzwilliam Place was the site of Baggotonia's most spectacular rendezvous, the Catacombs. Situated in the basement of 13 Fitzwilliam Place, its maze of dank pantries and windowless rooms regularly attracted up to sixty imbibers, eager to prolong the night after pub-closing. Devotees included sculptors Irene and Desmond Broe, Gainor Crist, Pearse Hutchinson, J.P. Donleavy, Anthony Cronin and Brendan Behan's admirer, the composer Freddie May. Also actor Dan O'Herlihy, Tony MacInerney, Communist leader George Jeffares, various retired revolutionaries and artists Tom Nisbet and Patrick Swift, who was married to John Ryan's sister, Oonagh. They converged clutching their passports, brown paper bags of stout and gin. The bottles were redeemed for cash next morning by the sharp-tongued landlord Dickie Wyeman. Many of the guests stayed overnight. Brendan Behan recorded: 'A crowd of people would assemble in the flat, each bringing a bottle of gin, or whiskey, or a dozen of stout. There would be men having women, men having men and women having women: a fair field and no favour.'

Two equally unsalubrious and unofficial drinking places were Dolly Fawcetts on Bolton Street, where one might find whiskey mixed with tea, and Nassau Street's ATS club. Here, Simone de Beauvoir's boyfriend, Nelson Algren, witnessed one of the friendly garda raids: 'I was reaching for a drop of wine when the glass was snatched from my hand by the proprietor's stout wife, seizing all the glasses empty or full out of the hands of the drinkers, thirsty or dry. Under the tables went the lot. Everyone sat up straight as in church, with nothing before them but ashtrays. Two inspecting officers entered from offstage, where they had been waiting their cue, inspected the ceiling, clothes racks, flower-pots, tabletops and juke boxes without finding anything.'

Des MacNamara's studio at 39 Grafton Street, opposite the birthplace of 'The Bohemian Girl' composer Michael Balfe, was Dublin's equivalent of a Fabian salon. While diva Margaret Burke Sheridan regaled ground-floor café guests with Balfe and other arias, voices also rose in Des's garret, where John Ryan and Brendan Behan jousted, and the latter's introduction to the Simpsons marked a key moment in his writing career.

John Ryan insisted: 'Grafton Street had been entertained by the likes of Shelley and Tom Moore, while Michael Davitt and the great John Butler Yeats had debated in the Contemporary Club. But I doubt if any of these matched the fervour of the gatherings that Des hosted, beside the turf fire and the coffee pot which bubbled around the clock. Reflecting his own restless mind, these featured the most amazing assortment of left-wing activists,

Artists and writers throng the Palace Bar in Dublin Culture *by caricaturist Alan Reeves published in* The Irish Times *in 1940.*

former political prisoners, writers, artists, composers, and such contrasting characters as Brendan Behan and Einstein's colleague, the physicist Erwin Schrodinger. The discussions covered every conceivable topic and tempers were frequently frayed, but Mac presided over all with the wisdom and grace which were his hallmark.'

Two of Dublin's most celebrated literary pubs in the thirties and forties were Fleet Street's Palace and Pearl Bars. Historian Eamonn MacThomais complained of the latter: 'If you miss the *Irish Times*, you miss part of the day and if you go into the Pearl Bar, you'll miss the whole bloody day!' The larger Palace Bar was originally baptised by Oliver St John Gogarty and sculptor Jerome Connor. The key to its success was the possibility that regular customer *Irish Times* editor Bertie Smyllie would provide either drink or a much-needed commission. A cartoon by New Zealand caricaturist and *Times* contributor Alan Reeves captured such notables as Austin Clarke, Padraic Fallon, Brinsley MacNamara, Cathal O'Shannon, and artists Harry Kernoff and Sean O'Sullivan. And, meditating in the background, a youthful Patrick Kavanagh, who never felt at home with those he perceived as Smyllie's toadies. Other visitors were Walter Starkie, critic and translator Con Leventhal, Dylan Thomas and William Saroyan.

The pub was the scene of the famous 1939 Battle of the Palace Bar, which erupted when Austin Clarke allegedly insulted fellow-poet Louis MacNeice. Poetic blows were exchanged as other writers waded in to defend their favou-

rites. Though some credited Patrick Kavanagh with the original offending remark, the Monaghan poet recorded his disdain for the resultant shenanigans:

> They fought like barbarians, these highbrow grammarians,
> As I have recorded for the future to hear.
> And in no other land could a battle so grand
> Have been fought over poetry, but in Ireland so dear.

Like Kavanagh, Anthony Cronin's character in *The Life of Riley* embraced the womb of the hostelries after losing his secretarial job:

> The days were untroubled but not monotonous; the light coming on in the pub, for it was already winter, about half-past four or five; the influx of released employees, eager to drop the cares of the day, shortly afterwards; the atmosphere of genuine friendship and relaxation that prevailed during those winter evenings while the rain poured down outside, the editor of *Furthest Horizons*, a review to which I sometimes contributed, distributed drinks to selected members of the company by a secret system of signals known only to himself and the barman.

Jame Joyce once asked if a person could cross Dublin without seeing a pub, a sentiment reiterated a generation later by J.P. Donleavy. Replicating La Rotonde and Café du Dome in Paris, the Joycean strongholds of Davy Byrne's and the swing-doored Bailey faced each other across Duke Street. Their roll-call of customers included Joyce's hero, Charles Stewart Parnell, and later political leaders Michael Collins and Arthur Griffith. Also Oliver St. John Gogarty, Tom Kettle, Sir William Orpen and James Stephens, who was thrilled to hear poetry being discussed 'with the assured carelessness with which a carpenter talked of his furniture making'. Before his premature death in 1928 at the age of 46, the impecunious Padraic O'Conaire frequently tethered his donkey to the Bailey's railings, to the discomfiture of literary editor Seamus O'Sullivan: 'Here comes O'Conaire who will soon be drinking beyond our means.'

Padraic remains one of Ireland's neglected writers. Born in Galway in 1882, the fluent Gaelic speaker wrote over twenty books and many short stories. He worked as a civil servant in London where he started writing, before returning to wander around Ireland with his donkey and cart. He frequently camped in Glencree valley, close to Cecil Salkeld's cottage. Clarity of vision and a light vocabulary elevated his direct and warm work. Drink, including

stout laced with black pepper, animated his daily life. On a rare attendance at Mass, he heard the priest lecturing on the evils of alcohol. 'Is there anything worse than the demon drink?' the reverend asked rhetorically. 'Thirst!' shouted Padraic, before re-embracing the sunshine and the convolutions of the real world.

Also frequented by Joyce's friend Samuel Beckett, Davy Byrne's was honoured with a mention in *Ulysses*:

> Davy Byrne came forward from the hindbar in tuckstitched shirt-sleeves, cleaning his lips with two wipes of his napkin.

Joyce chose the pub as the setting for Bloom's lunch:

> Mr Bloom ate his strips of sandwich, fresh clean bread, with relish of disgust, pungent mustard, the feety savour of green cheese. Sips of his wine soothed his palate. Not logwood that. Tastes fuller this weather with the chill off.

James Joyce was introduced to serious drinking by Oliver St. John Gogarty. He decided on the title *Chamber Music* for his first published poetry collection after Gogarty brought him to see a widow friend. Joyce recited his poems but the trio drank so much that the lady had to use a chamber pot behind a screen. 'There's a critic for you!' Gogarty exclaimed. Had he not had the strength of character and sufficient artistic ambition to flee to Paris, Joyce could have ended up a non-productive alcoholic with many of his boon companions. Like Charles Lamb, his capacity for alcohol was small, and he soon discovered the

Harry Kernoff's study of the interior of Davy Byrne's, with Davy himself on the right

hazards of premature insobriety. In June 1904, he was given a black eye by the boyfriend of a girl he addressed in Stephen's Green. He collapsed the same night at a rehearsal of Synge's new play, *The Well of Saints*. One of the actresses fell over him and Joyce was thrown into the street by the company's directors, Frank and William Fay. The battle-scarred Romeo commemorated the incident with a poem:

> But I angered those brothers, the Fays,
> Whose ways are conventional ways,
> For I lay in my urine
> While ladies so pure in
> White petticoats ravished my gaze.

Forty years later, Davy Byrne's was a favourite haunt of artists Harry Kernoff and Cecil ffrench Salkeld. In 1942, Salkeld painted the Bacchanalian murals which now illuminate its main wall, beside the Kernoff portrait of James Joyce. Known as *Morning, Noon and Night* or *The Triumph of Bacchus* they show George Bernard Shaw, Micheál MacLiammóir and other artists and writers disporting themselves on an eternally sunny Dublin beach. But none glowed as brightly as Cecil, who returned to retouch the pictures each year, a task which required an increasing number of well-lubricated days.

Two other artist customers were Edward McGuire and Patrick Collins. Gallery owner Hugh Charlton remembered Collins asking him how anyone could get through the day without a drink, while the meticulous portraitist McGuire confided once: 'When I wake up in the morning, I think of Goya. He's done it all. Then, I say to myself, I'll have a pint of Guinness. After that, I feel like Napoleon, I can conquer the world!'

Owned in 1880 by a James Joyce – no relative of the writer – the Bailey became the favourite of a new generation of actors and literati. These included Cyril Cusack, Michael Hartnett and visitors Richard Murphy, Ted Hughes and Sylvia Plath. *Envoy* founder John Ryan bought the bar in 1956, which was good news for Patrick Kavanagh who had previously been barred for wearing his hat. J.P. Donleavy and friends adjourned here to ponder the banning of the play of *The Ginger Man*, after only two nights at the Gaiety in 1959. 'Words that glitter and cut like a welding torch,' celebrated the *Irish Times* reviewer. 'An insult to religion and an outrage to normal feelings of decency,' countered *The Independent*.

Donleavy recalled: 'The Bailey was jammed. Desmond MacNamara, the Irish sculptor seated at the bar, next to him Brendan Behan, the Irish play-

wright, both of them sipping vintage soda-water. Behan announcing: 'This is a sad day in this country. My uncle wrote the National Anthem and he might just as well have written "We Ain't Got No Bananas". Richard Harris announced that he was going to see the Archbishop, and if he didn't succeed he would fly with the script to the Pope in Rome.'

The Archbishop had his way, however. Weeks of effort and artistry, as well as the livelihoods of actors and actresses and the expectations of theatregoers, succumbed to dogma and crozier. But change was on the horizon. The tide turned as international interest in Joyce mushroomed There was money to be made. Eleven years after Donleavy's humiliation, actor Milo O'Shea and Patrick Kavanagh returned to the Bailey to unveil the original door from Bloom's fictional house at 7 Eccles Street. John Ryan had a hard time extricating the door from the nuns who now owned the house until he produced his cheque book: 'I suppose the order is having a hard time in the mission fields these days?' The unveiling marked one of Patrick Kavanagh's last public appearances. 'I now declare this door shut forever,' he pronounced to happy applause. Christy Brown continued the Bailey's literary tradition when he launched *Down All Those Days* there in 1970.

Another pub in which censorship sorrows were drowned was Phil Ryan's Baggot Street lounge, known as Lampshades on account of the paper lanterns which hung from its high ceilings. As well as Liam Miller and his guests, it attracted actors from the nearby theatre clubs, including Milo O'Shea, Marie Conmee, Marie Keane and theatre owner Madame Toto Cogley. The Pike's Alan and Carolyn Simpson, musician George Hodnett and their supporters retreated there in 1957, after the former's prosecution for indecency over their staging of Tennessee Williams' *The Rose Tattoo*.

Peter Keogh remembered: 'The Simpsons and the Pike actors and actresses were decent hard-working people. We were delighted with the big celebration they held here after *The Quare Fellow* launched both them and Brendan Behan into the headlines. But they were all very frightened and shocked by that prosecution, as we were. Don't forget, many of them were very young and making big sacrifices to do something they believed in. We gave them what support we could – as well as a great send-off, when they all marched down together to the court on the quays.'

Like many local landmarks, Lampshades fell victim to developers, together with neighbouring buildings and every cottage in East James's Street. Georgian grandeur was replaced by the glass offices which now disfigure the once gracious street. Owen Walsh lived at 108 Baggot Street, directly opposite

the bank which replaced the bar. 'I'm confronted by this effing monstrosity every morning I pull back the curtains,' he complained. 'Even when I'm painting, it invades my eye. And to add insult to injury, another bunch of modernisers covered over my rugby mural in Larry Murphy's.' In time, though, that story was to have an unexpected and happier conclusion, unlike the tribute to Joyce's *Anna Livia* – and the street's only fountain – by sculptor Eamonn O'Doherty, which Dublin City Council removed from O'Connell Street (since re-erected at Heuston Bridge).

Other Baggotonian haunts were Doheny and Nesbitt's, second home to journalists and Dáil deputies. And O'Donoghue's bar, beside Mary Lavin's favourite Unicorn Restaurant, where the dynamism of Ronnie Drew and friends exploded into the Dubliners folk group. Nevill Johnson captured the mood of these hostelries in *The Other Side of Six*:

> Doheny and Nesbitt's is a small pub in Lower Baggot Street standing little changed but in name for many generations. Same door, same snugs, same counter: a few round tables on sturdy cast-iron stems, high wood stools: still a breadboard and butter bowl on the counter where they make sandwiches. In the snug by the entrance on a bright morning in 1949 sat a lone and rather bewildered man of thirty eight. Wife and home gone he was back on his heels. A sandwich of tender ham, home-cooked, offered some solace as he searched in the *Irish Times* for a room to let.

Pubs boasted their own intelligence networks. Nevill's quest had a happy ending, when he was directed to Mooney's, where Liam O'Flaherty regularly lunched. The curate sent him to Mrs Hope-Beresford in Raglan Road, where he found not only a room but also romance. It was in Mooney's that a rare photograph was taken of Brendan Behan and Patrick Kavanagh drinking together before they fell out. When Brendan became a Mooney's regular, Patrick moved to Searson's and the Waterloo Lounge, both closer to his flat

in Pemroke Road. It was in the Waterloo that Patrick tried out the Americanism he had acquired on a visit to his brother Peter in New York. 'A scotch on the rocks,' he ordered. The barman returned after a consultation with the manager: 'I'm sorry, Mr Kavanagh, we can't give anyone credit.'

Neary's in Chatham Street was another theatrical outpost, one of whose original customers was the colourful Endymion of *Ulysses* fame. Conveniently situated opposite the Gaiety stage-door, its poised lanterns welcomed generations of actors from Cyril Cusack to Michael Caine. Stephen and Kathleen Behan were regulars and adjourned here with most of their family and the cast, after the noisy premiere of Dominic Behan's *Posterity be Damned* in 1960. Another patron was comedian Jimmy O'Dea, who was often joined by Sean O'Sullivan, Flann O'Brien and Harry Kernoff. John Ryan recalled the day he left Neary's for Mirrelson's betting shop with Patrick Kavanagh and myopic English poet John Heath-Stubbs: 'Never having even seen a bookie's shop, but dimly comprehending a counter, assistants and noisy, beery customers, Heath-Stubbs, thinking that we were in yet another bar, called for a fresh round for the whole company!'

Two other intimate establishments were Peter's Pub and The Old Stand on Wicklow Street, the setting for Joyce's 'Ivy Day in the Committee Room'. The Old Stand corner features one of Dublin's remaining street newsvendors and friend of many bookies, Peter Hayes. Other artistic pausing stations were Sean O'Sullivan's favourite, the subterranean Dawson Lounge, and Tobins, now the Duke. Also, Kehoe's in South Anne Street, which Brendan and Beatrice Behan visited, and Buswell's Hotel in Molesworth Street, where James Joyce's daughter Lucia stayed on a 1935 visit. Lucia was born in Trieste, where Molesworth Street's most prominent resident, the popular novelist Charles Lever, died in 1872. Among J.P. Donleavy's favourites was the adjacent Royal Hibernian, where 'gentlemen surveyed all from behind their flashing monocles. And who spouted Anglo Irish vowels so echoingly haughty that they made tables' glasses shiver and tinkle where they touched.'

Close to the honeymooning Behan's Lincoln Inn, Kennedy's at the junction with Westland Row was well known to both James Joyce and Samuel Beckett. The latter paid homage to pub ambience in the days before distractive muzak, television and the conversation-killing mobile phone: 'The bottles drawn and emptied in a twinkling, the casks responding to the slightest pressure on their joysticks, the weary proletarians at rest on arse and elbow, the cash-register that never complains, the graceful curates flying from customer to customer, all this made up a spectacle in which Belacqua was used

to take delight and chose to see a pleasant instance of machinery decently subservient to appetite. A great major symphony of supply and demand, effect and cause, fulcrate on the middle C of the counter and waxing, as it proceeded in the charming harmonies of blashemy and broken glass and all the aliquots of fatigue and ebriety.'

'Holy Hour' was the bane of serious drinkers, when pubs closed from 2.30 to 4.30 each day. Railway station bars, however, remained open, and nearby Westland Row terminus attracted such urban voyagers as Brendan Behan, John Montague and Brian O'Nolan. The latter was intrigued by the street's associations with Joyce, whose father had worked in Westland Row and whose mother, May, had sung Palestrina in next-door St. Andrew's Church. Joyce himself had sung with John McCormack in the nearby Antient Concert Rooms, where he also made his well-reviewed acting debut in 1903. And it was in local Sweny's chemist shop that Leopold Bloom purchased for Molly a facial lotion of 'sweet almond oil and a tincture of benzoin'. If the holy hour was a trial for serious imbibers, nighttime closing proved an even greater tribulation. Those with transport could adventure to distant pubs which catered to bona fide travellers.

Dublin's most notable restaurant, Jammet's

Anthony Cronin recorded: 'At ten o'clock the cars swept out along the mountain roads as if all those who could muster transport were fleeing before a plague: at half-past twelve they swept back, awash with song and Guinness.'

Dublin's most notable restaurant, first-floor Jammet's, lorded over Nassau Street, its walls decorated by Bossini's voluptuous *Four Seasons* murals. A visitor wrote that it supplied the finest French cooking and wines between the fall of France and the liberation of Paris. While France and Britain starved during World War Two, bow-windowed Jammet's – and the Dolphin Hotel nearer the river – served the best steak, pheasant, turbot and oysters on monogrammed porcelain. The clientele were mainly business people. Louis Jammet's wife, Yvonne, was a member of the White Stag group and regulars included Sean O'Sullivan and Cecil Salkeld. O'Sullivan is said to have influenced Robert Newton's playing of the artist character in *Odd Man Out*. As well as Newton, Jammets' marble counter also attracted Hollywood stars Orson Welles, Rita Hayworth, James Cagney and Tyrone Power, some of whom left with woodcuts by the persistent Harry Kernoff.

Light-years socially from Jammet's, Anthony Cronin described the edifice which became Dublin's most famous post-war literary pub: 'McDaid's was a narrow high-ceilinged place whose proprietor had made unsuccessful attempts to turn it into a lounge, with leatherette seats against the walls and an odd cork-topped counter which soon became pockmarked by cigarette burns. It had become the headquarters of one of Dublin's bohemias, though that word scarcely fits, for this one had the Irish virtue of being uncategorizable, composed as it was of many different kinds of layabouts, piss artists, idle rentiers, distressed gentlefolk and dissidents, breakaway or retired subversives. Now, with the advent of the magazine, McDaid's took on a more literary or rather anti-literary character.'

McDaid's earliest literary association was a visit by James Joyce's father, John Stanislaus, who fell down the stairs, a mishap later attributed to Tom Kernan in the short story, 'Grace'. Originally a Moravian church, the Harry Street bar was just around the corner from Desmond MacNamara's studio and *Envoy's* office. The sculptor's unconventional guests were the first Bohemians to worship there in the late forties, *Envoy's* clientele completed its reconsecration in the early fifties. Gainor Crist, J.P. Donleavy and Flann O'Brien were patrons. A new and more self-confident generation included Pearse Hutchinson, Val Iremonger and John Jordan. Also Louis MacNeice,

Stephen Spender, Theodore Roethke and the White Stag group's T.H. White, who wrote *The Once and Future King* which became the musical, *Camelot*.

McDaid's best known regulars were Brendan Behan and Patrick Kavanagh, who found here the stimulating company he had long sought in Dublin. Though the poet had gladly accepted Bertie Smyllie's commissions, he now rounded on those he dismissed as Pearl Bar sycophants:

> In the corner of a Dublin pub
> The party opens–blub-a-blub–
> Paddy Whiskey, Rum and Gin,
> Paddy Three Sheets in the Wind,
> Paddy of the Celtic Mist,
> Paddy Connemara West,
> Chestertonian Paddy Frog
> Croaking nightly in the bog.

Kavanagh's much-publicised action against *The Leader* made McDaid's and himself household names. The bar's fame also owed much to its manager, Paddy O'Brien, whom Leland Bardwell described as: 'One of the most outstanding barmen of all time. He enjoyed this melange of artists and writers and hangers-on, while at the same time maintaining order and acting as bank and nursemaid to all and sundry.'

Before he died in 1989, Paddy reminisced about his quarter of a century in McDaid's: 'A day on was a day off, I loved every minute of it. When Brendan Behan first came in here, he was working as a housepainter. He was really at his best then, with a load of stories and a flair for remembering names and nicknames. Brendan's

often been described as a bowsie but the people who said that knew nothing about him. He was a lovable and good-natured man with a heart of gold, always lively and full of fun.'

Patrick Kavanagh was the bar's most famous customer. 'Patrick was more of a loner who had few words to say to anyone. Sometimes, he would look around the door and choose a group to join. But, more often, he'd sit quietly in the corner and after picking out the likely winners, he'd flash through the papers, chuckling to himself when he came across something funny. None of them ever had much money but we never saw them short and we were always repaid one way or another. We had many artists too, like Sean O'Sullivan and Harry Kernoff. Sean was a fine-looking but gentle man, he spoke so loudly, people could hear him outside in the street. Harry Kernoff was very quiet. He occasionally asked me to take a signed print to pay for his drink, which once got me into big trouble with Mr. McDaid.'

Paddy never ceased to wonder at his customers' literary output: 'How they got time to write, I'll never know. They invariably went home legless, so they must have been geniuses!' He was bemused by his customers' subsequent fame: 'When they were alive no one paid much attention to them or their work. They were seldom invited anywhere because they had a reputation for upsetting the applecart. I remember going down Grafton Street one day with Behan and as soon as a certain literary man saw us, he darted to the other side of the road. But no sooner was Brendan gone, than your man was writing a book about him!'

McDaid's manager tried to buy the pub in 1972 when its proprietor retired, but he was outbid by a wealthy lady who was determined to own a literary pub. Paddy was employed by Tommy Smith of Grogan's Castle Lounge and McDaid's literati immediately followed him across to South William Street. Dublin's last Bohemian pub, smoke-filled Grogan's clientele included artists Brian Bourke, Charlie Brady and Owen Walsh. And such writers and poets as John Jordan, Aidan Murphy, Michael Hartnett, Macdara Woods and Hayden Murphy. Until his death in 2008 at the age of 89, Grogan's each year welcomed a very special guest, London exile Des MacNamara. The McDaid's founder's entourage included his second wife, Skylla, and their actor son Oengus – well known in the UK for his performances in the plays of Beckett and Behan.

The salons of Lady Morgan and Sarah Purcell had long vanished. But, a sign of changing times, a new establishment arose in Baggotonia which mortified the mainly all-male clientele of McDaid's. Opposite James Liddy's

favourite Pembroke Bar, this was Gaj's Café on the corner of Baggot and Pembroke Streets. Founded by the pacifist Margaret Gaj, it ran from 1959 to 1980 and was frequented by such women as Lady Christine Longford, Nuala O'Faolain and Patrick Kavanagh's wife, Katherine Moloney. Gaj's passionate debates gave birth to the Irish Women's Liberation Movement.

Two other favoured female rendezvous were Roberts and chandeliered Mitchells in Grafton Street. The aroma of roasting coffee beans signposted nearby Bewley's restaurant on the site of Whyte's Academy, where Thomas Moore and Richard Brinsley Sheridan had studied. Artist Marie Carroll and writer Mary Lavin captured the bustle of Bewley's, where Maeve Binchy passed happy student afternoons: 'Nobody wanted to leave the warm, happy coffee and sugar-flavoured fug and go out into the cold, rainy streets.'

Though pub managers were masters of diplomacy, they sometimes were forced to eject even favoured customers. James McKenna was reciting his poem about exile one night in Davy Byrne's, when a group of English visitors arrived. In blissful ignorance of McKenna's London experiences of 'No Blacks, No Irish' accommodation advertisements, they leaned across his pint to admire Cecil Salkeld's murals. The sculptor erupted: 'I hate the fucking English. I had to work as a milkman there to survive – and you shat on me, you artless humourless bastards.' The manager's speed matched that of the visitors' flight. 'Never darken this establishment again, you bowsies,' Frank ejected James and an author friend.

As Celtic Tiger money surged and customers increased, and manners and service declined, generations-old atmosphere was dissipated. But not all succumbed to the lemming fever. Places like Neary's, the Old Stand, Peter's Pub, Davy Byrne's and Grogan's maintained their individuality and service.

Tom Gilligan, proprietor of the Duke said: 'The key to a successful pub is civilised service, the human element. My son and daughter and staff know our customers by name. And we're always conscious of our history – I think the ghosts of the past keep a regular eye on us! The likes of Behan and Kavanagh – and James Joyce and James Stephens, who mused here on sharing the exact same birthdate. I am always conscious of those giants who came through our door. We owe them a responsibility to maintain the welcome and the atmosphere which they enjoyed.'

And in times to come if you want to dip
Back into the past, through these pages flip
and, if you enjoy it, raise a glass to your lips
and drink to the soul of Michael Hartnett!

Impish Michael Hartnett knew the inside of many hostelries. 'This stuff will kill me,' he prophesised one night to proprietor Paddy Morrissey in his favourite Leeson Lounge. Though acknowledging their role in the lives of artists and writers, biographer Peter Costello thought that accounts of literary pubs should carry what he called a Literary Health Warning. Drink, sadly, hastened the deaths of Michael, Patrick Kavanagh, Brian O'Nolan, Sean O'Riada, the diabetic Brendan Behan and artists Edward McGuire, Cecil Salkeld, Sean O'Sullivan and Robert MacBryde, killed in 1966 as he weaved homewards through the Leeson Street traffic. Also producer Jim Fitzgerald, actors Newton Blick and Eamonn Keane, and countless would-be scribes who endured palsied mornings and died in anonymity and unpublished. Mayo poet Michael Mannion, whose own motto was never do today what could be put off to tomorrow, wrote the obituary of one:

Michael Hartnett

He lived a life of doing soon,
And died with nothing done.

The warm and smoky pubs guaranteed camaraderie and a refuge where sorrows, inhibitions and work doubts were drowned. But despite extravagant dreams and fulsome promises, books were never produced there. Many UK agents left McDaid's and the Pearl Bar, their ears ringing with promises of novels and brilliant new interpretations of James Joyce which never materialised. As James Plunkett observed: 'Some drifted in a whirlpool of lost en-

deavour, some drowned.' Beckett saw the writing on the wall and took early departure while still young and healthy. John Jordan fled to a Newfoundland lectureship but he had left it too late and died at the age of 58.

Peter Costello, who did write about Joyce and other subjects – and was by no means averse to a drink himself – often quoted a salutary warning from critic Edward Garnett to a young Sean O'Faolain: 'Literature isn't produced by Dublin, or London, or Paris, or anywhere else. It's produced by a few men sitting alone in their rooms before the blank page. You will find a few, and damn few, doing that in Dublin; a few more writing about literature; and a lot of fellows talking about those few. Stick to your desk, my boy!'

A Quiet Pint *by Pete Hogan*

Chapter Seven

LAUGHTER IN COURT:
A LITERARY LIBEL CASE

It's a good job that the courts don't sit in the evening. –
Dublin theatre manager

'YOU HAVE ATTACKED ALMOST EVERY contemporary Irish writer,' insisted defence counsel John A. Costello.

'I have attacked the writing but never the writer. I never intruded on the sacred personality of any man,' plaintiff Patrick Kavanagh responded.

Costello quoted Patrick's criticism of Robert Farren and of Radio Éireann for employing Austin Clarke. 'You were very destructive in your criticism,' he reiterated.

'A lover is often destructive,' Patrick shifted in his seat.

'Austin Clarke is highly regarded as a poet,' Costello repeated.

'He's not in *The Faber Book of Twentieth Century Verse*,' Patrick's rash reaction belied the loving image. There was laughter in court.

Dublin's Bohemia burst into the national consciousness in 1954 with Patrick Kavanagh's libel action against *The Leader* current affairs paper. Hitherto, the literati and their activities had been confined to a small quarter of the city, whose citizens lived remote from Bohemia's struggles and jealousies. But the blanket coverage of the Kavanagh case and the daily drama between the poet and defence counsel, John A. Costello, made national headlines. Soon, everyone in the country knew about Patrick's feud with Brendan Behan and his low opinion of most fellow-scribes including the productive Austin Clarke. People who rarely read books became critics overnight. Crowds

peered through the windows of McDaid's pub, which was the setting for the offending feature.

> 'A pard-like spirit, beautiful and swift' is hardly the phrase that would occur to the mind of the casual observer watching Mr. Kavanagh hunkering on a bar stool, defining alcohol as the worst enemy of the Imagination. The great voice, reminiscent of a load of gravel sliding down the side of a quarry, booms out, the starry-eyed young poets and painters surrounding him – all of them twenty or more years his junior, convinced (rightly, too) that the Left Bank was never like this – fervently cross themselves, there is a slackening, noticeable enough in the setting-up of the balls of malt.
>
> With a malevolent insult which, naturally, is well received, the Master orders a further measure, and cocking an eye at the pub-clock, downs the malt in a gulp which produces a fit of coughing that all but stops even the traffic outside. His acolytes – sylph-like red-heads, dewey-eyed brunettes, two hard-faced intelligent blondes, three rangy university poets, and several semi-bearded painters flap: 'You have no merit, no merit at all' – he insults them individually and collectively, they love it, he suddenly leaves to get lunch in the Bailey and have something to win on the second favourite. He'll be back.

Thus began the anonymous profile of Patrick Kavanagh which appeared in the fortnightly *The Leader* of October 11, 1952. Though uncharitably contrasting Shelley's image of the poet, a pard-like spirit, with the insulting and whiskey-swilling Monaghan man, the tabloid's feature hardly seemed libellous. The profile in fact concluded with praise for Patrick's poetry and sympathy for the lack of public recognition of his work. It insisted that 'The Great Hunger' was the best poem produced in Ireland since Goldsmith's 'The Deserted Village'.

Patrick, however, was unimpressed by what he saw as an expression of fake impartiality. He maintained that he had been held up to ridicule. Sensing a conspiracy by jealous fellow-writers from Brian Inglis to Valentin Iremonger and his *bete-noire*, Brendan Behan, he decided to sue. The result was one of Ireland's most celebrated libel cases.

The poet's action was ironic in view of the scalding he and his brother had inflicted on individuals and organisations in their recently concluded

Kavanaghs Weekly. Objectivity, however, was not a Kavanagh characteristic. Worse still, law and litigation ran in the family genes. With knowledge gleaned from the family's 1891 *Pears Encyclopedia*, Patrick's shoemaker father, John, advised neighbours on wills and land disputes. Just as Patrick's maiden 1949 Derby coup launched a fatal horse-racing addiction, his ultimate legal downfall owed much to his successful court claim after a 1940 accident. Memories of that easy windfall encouraged the blithe assumption that, rather than fight the case, *The Leader* would offer a public apology. And, more importantly, much-needed largesse.

John Jordan regarded the profile by acquaintances who knew the sorry state of Patrick's health and finances as 'a classic case of moral and intellectual sadism'. But, like John Montague and barrister Eoin Ryan, the critic and poet felt that Patrick should not have sued. Another friend said: 'We thought he might have expected something like this after all the attacks in his own paper! Some suggested that the article was no more than the normal jealous banter between poets and writers and that Patrick should have ignored it and got on with his work.'

Up to shortly before the trial, both Patrick and Peter were confident that the case would not go to court, that *The Leader*, which Peter described as an anti-intellectual and ultra-nationalistic rag, would gladly settle to avoid a costly trial. Sharing Patrick's suspicion of a conspiracy, Peter, not noted for moderation, wrote: 'Behind this seemingly innocuous essay we knew were those representing the most evil elements in Irish society. There was now a moral issue at stake and Patrick decided that he had no choice but to sue for libel. I was also libelled in the Profile but Patrick decided he had the stronger case. Besides, there was no point in risking us both in the same battle. Apart from the moral issue there was also the prospect of heavy punitive damages. This was cheering.'

In a letter to his brother, Patrick reiterated: 'At all events I am confident of getting anything from 500 pounds upwards.' But as *The Leader* went ahead with its defence, Patrick belatedly began to question his rash action. A private man, he suddenly feared that his life and activities would be exposed for the whole country to hear and ridicule, including the white lies about his age for publishers' biographical notes. Peter recalled: 'Patrick expressed a willingness to settle for nominal damages and an apology but the defence would have none of it. They were out for revenge.'

Patrick's friends insisted that, on account of his fiery contribution to *Kavanagh's Weekly*, Peter should be kept in the background. Though he would

not be photographed with his brother, this did not inhibit Patrick from borrowing Peter's new Burberry showerproof and briefcase in order to create a good impression. Peter had to wear an extra inside shirt to make up for his loss of an outer coat. The stage directions given to Patrick by his friends accentuated the theatricality.

Peter, who resented these advisors, noted: 'By the time I arrived at the Four Courts, Patrick was already inside after being photographed in his borrowed attire. There he was in the court, sitting with his good friends as they gave him final instructions on how he should set the angle of his jaw, and how his demeanour should be.'

Kavanagh's Weekly *contained many 'fiery contributions' by Peter Kavanagh*

With little happening in the country and no distracting television, the clash between the belligerent defence counsel and the easily riled plaintiff made immediate national headlines. All the morning and evening media covered the case in depth. The *Irish Times* devoted several pages of reportage and photographs to each day's proceedings. The case became the city's leading social event. Extra security staff had to be employed, as over a hundred people queued from early morning for the public gallery. Well known public figures competed with the ordinary citizens for seats; many were turned away. One newspaper commented on the preponderance of fashionably dressed women and girls.

Kavanagh's legal team was led by Sir John Esmonde; *The Leader* was defended by the former Attorney General and Taoiseach, John A. Costello. The latter afterwards agreed that he had some sympathy for Patrick, but considered him ill-advised in taking the action. Counsels' tables groaned beneath the weight of periodicals, books and newspapers as the four-day case opened in Dublin's High Court on Wednesday, February 3, 1954. Patrick claimed that he had been gravely injured 'in his character, credit and reputation, and in his profession as a writer and journalist, and he has been brought into public

hatred, scandal and contempt'. *The Leader* maintained that the profile represented fair comment and was not malicious.

Responding to questions by his own team, Patrick maintained that the profile had represented him as a buffoon. He reiterated his frequently manifested opposition to unproductive Bohemianism: 'My argument has been that literature is not an activity of wild bohemians but is part of the religious mind. That it is, in fact, part of religion. All that gloomy and wild life is anathema to me.'

Sadly, Patrick's argument backfired when, referring to his novel, *Tarry Flynn*, Costello's first question was: 'I suppose it was because of your religious attitude that your book was banned by the censor for three days?'

Costello poked gentle fun when he observed: 'I suppose there will be many a chuckle among the intelligentsia when they hear the description of your counsel that you are a simple, quiet, unassuming, early-to-bed man who only wants to be considered seriously to earn his living.'

When Costello pointed out that the offending profile had referred to him as Ireland's finest poet, Patrick replied: 'There are various ways of sneering at a man. One of the ways is that I have been sneered at in public by people who do not like me. I remember once people calling me "Will Shakespeare". That is an insult because it is not true. Ignorant people say that kind of thing all the time. They build you up and make you look outrageous.'

The court audience was amused by many of the exchanges. Costello quoted from the poet's attack on Radio Éireann in which he said that the radio was in the hands of mean little men. Patrick replied: 'As a matter of fact, the policy was changed as a result of my activities!' This provoked so much laughter that Justice Teevan had to call for order in the court.

Costello introduced the first paragraph of *The Leader* profile and asked how Patrick could see anything wrong with a description of him sitting on a bar stool and if he went to pubs habitually.

'Occasionally,' Patrick adjusted his spectacles.

The counsel continued: 'It is alleged that we have accused you in that paragraph of being of intemperate habits.'

Patrick replied: 'It is in there. It is in the whole build-up of that paragraph. It is a monstrous paragraph. . . . I read into it the implication that I am intemperate and everybody else who spoke to me about it said the same. The whole impression is that I am almost never out of pubs.'

When Costello suggested that there had hardly been an article of Patrick's in which he had not referred to pubs, he conceded: 'Maybe so.'

Patrick Kavanagh in Wicklow, 1951

Patrick was further rattled when, possibly to show that he kept disreputable company, Costello referred to his relationship with Brendan Behan, who had been mentioned in the profile. In response to repeated questioning, Patrick denied that Behan had ever been a friend: 'I have said here and now that that man was never a friend of mine. He was never a friend of mine and he has never been a friend of mine. . . . Have I to state it again? Never was a friend of mine.'

Costello asked if Brendan had distempered his flat; Patrick replied that a painter had painted it. When Costello reiterated that Brendan had been a friend and that he had decorated the flat for nothing, Patrick could not restrain his animosity towards the Dublin writer: 'He is no friend of mine. He is a friend of your friends that you are appearing for. I do not want him as a friend. I can choose my friends. My Lord, I don't want to be dragged into saying anything about any other man's character here in this court, but it is enough for me to say that I can choose my friends. That is all I say. That man never was, and never would be, a friend of mine. . . . I have chosen my friends from the noble and virtuous.'

The exchanges between Costello and the poet were reported verbatim in the national media. As the crowds increased, Flann O'Brien complained in the *Irish Times* of the overcrowding and poor acoustics. The case became pure theatre. The newspaper's *Irishman's Diary* recorded: 'It's a good job,' said the Dublin theatrical manager fervently, 'that the courts don't sit in the evening. If they did, we might as well close down.' He spoke with feeling, having just previously cast an envious eye over the queues for the Kavanagh libel action. 'I know they don't have to pay,' he said, 'but there hasn't been a queue like it in Dublin since Maurice Chevalier played at the Royal.'

The *Diary* catalogued the notable attendees: 'As for the brave men – the eve of Waterloo had nothing on yesterday's assembly. Among the public, there were at least 3 TDs, 2 senators, a whole shoal of scholars and savants, poets, professors, actors and actresses, and representatives of the learned and scientific professions, while outside the court the queues waited hopefully, from mid-morn till dewy eve, anxious to get in for even five minutes of the hearing.'

Inside the Four Courts, Costello continued his cross-examination by cataloguing the attacks made in *Kavanagh's Weekly*, including the suggestion that the defence forces were only capable of defending a field of turnips from an invasion of crows, and that Radio Éireann 'supported out of the taxes, is in the hands of mean little men who are partial to their own pathetic point of view'.

There were audible titters as *The Leader's* defence counsel also read from the feature entitled *Diplomatic Whiskey*: 'Are these representatives doing anything worthwhile to promote trade with Ireland or to increase the country's prestige, or are they sitting in their embassies and consulates drinking whiskey and praying for the repose of the souls of the Christian Brothers who got them into the Civil Service? The embassy in Washington is almost as large as the Dublin bus station, is fitted out in the style of a Medici palace and has, apparently, as many employees and servants as would outfit the United Nations Assembly.'

Pursuing his theme that Patrick could dish out criticism with abandon but could not accept it, Costello quoted: 'The Arts Council, recently established, is to get £10,000 a year. The chairman is Patrick Little, ex-Minister for Posts and Telegraphs. The money will, no doubt, be spent nice and quietly.'

The jury was hardly impressed as Patrick deflected responsibility for many of the *Weekly* attacks on to his brother. The London *Spectator* reported: 'Kavanagh was determined not to let anyone get him in a corner. He ducked, side-stepped, swerved and in the intervals swung some haymakers, which to judge by the response from the ring-side, seemed to be registering with a clang.'

Costello quoted from Larry Morrow's interview in *The Bell*, which referred to the poet's uncouth ways and described him as 'a stage Irishman about town'. He asked Patrick why he objected to *The Leader* profile when he had not reacted to *The Bell* interview. The poet replied: 'The mood of humour is all through it. That took the evil out of it.'

While cross-examination continued, Costello lost no opportunity in allowing Patrick to project himself as a person apart from the masses. The poet versus the mob. As Anthony Cronin noted, 'dropping pearls before swine in prolonged, nasal Monaghan vowels which gave an impression of the utmost distaste'. An educated and sophisticated man, Costello's occasional feigned ignorance allowed Patrick further scope to antagonise the jury with his literary superiority and, unforgivably, his preference for London to their Dublin.

According to Cronin: 'Costello kept turning to the jury with a mixture of sarcasm, condescension to the "quare poet" and occasional winks of heavy understanding.' This was a ploy which in a previous case had been the downfall of Samuel Beckett. When opposing counsel deliberately mispronounced the name of Marcel Proust, Beckett immediately corrected him in impeccable French. Turning to the jury, the counsel humbly acknowledged that he stood corrected.

Costello's *coup de grace* came with his surprise introduction of a copy of Patrick's novel, *Tarry Flynn*. After reminding Patrick that he had said he was never a friend of Brendan Behan's, he handed the book to the poet and asked if the flyleaf handwriting was his. The court fell silent as Costello read out the book's inscription: 'For Brendan, poet and painter, on the day he decorated my flat, Sunday 12th, 1950.' Annoyed with Patrick's denunciation of Brendan, the latter's half-brother, Rory Furlong, had given the book to Costello that morning. Another brother, Seamus, told Costello that he had met the poet in Brendan's company in Grafton Street.

Patrick's shoulders fell: 'That is my handwriting, surely. I have been weak on many occasions, and have given my books and written my name. I was cajoled into doing that. One of the reasons I did it was the man was so offensive every time he met me in the street . . . hoping that I would be free from the horror of his acquaintance.'

As the case proceeded, Patrick was made to look more like the defendant than the plaintiff. The strain of the unrelenting cross-examination began to tell on the 50-year old poet. He was in the witness box for many hours without a break. Proceedings were adjourned on the second-last day while he composed himself after taking medical advice. But the dramatic demonstration of the inscribed book had destroyed his credibility. Jury members might not have comprehended the literary exchanges but they could understand an apparent untruth. His brother's couture could not help Patrick now. It took the jury little over an hour to decide that *The Leader* had no case to answer.

Patrick Kavanagh and Brendan Behan in Mooney's:
'That man was never a friend of mine.'

Patrick took the news badly, but later that night, he had recovered sufficiently to laugh with his brother at some of the case's more absurd aspects. And it was not long before, in the best Irish tradition, his defeat earned the poet martyr status, a state, some suggested, that he may even have deliberately courted. Patrick was now the most talked-about person in the country. Admirers and friends rallied to his aid. An Appeal Fund attracted contributions from John Betjeman, T.S. Eliot, Anew McMaster, Lord Moyne and The Pope O'Mahoney, and private sympathisers like Patrick's bookie, J.J. Fogarty and artist Brigid Ganly, a former victim of the poet's criticism.

The appeal resulted in the reordering of a new trial. But, aware of the public sympathy for Patrick, *The Leader* decided to settle out of court. Peter Kavanagh noted: 'Everyone knew Patrick hadn't a cent to his name and that his lawyers were acting on speculation. What surprised Patrick and myself – and filled the lawyers with dismay – was the revelation that the opposition was almost as broke as we were. The lawyers were the real losers in the Kavanagh libel trial!'

Who wrote *The Leader* profile? Patrick was wrong to suspect Brendan Behan. It is likely that it was penned by poet and diplomat Val Iremonger,

whose Department of External Affairs had been the butt of the *Diplomatic Whiskey* attack.

Years later, Peter Kavanagh recalled: 'Iremonger was one of those associated with the writing of the profile. I will never forget the evening, before the profile was published, when he blew up into a rage with me near the top of Grafton Street, when I brushed off his advances. My brother did not fancy any of these people or their society.'

Early in 1955, Patrick was hospitalised with cancer. Doctors removed his left lung and a rib. But his great physical reserves came to the rescue and he gradually improved. Visits by his former inquisitor, John A. Costello, Professor Tierney of the national university and Archbishop McQuaid greatly boosted his status among staff and fellow-patients. And as he savoured the institutional shelter from the daily grind of money, food and work worries, he soon had something else to celebrate. Costello and Dr. Tierney helped him to secure an extra-mural lectureship at University College Dublin at a yearly salary of £400. The poet's rash action might have been profitable after all.

Once out of hospital, Patrick was greeted as a returning hero by the management of McDaid's. The libel case had also enhanced its coffers. Paddy O'Brien celebrated: 'Everyone in the country was talking about Paddy and McDaid's. And, as many more came here to see the place that had been in all the papers. There were even coaches in the street. It was better than Cartier-Bresson's photographic session, McDaid's became a national institution!'

Chapter Eight

Patrick Kavanagh – A Most Unlikely Poet

*Courage he had and was content to be
Himself, whatever came his way.* – Brendan Kennelly

'Grafton Street was always a very sedate place,' Paddy O'Brien recalled. 'But as I was going up there one sunny morning, the genteel murmurings were suddenly interrupted by a roar from the opposite side of the street. "Look, the fucker from Mucker! The meanest bog fucker in the whole of Ireland."

'It was Brendan Behan, white shirt undone, shouting across the street to Patrick Kavanagh, who was lumbering down my side.

'"You're a low-class cur and a convict! You'll never be anything but a gurrier," Patrick bellowed back from under his angled hat and continued towards me.

'Neither writer was much welcome in Dublin's most exclusive thoroughfare. Like the visitation of a thunderbolt, there was a collective intake of breath before polite conversation resumed.'

Patrick Kavanagh was one of Grafton Street's most incongruous sights from the 1940s to the 1960s, equalled only by boxer Jack Doyle parading film star Movita and their Irish wolfhound. Clumping along in gargantuan boots, Patrick towered above most pedestrians. His countryman's ungainly gait distinguished him from the measured pace of the city folk and the mainly Anglo-Irish boulevardiers. But he frequented the street almost every day, newspapers under his arm. Not just as a short-cut to McDaid's sawdust pub,

but in the unlikely and equally persistent hope of meeting a rich woman in Mitchell's or Robert's restaurants:

> Money is the stomach of the soul
> And sin is when it's empty – all the shame
> Of being damned. I know, I know it all,
> The degradation and the self-blame.

Patrick's obsession with poetry was matched by his need for money for survival. But dark comedy attended his get-rich-quick endeavours. As a teenager, he was dismissed from his football club after purloining funds to buy cigarettes. It was a Grand Poetry Competition prize of five shillings which first encouraged him to inflict verse on a local newspaper. He came second, to a plagiarist. Replicating Dr. Johnson's alcohol experimentation, he built a still in his Pembroke Road flat to make poteen. From selling fire-grates and representing a crooked gang who paint-sprayed rural barns, he proceeded to editing a government minister's poetic works, until cold weather forced him to let the fire complete the job. He returned daily to the bookies in the hope of repeating his early successes. The bookies banned him on suspicion of having inside information, unaware that his winning streak was the result of backing any horse whose name contained the letter Z.

Patrick's father, James, was a farmer, shoemaker and hob-lawyer in Mucker, outside Iniskeen village in northern County Monaghan. Frugality and gossip marked Patrick's youth, the regular return of beggers and itinerant cobblers signalled the seasons. His first day at school provoked a panic when he wandered off and was only found hours later under a railway bridge. It was a wise move, his main teacher turned out to be a disciplinarian. But despite his disinterest in school, it was a senior pupil's recitation of a poem by James Clarence Mangan which first sparked Patrick's interest in poetry:

> I walked entranced
> Through a land of Morn:
> The sun, with wondrous excess of light,
> Shone down and glanced
> Over fields of corn
> And lustrous gardens aleft and right . . .

Leaving school at the age of thirteen, Patrick proved no great asset to either his father's shoemaking or farming. James complained: 'You broke every tool about the place except the crowbar, and you bent that.' But Patrick

grew strong and fit and, like Albert Camus in Algiers, played as goalie for the local football team. He excelled at high jumping until he broke his collarbone while vaulting a gate. His other pastime was playing pitch and toss with the rare pennies which came his way. At the age of 16, a neighbour allowed Patrick access to his books. The works of Byron, Shelley, Goldsmith and *Palgrave's Golden Treasury* soon filled Patrick's daydreaming. His first efforts echoed the homespun local ballads. Biographer Antoinette Quinn discovered a poignant signpost to his future in the Cobbler's Account Book: 'I'm sitting on a bag of oats on the loft; the sun is shining most beautiful on me: 8th May 1923.'

A young Patrick Kavanagh

Patrick first saw himself in print at the age of 24, when the *Irish Weekly Independent* published two poems. Literary journals did not penetrate to Iniskeen but a new world of poetry opened up when he came across the *Irish Statesman* at a Dundalk market. Highbrow it might have been for him but, as he later wrote, 'it had a meaning and a message that had come from the hills of the imagination far beyond the flat fields of common sense'. The *Statesman's* editor, George Russell, accepted three poems in September 1923. Though it would take many years, Patrick Kavanagh the unlikely poet was on his way. One of those poems was 'Ploughman':

> I turn the lea-green down
> Gaily now,
> And paint the meadow brown
> With my plough.

James Kavanagh died in 1929. While his young brother, Peter, progressed to secondary school, it looked as if ploughing was to be Patrick's future. But, generations before fellow-farmer John McGahern, Patrick made time to read and regularly write, to the joy of every joker in the hamlet, who cruelly mocked his strange interests. Writing by candlelight after a hard day's work, Patrick's persistence slowly bore fruit. The *Dublin Magazine* published further poems. He scored impressive hits with *John O'London* and *The Spectator*. His biggest success came when Jonathan Cape included 'Ploughman' in its anthology *Best Poems of 1930*. Not bad for an unschooled ploughman.

> In these small fields
> I have known the delight
> Of being reborn each morning
> And of dying each night.

And in 1931, he finally met his mentor, George Russell. Used to tramping to places as distant as Galway, the three-day walk to Dublin in the depths of winter did not faze Patrick. AE received the lean and dusty traveller kindly and bolstered him with the unexpected gift of many books, just as in 1902 he had encouraged another uninvited midnight visitor, James Joyce. The books' weight worried the Monaghan voyager, but not their contents, which he perused as he settled down for the night in Dublin's Iveagh Hostel – Emerson, Whitman, Browning, Dostoevsky, James Stephens and George Moore. A self-educated man himself, Russell continued until his death in 1935 to send Patrick books he would have otherwise not have seen. Through him, the aspiring poet also met the writers Frank O'Connor and Sean O'Faolain.

The success of Dundalk playwright Paul Vincent Carroll further encouraged Patrick. Reading Ezra Pound, W.B. Yeats, as well as Padraic Colum and James Stephens, encouraged experimentation. He hid their works in the hedges, so that he could read them while working in the fields, just as Doctor Johnson had studied Virgil and Ovid in the meadows around equally remote Lichfield. Though the farm had to be attended to, his mother, Bridget, and brother, Peter, supported Patrick's writing. His confidence was encouraged when the *Irish Times* published four poems in 1935. The following year, he was invited to read from his own work on the national radio station. Despite his slight output, Macmillan published *Ploughman and other Poems* in its 1936 Contemporary Poets series. The *Dublin Magazine* accepted additional poems including 'Sanctity':

> To be a poet and not know the trade,
> To be a lover and repel all women;
> Twin ironies by which great saints are made,
> The agonizing pincer-jaws of Heaven.

Unlike most provincial writers who first headed for Dublin, Patrick made the bold move to London in May 1937. Fellow-poet John Gawsworth, the King of Redonda, provided both accommodation and introductions. Constable reader and compatriot Helen Waddell commissioned an autobiography, *The Green Fool*, which Michael Joseph published in 1938. Harold Nicholson welcomed it as an overdue departure from the usual 'Celtic crooning'. The *Times*

Literary Supplement enthused: 'It is a book which no one who opens can fail to read with pleasure.' There was one dissenting voice. Oliver St. John Gogarty, himself feted as an arch-wit, inexplicably sued over a joke which implied that he might have a mistress. Patrick's mention of Ely Place cost its publisher dearly. The book was taken out of circulation, its author's dreams of riches and success were confounded. To add insult to injury, the call to Gogarty's house had been an unnecessary fictional flourish.

> It has always been in my mind
> To praise woman's rotating behind
> God's loveliest blessing for mankind.

The poet always had a lively interest in women. While he met an encouraging Sean O'Casey in London, he was even more excited by an approach from two benevolent English ladies. Café owners in Gerrard's Cross, they volunteered to help him produce further masterpieces. They provided him with free food and accommodation – and his very own typewriter. Sadly, the virginal sisters caught him groping one of their waitresses. Patrick was evicted. He returned to his fountain pen and to Ireland.

Patrick at 35 had reached a crossroads. He could bury himself in the family's water-logged fields or attempt to be a poet elsewhere. His brother Peter, who had qualified as a teacher, supported his decision to earn his living by writing. Like Theo Van Gogh, Peter was to prove a constant support to his artistic brother. Patrick dropped anchor in 1939 in Dublin, where he would remain for the rest of his life. The brothers set up house – a tiny bedsitter – in Haddington Road, just off Baggot Street. They dined regularly at Trinity College's buffet; Peter paid.

Patrick soon became a familiar sight, as he promenaded along Baggot and Grafton Streets, and in the Palace Bar, where *Irish Times* editor Bertie Smyllie commissioned three short articles and a football final report. The Palace was the city's literary hub, and Patrick soon became friends with writer Brinsley MacNamara and artist Sean O'Sullivan, who sketched an early portrait. His Palace contacts in turn led to invitations to exhibitions and lectures. To many of the literati, however, he was an outsider. A figure of derision, with his uncouth manner and seven-league boots:

> He stands on the perimeter of the crowd
> Half drunk to show that he's not proud
> But willing given half a chance
> To play the game with any dunce;

While Peter's was the only income, Patrick's fortunes and morale received a major boost when he was awarded the AE Memorial Fund prize of £100, the equivalent of half a year's pay for Peter. Within three months, the windfall was spent and Patrick resumed work on a novel. But opportunity was just around a corner in Tara Street. Patrick was knocked off his bicycle by a B&I Steampacket Company horse dray. Reflecting his father's litigation pedigree, he immediately sued the shipping company. Though he wrote during the period, he claimed to have lost six weeks' earnings. On finding that Patrick had penned the agreeable article he had read that very morning on the Croagh Patrick pilgrimage mountain, the judge found against the B&I and awarded the wholesome author £36 damages – more than he would have earned in months.

Controversy was never far from Patrick's *Irish Times* book reviews, which ensured more publicity than that enjoyed by equally dedicated poets such as Austin Clarke. A derisory remark about the Boy Scout movement resulted in angry letters to the editor. Brian O'Nolan and a friend commenced a correspondence on Patrick's poem 'Spraying the Potatoes'. 'A city newspaper should print some-thing more uplifting than the warblings of a rural yokel.' The controversy did Patrick no harm. It provided publicity and an opportunity to round on the uncultured educated 'ploughmen without land'. The controversy also benefited O'Nolan and a generation of *Irish Times* readers. On the strength of his letters, editor Smyllie invited O'Nolan to contribute a regular essay which became the long-running *Cruiskeen Lawn* column.

The columnist witnessed Kavanagh's poverty-induced sleight of hand in a Baggot Street pub. Arguing with a fellow-drinker about the labelling of Irish whiskey, Brian insisted that Powers and Jameson were described as Dublin rather than as Irish whiskey. The obliging barman brought down a bottle to show his audience. He left to attend to other customers. When he returned, the bottle was gone, as was Patrick, who had been sitting on the periphery of the company.

Patrick's art criticism annoyed many painters. He described Monet's work as ideal decorations for a bungalow in Killiney. He lambasted the RHA and women artists: 'Women add slickness to an art, but in proportion as women succeed in that art the level of criticism sinks.' Brigid Ganly and Norah McGuinness declared that a poet had no business criticising painting. Brian O'Nolan rushed manfully to Patrick's defence: 'What a world it would be if you could not complain about the quality of a pint unless you were a brewer, or complain about a play unless you were born and bred in the Abbey.'

The poet enjoyed a brief affair with a lady who was already bethrothed to another. Though it resulted in memorable poems, his quest for a compatible female would prove as arduous as that for literary success. Contact with Frank O'Connor and Sean O'Faolain led to *The Bell's* ventilation of further poems. But it was the publication of the emotionally powerful 'The Great Hunger' in 1942 which finally established Patrick as a major poet. His social realism mirrored Joyce and drew a line under the Literary Revival's romantic peasant. Criticising the church's attitude on the subject, his 750-line poem vented a howl of sexual frustration. For Kavanagh, the big sin was repression, not indulgence: 'For the strangled impulse there is no redemption.' Inexplicably, though two gardaí called, 'The Great Hunger' escaped the vigilant Censorship Board, possibly because it first appeared in the low-circulation *Horizon* magazine. Peter Kavanagh surmised that the following passage may have offended local crawthumpers:

> O he loved his ploughs
> And he loved his cows
> And his happiest dream
> Was to clean his arse
> With perennial grass
> On the bank of some summer stream;
> To smoke his pipe
> In a sheltered gripe
> In the middle of July –
> His face in a mist
> And two stones in his fist
> And an impotent worm on his thigh.

The special Irish edition of the magazine had been arranged by John Betjeman, the newly-appointed British embassy press attaché. Tiring of Palace Bar idlers and stage-Irishmen, Patrick basked in the unexpected friendship of the affable English poet, who had learned Irish, signed his books Sean O'Betjemain and had written of his adopted country:

> O my small town of Ireland, the raindrops caress you,
> The sun sparkles bright on your field and your Square
> As here on your bridge I salute you and bless you,
> Your murmuring waters and turf-scented air.

Betjeman introduced such visitors as Professor Joad, art historian Kenneth Clarke and artist Osbert Lancaster, and also persuaded Laurence Oliv-

ier to film *Henry V* in Ireland. Patrick dedicated a poem to the Englishman's Dublin-born daughter, Candida, and used his influence with editors Cyril Connolly and John Lehmann. Emulating Samuel Beckett, Patrick also played cricket on Trinity College Green for the British ambassador's team. Betjeman recommended using him to spy on Axis sympathisers in Lisbon. Though saner counsel prevailed, Patrick prepared by acquiring a passport and studying a Hugo's Portuguese manual.

Patrick grew to love Dublin, though he was too forthright for such a small city. Fearless in voicing his opinions, he hurt friend and foe alike as he pricked bubbles of cant and pretension. Honor Tracy recollected meeting him: 'He launched, in his beautiful voice, a diatribe against Ireland and all her works, her passion for mediocrity, her crucifixion of genius; he lamented the passing of his best years among marshmen and Firbolgs; he threatened to shake the dust of her off his feet and to seek his living henceforward in strange places among foreign men.'

A regular *Irish Press* column provided Patrick with a platform and much-needed income. At the end of 1943 he moved into a spacious first-floor flat at 62 Pembroke Road. Film critic for *The Standard* from 1946 to 1949, he wrote himself out of the job when he insisted that few of the cinematic offerings could be recommended for people of average intelligence. Macmillan published *A Soul for Sale* in 1947, which was well reviewed in England and North America. Patrick received a further boost the following year, with the publication of *Tarry Flynn*, a lyrical account of rural life.

Like London's Dr. Johnson, whose manner and lack of style and political correctness he replicated, Patrick was now an established part of the Dublin scene and a target for visiting journalists. Larry Morrow dined with him: 'A great root-like hand shoots across the table to the toast-dish, casting a thunder-cloud shadow on the cloth. Patrick Kavanagh, without warning, suddenly crosses his legs, jerks the table a good two feet in the air, cups and dishes a-jingle-jangling, and continues his conversation as if no earthquake had occurred. Or he as suddenly hunches the enormous, mountainous shoulders, and chairs, table, walls even, seem to shiver with him. Nuclear fission (one reflects) is a ripple in a teacup compared to Mr Kavanagh in a tea-shop.'

Two literary magazines came to Patrick's rescue in the early 1950s. Edited by Anthony Cronin and Peadar O'Donnell, *The Bell* marked a watershed and nurtured the development of Kavanagh, the city poet. It published 'Intimate Parnassus' and other poems which would appear in the *Come Dance with Kitty Stobling* collection. Farming and the country became subjects of

the past; Patrick embarked on a more humorous and confessional mode. He also used his regular Diary in the new *Envoy* magazine to berate the Abbey Theatre, Radio Éireann and even his former Pearl Bar drinking companions. He preached: 'There is an instinct in mankind which recognises the priestly nature of the poet's function. This instinct has never been strong in Ireland, for Ireland is a particularly cynical and materialistic country – for all its boastings about religion.'

As well as recording his appreciation of 'the incomparable George Moore', the country-born poet expressed his special regard for the urban James Joyce, whose *Ulysses* he regarded as only incidentally about Dublin and fundamentally the history of a soul. He suggested that Joyce had done more for Ireland than Yeats and the Irish Literary Revival: 'The most important thing that was happening in Dublin at this time was not the activity of Yeats and his followers but the fact that wandering in the city, unknown and ignored, was a young man whose observant eye and ear was capturing the epic city that is to be found in *Ulysses*. As Cyril Connolly says, "What Baudelaire and Laforgue did for Paris or T.S. Eliot for modern London, Joyce did for Dublin." As an evocation of a city, as the truth that never gets into the history books, it would be impossible to over-estimate the importance of *Ulysses*.'

Portrait of Patrick Kavanagh by Patrick Swift

Patrick sometimes acted as *Envoy's* unofficial editor. J.P. Donleavy arrived one day to witness the gale force of a Kavanagh editorial assessment. As he threw one of the Irish-American's own manuscripts at him, the poet proclaimed: 'Rubbish. Utter drivel and the most appalling nonsense I have ever had the disinterest to read.' Among other new writers he met were John Jordan and James Liddy. The association with younger congenial spirits unfortunately accelerated Patrick's alcohol consumption in the too-convenient annexe of McDaid's.

One of the writers Patrick met in 1950 was Brendan Behan, twenty years his junior. Brendan painted Patrick's flat in preparation for a visit by an American beauty. It was a short-lived acquaintanceship which was replaced by permanent and bitter hostility. Brendan focused his antipathy to country people on Patrick. In McDaid's, he derided his eternally indigent elder as a sponger and a failure. He also described him in a Paris magazine as 'our Monaghan wanker'. Recoiling from Brendan's drunken hysteria, Patrick regarded him as an unstable gurrier. He resented Brendan's exhibitionism and the ease with which he gained publicity and premature success.

Patrick had a horror of violence and the pair never came to blows. But though the poet usually fled if he saw Brendan, they frequently traded insults when their paths inevitably crossed in such an intimate city. Senator David Norris observed the duelling duo: 'As a teenager, my natural instinct was to watch these fascinating specimens from afar, as you would on a safari observe dangerous animals from a jeep. Both of these gentlemen, in addition to being fine creative artists, were men of volatile temperament and you could never quite tell what would happen if you engaged them in conversation.'

According to *Balcony of Europe* author Aidan Higgins, however, the animosity between the pair was nothing unusual for the period: 'W.B. Yeat's "Great hatred, little room" remark was an apt summing up of the state and flux and general venom of the fifties. Where Myles detested Kavanagh and the latter loathed the Omagh man turned city slicker, who in turn mocked Synge and was jealous of Joyce. No good word too for Beckett who was making a name for himself in Paris. Mucker Man was also impolite to the ever-polite McGahern. "Scoundrel," he growled one night.'

Critic John Jordan saw Patrick Kavanagh at closer quarters and enjoyed happy discussions on Goldsmith, Tom Moore and Samuel Johnson, and Patrick's rendition of his favourite ballad, 'From a Munster Vale They Brought Her', by Toomevara poet, Richard Dalton Williams. John Ryan was one of Patrick's most supportive friends. Though awed by Brian O'Nolan, *Envoy's* editor insisted: 'Patrick had the best mind of the lot.' Appointed to the newly formed Cultural Relations Committee in 1951, John tried to redress Patrick's chronic cash shortage with a sponsored trip to the US. The Minister for External Affairs, Sean MacBride, would not even allow Patrick's photographs to be sent. His successor, Frank Aiken, went one further and vetoed the trip. He would not risk Ireland being represented abroad by such an unconventional and outspoken figure. John Ryan resigned in protest from the committee, to which Patrick gave a final poetic riposte:

> Card-sharpers of the art committees
> Working all the provincial cities,
> They cry 'Eccentric' if they hear
> A voice that sounds at all sincere,
> Fold up their table and their gear
> And with the money disappear.

Equally disastrously, *Envoy* closed in July 1951. The demise of a mouthpiece and a source of income was a body blow. But Peter Kavanagh once more raced to the rescue. When he arrived on holiday from America where he was teaching, Peter decided to pour his savings into a weekly magazine which the brothers would jointly run. One of the most extreme periodicals ever seen in Dublin, *Kavanagh's Weekly, A Journal of Literature and Politics* attacked almost every Irish institution from April 1952 until its demise thirteen weeks later.

For a man who had insulted so many in his *Weekly*, Patrick soon proved remarkably sensitive himself when he sued *The Leader* over its profile of him. Media coverage of the four-day libel trial in February 1954 made Patrick the most talked-about man in the country. But the experience damaged his health; he slowed visibly, his whiskey intake increased dramatically. 'I don't want to miss Leopardstown races,' he vainly protested, as doctors rushed him to Rialto Hospital on March 1, 1955. He was diagnosed with cancer, a likely legacy of his life-long smoking. Surgeons removed his left lung and a rib. His life hung in the balance for several weeks. But his great physical reserves came to the rescue, he gradually improved to celebrate:

> A year ago I fell in love with the functional ward
> Of a chest hospital: square cubicles in a row,
> Plain concrete, wash basins — an art lover's woe,
> Not counting how the fellow in the next bed snored.
> But nothing whatever is by love debarred,
> The common and banal her heat can know.

Archbishop McQuaid's influence helped to secure Patrick's extramural lectureship at University College Dublin. He ungratefully satirised the Archbishop in *By Night Unstarred*: 'His grey long face was the face of an ascetic, or of a dealing man from some mountain district in the county Leitrim.' But the poet narrowly escaped poetic justice when the Archbishop paid an unexpected Christmas visit to Pemroke Road, where Patrick was entertaining a lady of uncertain virtue.

Patrick had an early-warning system, a truck mirror, through which he could spot visitors. Preoccupied with his guest, he didn't notice anyone until he was disturbed by the knocking. He looked down and was shocked to see the Archbishop's Austin Princess. It took all of the dishevelled poet's persuasive powers to encourage a later visit. As he emerged from the Archbishop's car with cigarettes, whiskey and a hand-knitted sweater, his own princess pulled up the window and shouted down, 'Your time's up, are yez comin' back or not?' Patrick bellowed his farewells until the car disappeared up Baggot Street.

The exceptionally warm summer of 1955 marked Patrick's rebirth at the age of 51. He convalesced close to Parsons Bookshop in what he called his Parnassus. John Banville saw him in Parsons: 'My fondest memory is of Paddy Kavanagh sitting in the window – in the window, yes, among the volumes on display – and deep in a book.' Embracing his new life and idling without guilt, Patrick recorded: 'I have been thinking of making my grove on the banks of the Grand Canal near Baggot Street Bridge where in recent days I rediscovered my roots.' Fresh from his near-death experience, he saw everything with a fresh and accepting eye. Reunited with the beauty of nature and the magic of light, he scooped up his canal baptismal water in handfuls from under Baggot Street Bridge:

> Leafy-with-love banks and the green waters of the canal
> Pouring redemption for me, that I do
> The will of God, wallow in the habitual, the banal,
> Grow with nature again as before I grew.

His recovery complete, Patrick headed for London. His close brush with death caused many to reassess their opinion of the poet. The critics had even more reason to be startled when a selection of his new work appeared in the London literary journal, *Nimbus*. Editor David Wright celebrated: 'I am incoherent with enthusiasm; he is not an Irish poet, he is *the* poet. This is the goods.' *Nimbus* sold out in Dublin and London. It re-introduced Patrick to the British public and led to the success of his next volume, *Come Dance with Kitty Stobling*. Younger writers admired Patrick for liberating poetry from the academics. As he confirmed in *Auditors In*, this was the end of the curmudgeonly poet and the start of the new, more relaxed and more confident 'Canal Man':

> I turn away to where the Self reposes
> The placeless Heaven that's under all our noses
> Where we're shut off from all the barren anger
> No time for self-pitying melodrama . . .

Patrick's growing fame brought a further unexpected bonus. A friend met him one morning: 'How are you?' he asked the poet.

'Fucking awful. I was up all night rewriting 'The Great Hunger'!'

Patrick explained to Tony McInerney that he had been approached by an Englishman who wanted to purchase manuscripts of his work. The original drafts had long disappeared, but Patrick lost no time in purchasing copybooks in Parsons, on which he laboriously rewrote his famous poems. A guaranteed money-spinner, at last.

The poet left Pembroke Road at the end of 1958 after a fifteen-year stint. But Baggotonia was his bailiwick and he never moved far away. In between visits to England and the US, he spent the final nine years of his life in Baggot Lane, Leeson Street, Raglan Road and Upper Mount Street.

Nelson Algren described him at this time: 'A massively constructed slightly stooped man of 53 wearing double-lensed glasses and an overcoat that would have made Charles de Gaulle a better fit, if de Gaulle didn't care what he wore any more. Kavanagh's voice is a foghorn gone mad. What it was like when he had both lungs, I didn't care to consider but am content I wasn't in Dublin at the time.'

The title page of The Great Hunger, *published by the Cuala Press*

Patrick's poetry might have changed but not his legendary ingratitude. When novelist John Broderick declined to buy him a drink after having provided two already, Patrick abused him for being mean. A woman rashly reminded Patrick of his round: 'Can't you see I have a mouth on me?' The retort was swift: 'How could I miss it and it hanging between your two ears like a skipping-rope.'

Artist Robert MacBryde recalled Patrick insulting Lord Dunsany despite the two indigents being wined and dined at Leixlip Castle and 'despatched back to McDaid's well fed and drunken with £1 each & a half bottle of V.69 (whisky) each'.

Some of Patrick's acquaintances, however, queried the allegations of rudeness. Robert Greacen cautioned: 'Life had taught him to be on his guard.' John O'Brien, nephew of novelist Kate O'Brien and owner of the Parsons Bookshop building, met the poet many times in a Ballsbridge restaurant: 'Usually alone, he was always polite. I think he got a bad press. Years later, I was pleased to allow Peter McDonnell of the Monaghan Association erect a plaque to him on the wall of Parsons, to commemorate his long association with the place.'

Peter Kavanagh published the *Canal Poems* on a hand press he had built in his New York apartment. He followed this up with the *November Haggard* and the *Lapped Furrows* volumes of correspondence. On a visit to Dublin, he wrote in its Guest Book: 'Parsons was the bookshop that meant most to Patrick during those awful years 1940-1950 and beyond.' Patrick himself inscribed the book: 'When someone asks me to write something in this book the temptation is to go false, to try to put down "great thoughts". One feels too the impertinence of writing "I" this or that, as if we thought ourselves important. A man has no right to talk of himself, only as a by-product of his work. It is a June day, 1959. Profundity keeps coming up – Patrick Kavanagh for Miss O'Flaherty of Parsons' bookshop.'

The poet's brother later turned against May O'Flaherty, after she declined to contribute to a fund to purchase the Kavanagh Archive. The formidable Peter also demolished a London relief plaque he considered offensive to Patrick.

Des MacNamara remembered: 'I sculpted a suitable offering for the exterior of Patrick's favourite London watering hole, the Plough, which had also been frequented by Liam O'Flaherty and other writers. The inscription in Gaelic read – *Is ioma steall a chaith se anseo* – which meant "It's many a time he pissed here", which he had! When Peter heard of this in New York, he was furious. Some time later, the publisher Timothy O'Keeffe watched fearfully from inside the bar, as Peter and a few acolytes proceeded to hack my precious work to pieces. Peter wasn't renowned for a sense of humour.' Luckily for posterity, Dubliner Peadar MacManus has a replica of the original relief.

With his lectureship and a column in the *Irish Farmers' Journal*, Patrick was now better off than he had ever been. Appointed Irish judge of the Guinness Poetry Awards, he received 150 guineas and five expenses-paid trips to

London. Liam O'Flaherty recorded: 'Patrick is now assuming the manners of a distinguished literary gentleman. I actually saw him in Grafton Street, dressed reasonably well and clean, raising his hat courteously and bowing to somebody that passed. I've been told that he now has a cheque book.'

Sadly, Patrick over-used the book and launched another Kavanagh legend. Short of funds, he canvassed for friends who spray-painted haybarns. They allegedly pushed him into the canal after he exposed their scam in his *Farmers' Journal* column. But his reputation received a major boost when *Come Dance with Kitty Stobling* was selected as the 1960 Poetry Book Society's summer choice in Britain. His love life finally blossomed on a sojourn in Leland Bardwell's London house, where he met Katherine Moloney, a bookkeeper twenty years his junior. Dublin-born, she had herself kicked the traces and flown to Paris. She mixed with writers and artists and knew their ways. For the first time, the poet had someone who understood him and was prepared to look after him. 'I'd never seen him so contented,' said Des MacNamara, who sculpted him at this time.

In January 1961, Patrick spent three weeks in Baggot Street Hospital with pneumonia. His recovery was boosted by record sales of the paperback edition of *Tarry Flynn* and, the following year, he finally achieved long overdue national recognition. The new television station, RTÉ, broadcast his 'Self Portrait' to a huge audience. A commanding presence in his crisp check jacket, Patrick insisted to the camera: 'The real poverty was the lack of enlightenment to get out and get under the moon. . . . There is nothing as dead and damned as an important thing. The things that really matter are casual, insignificant little things, things you would be ashamed to talk of publicly. You are ashamed and then after years someone blabs and you find that you are in the secret majority. Such is fame.'

Patrick was acclaimed when he visited his native Iniskeen the following day. After years of derision, he was now seen as someone of whom the village could be proud. Even the schoolchildren hailed him:

> I wish you could have heard them cheer me
> A hundred girls as I passed the school
> In my native village. This was real fame,
> This was love. This was the poet who had succeeded
> Paddy
> Paddy
> Paddy
> They screamed delightedly.

A friend noted: 'Brendan achieved fame too quickly and it destroyed him. Patrick, who could have handled recognition better, had to wait far too long and that's what destroyed him. Apart from his cancer, his system was worn down by his increased drinking. He would now have a whiskey in one hand and bicarbonate of soda in the other. Had he met Katherine earlier and been appreciated sooner, it could have made his life both happier and longer.'

Patrick was the exception to the outpouring of grief which greeted Brendan Behan's death in March 1964. But he later confessed to John Jordan his appreciation of Behan's *Hold Your Hour and Have Another*. And many recalled Brendan's consistent regard for Patrick's poetry. Paddy O'Brien remarked on how much they had in common, their comic spirit, their iconoclasm, their courage in adversity.

Ben Kiely mused: 'Was it simply that Baggot Street was not long enough, heaven high enough, nor hell hot enough, to accommodate at the same time two such extraordinary extroverts? My heart and memory hold a warm place for the two of them.'

The poet's increased drinking led to another hospitalisation. Peter Kavanagh recalled that Patrick engaged the best room with a telephone service. He was also offered the service of a psychiatrist: 'This Patrick regarded as a most amusing suggestion but he politely declined. Some months later when he was approached on behalf of the hospital by a bill collector, he remarked "Now the hospital authorities could use the services of a psychiatrist."'

Parsons Bookshop enjoyed a bestseller when the Dolmen Press published *Self Portrait* in book form. Between Dublin and London addresses, the Baggot Street *poste restante* represented a constant and a contact point in Patrick's life. The former Taoiseach, John A. Costello, whom Patrick now referred to as a 'wonderful man', sometimes visited the shop to see if Patrick wanted a lift anywhere. Once, he offered to buy his passenger a half-bottle of whiskey in the Waterloo pub, from which the poet was barred.

James Liddy invited Patrick to contribute to his magazine, *Arena*. Patrick also made a record for Garech Browne's Claddagh Records. MacGibbon and Kee published *Collected Poems* the following year when Patrick turned sixty. The *New Yorker* raved:

> His *Collected Poems* reveals an astonishing talent – according to some enthusiasts, the finest, not only in Ireland but in all English speaking areas – that has kept on renewing itself not so much by a process of orderly growth as by a continual breaching of boundaries ... Kavanagh survives and flourishes

in that invigorating region where without respectable let or hindrance, the wild rivers run and the wild timbers grow.

Despite a bladder operation, Patrick had lost none of his iconoclasm. Invited in 1965 to celebrate the centenary of Yeats's birth by the Northwestern University in Chicago, he annoyed his more conservative listeners by eulogising modern American rebels: 'On the Road is an excellent book, one of my favourite books about America since Henry Miller's *The Air-Conditioned Nightmare*. And I like Corso, Ferlinghetti and Allen Ginsberg.'

Greeted with flower petals, he continued his love affair with the younger generation at London's Queen Elizabeth Hall, where he spoke with Ginsberg, Pablo Neruda and W.H. Auden:

> After the arrival of the Beatles and the Stones
> Anything goes
> And I am glad
> That freedom is mad
> Dancing with pot.
> Hurrah, hurrah,
> I say
> For this beautiful day.

Patrick attended an international writers' conference in Rome, where he met Jean Paul Sartre and Simone de Beauvoir. Hailed by younger poets such as Eavan Boland, Éilean Ní Chuilleanáin, Paul Durcan and Brian Lynch, he enjoyed further recognition when the Abbey Theatre staged *Tarry Flynn*. The once reluctant scholar was equally chuffed when the education department placed his poetry on the school syllabus.

Shortly after the publication of *Collected Pruse*, Patrick married Katherine Moloney in April 1967, at the Rathgar church where James Joyce's parents had sung. He kept the wedding a secret from both the media and his brother, who disapproved of Katherine, but it was a union of true friends. Katherine took care of him and helped him to reduce his drinking. She supported him when he unveiled the door of Leopold Bloom's Eccles Street house at the Bailey, and also at the launch of Henry Moore's statue of Yeats in Stephen's Green. And they both celebrated the unexpected windfall of a British Arts Council poetry bursary of £1,200.

Sadly, Patrick enjoyed only seven months of married bliss. He contracted pneumonia and died on November 30, 1967 in Herbert Street's Merrion

Wedding day of Patrick Kavanagh and Katherine Moloney

Home. Friends recalled his favourite parting phrase 'So long. Life goes on!' and his poem:

> On Pembroke Road look out for my ghost
> Dishevelled with shoes untied,
> Playing through the railings with little children
> Whose children have long since died.

The funeral morning was dark, grief overhung the canal as Patrick was brought home from Baggot Street to Iniskeen. John A. Costello was in attendance and Leo Holohan, Seamus Heaney, John Montague and David Wright spoke at the graveside. 'There goes all I will know of God in this life,' whispered Katherine, as he was lowered into the ground. A sentiment echoed by Brendan Kennelly's *Dublin Magazine* tribute:

> He lived according to his code
> And in his way was true to God.
> Courage he had and was content to be
> Himself, whatever came his way.
> There is no other chivalry.

Chapter Nine

Europe's Most Literary Waterway

My earliest beat was up and down the canal, from our front door steps as far as Leeson Street bridge. – Elizabeth Bowen

'Have you ever seen such pyrotechnics?' Owen Walsh brandished his new stick on the autumn canal bank by Wilton Place. 'Wouldn't Wordsworth have an almighty orgasm – though he may have phrased it more poetically?'

The mill-pond approach to the lock was golden with mirrored leaves. With the reflected sky, they alchemized the surface as if advertising some underworld Elysium. The Mespil Road traffic belonged to another planet. The spell was only broken by the squawking of territorial ducks and a sudden commotion of flapping wings. 'You can have Venice's waterways, the canals of Bruges and Doctor Johnson's mighty Thames,' the artist declaimed.

'No channel in the world boasts as many literary and artistic associations as this canal. When I amble between Mount Street and Portobello bridges, I am confabulating with Flann O'Brien and Jack Yeats and Sam Beckett. And alienated young Joyce, who also pondered here. Not to mention fellow-strollers Behan and Kavanagh – and unrewarded Harry Kernoff, who recorded Dublin like no other. "Will I ever make a penny?" Harry looked up at me once on this very bank. Now, the bastards are fighting for his work. No wonder my head is buzzing with fresh possibilities when I return to my Baggot Street studio!'

Irish writers spared water in their drinks but deployed it prodigiously in their works. James Joyce appropriated the Liffey. Patrick Kavanagh immortalised the Grand Canal and is commemorated by two canalside seats. Completed in 1791, the 82-mile waterway connected Dublin with the mid-

lands and the river Shannon. An active conduit for 170 years, its barges carried beer and other goods from Dublin to the west and returned with turf. Charles Lever and Anthony Trollope were among those who traversed it by passenger boat.

Fuel dumps and light industries sprang up along its banks. Elizabeth Bowen remembered the activity in the shadow of Baggot Street Bridge: 'The house was filled by the singing hum of the saw-mill across the water, and the smell of the newly-planed wood travelled across. Stacks of logs awaiting the saw overtopped the low tarred fence that ran along the bank on the opposite side. The woodyard was fed from some of the barges that moved slowly up or down the canal, sinking into then rising from the locks. Not much wheeled traffic went past our door, but from each end of Herbert Place, intermittently, came the ring and rumble of trams going over bridges.'

Having outlived its commercial purpose, the canal metamorphosed into an equally beneficial artery of inspiration. An oasis of calm in a busy city, its hump-backed bridges, brimming locks and pastoral towpaths an irresistable invitation to escape. They provide space for ordinary citizens to sit and think and, for artists and writers, maternal reassurance after a day's doubts.

Mespil Lock on the Grand Canal

Like Voltaire behind his Ferney shrubbery, walkers are screened from traffic noise and pollution by leafy sentries, which Oliver St. John Gogarty described as 'more sinned against than sinning'. Time stands still on the grassy banks, between which roach, rudd and an occasional pike excite urban fishermen. A haven for birds, moorhens, ducks and occasional swans, the canal's wild flowers and lofty elms illuminate the seasons. The tree roots which rib the towpaths are acceptable hazards.

The dressed granite bridges retain their elegantly scrolled titles, Macartney, Eustace, and La Touche. And Charlemont, named after Grattan's friend, the Earl of Charlemont. Punctuated by locks and rickety footbridges, the canal's one and a quarter-mile stretch from Lower Mount Street to Portobello neatly girdles Baggotonia. From where Samuel Beckett sat during his mother's last illness to the nursing home where Jack Yeats died. The water sparkles and soothes as it descends sixty feet between Portobello and Mount Street. The curtain of spray under Huband Bridge's curving balustrades sings an eternal sonnet to the art of the stonemason and the forgotten navvy. The kingpin of the delicate 1825 Peppercannister church seals the Georgian and artistic grandiosity.

Artists and writers have long celebrated the canal's atmosphere and moods. Its habitués mirror the progress of Irish writing, from Charles Lever and Irish Literary Revivalist George Moore to modernist Joyce and post-war poets, John Montague and Thomas Kinsella. Lever walked its banks when he enrolled at Sir Patrick Dun's Hospital. As did John Millingon Synge, when he studied at Harrick's English

Elizabeth Bowen grew up by the canal

school by Leeson Street Bridge, and Joyce's friend, Tom Kettle, who lived on Northumberland Road. Also, Portobello-born George Bernard Shaw, whose drunken father tried to throw him into the canal at the age of five. Historian Maurice Craig missed the canal while in London, where his friend L.T.C. Rolt 'reminded me of Parsons Bookshop and my original waterway when he wrote that excellent *Green and Silver* book on Irish canals'.

Elizabeth Bowen grew up beside the Grand Canal: 'My earliest beat was up and down the canal, from our front door steps as far as Leeson Street bridge. The neighbourhood seemed infused with a temper or temperament of its own, and my spirits, on morning or afternoon walks, corresponded with this in their rise and fall.'

James Joyce followed in her footsteps (though in *Ulysses*, he heretically confused the Grand Canal with its north-city Royal Canal counterpart). It was outside Elizabeth's house that Corley promenaded a new acquaintance in Joyce's 'The Two Gallants'. Near Mount Street Bridge, Stephen Dedalus revealed his theories of art to fellow-student, Lynch:

> To speak of these things and to try to understand their nature and, having understood it, to try slowly and humbly and constantly to express, to press out again, from the gross earth or what it brings forth, from sound and shape and colour which are the prison gates of our soul, an image of the beauty we have come to understand – that is art.

Huband Bridge on the Grand Canal

John O'Leary, friend of Joyce and Ivan Turgenev, occupied a book-lined house overlooking the canal in adjacent Warrington Place, once home to Sheridan Le Fanu. Many of his books had come from stalls by another waterway, the Seine, where George Moore and other Irish writers and artists had also lingered. O'Leary once shared lodgings in Paris with the artists James McNeill Whistler and Edward Poynter, who taught John Yeats. Poet W.B. Yeats, whom the benign patriot empowered, lamented his 1907 death:

> Romantic Ireland's dead and gone,
> It's with O'Leary in the grave.

The canal was also a favourite of George Moore. After returning from Paris in 1901, the early champion of the Impressionists paused there one evening: 'Gill and I leaned over Baggot Street Bridge, watching the canal-boat rising up in the lock, the opening of the gates to allow the boat to go through, and the hitching on of the rope to the cross-bar. The browsing-horse, roused by a cry, stuck his toes into the towin-path, and the strain began all the way to the next lock, the boy flourishing a leafy bough, just pulled from the hedge. We continued our interrupted walk, glad that we had not been born canal-horses.'

A later resident daily trudged this stretch of water to 'the sinister portals of Synge Street School'. He was Brian O'Nolan, the future novelist Flann O'Brien, who lived from the age of fourteen to seventeen in high-stepped 25 Herbert Place. The nearby Eastwood Hotel provided the setting for the Red Swan Hotel in *At-Swim-Two-Birds*. Brian ran a toy train in the top floor room where he also staged plays, developed photographs and frightened evening strollers with explosive flashes from photography chemicals. Trains would regularly resurface in the *Irish Times* column of Ireland's greatest modern satirist, and in his *Bash in the Tunnel* tribute to James Joyce.

Samuel Beckett was another dark humourist who regularly walked the canal banks when visiting Jack Yeats in the Portobello Nursing Home. Alone in the cold, he reflected on the meaning of life beside Huband Bridge in 1950, as he waited for his own mother to die in nearby Merrion Nursing Home: 'There I sat, in the biting wind, wishing she were gone. Hardly a soul. Just a few regulars, nursemaids, infants, old men, dogs . . . the blind went down, one of those dirty brown roller affairs. I happened to look up and there it was. All over and done at last.'

While nursemaids slept, other ladies plied an older trade along the canal banks for most of the twentieth century. Lulu in Beckett's story 'Premier Amour', is based on one of the prostitutes the writer allegedly helped finan-

cially. Several of Beckett's characters also frequented the waterway, which Belacqua described as a sanctuary of calm and a monument to beauty, worthy of Giovanni Antonio Canaletto. On his typsy way to a party at nearby Casa Frica, Belacqua sat down on the parapet of Baggot Street bridge:

> Next, resolved to get full value from the bitter nor'wester that was blowing, he slewed himself right round. His feet dangled over the canal and he saw, lurching across the remote hump of Leeson Street bridge, trams like hiccups-o'-the-wisp. Distant lights on a dirty night, how he loved them, the dirty low-church Protestant!

The canal was also familiar to J.P. Donleavy's Ginger Man, as he pondered what excuse to give his wife Marion after being delayed by his girlfriend, Chris. Jack Yeats admired its swans, whom Nelson Algren also knew. 'Through the perpetual dark green mists that forever abide, we walked the banks of The Grand Canal,' he wrote of a fifties visit to poet John Montague. 'We walked as night was falling to see the swans come down. They came like ghosts of swans, silently, one by one. John Montague spoke the name of each as it passed, softly, in some tongue I had never heard: as though he had known each when they were man.'

Aspiring artist Jay Murphy greeted a tethered goat every morning, as she crossed the Mespil footbridge on her way to Leeson Street convent. Mannix Flynn, a later animal lover, studiously avoided school: 'We would meet in St Patrick's Park in Bride Street and off we would go for the day, up along the canal and down to the cats' and dogs' home in Grand Canal. We would have a good look at the dogs, petting them, feeding them and all the time trying to find a way to open the cages and let them out.'

Scrap-metal dealers and welders sent sparks flying in nearby Upper Lad Lane, where widowed novelist Mary Lavin occupied a mews house from the late 1950s until 1983. Mary had happy memories of the house where Frank O'Connor was a regular visitor: 'Though the area became increasingly busy with the influx of offices, we were never without birdsong and Parsons civilised bookshop was only a stroll away along the canal.'

Mary's daughter, Caroline Walsh, recalled: 'Our house was always full of writers, people like Patrick Kavanagh, Padraic Colum and younger writers such as John McGahern and Tom MacIntyre. I remember Patrick offering me ten shillings one night if I could name a US state for each letter of the alphabet. A good way of keeping a child out of the way!'

On her way to the bookshop, Mary Lavin passed the Wilton Place home of Liam O'Flaherty, who wrote about the canal in his 'Wolf Lanigan's Death' story:

> It was a frosty January night about ten o'clock. A large barge drawn by two horses was coming slowly down the canal nearing its destination at Portobello Bridge, Dublin. There was no moon, but now and again glaring lights from the tramcars that rattled over the Bridge lit up the dark waters of the Canal, the grey bulk of the barge, the taut rope, the narrow gravel path and the two lean horses walking slowly in single file with their heads drooping.

Mary Lavin

O'Flaherty lived from 1954 until his death in 1984 in Court Flats, where Frank O'Connor also spent the final six years of his life. The latter's outspoken criticism of censorship led the government to oppose his proposed graveside oration for W.B. Yeats. As a result, Jack Yeats allowed no speeches for Ireland's greatest poet. Brendan Kennelly was one of Frank's many visitors:

> I see you standing at your window,
> Lifting a glass, watching the dying light
> Along the quiet canal bank . . .

The same continually changing light and seasonal pageantry attracted many artists. Young Mainie Jellett first sketched beside the canal. Sarah Purser lived in canalside Harcourt Terrace. One of her regular models in the 1920s was Kathleen Kearney, mother of Brendan Behan. The lithe Kathleen features in Purser's nude studies but, wary of puritanical reaction, never subsequently broadcast her earlier modelling. Opposite Purser's studio lived

An oasis of calm in a busy city

Alan and Carolyn Simpson of the Pike Theatre, whose production of *The Quare Fellow* catapulted Kathleen's son to fame.

Percy French resided at 35 Mespil Road and captured the canal's moonlit atmosphere in haunting watercolour. 'Drop in sometime,' he ambiguously invited an unwelcome guest. Harry Kernoff regularly painted the canal bridges, including his favourite Huband Bridge. Nevill Johnson recorded the bare reflections of winter trees and the High Cross-like mooring posts, inscribed with the spirals of long apprenticeships. Later regulars were the lyrical Tom Nisbet, Michael Kane, Liam C. Martin and Sunny Apinchapong, whose Impressionistic studies of the bridges and old mews houses were an Oriel Gallery sell-out.

Two of the canal's best known characters were amateur artist and horseman Billy Noyek and D-Day American survivor Kevin Monahan. Like Jack Yeats, Billy never appeared without a red rose. Kevin sported a Salvador Dalí moustache and, each morning, a tie more lurid than the previous day's.

But Kevin was outshone by 1980s newcomer Francis 'Bunch' Moran. Sister of Madrid-based sculptor Cynthia Moran Killeavy, Bunch painted in

all weathers, wrapped in lurid thermal gear or, more happily, enveloped in spring or summer finery. Her favourite day of the year was Bloomsday, when a suitably fantastic hat made her an instant target for photographers in Duke Street's Joycean pubs. Bunch was as opinionated as her male rivals: 'Everyone tells me what a draughtsman Harry Kernoff was. Sure the man couldn't draw a straight line.' Brendan Behan likewise came under fire: 'He should have encouraged Beattie to continue her painting.' Bunch was territorial. She shooed off fellow-artist Noel Lewis, when he attempted to set up his easel close to her at the Mespil Lock.

The canal flowed under the gable window of Parsons Bookshop. One day, as May O'Flaherty tidied the area around the Patrick Kavanagh memorial seat, Mary King celebrated: 'Aren't we very lucky, thanks to John Ryan and other campaigners, that it wasn't made into a roadway as Dublin Corporation suggested in the sixties?' Mary frequently met Brendan and Beatrice Behan on the canal towpath. And, in later years, Beatrice, alone. Cycling to Crumlin on Fridays, her basket laden with fish for her mother-in-law, Kathleen. Paul Durcan remembered Mary and other canalside residents, as he walked the canal one night:

Paul Durcan

> Singing the praises
> Of water, of catwalks, of locks,
> Of artisans,
> Of the total absence
> Of dogs at this time of night,
> Of towpaths, of canal bank seats,
> Of lanes, of bookshops, of women –
> Of women at pianos alone in flats
> Playing Field Nocturnes,
> Of Mary Lavin's daughters in Lad Lane,
> Of the Misses King and O'Flaherty in Parsons Bookshop,
> Of Michael Kane at his window in Waterloo Road.

En route one hot day to the Radio Éireann studios, Brendan Behan dived in and joined the children under Leeson Street bridge. 'Despite his infatuation with the canal, Patrick Kavanagh had to wait until he was pushed in!' Mary King joked. In a 1959 *Farmers' Journal*, Patrick rashly exposed the spray-painting scam of some friends. After a session in Searson's pub, he was pushed against Baggot Street bridge at 1.30 one October morning. The last words he heard were: 'Over you go, you fucker you!' The icy water revived him and, minus a shoe and his spectacles, he clambered out and sloshed to the Wilton Place house of *Nonplus* magazine editor, Dr. Patricia Murphy.

The three who manhandled him claimed that Patrick had simply rolled down the bank and into the water by himself. In his next column, wisely refraining from mentioning names, the poet loftily concluded: 'The ostensible reason for this dreadful affair was something I had written about the Dublin underworld, but I believe it was basically something to do with envy – envy of the poet.'

Nelson Algren, 'hypnotised by the nighttime water'

Owen Walsh survived an equally numbing experience at the same place. Unimpressed with Owen's treatment of his daughter, his father-in-law came looking for him, with a shotgun. The artist hid under the bridge for most of the night. Though Owen recovered to paint the waterway in safer times, he insisted: 'If Kavanagh had spent a night with shadows and rustlings and the constant dripping of water, he might have spared us all those bloody canal panegyrics.'

Nelson Algren was hypnotised by the nighttime water: 'To leave me adrift in those pepper mists that forever drift along the banks of the Grand Canal.' Sadly, the same mists shrouded many tragedies. Five died when a coach fell into Portobello Lock in 1861. Tom Casement, brother of Sir Roger, was another casualty, as was the wife of a local gallery owner. A well-known actor was found floating near Baggot Street Bridge just before Parsons closed. Liam O'Flaherty opposed John Ryan's Save the Canal cam-

paign, after his cleaning lady's son was drowned. Mespil Lock witnessed another double tragedy. One of the McCann family of travellers fell into the water after drinking too much. His younger brother jumped into the lock two nights later and also drowned. Two prostitutes were murdered near Huband Bridge in the 1980s.

Baggot Street Bridge was the scene of an escape which might have changed the course of Irish history. In the 1920s, the British army raided a house in Mespil Road, where Michael Collins was due to arrive. A servant ran up just as Collins crested the bridge on his bicycle. He wheeled left and sped along the canal to safety. Another cyclist who frightened the locals was legendary *Irish Times* editor, Bertie Smyllie, who daily wobbled over Baggot Street Bridge on his ancient Raleigh, clutching his sombrero and typewriter. Weighed down with later subversion, Peter Kavanagh cycled over the bridge on his way to distribute *Kavanagh's Weekly*.

A fitting memorial to poet Patrick Kavanagh

The canal will forever be associated with Patrick Kavanagh, who first walked its banks when he came to live with Peter in 1940. The waterway became his favourite refuge in a frequently hostile city. Here he savoured the tranquillity which reminded him of his own original damp Monaghan acres: 'Where I imaginatively stand now, looking across to Slieve Slieve Gullion and South Armagh.' Weakened by cancer, the canal banks became Patrick's recovery ward in 1955 and energised that final productive flaring of more joyous and less self-conscious poetry.

Patrick bequeathed what is perhaps the most famous tribute to the waterway, 'Lines Written on a Seat on the Grand Canal, Dublin'. The seat had been erected beside the Mespil Lock by artist Dermod O'Brien in memory of his wife. When not loafing on the slope to Baggot Street Bridge, it was the poet's favourite vantage point, where he could read, ponder and greet the home-going schoolchildren. Patrick's poem is engraved for posterity on the Kavanagh memorial bench, designed by Michael Farrell from John Ryan's sketch on a Bailey pub drip-mat.

> O commemorate me where there is water,
> Canal water preferably, so stilly
> Greeny at the heart of summer. Brother
> Commemorate me thus beautifully.
> Where by a lock Niagarously roars
> The falls for those who sit in the tremendous silence
> Of mid-July. No one will speak in prose
> Who finds his way to these Parnassian islands.

Chapter Ten

Parsons Bookshop

A wonderful institution, a haven of civilization in a barbarous little country. – John Banville

'I was reading *The Standard*, when I sensed there was someone looking into the shop,' May O'Flaherty recalled.

'The next minute, there was a musical clang. I looked up to see a man hit his bowler hat against one of the hanging buckets we kept for children who fished in the canal.

"Are you looking for somebody?" I enquired.

"I represent the Oxford University Press," he bowed, though whether out of politeness or fear of another accident I didn't know.

"Come in and have a cup of tea," I invited. I'd say that was the first time he'd ever had a cuppa in a shop!'

Parsons Bookshop was the Dublin equivalent of Sylvia Beach's Shakespeare and Company and Adrienne Monnier's La Maison des Amis des Livres, which provided a welcoming ambience for the intelligentsia of early twentieth century Paris. Straddling Baggot Street Bridge, Parsons defined the Bohemian quarter of Baggotonia from 1949 to 1989. It outlived its Parisian counterparts and became Ireland's most famous bookshop, attracting distinguished writers, artists and many of the country's leading academics, politicians and churchmen. Like the Paris shops, Parsons also boasted an all-female staff. Proprietor May O'Flaherty, manageress Mary King and three colleagues, Carmel Leahy, Mary O'Riordan and Patricia Ronan. Poet James Liddy wrote of May and Mary King: 'Some locals referred to them as Scylla and Charybdis, intimidating sirens perched by the waters of Baggot

Street Bridge. Their songs took the shillings out of your pockets for words on paper.'

When the Anglo-Irish left the Baggot Street area, there was no shortage of tenants for their divided Georgian mansions, from civil servants in the nearby government offices to students of the two city-centre universities, as well as actors, artists, poets and writers, who found the area congenial, with its pubs, restaurants and canal walks. A ready-made market for books. Antiquarian bookseller Stephen Stokes observed: 'Dubliners were noted for their interest in books. One of Walter Osborne's most arresting nineteenth century city studies shows a crowd around an O'Connell Bridge book barrow. An eighteenth century Dublin bookseller, Richard Crampton, did so well that he built Crampton Court off Dame Street and also became Lord Mayor of Dublin.'

James Joyce and Sylvia Beach in front of Shakespeare and Company

Bookshops and barrows proliferated along the quays until the 1950s. Here James Joyce bought and, more frequently, sold books. Browsers included Padraic Colum, James Stephens, Arthur Griffith and John O'Leary. In his essay, 'Bookcarts and Bookmen', Seamus O'Sullivan recorded Saturdays, the gala day of the bookcarts: 'College professors in their long black coats, book-seeking navvies with scarfed necks, shrill-voiced schoolboys and elegant women, all were there, eagerly intent, and as oblivious of each other as gold-seekers in the rush for some newly-found mine.'

But it was far from books and barrows that Parsons Bookshop originally started life. Father Aidan Lehane, nephew of May O'Flaherty who bought Parsons hardware store in 1948, explained: 'My aunt originally had absolutely no idea of opening a bookshop. After being made redundant in Leon's furriers, she just wanted to be her own boss and run her own business. She

fell for Parsons, which had been built in 1916. She liked its situation on the crest of the canal bridge, with its view out the door and the broad windows on the passing street life. She purchased the lease immediately.'

There was a fine irony in Father Lehane's assistance in the launch of what would become Dublin's most progressive bookshop. He subsequently succeeded John Charles McQuaid as president of Blackrock College. As Archbishop of Dublin, McQuaid encouraged the country's draconian censorship of books.

May – or Miss O'Flaherty, as she was always known to her customers – was quite happy with her *Irish Times* round and with selling hardware, stamp collections and nets for the children who fished in the canal. But, after a spring clean of her home, she left some books on a table outside the shop. They sold immediately. Regular newspaper customer Patrick Kavanagh suggested that there might be a market for literature and advised her to contact the Oxford University Press. The idea of selling books may have appealed to May's snobbier side; it was a decidedly more genteel business than hardware. But she had an early warning of how strange poets could be. While she and everyone else mourned the burning of the Abbey Theatre, Patrick celebrated: 'Now, we can make a new start!'

When the first rep from the Oxford University Press banged his bowler hat against the bucket, May thought that would be the end of her bookselling dreams. But, once he recovered from the shock of finding a hardware rather than a book shop, the salesman fell victim to May's enthusiasm and hospitality. He was also no doubt impressed by her trademark tweedy attire and her thoughtful way of speaking.

May recalled: 'He knew more about Irish literature than I did. I was thrilled when he told me that the person behind the very first Oxford English dictionary was a former Archbishop of Dublin, Richard Chevenix Trench. And that the Oxford University Press had based its title on that of a famous eighteenth century Irish publishing house, the Dublin University Press.'

Her enthusiasm roused, May ordered some dictionaries, *The Letters of Samuel Johnson* and titles by former Merrion Square resident L.S. Le Fanu, and Anthony Trollope, who had lived in Donnybrook. She conscripted Father Lehane to ferry further volumes from the quayside publishers, Burns Oates. Gradually, books and periodicals encroached on the window display of hardware and stamps. The shop's strategic situation at the confluence of flat-land Bohemia and the affluent Ballsbridge suburbs was a major advantage.

Former taoiseach Dr. Garret Fitzgerald remembered: 'There were few bookshops around when I first visited Parsons. My wife Joan and I lived in Eglinton Road nearby, and it was great not to have to go into town to buy a book.' Miss O'Flaherty would also source books which were otherwise unobtainable in Dublin.

The affordable Penguin paperbacks attracted many local university students. *Envoy* and other literary magazines drew Brendan Behan and canalside residents Thomas Kinsella, Mary Lavin, Frank O'Connor and Liam O'Flaherty. The writers' presence in turn consolidated the shop's reputation and attracted further customers. The Oxford University Press man returned one day in 1953. 'Where are the buckets?' he enquired.

May O'Flaherty's reputation and business grew. Parsons resounded to the sound of hammering and sawing, as workmen built extra shelves for larger quality books. Soon, her regular customers included Brian O'Nolan, Ben Kiely, James Plunkett, UCD president Dr. Michael Tierney and Archbishop George Simms.

Parsons' most consistent customer was Patrick Kavanagh, but he never read any of the books, only newspapers. May O'Flaherty recalled: 'He would stroll in each morning and perch himself on a little stool which he called his cow stool, even though it had four legs. He would go through the papers, maybe say something about the weather and then he was off again, usually across the road to Mrs. Murray, whose bet he would take to the bookies. Soon he was part of the furniture and if he ever missed a morning, customers would ask "Where's Patrick today?"'

Apart from Patrick, May O'Flaherty also sought advice from local academics, who vetted new publications and suggested saleable titles. Broadcaster David Hanly confirmed: 'I don't know whether May read any of the books – but perhaps she didn't need to, as she had her own panel of advisors. When my novel *In Guilt and in Glory* was published in 1979, she showed me part of her assessor's report, but she kept her hand over the signature, so I never discovered who it was!'

As well as selling books, Parsons began to appear in books. Including David's novel and *Balcony of Europe* by Aidan Higgins:

> The ghost of Teilhard de Chardin stalked along the Grand Canal and peered through the windows of Parsons Bookshop near Baggot Street bridge, saw the reflection of his own austere countenance superimposed on many volumes of his own works.

Title page of Kavanagh's Self Portrait, *inscribed to May O'Flaherty, 1963*

May O'Flaherty's knowledge of books did not match her business acumen; she once confessed that the *Catholic Messenger* was literature enough for her. But she found the perfect manageress when booklover Mary King arrived from Moyard, Connemara in 1954. The pair complemented each other perfectly. An easy mixer, the diminutive Mary's down to earth manner and engaging chuckle balanced May's natural aloofness. Mary read virtually every book which passed through Parsons over the next thirty five years. She also knew the characters in most of the Irish novels, no matter how well disguised. Happy in her work, she frequently quoted Longfellow:

> The love of learning, the sequestered nooks
> And all the sweet serenity of books.

Mary soon knew many of the country's leading authors, including Brendan Behan: 'Unlike Patrick, Brendan was a showman who loved an audience. He'd march into the shop, maybe say something funny or outrageous, then glance around to see how listeners reacted. When a customer whispered

about jailbird writers one day, Brendan turned around and advised her: "An honour I share with Cervantes, O. Henry, Voltaire and Wilde." He was exuberant but he could be very thoughtful and would chat about books, his knowledge of which was considerable, especially French authors. His inherited socialism gave him an international dimension and his Paris adventures kept him abreast of the latest movements. His understanding of modern literature put many academics to shame, he was the only one directly in the tradition of Joyce.'

Brendan's flair and spontaneity made him a favourite of journalists. Patrick Kavanagh resented the playright's rapid success and media-appeal. Mary King recalled: 'Patrick could be irascible and touchy at times, and would easily take offence. He could spot phoniness and pretension miles off. But behind the gruffness was a sensitive thoughtful individual with a great underlying vein of wisdom, spirituality and depth of vision. Above all, one sensed an honesty in the man that he could neither be bought nor flattered. And one didn't presume that much with Patrick, he was a proud man and conscious of his worth.'

May O'Flaherty harboured hopes of reconcoiling her two favourite customers. But even her legendary diplomacy failed: 'After seeing them avoid each other in the shop, I decided to leave them to do their own matchmaking!'

Parsons' wooden counter and floorboards remained unvarnished for its four decades. May O'Flaherty asked: 'Paint? What's the point of decorating the place, when books will only cover up the paintwork?' The shop was open weekdays from 8.30 until May locked its little iron security gate in the evening at 6.30. May stood by the cash till, under her portrait by Owen Walsh. To her right, ranged the shelves of Penguins and a display of literary and current affairs magazines. The wall behind the counter featured a watercolour by Pete Hogan of Patrick Kavanagh's home and a print of Pope John XXIII. A bottle of brandy gathered dust on a ledge beside the Pope. 'For emergencies, in case anyone falls ill in the shop,' May explained. With heating confined to a small electric fire and two storage radiators, Patricia Ronan suggested it might be better used in reviving the staff.

Mary King stood in the inner left-hand corner, behind a crude bookcase which was well scuffed by the boots of Brendan Behan, John Broderick, Ben Kiely and the many who shared her knowledge and literary gossip. The bookcase featured art and hardcover books, the Dolmen editions and more expensive volumes protected by cellophane covers. Between Mary and the door was a shelved pillar with outsize volumes. In the centre of the creaking floor, under

the shop's bare strip lights, a wooden stand featured additional paperbacks. Behind them were slanted hardcovered books and a shrine to Patrick Kavanagh, which featured his works and a photograph of the poet in his beret and bawneen sweater.

The opening of the tourist board's canalside headquarters attracted new customers, including Dr. Peter Harbison, Nelson Algren and poet Theodore Roethke. Fellow-poet John Berryman completed his decade's work on *The Dream Songs* while on a year's sabbatical from the University of Minnesota in 1967. Rarely out of a bar, one of his drinking companions was Ronnie Drew of the Dubliners. Despite his regard for Yeats, Mary King never warmed to Berryman who, ironically, complained of boring Irish drunks: 'The poor man was always drunk. I wasn't surprised later to hear that he committed suicide.'

The most unlikely customers were the Japanese. Mary King recalled: 'It was a revelation how interested they were in Irish literature and history. I particularly remember a lady professor who could write and speak Irish and to whom I later posted a couple of dozen copies of the Christian Brothers Irish Grammar. She brought her students to Ireland each year and they visited places of interest from Newgrange to Donegal. There were also Joycean scholars from Japan. Owen Walsh said they were probably the only ones who could make sense of *Finnegans Wake*!'

Interior of Parsons Bookshop, including the shrine to Patrck Kavanagh

Once again, the books were covered as May O'Flaherty reinforced the shelves to cater for the new demand for architectural books. 'One of the few books we had on architecture was Maurice Craig's very informative *Dublin, 1660-1860*, which always sold well since its publication in the 1950s. But suddenly there was a new demand, as many architects established their offices nearby, including Niall Montgomery, Michael Scott and Brendan Ellis, whose

designs changed the face of Dublin for better or worse.'

Brendan's son, Gerard, confirmed: 'Parsons played its part in the architectural revolution as at the time it was probably the leading purveyor of books on the subject. I would think every prominent Irish architect passed through its doors.'

Parsons' door always remained open, no matter the weather. 'Books are insulation in themselves,' May O'Flaherty explained to incredulous customers and her sometimes freezing staff. The open door tempted many passers-by, particularly locals marooned by family or social change. Two regulars were Sir Anthony Houghton and the heiress, Miss Brown. The minimalist Sir Anthony sometimes wore only a sack, while he sipped wine at the counter. Miss Brown was rarely out of her fur coat, even in summer. A favourite of the staff, she lived in a suite in a nearby hotel and never arrived without a treat for her hosts.

Maurice Craig's popular book on Dublin's architecture

May O'Flaherty's tea-fuelled hospitality delighted Laurie Lee and John Calder, publisher of Aidan Higgins' *Langrishe Go Down* and *Balcony of Europe*. Laurie insisted that the Irish were the most honest race in the world, after gardaí returned the wallet he had dropped while under the influence of cider. John Calder recalled fellow-publisher John Murray's 1775 visit, when a soldier returned the watch the Londoner had left in a house of ill-repute. No such levity marked the sojourn of American David Krause, hard at work on the letters of Sean O'Casey, whose artistic integrity he bravely defended to May O'Flaherty.

Mary King recalled: 'Like Sir Anthony Houghton, John Calder could discourse on all the modern authors, particularly Samuel Beckett, who was a close friend since the 1958 publication of *Malone Dies*. John had been a leading light in the Campaign for Nuclear Disarmament's programme of civil disobedience. He told us that, together with Bertrand Russell, he once shared Bow Street dock with no fewer than eight playwrights, including John Osborne and Rob-

ert Bolt. He was always in and out of the courts, defending banned authors. Miss O'Flaherty stocked some of his titles – luckily he did not offer her anything by Henry Miller and William Burroughs whom he also published!'

Baggotonia boasted its very own local publisher, Liam Miller, who founded the Dolmen Press around the time Parsons opened. John Calder admired Liam's original typography, which excited praise from the international publishing community. The Dolmen's success was followed by a proliferation of local houses from the 1960s onwards. Imprints like Gallery Press, Gill and Macmillan, Liffey Press, Lilliput, Mercier Press, Poolbeg, Raven Arts Press, Townhouse, Wolfhound, and Appletree and Blackstaff in Belfast. Launched in 1967, Jeremy Addis's monthly *Books Ireland* further boosted interest in books.

Liam Miller of the Dolmen Press, Baggotonia's publisher

May O'Flaherty always had a special welcome for Liam Miller. Hadn't he created the design for the new Roman Missal and met Pope John Paul himself in Rome? May attended Mass each morning in nearby Haddington Road church. Fellow-Catholic Mary King was less dogmatic. While May ensured the wholesomeness of the window display, Mary introduced the latest avant-garde works. Some observers felt that May tolerated these because she

neither read nor understood them; others suggested that she was a good business woman who knew what would sell. Either way, she still worried about her customers' spiritual welfare. Cartoonist Tom Matthews recalled that May countered the perceived immorality of *Ulysses* by enclosing a Catholic Truth Society pamphlet with a customer's copy. 'I do not approve of that man, Joyce,' she informed Merriman School founder, Con Howard.

Though she tolerated the frequently boorish Patrick Kavanagh, May O'Flaherty chided some of her customers and tried to influence their choice of literature. Despite Parsons stocking his first book on Dublin, printmaker and writer Brian Lalor felt her wrath when she reprimanded him for handling an expensive book with inky hands. May tried to divert biographer Peter Costello from his preferred Arthurian byeways. She regularly recommended books to acquaintances and passers-by. Insurance broker George McDonnell recalled that he could never pass her door without being invited in to see a new arrival. Despite her persuasive ways, John Banville described May's creation as: 'A wonderful institution, a haven of civilization in a barbarous little country.'

Nobel Prize winner Seamus Heaney also sensed a controlling spirit: 'Because of the decorum and general propriety of the ladies, not to mention a certain natural grandeur in Miss O'Flaherty, the shop felt a little bit like a domestic establishment. It was an emporium, of course, but it wasn't entirely a public house. Something told you that this was a slightly privileged zone. It reminded me of going into my aunt's home in Castledawson. You were welcome but you were there to behave yourself. And the books for sale gave the same sort of message: they weren't exactly neuter products, but bore the stamp of Kingly and Flahertish approval.'

Seamus Heaney: 'you were welcome but you were there to behave yourself'

Patrick Kavanagh remained May O'Flaherty's favourite; she frequently spoke of his spiritual presence. Not a sentiment shared by colleague Patricia

Ronan, who insisted when May's back was turned: 'God forgive me, but he was a rude ignorant bogman. He was always spitting – and you should see the way he searched the papers for racing tips, and then scattered the pages all around the place as he finished with them.'

Mary King retained a particular regard for George Bernard Shaw. She maintained that his writings had played a major role in Britain's social revolution and Ireland's slower development. Two other writers she admired were the emerging Clare Boylan and the equally stylish Julia O'Faolain, daughter of Sean O'Faolain. And the frequently unpredictable Liam O'Flaherty, who had known both Sylvia Beach and Ernest Hemingway in Paris: 'John Broderick, who had few equals as a critic, said that Liam was one of the first of the modern revolutionary novelists, men like Hemingway and Malraux, who wrote about their experiences of rebellion and their own development as artists through it. As passionate in real-life as he was in his writing, Liam was an all-action man like Hemingway. No sooner had the treaty been signed in 1922, than he caused consternation by leading a band of the unemployed into the Rotunda, over which he hoisted the Red Flag!'

Liam regularly visited the shop in the late fifties, buying the morning papers for their horse racing intelligence. When he took his custom elsewhere, May O'Flaherty surmised that he had become jealous of Brendan Behan, who shared his admiration for one of the shop ladies. Liam was not a man for literary cliques, however, Mary King once saw him sneak around a corner to avoid Francis Stuart and his wife. Wearing his trademark tweeds and hat, Liam cut a dash up to his death in 1984 at the age of 88.

Mary recalled: 'Heads would turn at his passing, for he remained a fine-looking man. Owen Walsh and he were great friends and I heard them once way down on the canal, arguing loudly – in Irish! We all got a big shock one day in the late seventies, when Liam marched into the shop. He had seen the window display of copies of *Famine*, which Wolfhound has just re-issued, and he offered to sign them for us. He was then in his eighties but, though he was a little deaf, he looked as if he was only about sixty.'

Parson's most unobtrusive customer was Brian O'Nolan, better known as Flann O'Brien or Myles na Gopaleen, from his *Irish Times* column. He would regularly hover in the shadow of the centre bookshelves. Staff would forget his presence until, doffing his hat, he left as silently as he had arrived. He spent most of his time browsing the *Oxford Dictionary* but, unlike Patrick Kavanagh, he occasionally bought a book.

Another Parsons regular, the 'unpredictable' Liam O'Flaherty, by his friend Harry Kernoff

Frank O'Connor was loved by all the Parsons staff. Mary King recalled: 'With his smart couture, white hair and warm manner, he breathed music into our tired bones whenever he called. I only once saw him stuck for words, the morning that Miss O'Flaherty asked Hugh Leonard what he thought of Frank O'Connor. "A wonderful writer but maybe a hard man to live with," Hugh replied, not seeing Frank behind him! Frank was one of the few not to acclaim Hugh's marvellous *Stephen D* adaptation of *Portrait of the Artist*. Unlike most of his contemporaries, Frank never warmed to Joyce's realism.'

Though more disciplined and abstemious, Frank's sense of humour and insatiable curiosity reminded Mary of Brendan Behan. Frank was as keen on the novels of Simenon and Dashiell Hammett as he was on more serious literature. A revolutionary of a previous generation and fearless in denouncing censorship, V.S. Pritchett described him as 'possessed of the savage indignant faith of Swift'. Unlike the reclusive Liam O'Flaherty, Frank welcomed guests to his pipesmoke-filled apartment including Thomas Flanagan, Niall Montgomery, James Plunkett and John Betjeman. Ironically for an agnostic, Frank's last lecture was given in the Catholic bastion of Maynooth College in February 1966. A fortnight later he died of a heart attack. Brendan Kennelly mourned his passing in 'Light Dying':

> Climbing the last steps to your house, I knew
> That I would find you in your chair,
> Watching the light die along the canal,
> Recalling the glad creators, all
> Who'd played a part in the miracle:
> A silver-haired remembering king, superb there
> In dying light, all ghosts being at your beck and call . . .

Brendan Kennelly was one of the new generation of Parsons' poets which included Paul Durcan, Richard Murphy and Seamus Heaney. Like Patrick Kavanagh, some used the shop as a *poste restante*. Parsons staff kept in touch with former customers such as James Liddy and Peter Kavanagh. When John Montague settled in Paris with Madeleine, Mary King regularly sent him books and newspapers. Mary sensed that the new writers were more industrious than their forebears. She noted: 'Like newly released donkeys rolling in an evening field, they were also gloriously free of the post-colonial inhibitions which had dogged earlier generations.'

James Plunkett was hailed for his novel *Strumpet City*, which was made into a successful television series. Another acclaimed Parsons' customer was future Nobel Prize winner Seamus Heaney. 'We got to know Seamus Heaney around the late sixties or early seventies. He was a warmhearted and friendly man and we were all delighted when he won the 1976 W.H. Smith Literary Award in London for his poetry selection, *North*. I always sensed a great depth of purpose and industry in him.'

Maeve Binchy also became a Parsons regular, with writers Adrian Kenny, David Marcus and biographers Charles Lysaght and Peter Costello. Peter's greatest day was

Frank O'Connor was much loved by the Parsons staff

when he was appointed librarian at Gonzaga College and sent with a cheque to Parsons to buy books. Many leading politicians regularly visited Parsons, from Taoisigh John A. Costello, Jack Lynch and Garret Fitzgerald to the reforming health minister, Dr. Noel Browne and Tanaiste Michael O'Leary. Academic regulars included Professors George O'Brien and Gus Martin, while visiting clergymen were Dean Swifts's successor, Archbishop Simms of St. Patrick's cathedral, and Archbishop Fisher of Canterbury, who was impressed when Patrick Kavanagh quoted passages from the bible.

Patrick's brother, Peter, was one of the shop's few contrary customers. Parsons was the first shop to stock both Peter's Abbey Theatre history and

Kavanagh's Weekly, but gratitude was not a Kavanagh characteristic. Mary King remembered: 'I always thought of him as a rather driven man. But he deserves great credit for his work over the years in writing those memoirs and publishing the correspondence which gives us a greater insight into Patrick, both as a man and poet. Sadly, Peter later turned against Miss O'Flaherty, after she declined to contribute to a fund to purchase his Kavanagh Archive. May rightly told Gus Martin "I gave Patrick money and helped him when he was alive and that's all that matters." Peter wasn't very happy with this. "That bitch," he wrote to a customer of ours!'

Mary King encountered an increasing number of scholars compiling theses on their former customers. She remembered John Ryan's insistence that 'such a singular body of characters would hardly ever rub shoulders again in Dublin'. But as the late eighties approached, the characters were becoming harder to find. Exiled Michael Mannion marched into Parsons one afternoon. Known as the Bard of Kensington and friend of Modigliani's companion, Nina Hamnett, Michael complained: 'I've been to every shebeen in Baggot Street and not a Behan or Kavanagh or scribe of any three-dimensional denomination in sight. I'm told the new generation composes at home – on computers. And they don't drink! There's no passion in a machine. Are we all becoming history?'

Anno domini inflicted its toll on Parsons' customers. Thomas MacGreevy died in 1967 and Cecil Salkeld in 1969, two years before composer Sean O'Riada. Patricia Lynch died in 1972, Elizabeth Bowen a year later and both Austin Clarke and Kate O'Brien in 1974. Inevitably, the arrival of computerisation and chain bookstores also spelt the end of the casual chaos of Parsons. Shortly before the shop closed in May 1989, Mary Lavin complimented May O'Flaherty on having stocked the city's most comprehensive range of books.

May, who also hung Jim Fitzpatrick's iconic 1968 Che Guevara poster, commented: 'It seemed a long way from our early hesitant start, when I'd arrange a window display with Father Lehane and secretly wonder if I was doing the right thing at all. But I was happy that I'd made the decision to stock only quality work and I suppose that policy helped to make Parsons a success.'

May had not anticipated her customers' input: 'They were unpaid directors, they suggested most of the books they would like to read and usually there was nothing better on the particular subject. You wouldn't have met such inspirational people in any other business. As architect Brendan Ellis

insisted, visitors to Parsons were friends as well as customers. In fact it was from Brendan that I purchased the little Volkswagen which served me so well for almost the life-span of the shop!'

Parsons closed on May 31, 1989. A week-long sale emptied the shelves, a bright patch illuminated the wall when May O'Flaherty removed her portrait by Owen Walsh. The staff were given a a surprise reception by regular customers including Beatrice Behan, Mary Lavin and her daughter, Caroline, Jeremy Addis, the Downes and Gaffney families, former Taoiseach Garrett Fitzgerald and artists Owen Walsh and Michael Carroll. Owen sketched the five ladies and columnist Michael O'Toole recorded the occasion for posterity. A local author read a farewell letter from Lord Mayor Ben Briscoe. Architect Peter Stevens lamented: 'Parsons has been so much part of the local landscape that it is difficult to imagine life without it. I can no more think of Baggot Street without the shop than I can see it without the bridge.'

The shop was May O'Flaherty's life; she worked there every day including Saturday. She survived its closure by only two years, dying in 1991 at the age of 86. She was buried in Glasnevin cemetery, close to former customers Brendan and Beatrice Behan, Maura Laverty and Patricia Lynch. Mary King

May O'Flaherty (left) and staff on Parsons' last day

passed away aged 83 in 1995 and was buried in her local Ballinakill, Connemara cemetery. The lady who loved literary gossip could not have chosen a more convivial final resting place, only yards away from arch-entertainer, Oliver St. John Gogarty.

Poet James Liddy wrote: 'I miss these goddesses, one who loved writers, one who loved poets. I felt May was a prelate to whom one paid respects while Miss King was a priest to whom one went for gentle confession. The loss of Parsons signalled the shut down of Dublin as a literary city.'

Parsons Bookshop, by Pete Hogan

Chapter Eleven

BRIAN OF THE MANY MASKS

A real writer with the true comic spirit. – James Joyce

'WHO'S THAT MAN IN THE SUIT WHO consults the *Oxford Dictionary* as large as himself and then disappears with a nod of his hat?' May O'Flaherty often asked Patricia Ronan.

Parsons' proprietor finally got her answer. Brendan Behan arrived one morning with the mysterious man in tow. After browsing through the books, the pair headed across to Mooney's.

Brendan slipped back. 'Do you know who that fella was?' he asked May.

'Well, I was going to ask you the very same question!' she admitted.

'That was Myles na Gopaleen,' he confided.

'Myles of the *Irish Times*? Never, he looks so insignificant,' May replied.

'That's the whole point!' Brendan laughed.

'What's he like?' May enquired.

'There you have me,' Brendan headed back to Mooney's.

Trinity College is rightly proud of Swift, Goldsmith, Wilde and Beckett. And that it was its 1765 degree which conferred Samuel Johnson with the prefix Doctor by which posterity knows him. But it was University College Dublin which produced the master of twentieth century Modernism, James Joyce (an achievement it studiously ignored for decades). And fellow-author Brian O'Nolan, the parodist and punster whom the master himself pronounced 'a real writer with the true comic spirit', after reading *At-Swim-Two-Birds* in 1939. O'Nolan's first fiction attempt written in Irish owed much to Joyce's wordplay. An early admirer of Joyce, he also interviewed the writer's father, John Stanislaus, shortly before the latter's

Patrick Kavanagh and Anthony Cronin conclude the first-ever Bloomsday pilgrimage outside Davy Byrne's, June 16, 1954

death in 1931. It was entirely appropriate that Brian, alias Flann O'Brien, alias Myles na Gopaleen, should co-organise the first-ever Irish celebration of Bloomsday, a title coined by publisher Sylvia Beach for the day on which *Ulysses* was set.

John Ryan hired two weather-beaten broughams on June 16, 1954, with the intention of retracing the route of Paddy Dignam's funeral. He and Brian O'Nolan were accompanied by Patrick Kavanagh, the lecturer and critic Con Leventhal, dentist Tom Joyce and the young writer and poet, Anthony Cronin. John recalled: 'Our plan was to traverse most of the places mentioned in *Ulysses*, from Sandymount Strand to Glasnevin cemetery, the National Library, Holles Street maternity hospital, Barney Kiernan's pub and, of course, Nighttown. And in memory of Joyce's colourful father, John, to toast the four corners of the metropolis from the top of Nelson's Pillar with Cork whiskey.'

Brian and John had been early Joyceans and had collaborated on a special James Joyce edition of *Envoy*. *Ulysses* had come to John as happily as to Patrick Kavanagh: 'clean and unencumbered, with no layers of pseudo-scholarship to contend with. My conversion to Joyce took place at the age of 17, when I was bedridden with bronchitis. It was like starting my education all over again. I had discovered a rich and inexhaustible lode.'

Patrick Kavanagh immortalised their maiden Joycean celebration:

> I made the pilgrimage
> In the Bloomsday swelter
> From the Martello Tower
> To the cabby's shelter.

It soon became apparent that Brian O'Nolan had beaten everyone to an early-morning Bloomsday toast. He argued with Kavanagh, and then attempted to dislodge him from architect Michael Scott's garden wall, while he was trying to access the Martello Tower where *Ulysses* commenced. Scott's timely stirrup-cup restored peace. Brian's china-blue eyes receded; his normal waxy pallor returned. 'Oft in the Stilly Night'. Anthony Cronin and the dentist diverted the company with favourite Joyce songs, and they reached Blackrock in good order.

The landlord of the pub outside which they stopped assumed from Brian's sombre appearance and black Homburg that he and his cronies were coming from a funeral in nearby Deansgrange. As the landlord shook his hand, Brian explained that they were remembering a writer friend who had died. 'What's his name, maybe I know him?'

'James Joyce,' replied Brian.

'Not little Jimmy the signwriter from Newtown Park Avenue? Sure, wasn't he sitting where you are now only last Wednesday,' the landlord lamented.

The next stop was at Sandymount strand, where the merry mourners crunched shells in the footsteps of young Stephen Dedalus. An unscheduled halt was made at a betting shop, where the otherwise informed Joyceans missed the chance of replicating Leopold Bloom's Ascot Gold Cup success. John Ryan reflected: 'Throw-away had won the original Bloomsday cup at forty to one. But we failed to notice Elpenor, named after a friend of Ulysses, which ran away with the race – at fifty to one!'

To add insult to injury, Homer's Elpenor was paralleled in Joyce's book by Paddy Dignam. When Anthony Cronin explained this to Kavanagh, the poet accused him of withholding information.

Celebrating Bloomsday, June 16, 1954, on Sandymount Strand. Left to right: John Ryan, Anthony Cronin, Brian O'Nolan, Patrick Kavanagh, and Tom Joyce, a cousin of James Joyce

Their own horses' slow pace and the discomfort of the antedeluvian carriages necessitated further refreshment and comfort stops. It was afternoon before the Bloomsday pathfinders hove to in Duke Street, between the twin Joycean landmarks of Davy Byrne's and the Bailey. They cancelled the rest of the trip and adjourned to the back bar in Davy Byrne's. A sepia photograph showed Patrick Kavanagh engrossed in *Ulysses*, while Brian O'Nolan guffaws at a joke by Anthony Cronin.

But while acclaimed as Ireland's greatest comic genius, the reality of Brian O'Nolan's personal and professional life was less cheering. Disappointment flourished beneath the mask. Like artist Sean O'Sullivan, Brian drank to overcome his innate shyness. Though he probably lacked the temperament, had he wanted to, he could never flee to pursue his art as Joyce had done. His father's premature death meant that he had to stick to his civil service work to support his siblings. Like many, he felt he did not fulfil his promise. Reflecting on how most commentators had missed Joyce's essential humour, Brian's summary of the writer could equally be applied to

himself. Describing humour as the handmaiden of sorrow and fear, he wrote of Joyce: 'With laughs he palliates the sense of doom that is the heritage of the Irish Catholic. True humour needs this background urgency; Rabelais is funny, but his stuff cloys. His stuff lacks tragedy.'

Of the trio of Behan, Kavanagh and himself, Brian was the only one who had been to university. Conversely, he was also the only one of them not to have seen the inside of a primary school. Born in George Sigerson's Strabane on October 5, 1911, the third eldest of twelve children, Brian was educated at home. He first spoke and wrote in Irish, in which his parents were fluent. His father, Michael Nolan, was a civil servant who introduced his children to books and chess. A disciplined and pedantic figure with literary pretensions, Michael impressed a UK publisher with a detective story. One of Michael's brothers was a playwright, another was professor of Irish at Maynooth College. The latter taught his nephew match puzzles and card tricks which Brian would regularly play in later life. Brian's more relaxed mother, Agnes, came from a musical family. One of her brothers was a journalist, another an accomplished violinist and composer.

Government transfers resulted in various migrations until the family moved south to Tullamore in 1920. Five years later, they settled in Dublin at 25 Herbert Place, beside the Grand Canal and the landmark Peppercannister church. Brian had by now read most of his father's collection of books by Charles Dickens, Daniel Defoe, James Clarence Mangan and George A. Birmingham. The big city brought the additional excitement of the stage. The Nolans were regular theatregoers and Brian was introduced to the Abbey, the Gaiety and the Theatre Royal, where he saw John McCormack and the pianist Jan Paderewski. Plays and performances were discussed in their home, whose centrepiece was an overused gramaphone. The children staged dramas in a top floor room, where Brian developed photographs in a makeshift darkroom. He also practised the violin, which he had first learnt to play in Strabane. The visits of his lively journalist uncle George led him to compile a 'newspaper', which he called *The Observer* and illustrated with his own drawings.

But the Big Smoke also introduced Brian and his brothers to the discipline of school, and what he perceived as the nightmare cramming institution of the Synge Street Christian Brothers. The un-Christian punishment routine was a shock after his more carefree home tutoring. Brian's only escape was physics and chemistry. His unhappy school experiences and the covering up of clerical excesses coloured his subsequent attitude to authority. Though it

was unfashionable to criticise the religious orders, he later wrote: 'I remember a loutish teacher announcing that since it was only six weeks to the Inter Cert exam he was about to start a reign of terror. "I'll make ye dence," he said, with unintended pronunciational ambiguity. I would not be bothered today to denounce such people as sadists, brutes, psychotics. I would simply dub them criminal and would expect to see them jailed.'

Brian was fond of cycling and rode with his brothers to the Donegal Gaeltacht, an experience he put to good use in a subsequent book. He was happier at Blackrock College, where he concocted a series of letters from parents concerned about the pressure of school homework. Published in the Catholic *Standard*, these were the first of many such diversions. The move to University College Dublin in October 1929 provided increased scope for his satirical proclivities. An enthusiastic member of the Literary and Historical Society, Brian achieved notoriety for the eloquence of his humorous sideline interjections. These gained him the society's Impromptu Medal and marked the start of his lifelong role as an observer and debunker. UCD and nearby Grogan's of Leeson Street initiated an equally sacrosanct association with drink. After prayer, alcohol was the second most widely accepted means of sublimating the libido in those sex-starved days.

Among Brian's university friends were the budding poet Charles Donnelly, who died in the Spanish Civil War, Donagh MacDonagh, son of an executed 1916 leader, and future architect Niall Montgomery, who lent Brian his precious copy of *Ulysses*. Many students were disillusioned by the contrast between the original splendid ideals and the grubby mediocrity which had emerged from the fight for Irish independence. Joyce added the ingredient of church criticism to the prevailing cynicism. Brian's faith in public affairs was further dented when, despite his popularity, he ran a poor second to Taoiseach de Valera's son, Vivion, in the Literary and Historical Society's 1933 auditorship election.

Brian soon found compensation in the students' *Comhthrom Feinne* paper, in which he wrote over the first of many literary aliases: Brother Barnabbus, statesman, and international financier. One suggestion was the one-sentence All-Purpose Opening Speech. This could be translated and used all over the world by the most uneducated ignoramus for any occasion from a foundation-stone laying to a Presidential inauguration: 'Unaccustomed as I am to public speaking, and reluctant as I am to parade my inability before such a critical and distinguished gathering, comprising – need I say – all that is best in the social, political, and intellectual life of our country, a coun-

try may I add, which has played no inconsiderable part in the furtherance of learning and culture, not to mention of religion, throughout all the lands of the known globe, where, although the principles inculcated in that learning and that culture have now become temporarily obfuscated in the pursuit of values as meretricious in seeming as they must prove inadequate in realisation, nevertheless, having regard to the ethical and moral implications of the contemporary situation ...'

It was in a *Comhthrom Feinne* story entitled 'Scenes in a Novel' that Brian first hinted at the work which would become *At-Swim-Two-Birds*: 'The book is seething with conspiracy and there have been at least two whispered consultations between all the characters, including two who have not yet been officially created. . . . Candidly, reader, I fear my number's up.'

Brian O'Nolan, aka Myles na Gopaleen, aka Flann O'Brien

While completing his MA studies, Brian became editor of a shortlived satirical magazine, whose masthead proclaimed:

> *Blather* has no principles, no honour, no shame. Our objects are the fostering of graft and corruption in public life, the furtherance of cant and hypocrisy, the encouragement of humbug and hysteria, the glorification of greed and gombeenism.

But though Brian wrote every day, duty took precedence. The 24-year-old graduate followed his father into the Civil Service in July 1935. His surrender to office routine was copper-fastened two years later when his father died suddenly. Brian became the sole breadwinner for a large family. He assumed even further responsibility when he was appointed Private Secretary to the Minister for Local Government.

Despite his family commitments, Brian continued to overwork his primitive Underwood on a table he made himself from discarded garden trellis. He gave his erudition full rein in *At-Swim-Two-Birds*, which Longman published in March 1939. Synthesising themes and styles, it was a discursive romp which Graham Greene compared to *Tristram Shandy* and *Ulysses*: 'On all these, the author imposes the unity of his own humorous vigour, and the technique he employs is as efficient as it is original.' A subversive novel within a novel, the book's characters get revenge by wresting command of the story from its author, despite his attempts to control them:

> 'I was talking to a friend of yours last night,' I said drily. 'I mean Mr Trellis. He has bought a ream of ruled foolscap and is starting on his story. He is compelling all his characters to live with him in the Red Swan Hotel so that he can keep an eye on them and see that there is no boozing.'
>
> 'I see,' said Brinsley.
>
> 'Most of them are characters used in other books, chiefly the works of another great writer called Tracy. There is a cowboy in Room 13 and Mr McCool, a hero of old Ireland, is on the floor above. The cellar is full of leprechauns.'

Samuel Beckett presented James Joyce with a copy of the book, which it took the almost-blind writer a week to read with his magnifying glass. Brian had complained that commentators on *Ulysses* had failed to recognise its humour. Joyce in turn praised the wit and writing of Brian's first offering. Before war intervened, he also used his influence to have the book reviewed in French journals. John Ryan lamented that Joyce and the new Irish author never encountered each other: 'Had they met we might have got something a great deal more mordant and witty than, say, the disastrous meeting of Joyce and Proust.'

The two experimenters, Joyce and Beckett, fled the Irish nets of language, nationality and religion, and the siren spell of the equally debilitating Dublin pubs. Many wonder what Brian O'Nolan would have accomplished had he also flown, but he never exhibited the ascetic duo's artistic zeal. His family responsibility and love of order were also sturdy brakes. He possibly paid a higher price than Beckett or Joyce as he settled for the security of home and accommodated with decreasing dexterity that which he did not wholly believe.

World War Two commenced shortly after the publication of *At-Swim-Two-Birds*. While Joyce used his influence to assist Jewish friends to escape the Nazis, the war was an untimely diversion which distracted from his long-gestating *Finnegans Wake*. It had equally serious consequences for Brian O'Nolan. It robbed him of the momentum generated by a brilliant debut book. As if that was not enough, German incendiaries destroyed London's Paternoster Row publishing quarter and consumed the entire stock of his book.

Early in 1939, Brian and Niall Sheridan used the pages of the *Irish Times* to conduct a correspondence in which they satirised the writings of Frank O'Connor and Sean O'Faolain. Brian repeated the exercise a year later, ostensibly commenting on a review under the heading 'Spraying the Potatoes' by Patrick Kavanagh:

> I am no judge of poetry – the only poem I ever wrote was produced when I was body and soul in the gilded harness of Dame Laudanum – but I think Mr. Kavanagh is on the right track here. Perhaps the *Irish Times*, timeless champion of our peasantry, will oblige us with a series in this strain covering such rural complexities as inflamed goat-udders, warble-pocked shorthorns, contagious abortion, non-ovoid oviducts and nervous disorders among the gentlemen who pay the rent.

Unlike its two main politically aligned rivals, the *Irish Times* was an enlightened and lively newspaper with an influence out of proportion to its smaller circulation. Readers were regaled for weeks by the correspondence which finally led editor Bertie Smyllie to seek out its main author. He invited 29-year-old Brian to write a regular column in similar vein for the *Irish Times*. This was the start of the column enititled *Cruiskeen Lawn*, Irish for the 'little brimming jug'. As Brian was a civil servant, he was not supposed to publish anything without permission. The column first appeared on October 4 in Irish over the byline *An Broc*, 'the badger'. For all subsequent columns Brian used yet another pen-name, Myles na Gopaleen, after a rogue in a Dion Boucicault play.

Brian liked the city's more down-to-earth pubs such as Mulligans of Poolbeg Street and Sinnott's marble-countered hideaway in South King Street. And the Scotch House on the quays, where Joyce had supped and which featured in *Dubliners*. Here, in what he referred to as his office, Brian polished his Dublin accent and met unselfconscious city characters and pub

philosophers for whom surnames and background were immaterial. *Irish Times* readers were soon acquainted with a host of diverting personalities, ranging from 'the brother' and 'the Da' to 'the Plain People of Ireland'. They also enjoyed the absurd inventions of Brian's 'Research Bureau', many illustrated by doctored engravings from an old encyclopedia he had purchased on the quays.

Mirroring the *Daily Express*'s Beachcomber column, Brian's targets included politicians, bureaucracy and various national absurdities. For a prodigious reader whose authors ranged from Joyce to Hemingway and Kafka, books also inevitably featured. One column was devoted to a service he would provide for affluent collectors who bought books for display purposes. This would save them valuable time when building up their library. The volumes would be marked by special handlers, to show that they had been read. For an extra fee, a 'Master-Handler' would underline selected passages or insert an appropriate commentary, or even an inscription from the author. The business of limited edition books was also scrutinised: 'I beg to announce respectfully my coming volume of verse entitled *Scorn for Taurus*. We have decided to do it in eight point Caslon on turkey-shutter paper with covers in purple corduroy. When the type has been set up, it will be instantly destroyed and NO COPY WHATEVER WILL BE PRINTED.'

Brian's column became the first port of call for *Irish Times* readers. It alleviated the pall of censorship and war, and brightened the lives of a whole generation. John Ryan remembered that, even when under the influence, Brian could dictate word-perfect columns, without notes or revision. He concluded that Brian's writings did as much as Joyce's to preserve their city: 'The Dubliner of the post-natal Free State and the subsequent Éire, as indeed the entire ethos of the Plain People of Ireland during the first heady morning of Nationhood, their manners and mores, vices and virtues, the incredible posturings and grotesque "patriotic" antics of the founding fathers, the proliferating tangle of bureaucracy that envelops the nouveau-Irish, are by him recorded as lovingly and faithfully as Joyce, a half century earlier, recalled his own post-Parnellite, Edwardian Dublin.'

For over a quarter of a century, Brian coped with the demands of an almost daily column for the *Irish Times*, time and creativity which might have been better invested in more serious writing. He translated a medieval Irish poem in which the original scribe's complaint could well have been his own:

> My hand has a pain from writing,
> Not steady the sharp tool of my craft,
> Its slender beak spews bright ink –
> A beetle-dark shining draught . . .
> My little dribbly pen stretches
> Across the great white paper plain.
> Insatiable for splendid riches –
> That is why my hand has pain!

The outbreak of war diluted the impact of *At-Swim-Two-Birds*, and Brian's confidence suffered further when he was unable to find a publisher for his next book, *The Third Policeman*. Rather than admit this, he told friends that he had lost the manuscript, possibly on a tram. He advised one acquaintance that wind had whipped the pages out of the car boot while on holiday in Donegal. The rejection of a book, whose subsequent publication enhanced his status, induced an unnecessary and persistent self-doubt.

But in 1941 Brian was in print again with *An Beal Bocht*, an Irish-language parody of the fashionable Gaelic autobiographies, and a riposte to the staid patriots who had robbed the language of its original colour and earthiness. The book's hero is Bonaparte O'Coonassa:

> I cannot truly remember either the day I was born or the first six months I spent here in the world. Doubtless, however, I was alive at that time although I have no memory of it, because I should not exist now if I were not then and to the human being, as well as to every other living creature, sense comes gradually.

Mirroring an earlier namesake, Brian Merriman, Brian's wit and lively intelligence infused the Irish language with long-lost gaiety and vitality. Much to the chagrin of the traditionalists, whom a contemporary described as: 'Old pedants, obsessed with the fear of sex and beauty, and clad in crumpled navy suits festooned with nasty little emblems and watch chains with hurling medals, and spitting words uncouthly through neglected teeth.'

Sean O'Casey and most critics were delighted with *An Beal Bocht*. But, as with Brendan Behan, the value of Brian's Gaelic work and his translations of early Irish poets were never fully appreciated. *The Poor Mouth* translation, illustrated by Ralph Steadman, delighted a later audience, despite losing in translation. According to Anthony Cronin, *An Beal Bocht* remained Brian's favourite early book. But it was more than a satire on the

Flann O'Brien, by Harry Kernoff

Gaelic literary tradition. Comparing the book's view of the human condition to that of Beckett's, Cronin described it as 'an unrelentingly bleak view of human existence which is also a comic triumph'.

While commentators lamented that Brian O'Nolan did not bequeath a larger body of work, the miracle may be that he accomplished so much. Brendan Behan and Patrick Kavanagh could devote all their time to writing. Brian had to polish his shoes and don his suit, waistcoat, tie and hat each morning, and endure a day's office boredom, before he could pen a creative word. That is if one excepts the additional task of speech-writing for his ministerial bosses. Nevertheless, he wrote a sketch, *Thirst*, for the Gate Theatre's 1942 Christmas Show. The following year, the Abbey staged his *Faustus Kelly* play about a councillor who sold his soul to the devil in return for election to the Dáil.

Something more dramatic encroached on Brian's life in April 1943. A conflagration in a Cavan orphanage run by a religious order reduced thirty-six young girls to charcoal. Brian was appointed secretary to the investigating tribunal. Why were the doors locked? Why did all the nuns escape but not one child? Was it true that the nuns had not wanted firemen to see the girls in their nightclothes? As secretary, Brian had to sit through harrowing repeat accounts of the fire. The bland conclusions of the tribunal which attributed no blame were to be expected; there could be no criticism of a religious order in those days or of the local bishop's fatuous reaction: 'Dear little angels, now before God in Heaven, they were taken away before the gold of their innocence had been tarnished by the soil of the world.' Brian saw church and officialdom's indifference, pettiness and hypocrisy at uncomfortably close quarters. He later composed a limerick with his friend, T.F. O'Higgins:

> In Cavan there was a great fire
> Joe McCarthy came down to inquire,
> If the nuns were to blame,
> It would be a shame,
> So it had to be caused by a wire.

The Cavan experience endorsed Brian's innate scepticism, and the 1939-1945 war reinforced his pessimistic view of human nature. He devoted three successive columns to the bombs which destroyed Nagasaki and Hiroshima. Des MacNamara recalled: 'He would refer to the Manichaean belief that the encounter between God and the rebel Lucifer had, despite all we were told, in fact gone the other way!'

Apart from a possible initiation on a pre-war trip to Germany, sex never featured in Brian's life or work. Many were surprised when he married his civil service friend, Evelyn McDonnell, in 1948. Evelyn's mothering postponed his drinking's inevitable reckoning day. The *Irish Times* had the good sense to reject Brian's story 'The Martyr's Crown', which *Envoy* later published. This featured a woman of exemplary piety, Mrs Clougherty, who sheltered men on the run in the 1920s. One afternoon came the dreaded rumble of lorries and the knock on the door, the Black and Tans. In a flash of inspired and unselfish patriotism, Mrs Clougherty decided to give her all for the cause. The sheltering men saw her enter a room with the officer in charge. A short time later the couple emerged, the lorries left, the men were safe. Nine months afterwards, she gave birth to a healthy son.

> And he, of course, was that collector's item, not just one of your countless numbers who had merely died for Ireland but one who had actually been born for Mother Eirinn! No medals for it – but what a distinction!

Brian's criticism of public figures and institutions was fuelled by the strong sense of propriety which also dictated his attitude to language and vocabulary. Inevitably, government politicians tired of his public rebukes. His permanent pensionable job came to the end that many had long predicted. A new government minister, who lacked the literacy and easy-going nature of his predecessors, encouraged Brian's 1953 retirement on a derisory pension of £5 per week. It was perhaps only a coincidence that the minister hailed from Cavan, scene of the 1943 fire. A few years later, Brian himself entered the public arena when he stood for the Senate elections. Unable to canvas or use his *Irish Times* column, he received few votes. His attacks on the politicians went up a gear.

Though he felt overshadowed by 'James Aquinas Joyce', Brian never lost his regard for the writer whom he mentioned in over 100 columns. John Ryan invited him to edit the special Joyce edition of *Envoy* in 1951. Three years later, the pair decided on the pilgrimage to mark the fiftieth anniversary of

Bloomsday, the first time that Joyce had been commemorated in the city he had immortalised. Describing Brian as a prodigy, John Ryan wrote: 'His erudition was frightening and indeed many were frightened by it. His knowledge of languages and the complexities of semantics was as deep and widespread as James Joyce's. Indeed, the existence of Myles explodes any theory that Joyce's appearance on the Irish literary scene was a unique event, never to be in any way repeated.'

Typically, Brian would later tire of the burgeoning Joyce industry. In a subsequent column, he referred to 'the 4,000 strong corps of American simpletons now in Dublin doing a thesis on James Joyce'. But he himself became the subject of American interest after Pantheon Books reissued *At-Swim-Two-Birds* in New York in 1950. Scholars and interviewers sought him out, his international reputation grew. Making a pensive appearance in Alan Reeves' Palace Bar *Dublin Culture* cartoon, he was also painted by Sean O'Sullivan and Harry Kernoff. His confidence on the rise, Brian finally resurrected the manuscript of *The Third Policeman* and asked fellow-writer Mervyn Wall for his opinion.

With John Jordan and Harry Kernoff, Brian was one of the few who combined close friendships with the warring Brendan Behan and Patrick Kavanagh. The latter, who was not given to compliments, once described him as incomparable, 'the only true sophisticate in the whole bloody country'. Paddy O'Brien regularly served the pair of them in McDaid's: 'Brian would arrive at the same time every day, half past one, dressed in the same coat and hat you see in all the photos. When the ball of malt was set in front of him he'd turn to Kavanagh at the end of the counter and ask – "Are you buying me that?" Kavanagh would give him dirty look and Myles would remark, "You mane Monaghan bastard." Then Kavanagh would pretend to get very upset and in his deep Monaghan voice he'd reply "Be God, if you don't shut up I'll take the head off you one day!"'

Brendan Behan was not the only Dublin scribe to write a thriller. Brian claimed to have written Sexton Blake detective books under yet another pen name, Stephen Blakesley. Brian and the younger Brendan became friends in the early 1950s. It seemed an unlikely friendship, the anarchic exhibitionist jailbird and the fastidiously private graduate with an ingrained sense of order. But, as well as sharing a comic spirit, each spoke Irish and had written in the language. And while *At-Swim-Two-Birds* might be light years from *The Quare Fellow*, each of the chronic self-doubters was a columnist who thrived on an audience. They also shared an interest in drinking. The difference was

that Brendan lacked the discipline of his elder who would conscientiously write even when under the influence. Brian observed after Brendan's death: 'You're in danger all the time not only from death but also from boredom. Brendan Behan made the choice.'

Brian's drinking made serious inroads on his health. Shy and pointedly courteous when sober, he was frequently rancourous and truculent when under the influence. He gave short shrift to an English journalist who 'arrived with drink in him but not on him'. A vindictive streak sometimes mitigated the humour of his column. As his hat was pushed steadily backwards, he was capable of withering abuse, which was at odds with his suited civil servant appearance. 'Unhand me, you turnip-snaggers,' he reproached two students who picked him and his hat up after a fall in Baggot Street. A friend recalled: 'He was often bad tempered and inclined to lecture people in a kind of sing-song voice.'

While illness and disputes interrupted his demanding *Irish Times* column, Brian also wrote for provincial newspapers. In the *Southern Star*, he explained his allegiance to his high-crowned trademark accessory: 'My hat is disgracefully aged. Its useful life is long since over. It is stained. It is no exaggeration to say that it is frumpy, but its many years of faithful service have turned it into part of me. To a large extent, I have become myself simply something that fits in under the hat.'

The republication of *At-Swim-Two-Birds* by MacGibbon and Kee in 1960 introduced Brian to a new generation of readers. Richard Boston described it in *The Guardian*: 'A book of ever-growing reputation which makes him a third musketeer along with Sterne and Joyce, wreaking havoc on the conventional idea of what is a novel in a way that Laurel and Hardy could hilariously demolish a respectable middle-class house.'

Greatly encouraged, Brian shed his diffidence and set to work on *The Hard Life*, which was published in 1961. It detailed the lives of two orphans growing up in the whiskey-reeking home of a Mr Collopy, who is engaged on mysterious humanitarian work for women. *The Dalkey Archive* followed

Flann O'Brien's reissued classic

three years later. Its equally fantastic characters included St. Augustine and an elderly James Joyce, now employed as a barman in Skerries and dismissive of his literary work. Also a mad scientist, de Selby, who atempts to suck all the oxygen out of the world using an instrument he calls the DMP.

By a touch of Mylesian irony, the originally rejected *The Third Policeman* became Brian's most widely read book. A murder thriller and a comic satire about an archetypal village police force, it featured a surrealistic vision of eternity and a brief unrequited love affair between a man and his bicycle. And the much-quoted theory of the exchange of molecules between human and velocipede:

> The gross and net result of it is that people who spend most of their natural lives riding iron bicycles over rocky roasdsteads of this parish get their personalities mixed up with the personalities of their bicycles as a result of the interchanging of the atoms of each of them and you would be surprised at the number of people in these parts who are nearly half people and half bicycle.

The book's eccentric philosopher no doubt echoed his author's view of life:

> De Selby likens the position of a human on the earth to that of a man on a tightwire who must continue along the wire or perish, being, however, free in all other respects. Movement in this restricted orbit results in the permanent hallucination known conventionally as 'life' with its innumerable concomitant limitations, afflictions and anomalies.

Ireland's new RTÉ national television station broadcast two of Brian's plays in 1962, when he temporarily ceased his *Irish Times* work. Though hospitalisations with a broken leg, uraemia and pleurisy interrupted his writing, he also penned a successful series of television sketches for his Neary's drinking companion, Jimmy O'Dea. The shock death of another friend, Sean O'Sullivan, led Brian to attempt a cure for his alcoholism in St Brendan's Hospital, where Sean had also sojourned. But his absence from the pubs was short-lived; he renewed his steady drinking while he attempted a new novel, *Slattery's Sago Saga*.

The man behind the 1960 reissue of *At-Swim-Two-Birds* was Timothy O'Keeffe. He had unsuccessfully tried to interest another publisher a de-

cade previously. How much would Brian have written in his latter years had O'Keeffe succeeded then; would the exercise and stimulation of new work have curtailed his drinking? One of Brian's final nights of fame was the premiere of Hugh Leonard's dramatisation of *The Dalkey Archive* at the Abbey Theatre in September 1965. Brian's stage speech was cheered by the full house. *The Saints Go Marching In* was a sell-out for almost two months. Like Patrick Kavanagh in his final days, Brian was now a national figure and his poem 'The Workman's Friend' had become the country's drinking anthem:

> When money's tight and is hard to get
> And your horse has also ran,
> When all you have is a heap of debt
> A pint of plain is your only man.

A contemporary recalled: 'In the mid-sixties, there was a sense that Dublin was changing. The Theatre Royal had already been demolished when, in January 1965, Jimmy O'Dea died, shortly after reducing the Gaiety audience to tears with his final bow: "Farewell, my friends. I'll see you all one day in Glocamara." Simultaneously, Brian, his drinking friend, was diagnosed with cancer. No more Myles na Gopaleen in the *Irish Times*, we couldn't believe it.'

Brian was admitted to hospital with cancer of the pharynx in March 1966, the result of smoking for most of his 54 years. In the *Manchester Guardian*, he surmised that his illness was St. Augustine's revenge for being mocked in *The Dalkey Archive*: 'I have not been in my health since I wrote that book or thought of writing it. I thank only Augustine.' He celebrated in a letter to May O'Flaherty that he had finally convinced his nurses: 'I was not the gobdaw they took me for but a writer of international standing, nearly as famous as the Beatles!'

Brian's cancer spread rapidly. He died on April 1. Friends who heard the news assumed that it was a joke. 'Very funny. Brian's dead – and today is April Fool's Day! How is he really?'

The writer had frequently denigrated the Joyce gravy train. He was not long dead himself before Flann O'Brien mania gathered steam. Fellow-author Tony Gray observed: 'If he were still around, I have no doubt in the world what the prime target of his devastating scorn would be: the Flann O'Brien spin-off industry and all the pretentious cod that has been written about him and all the bits and scraps of his early writing which have been unearthed and published and agonised over by gombeen-men scholars and literary blatherers.'

Brian would probably have recommended one of the revolutionary new pills he had once discussed with Gray, solidified cubes of a well-known drink: 'Everybody carries a little box in the waist-coat pocket. Think of the trouble it would save. You're doing your finals in the National. You've a terrible hangover, and you can't bring yourself even to read the examination paper. You pop one of these tiny cubes into your mouth and suddenly all becomes clear. Or suppose you're forced to go to Mass with the wife. In the middle of the boring sermon you suck on one of these, and suddenly the world seems a different place.'

Chapter Twelve

BERTIE SMYLLIE – 'THE EDITOR'

Pissmires and warlocks stand aside! – Bertie Smyllie

'Never, never begin a sentence with a shuddering preposition,' *Irish Times* editor Robert Smyllie educated junior reporter, Patrick Campbell.

'A preposition has never initiated a sentence and never will,' he excised the ands and the buts from Patrick's story.

The editor spotted a split infinitive. '"To actually justify!"' he banged both fists on the desk.

'"To actually justify." Listen to it. It turns the stomach. If you must – "actually to justify".'

'But what's "actually" doing there anyway? It's superfluous. It's even otiose. The graces of style, Mr. Campbell. The graces of style.'

Known as the d'Artagnan of Irish journalism, Robert Maire Smyllie drank copiously and kept irregular hours. The uncut nail of his right little finger was as long as a Mandarin's. And, each morning and night, he could be seen cresting Baggot Street Bridge, his portable typewriter swaying from the front handlebars of his antiquated Raleigh. 'Cruelty to bicycles,' a schoolboy once admonished. By no stretch of the imagination, however, could 18-stone Smyllie be described as a Bohemian. He came from an impeccable Presbyterian Unionist background. He played cricket, golf and tennis and knew the right people. He lived comfortably with a wife and maid in the upper-class suburb of Ballsbridge. Most of his friends never knew that he narrowly escaped being shot by British soldiers in 1921.

But several Bohemians owed their lives to the *Irish Times* editor. The great man of hope to the west of Baggotonia, his largesse heated many a cold

garret. *Envoy* founder John Ryan christened him 'Lorenzo the Magnificent of Westmoreland Street'. Brendan Behan and Patrick Kavanagh were among those who benefited from his commissions. Without his support, several more poets and writers would have starved or heaved their guts out on the Holyhead mail boat. But for his initiative and encouragement, Brian O'Nolan would never have written his famous *Cruiskeen Lawn* column.

Robert Smyllie grew up with printing ink and liquor in his bloodstream. He was born in Glasgow in 1894, the son of a Kerry mother named Fitzgerald and a Scottish journalist, Bob Smyllie. The family moved to Sligo, where Bob became editor and proprietor of the conservative *Sligo Times*. More sociable than businesslike, Bob declined to prosecute when his manager bankrupted him by fleeing to the US with his capital. But he passed his love of newspapers to his son, who occasionally set articles up in print by hand.

After enrolling at Trinity College Dublin to prepare for a consular career, young Robert, better known as Bertie, got a job tutoring the son of an American. The latter rashly dallied in Munich at the outbreak of the first world war. Smyllie was interned for its duration at Ruhleben racecourse near Berlin. 'We both spent the best years of our lives locked up!' Brendan Behan reminded him years later. Smyllie occupied his time profitably, editing the camp magazine and producing plays by compatriots Shaw, Synge and Yeats. More importantly, he met artists, businessmen, musicians and writers from diverse cultural backgrounds and acquired a comprehensive understanding of European history and politics. He participated in debates and discussions, learned to speak both German and French and made many useful contacts.

Unlike Brendan Behan, Smyllie managed to escape from internment and display the initiative that would distinguish his *Irish Times* career. He told *The Bell*: 'When the German Revolution broke out, I broke out too. I escaped and went to Berlin and I got in touch with Scheidemann, the President of the new German Republic, and told him I was an English journalist and wanted an interview. Scheidemann gave me the interview and a corking good one it was too.'

Repatriated to Ireland, Smyllie sought work with the *Irish Times*. Its editor, John Healy, immediately sent him back to the continent to cover the Versailles Peace Conference. The new reporter's biggest coup was an exclusive interview with David Lloyd George, which was quoted by many international newspapers. On Smyllie's return to Dublin, he was promoted to editorial assistant. Ireland in the 1920s proved to be as dangerous as continental Europe had been. Nationalist extremists doubted Britain's commitment to Home

Rule and launched a campaign of violence to gain idependence. On one Sunday in 1921, republicans shot fourteen alleged British agents. Later that day, Black and Tan forces opened fire in Croke Park and killed as many spectators. Smyllie and John Healy narrowly escaped death. Arrested by drunken soldiers, they were threatened with execution before being identified as from the *Irish Times*.

Irish independence was followed by an even more cruel and divisive civil war. Former republican P.S. O'Hegarty recorded its legacy: 'We turned the whole thoughts and passions of a generation upon blood and revenge and death: we placed gunmen, mostly half-educated and totally inexperienced, as dictators with power of life and death over large areas. We decided the moral law, and said there was no law but the law of force, and the moral law answered us. Every devilish thing we did against the British went its full circle, and then boomeranged and smote us tenfold: and the cumulative effect of the whole of it was a general moral weakening and a general degradation, a general cynicism and disbelief in either virtue or decency, in goodness or uprightness or honesty.'

The fighting and the civil war impoverished Ireland financially as well as morally. As the British influence declined, nothing more represented the changes than Smyllie's appointment as *Irish Times* editor in 1934. With his colleagues, he exorcised the *Irish Times* of its previous staunch Unionism and was the catalyst for its transformation to mainstream thinking and a new readership of future voters and leaders. While arguing that the contribution of the Anglo-Irish class to Ireland should not be ignored, he explained: 'When the British left Ireland, the bottom fell out of the world in which the *Irish Times* previously existed. Quite frankly, we had been the organ of the British government. The bulk of our readers were British civil servants and army people. We had now to write for a totally different public. In other words, we had to write for a public that simply wouldn't have had us on their tables before.'

A contrast to former aloof editors, Smyllie's gregarious nature and light touch brought a new vitality to the 70-year-old newspaper. Smiles replaced stern faces, as he relaxed its staid editorial atmosphere. His style was unorthodox. He advised new staff man and future author Tony Gray: 'It has always seemed to me, Mr Gray, sir, that the best newspapers are always run by a committee. A committee of one. The Editor. In this particular case, my good self.'

Smyllie had often accompanied artist Beatrice Lady Glenavy in singing comic songs at the United Arts Club. Her son, future television personality Patrick Campbell, became one of many notable *Irish Times* graduates. He later acknowledged: 'I count myself fortunate to have served under one who wore a green sombrero, weighed twenty-two stones, sang parts of his leading artitcles in operative recitative, and grew the nail on his little finger into the shape of a pen nib like Keats.'

Not that Patrick's initial interview with Smyllie proceeded smoothly. After advising him that there was absolutely no prospect of work, the editor asked him to go to the Phoenix Park and write one thousand words about the zoo. Campbell concluded that his employment prospects were hardly rosy: 'But I went to the zoo and I wrote the thousand words, making them as funny as I could. I delivered them to Smyllie in his office. He pointed silently to a tray on his desk, and returned to his typewriter. I went home, not knowing what to think, or what to hope for. Next morning, the piece about the zoo appeared in its entirety, filling a whole column of the paper.'

Robert Smyllie: 'The best newspapers are run by a committee. A committee of one. The Editor.'

Lionel Fleming's first meeting with the editor was as brief and bizarre. As he climbed the stairs to Smyllie's office, he heard what sounded like the last part of Beethoven's Choral Symphony. The air was Beethoven's, the words were Smyllie's:

Down the hall the butler wandered,
Bent on sodomistic crime,
For the parlour maid was pregnant
For the forty-second time,
Fo-or the forty,
Fo-or the forty,
FOR THE FORTY-SECOND TIME!

But Smyllie was much more than a colourful Dublin personality. An erudite, capable and pragmatic editor, he progressed the *Irish Times* when there was little cash for development and while fighting diabetes and other ailments inherited from his internment. He introduced key features including the famous An Irishman's Diary column. He used his pen-name, Nichevo, for the Saturday diary, and Quidnunc for the miscellany which he edited each other day. Future diarists would include Patrick Cambell, Brian Inglis, Seamus Kelly and G. Tynan O'Mahoney, the newspaper's practical joker and father of comedian Dave Allen.

The path-finding editor did not neglect foreign coverage. He renewed his internment contacts on regular visits to the continent. He frequently warned readers of the rise and dangers of fascism, while expressing his hope that 'the people who gave birth to men of the stamp of Goethe, Beethoven, Hegel, Mozart, Schiller and Bach will not tolerate for long the arrogant pretensions of Hitler'. He sent Lionel Fleming to provide objective coverage of the Spanish Civil War, much to the ire of religious activists who pressurised Catholic advertisers to boycott the paper. His feature series *Carpathian Contrasts* gained him the Czechoslovak Order of the White Lion, shortly before that country fell to the Nazis.

Though it never matched its rivals' circulation, the *Irish Times* under Smyllie established itself as Ireland's quality newspaper. While opposing his politics, businessman Todd Andrews acknowledged his success: 'Smyllie, in fact, integrated the *Irish Times* and what it stood for with the Irish nation and he was more than welcomed by the ruling group and by civil servants in particular. Favourable comment from the *Irish Times* made a minister's day. Favourable comment from the other two Dublin dailies was of no importance to them.'

Former *bete noir* Taoiseach Eamon de Valera also accorded the *Times* a surprise accolade when he revealed that he consulted the paper when in doubt about a topic for a speech. Despite this, the paper's reputation as a Protestant newspaper persisted for some time in Dev's native county. When

Frank McCourt was employed by a newspaper distributor in Limerick, he was told that one of the downsides of the job was having to deliver the *Irish Times*. He was warned on no account to read it, in case he might lose the Faith!

Smyllie supported de Valera's government's decision to remain neutral during the Second World War. In a leading article which would have been unthinkable a generation previously, he reiterated: 'We have said from the beginning that we thoroughly approve of Mr de Valera's policy of neutrality in the present war. In all the circumstances of internal and external affairs, it is the only feasible policy for Eire. Yet it would be absurd to pretend that the people of this country can remain as indifferent to the fortunes of Great Britain as, say, the inhabitants of Nicaragua. For one thing, there can be very few families in Eire that have not some relatives or friends in one or other of the British services.'

The war years witnessed a battle of wits between Smyllie and the Censorship Board. The Board was led by Joseph Connolly and the witty but conscientious civil servant, Thomas J. Coyne, who had a low opinion of journalists. While agreeing that the army had been over-zealous in keeping reporters away from the area of the German bombing in Dublin's North Strand, Coyne remarked: 'After all, news-hunting is a dangerous profession and the loss of a couple of dozen pressmen need not be too deeply deplored.'

Smyllie told *The Bell* that while he understood a certain degree of wartime censorship was necessary, 'it ought not be allowed to interfere with a newspaper's honest opinions'. His resentment of censorship reflected his fears that his country's isolationism would result in a renewed insularity and intellectual sterility. The *Irish Times* was subject of particular attention, because of its sympathy with the Allies and because its editor had consistently highlighted the danger of Nazism. All references to Irishmen serving with British forces were banned. When Brian Inglis enlisted with the RAF, Smyllie wrote that the *Times* staff man had gone to England to pursue his flying interests. Unable to mention that fellow-journalist John Robinson had been torpedoed in 1941 by the Japanese while serving with the Royal Navy, Smyllie wrote: 'The many friends of John Robinson, who was involved in a recent boating accident, will be pleased to hear that he is alive and well.'

One advantage of the war was that newspaper sales increased, as transport difficulties hindered the proliferating English media. But censorship restrictions and delays caused endless editorial problems. The editor ad-

Smyllie's riposte to the censor: The V for Victory edition

ministered a final riposte to the censor in the May 8, 1945 issue which celebrated the end of the conflict. The censor passed the newspaper's account of the German surrender and the unusually large number of mug shots of victorious Allied leaders, including Churchill and Roosevelt. As the printing presses roared into life, the photographs were scattered at random around the country edition. But before he cycled home along deserted Baggot Street, Smyllie personally rearranged them across the front page of the final city edition. In the form of a V for Victory formation.

Smyllie turned the *Irish Times* into Ireland's leading literary newspaper. One reviewer noted: 'The Saturday Books Page of the *Irish Times* is now the only real focus for Dublin writers.' The editor ran eight columns of book reviews even when wartime restrictions limited the number of pages. Samuel Beckett was a contributor to the paper which published 'Saint Lo' and other poems in 1946. James Joyce's *Finnegans Wake* received a 6,000-word review in 1947 under a banner lead 'Sprakie Sea Djoytsch'.

The *Irish Times* editor broke the news to W.B. Yeats that he had won the Nobel Prize for Literature. The poet's immediate reaction was: 'How much, Smyllie, how much?' Smyllie's acquaintanceship with Yeats led to a *Times* scoop. The poet gave him the text of his speech defending Sean O'Casey's

The Plough and the Stars, which had been drowned out by nationalist protestors. The paper celebrated Yeats's seventieth birthday with a two-page spread and praised him as virtually the first man since Swift who had been able to bring the Anglo-Irish tradition into line with a positive nationalism. As well as providing valuable space for new poets like Austin Clarke and Patrick Kavanagh, the *Irish Times* also saw the first publication of Yeats's iconic 'Under Ben Bulben' poem:

> Cast a cold eye
> On life, on death,
> Horseman, pass by!

Smyllie broke the news to W.B. Yeats that he had won the Nobel Prize for Literature

For many readers, Smyllie's most significant success was his commissioning of Brian O'Nolan's regular column, a move which also enhanced public interest in Brian and his books. The new column, *An Cruiskeen Lawn*, originally appeared in Irish on October 4, 1940 and eventually in English. Its popularity led to the commissioning of O'Nolan's Irish-language novel, *An Beal Bocht*, which the author dedicated to Smyllie whose leading articles he also sometimes parodied.

Typical of O'Nolan's sallies was his solution to wartime rationing: 'No matter who you are you must go to bed for a week. You see, when nobody is up you save clothes, shoes, rubber, petrol, coal, turf, timber and everything we're short of. And food, too, remember. What makes you hungry? It's work that makes you hungry. If nobody's up, there's no need for anybody to do any work. In a year, you'd save a quarter of everything, and that would be enough to see us right.'

Unlike the other two national dailies which were slavishly supportive of the majority Catholic Church, Smyllie's correspondence columns provided a rare forum for dissenting views. Particularly about literary censorship, on which he allowed the most forthright attacks seen in an Irish newspaper. In

December 1950, he allowed Donagh MacDonagh two columns for a review of the government's 308-page list of over 9,000 banned titles. Smyllie also supported Health Minister Dr. Noel Browne during the controversy over the 1951 Mother and Child health scheme. Dublin Archbishop John Charles McQuaid was shocked at the possibility of 'socialised medicine' and non-Catholic health professionals providing sex education. Profiteering consultants were similarly discountenanced. The government and Browne's party leader, Sean MacBride, capitulated and the minister was forced to resign. 'No Government, for years to come, unless it is frankly Communist, can afford to disregard the moral teaching of the Bishops,' McQuaid celebrated in a letter revealed by biographer John Cooney.

Smyllie castigated both Church and political leaders. Pointing out the propaganda value of the episode for diehard Unionists opposed to Irish unity, the editor regretted: 'This is a sad day for Ireland. It is not so important that the Mother and Child scheme has been withdrawn, to be replaced by an alternative project embodying a means test. What matters more is that an honest, far-sighted and energetic man has been driven out of active politics. The most serious revelation, however, is that the Roman Catholic Church would seem to be the effective Government of this country.'

It was Smyllie's dominance of George Ryan's Palace Bar, as much as his newspaper record, which established him as one of Dublin's leading personalities. As Alan Reeves' cartoon recorded, the editor was the king-pin of one of the city's greatest assemblies of literary and artistic talent. Habitually scanning the horizon, he sat at a square table in the centre of the lounge, flanked by four or five close friends such as Lynn Doyle, F.R. Higgins and Seamus O'Sullivan, and artists Sean O'Sullivan and William Conor, who had painted his portrait. One seat was left vacant for supplicants from the outer circles, seeking commissions, offering poems or soliciting book reviews. As soon as one aspirant concluded his sales pitch, another took his place. The nightly attendance also included resting actors, drama critics, Dublin intellectuals and book collectors.

When Smyllie moved to the less atmospheric Pearl Bar, even closer to his office, everyone followed. 'Pissmires and warlocks, stand aside!' was his war-cry when assailed by too many supplicants. Honor Tracy noted: 'The lounge of the Pearl Bar looked fuller than it was, owing to the presence of the editor of the *Irish Times*. This huge gentleman possessed the gift not only of creating by himself the sense of a party but of bestowing on the whole bar a distinguishing air. Vast, genial, he would sit there by the hour, his comfort-

able frame shaking with laughter at the sallies of his companions and draw sagely at his pipe: but should one enter whom he really wished to avoid this seemingly inert, apparently rooted, mass would suddenly vanish, now here, now gone, with the amazing vitality of a Bodily Assumption.'

Apart from cycling home, the furthest Smyllie ever travelled from Westmoreland Street was to renew his tobacco supply at Kapp and Peterson at the bottom of Grafton Street. He only once deserted the Fleet Street pubs. When Patrick Kavanagh had established himself with younger literati at McDaid's, the editor followed him to assess the Harry Street bar. The equivalent of a 1920s foray from Montmartre to avant-garde Montparnasse, Smyllie soon discovered it fell far below the Pearl's sedate standard. Brendan Behan was loudly singing 'I was Lady Chatterley's Lover' in one corner, while Gainor Crist was being sick on the opposite side. The editor swiftly fled to the sublimity of Fleet Street.

Smyllie's nightly return to the *Irish Times* offices was greeted by a regular queue of supplicants. Some seeking a handout, others chasing publicity for hare-brained schemes and, inevitably, a suburban lady banging her umbrella on the counter and demanding an immediate interview with the editor. Before his plays became successful, another regular was Brendan Behan whom Smyllie occasionally befriended with commissions. Once, when the editor was entering the offices, he was mystified to hear his name being called, though there was no one within sight. 'Mr. Smyllie. SIR!' He looked around again, the call seemed to come from on high. He finally spotted Brendan, complete with paint can and brush, beautifying the facade around the newspaper's famous clock.

Tony Gray described Smyllie's grand entrance from the adjacent Palace Bar: 'The double doors that lead into Westmoreland Street now burst open under the impact of a remarkably bulky member of the human race who has just hurled himself through them at a very high turn of speed for one so heavily built. He is wearing an enormous wide-brimmed sombrero, and his coat, open and flying from the shoulders like a cloak, billows out behind him. He has a round, chubby, reddish face, perfectly circular glasses, which give him a slightly Billy Bunterish expression, and under his snub nose a dark moustache from the centre of which protrudes a Sherlock Holmes pipe, firmly clenched between his teeth. The momentum with which he has precipitated himself through the swing-doors carries him half-way through the front office, almost to the foot of the staircase. The small group of people who were lying in wait for him now surge towards him, and then appear to be

sucked into his wake, like flotsam behind a great ship.'

Though one of the *Irish Times's* most significant editors, and certainly its most famous, Smyllie was by no means its most efficient. His small interior office was lit entirely by artificial light. Its furniture comprised a roll-top writing desk and an enormous wicker basket into which he threw the day's accumulation of galley proofs. He regularly replaced the much-travelled typewriter on which he rattled out leading articles with a wind-up gramaphone, on which he played classical music. Dominoes or drink passed the time while awaiting proofs. Smyllie and his assistant, Alec Newman, who was said to keep a barrel of whiskey in his office, improvised risqué operatic limericks which could be heard in adjoining offices. The editor frequently sang his leading articles, before sending them for setting.

'... a marvellous interlude, that period with Smyllie, but it was no way to run a newspaper.'

According to Brian Inglis, Smyllie's den was crammed from floor to ceiling with dust-laden articles awaiting consideration. Experience had taught the editor that all unsolicited contributions were worthless. Masterful inactivity was the password. To answer correspondence was his agony, to lose it his delight. Deputy Editor Bruce Williamson summed up the editor's two decades: 'It was a marvellous interlude, that period with Smyllie, but it was no way to run a newspaper. Certainly, as time went by, it became clear that this enclave of magnificent Bohemianism was totally unsuited to a modern newspaper.'

In September 1951, pedestrians in Westmoreland and Fleet Streets were startled by a loud detonation. This was followed by a volcano of flames from the *Irish Times* building. Some were surprised that the conflagration had not occurred earlier. The building was noted for the acrid smell of gas from the anthracite which the newspaper burned to keep the equally malodor-

ous printing metal molten. The wooden floors were saturated by decades of paraffin and petrol used in cleaning the thunderous printing machines. A *Dublin Opinion* cartoon showed the unruffled editor, complete with Trinity College tie, emerging under the famous clock from the smoke. On his head, a roll of newsprint replaced the famous sombrero. Under one arm, he carried his typewriter. Under the other, a Union Jack flag.

Smyllie calmly exits the Irish Times *building inferno* (Dublin Opinon)

The fire marked a suitably dramatic exit for the newspaper's most colourful editor. He never settled into the newly renovated building and soon became seriously ill. Increasingly, he worked from home. Staff visited him for instructions, and for the weekly Nichevo column which he dictated from his bed. Like a generation of *Irish Times* readers, they were shocked when he unexpectedly succumbed to diabetes and heart failure at the age of 59 on September 11, 1954. It was the end of an era for the *Irish Times*.

Journalist Cathal O'Shannon said on Radio Éireann that night: 'To his own men, and to all of us, he was the father of the family – often, indeed, jovial companion as well as confessor – giving to each a greater freedom to develop his gifts than in any other newspaper in Ireland in my time.'

The editor's funeral attendance included the country's leading artists and literati, civil servants, sports personalities, politicians and the President's aide-de-camp. And his former sparring partner, the war-time censor, T.J. Coyne. Friends fondly imagined Smyllie uttering his favourite war-cry as, typewriter under his oxter, he made a suitably grand entrance into the great editorial office in the sky: 'Pissmires and warlocks, stand aside!'

Chapter Thirteen

PEN VS CROZIER – BANNED IN IRELAND

When we look back at that great period of forty years ago, we see what the ideal might be and what has been lost.
– Sean O'Faolain

'THESE EXCERPTS SHOULD BE ERASED from the Senate records,' a flushed deputy banged his bench during the debate on the banning of the book, *The Tailor and Ansty*.

The affair ignited the Irish Senate for four days during the winter of 1942. A few hundred miles to the east, trainloads of Jews were being herded across Europe to Nazi extermination camps.

Liberal Senator John Keane was determined to demonstrate that the work was not obscene. He resumed: 'There is another passage, but it is only incidental, where they make fun of modern education because they find that some of the younger people, even though they are married, do not know the difference between a cow and a bull.'

Senator Magennis interrupted: 'I suggest to the Chairman that, before Senator John Keane reads the remainder of the passage, an instruction should be given to the official reporters not to record it. Otherwise, we shall have some of the vilest obscenity in our records, and the Official Reports can be bought for a few pence.'

Senator Keane's quotations were struck from the record. Senator Magennis's opinion of the tailor and his wife remained: 'The man is sex-obsessed. His wife Anastasia – called here 'Ansty' – is what in the language of American psychology is called a moron – a person of inferior mental development, who

may be 30 or 40 years of age but has reached only the mental stage of a child of four or five.'

Magennis concluded that there was a campaign being financed by American money to undermine Christianity: 'The endeavour to put in paganism, instead of the Christian creed and practice, includes Professor Joad and George Bernard Shaw.'

Samuel Beckett and fellow-Irish writers created fantastic plots and fables. But few of these could match the absurdity of the Censorship of Publications Act, which the Irish government passed in 1929. According to Liam O'Flaherty, the new Free State ensured that writers and intellectuals were now less free than they had been under British rule. Initial demands for censorship by Catholic organisations were aimed at the salacious contents of popular British newspapers. But now, anyone who considered a book as unsuitable could send it to the Censorship Board with the offending passages marked. The *Irish Times* declared the Act to be an open war on liberal culture and denounced the government policy 'which is operating, each day more surely, to isolate Ireland from an educated and progressive world'.

The Bill's purpose was to protect the newly independent population from contamination by indecent or sexually explicit influences. Indecent was defined as: 'Suggestive of, or inciting to, sexual immorality or unnatural vice or likely in any other similar way to corrupt or deprave.' Also taboo was anything that would advocate 'the unnatural prevention of conception or the procurement of abortion'. Oliver St. John Gogarty protested: 'It is high time the people of this country found some other way of loving God, than by hating women.' Fellow-Senator W.B. Yeats prophesised: 'It may drive much Irish intellect into exile once more, and turn what remains into a bitter polemical energy.'

Aldous Huxley had the honour of being the first author to be banned. His *Point Counter Point* and *Brave New World* headed a procession of titles including *A Farewell to Arms*, *The Grapes of Wrath* and Margaret Mead's *Coming of Age in Samoa*. The list of banned authors which outran any religious litany included Sherwood Anderson, James Baldwin, Honore de Balzac, Saul Bellow, Heinrich Boll, Taylor Caldwell, Truman Capote, Raymond Chandler, Noel Coward, Theodore Dreiser, William Faulkner, Scott Fitzgerald, C. S. Forester, Anatole France, Sigmund Freud, Martha Gellhorn, Andre Gide, Nadine Gordimer, Maxim Gorky, Robert Graves, Graham Greene, Ernest Hemingway, Christopher Isherwood, Alfred Jarry, Arthur Koestler, D.H.

Lawrence, Doris Lessing, Sinclair Lewis, Wyndham Lewis, Compton MacKenzie, Norman Mailer, Thomas Mann, Somerset Maugham, Alberto Moravia, Iris Murdoch, Vladimir Nabokov, George Orwell, John Dos Passos, John Cowper Powys, Marcel Proust, Philip Roth, Bertrand Russell, J. D. Salinger, Jean Paul Sartre, Mikhail Sholakov, Georges Simenon, Upton Sinclair, Muriel Spark, John Steinbeck, William Styron, Dylan Thomas, Signe Toksvig, John Updike, Evelyn Waugh, Thomas Wolfe and Emil Zola.

Ignoring Oscar Wilde's precept that there is no such thing as a moral or immoral book, only books that are well written or badly written, the censors did not spare the Dubliner's compatriots. The banned included Samuel Beckett, Brendan Behan, John Broderick, Austin Clarke, Louis D'Alton, J.P. Donleavy, Ernie Gebler, Oliver St John Gogarty, Norah Hoult, Ben Kiely, Walter Macken, John McGahern, Brian Moore, George Moore, Sean O'Casey, Frank O'Connor, Sean O'Faolain, Liam O'Flaherty and both Edna and Kate O'Brien – whose *Land of Spices* was praised by continental Catholic journals. Lee Dunne achieved the dubious distinction of being Ireland's most banned writer, with six proscribed titles. Frank O'Connor's English translation of Brian Merriman's *Cuirt an Mhean Oiche* was banned, while copies in the original Irish were being sold in the government's own publications office. Saint Columbanus had enjoyed Horace and Juvenal. Thirteen centuries later, the Knights of Columbanus, who packed the Censorship Board, proscribed classical authors from Ovid and Socrates to Apuleius and Boccaccio.

Contrary to widespread opinion, *Ulysses* was never prohibited in Ireland. Its obscurity, the pusillanimity of booksellers and the hostility of influential figures such as UCD President, Dr. Tierney, simply ensured that it never circulated. Brian O'Nolan's first sighting was the two-volume Tauchnitz edition, which was passed around like contraband at university. While W.B. Yeats defended the book's author as having 'the intensity of the great novelist', Joyce's former university teacher, the ubiquitous Professor Magennis, described *Ulysses* as 'moral filth'. Though *Dubliners* and *A Portrait of the Artist* were available, most Irish people were wary of the highly dubious author who, according to an *Irish Independent* review, had 'reviled the religion in which he had been brought up and fouled the nest which had been his native city'. Ken Monaghan recalled: 'My two unmarried aunts, Eva and Florrie, warned me never to admit that I was a nephew of James Joyce.'

One of the saddest results of censorship was 73-year old Francis Hackett's self-exile to Norway, after his book *The Green Lion* was banned in 1936. Its alleged indecency was probably his criticism of the Jesuit educational system.

Archbishop John Charles McQuaid

The veteran Independence campaigner and neighbour of Sean O'Faolain recorded: 'The censorship law is repugnant to every instinct of a free man, ignorant in its conception, ridiculous in its method, odious in its fruits, bringing the name of self-governing Irishmen into contempt.'

A lesser man than Patrick Kavanagh would have panicked when gardaí questioned him over the sexual implications of his poem, 'The Great Hunger'. Jazz was banned on the national radio station, despite which crooners such as Bing Crosby gradually replaced homegrown songstresses like Delia Murphy. Victor Waddington was denounced for hanging a reproduction of Manet's *Olympus* in his South Anne Street gallery. Archbishop McQuaid prevented artist Father Jack Hanlon from launching an exhibition in a Protestant school in Cork. In 1965, award-winning John McGahern's *The Dark* was banned and McQuaid ensured that the teacher's Dublin school contract was not renewed.

The Dark dealt with parental and clerical abuse. Its banning is particularly poignant and sinister in view of later revelations of child abuse in church institutions and the church's determined cover-up. Biographer John Cooney observed: 'Among the less acceptable features of the highly cen-

tralised clericalist system, which McQuaid directed with the assistance of a kitchen cabinet of young and devoted priest-secretaries, was the confinement by the courts of thousands of young boys and girls in virtual penal servitude in orphanages where many of them were physically and sexually abused by "celibate" priests.'

Honor Tracy recorded censorship's effect on writer such as John McGahern: 'A young man may produce a book that is perfectly honest and fresh and sincere and some pious yahoo may get hold it, read it with but a partial understanding, mark a few passages that he deems perilous to faith and morals and forward it with zeal to the censors. The words 'banned in Ireland' are something of a joke abroad but it is not so easy to smile them away at home. There may be social unpleasantness and repercussions in business affairs for the author: and in any case his natural and proper audience has gone.'

In four decades until censorship was eased in 1967, 12,000 publications were banned. Booksellers were warned by gardaí of the penalties for displaying proscribed works. While being on the list was sometimes seen as a mark of distinction, it deprived Irish authors of their principal home market and branded them in many eyes as writers of pornographic books. Sean O'Faolain remembered that after *Bird Alone* was banned, he felt like dirt, that he needed a wash.

Author Julia Carlson confirmed that W.B. Yeats's worst fears had been realised: 'Censorship has created a rift in Irish society, fostering the ignorance and provincialism of the Irish people and the intellectual and moral alienation of Irish writers. Many writers have left the country in anger and in search of greater intellectual freedom. Those who have remained have found themselves isolated and unable to give significant shape to Ireland's social, political, and cultural life.'

The most ludicrous book banning was probably that of Eric Cross's *The Tailor and Ansty*, a collection of earthy reminiscences and stories by tailor Tim Buckley, who lived with his wife, Anastasia, in a whitewashed cottage near Gougane Barra lake in Cork. Frank O'Connor described Buckley as a rural Doctor Johnson, with whom Shakespeare and Montaigne would have been at home. Once their black cow was attended to, he would sit by the side of the road, park his withered leg and regale friends with stories which he could relay even better in Gaelic than English: 'Sit down and take your aise, and don't be making a slave of yourself to an ould clock. The world is only a blue-bag. Knock a squeeze out of it when you can. I remember, in the old days, there was a man by the name of . . .'

Not only was *The Tailor and Ansty* banned, but the tailor and his wife were boycotted by pious locals, who even blocked their door with tree branches. Though he was defended by local priest Father Traynor, three other clerics called one day and made the tailor kneel on the hearth and burn his own copy of the book. 'It cost me eight and sixpence,' the tailor vainly protested.

Frank O'Connor pointed out that Ansty and the Tailor displayed more Irish culture than the educated betters who banned them, while pontificating about the Gaelic traditions: 'She and the Tailor both regarded sexual relations as the most entertaining subject for general conversation, a feature of life in Irish-speaking Ireland even in my youth, but which began to die out the moment English became the accepted language.'

On Archbishop McQuaid's recommendation to the Vatican, Senator William Magennis, who had derided the tailor and his wife, was created a Knight of St. Sylvester a year after the banning.

Imbued with patriotic fervour, Liam O'Flaherty wrote a series of stories in Irish for the Gaelic League. He and Padraic O'Conaire then decided that Irish language drama was the best means of launching a new literature. When the Gaelic Drama League staged the first play, gardaí had to protect the audience and cast from religious activists who protested O'Flaherty's perceived immorality. *The Informer* author saw censorship as a tool of the new narrow-minded middle class as much as of the church: 'The tyranny of the Irish Church and its associate parasites, the upstart Irish bourgeosie, the last posthumous child from the wrinkled womb of European capitalism, maintains itself by the culture of dung, superstition and ignoble poverty among the masses. And the censorship of literature was imposed, lest men like me could teach the Irish masses that contact with dung is ignoble and that poverty, instead of being a passport to heaven, makes this pretty earth a monotonous hell.'

British publishers Macmillan, Jonathan Cape and Michael Joseph profited from O'Flaherty, O'Casey and Yeats. But with wartime paper shortage and virtually no Irish publishers, it was the periodicals which gave newcomers Brendan Behan and his contemporaries their only opportunity of expression. Just as Joyce, Kavanagh and Sean O'Faolain made their debut in AE's *Irish Homestead* and *Irish Statesman* journals, later scribes from James Liddy and James Plunkett to John Montague were first published in *The Bell*, *Envoy*, *Irish Writing*, *Nonplus*, *Rann* and the *Dublin Magazine*. The Irish-language magazines, *An Glor*, *Feasta* and *Comhar* also featured Behan, Breandan O Heithir and Mairtin O'Cadhain. Donal O'Morain's Gael Linn organization en-

couraged Irish film music and the career of composer, Sean O'Riada. David Marcus's *Poetry Ireland* and *Irish Writing* published Cecil Day-Lewis and Samuel Beckett. Poet Robert Greacen celebrated: 'The literary magazines were marvellous, they played a major role. Belfast at that time was a wilderness, I will always remember my delight at coming south and discovering *The Bell*.'

Another Belfast arrival, like poets Gerald Dawe and Michael Longley, was Derek Mahon who appreciated the magazines and the writers who:

Sean O'Faolain, Editor of The Bell – *'like a rock in a foaming sea'*

> Knew London and Paris but preferred the unforced
> Pace of the quiet city under the Dublin mountains
> Where a broadsheet or a broadcast still count.

Published out of conviction rather than for gain, the lifespan of the periodicals was as limited as their circulation. Reflecting its miniscule budget, *The Bell* was described as the only magazine in the world which was printed on lavatory paper with ink made from soot. It was produced by a Dublin publisher between runs of more profitable bibles and abridged novels. But what it lacked in paper quality, it made up for with courage. Together with *Envoy*, it exerted an influence far beyond its lifespan or circulation. The journal ran from 1940 to 1954, under the editorship of former political prisoners, Sean O'Faolain and Peadar O'Donnell. It declared itself to be all-inclusive, belonging to Gentile and Jew, Protestant and Catholic, priest and layman. O'Faolain, whose lovers included Elizabeth Bowen and Honor Tracy, was described by the latter as standing out in Dublin like a rock in a foaming sea: 'In appearance he is like some respectable English burgher, tall and spare, rosy and blue-eyed: he pulls on a pipe in a calm English way and speaks in a manner imperturbable as it is urbane. He possesses moreover an integrity which is entirely alien to the Irish genius: and his mere presence soothes and reassures.'

*Irish literature owes a great debt to magazines
such as* Envoy *and* The Bell

Apart from censorship, O'Faolain was fearless in defending Irish writers from unfairness in any quarter. He wrote of Oliver St John Gogarty, who died in 1957: 'Joyce did him an immense and cruel injustice in *Ulysses* in presenting him to posterity as something approaching the nature of an inquisitive lout whose only function in life was to offset the exquisite sensitivity and delicacy of Stephen Dedalus. Gogarty was a kind and sensitive man, full of verve and zest. His essential nature, which nobody could ever possibly gather from *Ulysses*, was his nature as a poet – he was a fine poet.'

Thanks to academics' fear of involvement, *The Bell* never matched the intellectual range of magazines such as *The Criterion*. But it broke ground with short stories and poems by new writers, interspersed with documentary features on topics as diverse as prisons, hospitals and women in politics. Also, regular word-portraits of such figures as Elizabeth Bowen, Christine Longford, Maurice Walsh and businessman Denis Guiney. The influence of the energetic but sometimes unapplied Peadar O'Donnell (marvellously parodied in Anthony Cronin's *The Life of Riley*) ensured that it balanced urban with provincial appeal. As well as providing early ventilation for James Plunkett and Michael McLaverty, the journal featured the first appearance of Patrick Kavanagh's *Tarry Flynn*. Unlike the confrontational Frank O'Connor, O'Faolain always preached reason and restraint. But he lamented: 'When we look back at that great period of forty years ago, we see what the ideal

might be and what has been lost – an extraordinary catholicity of interest, a fine intellectual curiosity, a bond with the civilization of the wide world, a sympathy and understanding with all human sorrows and tragedies which give a universal quality to the best work of the time.'

O'Faolain was president of the Irish Association of Civil Liberty from 1953 to 1957. He listed a roll-call of the banned writers and highlighted such absurdities as the Gaelic Athletic Association's demand that the Minister of Defence be removed from office because members of the army played golf and soccer which were not national games. The National Athletic and Cycling's decision to allow women to compete at the same meetings as men had earlier been condemned as 'un-Catholic and un-Irish' by Archbishop McQuaid. Lamenting that the quality of Irish life had never sunk so low since Parnell's time, *The Bell* editor insisted: 'The truth is that the people have fallen into the hands of flatterers and cunning men who trifle with their intelligence and would chloroform their old dreams and hopes, so that it is only the writers and artists of Ireland who can now hope to call them back to the days when these dreams blazed into a searing honesty.'

Edited by Fathers Senan Moynihan, the glossy *Capuchin Annual* was a healthy contrast to the Catholic Truth Society's pamphlets, which focused on hemlines and the Communist threat. The *Annual* introduced writers and academics Ben Kiely, Francis MacManus and Gus Martin and was a valuable outlet for artists like Harry Kernoff. Another unusual but more trenchant periodical was *Kavanagh's Weekly, A Journal of Literature and Politics*, which Peter and Patrick Kavanagh launched with the former's $2,500 teaching savings. Though they did not know it, the Kavanaghs were following in the footsteps of James Joyce, who in 1903 had discussed the idea of another dollars-supported newspaper with his friend, Francis Sheehy Skeffington. It would combine Joyce's literary interests with Skeffington's politics of pacificsm, socialism and the emancipation of women. Pre-dating Patrick Kavanagh's literary pilgrimages, Joyce tramped the 26-miles round trip to Celbridge in a vain bid to secure the support of an Irish-American millionaire.

Kavanagh's Weekly was published in April 1952, under a masthead designed by John Ryan. The opening editorial was not calculated to endear the Kavanaghs to either the establishment or the masses:

> Thirty odd years ago the southern section of this country won what was called freedom. Yet from that Independence Day there has been a decline in vitality throughout the country.

> It is possible that political liberty is a superficial thing and that it always produces the apotheosis of the mediocrity. For thirty years thinking has been more and more looked upon as wickedness – in a quiet way of course. All the mouthpieces of public opinion are controlled by men whose only qualification is their inability to think.

Starting at Parsons, Peter distributed the paper himself by bicycle. Patrick and he lost little time in targeting Irish radio, compulsory Irish in schools, and what they saw as the delusion of Irish cultural and spiritual superiority. The Cultural Relations Committee understandably received generous space: 'Members of the committee were the usual mixture of ex-politicians and frustrated pedants.' Department of Foreign Affairs employees were outraged by the all too accurate *Diplomatic Whiskey* feature.

The Weekly wondered why Irish hospitals were under-funded, while millions poured into the Irish Hospitals' Sweepstakes charity. It proposed the withdrawal of subsidies from such institutions as the Abbey Theatre, the Arts Council and the Institute of Higher Studies. Though some considered the features wild and inaccurate, biographer and former Irish Congress of Trade Unions general secretary, Donal Nevin, recalled: 'Patrick Kavanagh did some serious research for his stories. He came and interviewed me at length after I'd asked some questions about the Irish Sweepstakes in a Labour party paper.'

Apart from contributions by Flann O'Brien and John Ryan, the entire *Kavanagh's Weekly* copy was written by Patrick and Peter, the latter being credited with the more pungent features. Too extreme to attract advertisers, apart from gallery owner Victor Waddington and Brown Thomas, the *Weekly* folded after thirteen issues. The unsold copies were burnt in the Pembroke Road fireplace. John Ryan observed: 'Soon the flat resembled the stokehold of the *Ile de France*. Mighty plumes of black smoke ascended in the daytime, by night the Pembroke skyline was an orange glow.'

Envoy ran from 1949 to 1951. Reflecting its Joycean editor, John Ryan, it was noteworthy for its European outlook and its enthusiasm for the visual arts. It published illustrated essays on emerging painters Hilary Heron, Colin Middleton and Nano Reid. Poetry editor Valentin Iremonger introduced new talent, the magazine featured Nathalie Sarraute, Francis Stuart, Ernest Gebler, Monk Gibbon and Conor Cruise O'Brien. It saw J.P. Donleavy in print for the first time and published Brendan Behan's earliest fiction story.

Envoy also published extracts from Beckett's *Watt*. Birth control and condoms were strictly taboo at that time, possession of the latter could result in prosecution. *Watt* recorded:

> For the State, taking the law into its own hands, and duly indifferent to the sufferings of thousands of men, and tens of thousand of women, all over the country, has seen fit to place an embargo on this admirable article, from which joy could stream, at a moderate cost, into homes, and other places of rendezvous, now desolate. It cannot enter our ports, nor cross our northern frontiers, if not in the form of a casual, hazardous and surreptitious dribble, I mean piecemeal in ladies' underclothing, for example, or gentlemen's golfbags, or the hollow missal of a broad-minded priest.

The circulation of the literary magazines was small, the influence of the Catholic Church universal. The pen may have been mightier than the sword, but neither of them could outrun a crozier. As well as campaigning against immodest dress and dances, Archbishop McQuaid's agents scrutinised radio programmes for suggestive lyrics. 'Burn it down,' screamed Maria Duce fundamentalists, who had to be restrained by gardaí as they picketed the Gate Theatre because of Orson Welles's alleged Communism. The 1958 Dublin Theatre Festival was cancelled after the Church's ire was raised by a dramatisation of *Ulysses* and Sean O'Casey's *The Drums of Father Ned*. The hierarchy also requested America's Cardinal Spellman to pressurise the Irish government into banning objectionable plays. Learning of his praise for the FBI's campaign against alleged Communist trade unionists, Edgar Hoover thanked Archbishop McQuaid for his 'highly valued support'.

The Archbishop opposed Sean O'Faolain's nomination as Director of the Arts Council in 1957. He also sent his secretary, Father McMahon, to have J.P. Donleavy's *The Ginger Man* removed from the Gaiety theatre. Richard Harris, who played the title role, telephoned Father McMahon. According to Harris, the priest denied visiting the Gaiety and, when asked what part of the play was offensive, told the actor to see his spiritual advisor and hung up. Donleavy remembered: 'Dark forces were at work then. Even telephone access to the outside world became mysteriously unavailable.'

Distinguished journalist Liam MacGabhann became another victim of the dark forces. A trip to the Soviet Union lost him his work with both Catholic newspapers and the national radio.

*J.P. Donleavy and producer Philip Wieman outside the Gaiety
on the evening* The Ginger Man *was banned*

Brendan Behan, himself a banned writer, experienced more individual censorship: 'When I asked a bookseller why he didn't have a copy of Plato's *Symposium*, he told me: "We've our own way of detecting indecency, no matter how ancient. We'd seen a bit of a run on it by the same sort of people, so we took it off the shelves. We don't have to be made decent-minded by an Act of the Dáil. We have our own way of detecting smut, no matter how ancient."'

The Dubliner found sympathy in an unlikely quarter after the banning of *Borstal Boy*. Complaining that a crowd of illiterate rural civil servants were depriving him of his livelihood and audience, Brendan sought the company of fellow-banned writer, Benedict Kiely. The pair adjourned to a pub in Moore Street, where they were joined by *Captain Boycott* author, Philip Rooney. Hearing the commotion about the forbidden book, a stranger at the bar turned to Rooney and enquired about its size. On finally extracting its physical as opposed to its literary dimensions, the man offered: 'Say the word and I'll run you over two thousand of them.' He was a cross-border butter smuggler, who measured everything by its cubic content.

Mary King of Parsons Bookshop remembered a customer boasting how Ireland had produced so many more great writers than pagan England: 'They may have been born here, I agreed. But we didn't cherish them all that well – how many of them fled to the freedom of London? After Goldsmith, we had Sheridan, Wilde, Shaw and Yeats, who lived in England longer than he did in Ireland and who, like Joyce and Beckett, also married over there. And AE was

forced out, after all he'd done for the country and he died in England, as did poor James Stephens – and indeed Wilde's mother, Speranza of *The Nation*. And we weren't all that supportive of Joyce and Beckett either, while Brendan was only recognised here after he'd been acclaimed in London. "Joyce and Beckett and Behan, three heathens who disgraced their country," she turned on her green heel and left the shop.'

Mary maintained that the prime movers in censorship were nationalists, and not the much abused church: 'The start of it all was *The Playboy* riots at the Abbey in 1906, which were orchestrated by the likes of Arthur Griffiths and other republican icons, not the church at all. And, later, this spread to the seizing of British newspapers. Our own Patrick Kavanagh, of course, had his independent, if not entirely objective, view on the subject. "Censorship does not concern the creative writer," he said. "You are not supporting literature by attacking the Censorship: you support it by supporting with cash a writer of talent if you know one!"'

There was another sort of censorship to which Patrick Kavanagh referred in his *Irish Times* columns, censorship by gelignite. Perceiving them as British relics, nocturnal patriots destroyed several Dublin monuments in the 1950s and 1960s. Not only the landmark Nelson's Pillar but also the Gough memorial in Phoenix Park, the country's finest equestrian sculpture by one of its greatest artists, John Henry Foley. Ironically, both Gough and Foley were diehard Dubliners, the latter sculpted Thomas Davis and the city's centrepiece O'Connell and Oliver Goldsmith monuments. Another sculpture was blown up in Stephen's Green, where the bust of Joyce's friend, Tom Kettle, was torn down and thrown into the lake. Despite his own youthful activities, Brendan Behan satirised the Gough monument destroyers:

> Neath the horse's prick, a dynamite stick
> Some gallant hero did place
> For the cause of our land, with a light in his hand
> Bravely the foe he did face.

As time progressed, some prelates proved more amenable than nationalist organisations and lay fanatics. Maynooth's professor of English, Fr. Peter Connolly, sought a more enlightened system of censorship and suggested that a creative writer should be added to the Board. While broadminded fellow-churchmen examined the question and embraced ecumenism, the Dominican *Spotlight* journal asked: 'If Rome can change, why not the GAA? It is out of tune with the ecumenical note of the times. Does it not seem a

little odd that when the Catholic Church is to allow its members to attend the services of other faiths, the GAA still pronounces excommunication on its members who attend other games?'

Former Public Relations of Ireland president John McMahon played an unwitting role in the artistic movement for change: 'Valerie, the wife of poet, Hayden Murphy once worked in my Fitzwilliam Place office, next door to the famous Catacombs. Years later she admitted that, unknown to me, she had used the office machine to type out Hayden's famous *Broadsheets*!

'I visited their home on Herbert Lane one evening, near the site of the Pike. With Francis Stuart and other writers in attendance, it was a hive of discussion – even at half six in the evening! It's hard now to imagine the sense of frustration that was as general then as the snow in Joyce's story, 'The Dead'. It was a forbidding and anxious time, with stagnation, emigration and the cloud of censorship. But, like the so-called Dark Ages, there was also a great intellectual vitality at work. Writers, artists and poets like Hayden never made any money but they deserve credit for being at the forefront of the campaign for reform. And in the 1960s change finally arrived, with the arrival of T.K. Whitaker and his programmes for economic expansion.'

Thanks to Whitaker and Taoiseach Sean Lemass, a virtual revolution occurred in the 1960s. As pioneering Yuri Gagarin blasted into space in April 1961, blinds also started to ascend in Ireland, together with living standards. Economic isolationism was ended, overseas investment encouraged. Free post-primary education and a national television station were established. There was a flowering of literary magazines such as *Arena*, Brian Lynch's *The Holy Door*, Ciaran Carty's *New Irish Writing* and John F. Deane's *Poetry Ireland*, which featured new talents Eavan Boland, Dermot Bolger, Theo Dorgan, Desmond Hogan, Frank McGuinness and Macdara Woods.

Trinity College composer Brian Boydell transformed the teaching of music. Sean Lemass refused Archbishop McQuaid's request to remove the RTÉ's liberal broadcasters, Jack White, Shelagh Richards and Proinsias MacAonghusa. Criticised by Peter Lennon in a *Guardian* feature on censorship in Ireland, 69-year-old McQuaid's dictatorship began to falter. The country joined the EEC in 1962, Lemass proclaimed: 'We are now citizens of the world.'

The 1963 visit of Irish-American John F. Kennedy as president of the world's most powerful country provided Ireland with a much-needed confidence boost. Shocked at official denigration of James Joyce, the president lauded the writer in his address to Dáil members. The official attitude soon cartwheeled to the music of jingling cash-tills. Joyci$m was born, as foreign

academics and scholars arrived to experience the city immortalised in *Ulysses*. 'Seven towns contend for Homer dead, through which the living poet begged his bread!' observed Michael Hartnett.

Mary King recalled the watershed: 'Mr. de Valera resigned from politics and Sean Lemass took over as a brisk no-nonsense Taoiseach who seemed to usher Ireland into a new era. I was very impressed when he went to Belfast to call on their Prime Minister, Terence O'Neill. Like thousands of others, I stood at the corner of Dame Street to welcome John F. Kennedy on that lovely June evening. As his car travelled to the Phoenix Park, with crowds everywhere, on the pavements, hanging out of lampposts and statues, and every window also packed, it seemed as if Ireland was coming of age at last. I felt a new optimism in the country.'

Abroad, but very relevant to Ireland, Pope John XXIII fostered ecumenism, change and discussion. Despite Archbishop McQuaid's opposition, Cardinal Conway removed the ban on Catholic students attending Trinity College. Censorship laws were finally transformed. International ridicule and the paperback book revolution made it harder to enforce restrictions on books. In 1967, two years before man landed on the moon, Minister for Justice Brian Lenihan introduced new legislation which abolished the permanent ban. Once-taboo books soon featured on the Leaving Certificate syllabus. Mary Robinson, whose progressive views Archbishop McQuaid had challenged, was elected Ireland's first woman president.

The changes arrived too late to save the Pike or to prevent the emigration of John McGahern and Francis Hackett. Or comfort the deceased Tailor and Ansty and Brendan Behan, who deeply resented the banning of *Borstal Boy*. Archbishop McQuaid and his acolytes used their immense power to crush criticism and dissent. Many commentators regarded the Archbishop as an unmitigated sex-obsessed dictator. Others more charitably saw him as another victim of the church's celibacy laws. Love did not feature in his life. His mother died in childbirth, it was revealed subsequently that he himself had been abused in boarding school.

The alleviation of censorship was a victory for a brave minority which included Frank O'Connor, John Ryan, Peadar O'Donnell and Sean O'Faolain. In his address at O'Faolain's 1991 memorial service, Conor Cruise O'Brien described the writer, together with Hubert Butler and Owen Sheehy Skeffington, as courageous intellectuals who had served their country well.

John Ryan marvelled at creativity's ultimate success over the dark forces: 'That it did not die was no thanks to priest, politician or technocrat, but to

poet and painter. It was these, without physical roots, and the dreamers, who finally hurled themselves against that green density of gombeen men, crawling hack, bogus patriot and pietistic profiteer.'

John was one of the most versatile dreamers of the period. An accomplished artist, he exhibited at the annual RHA shows and designed theatre sets for the Abbey, Gate and Olympia Theatres. He played a major role in establishing the Sandycove Martello tower as a Joyce Museum which Sylvia Beach opened in 1962. John's well-thumbed copy of *Ulysses* was buried with him in Glasnevin cemetery in 1992.

A contemporary insisted: 'Few people did as much for Irish literature as John did in the lean fifties, when he provided hospitality and encouragement to many an aspiring artist and writer. He was a Renaissance man.'

Some commentators insisted that Irish censorship was hardly as ridiculous as that of other countries. *Alice's Adventures in Wonderland* was banned in China in 1931, a year after US Customs seized Voltaire's *Candide* for obscenity. Writers in Ireland did not risk a death sentence like the hapless Salman Rushdie. Authors Brian Fallon and Peter Costello maintained that the effects of censorship were exaggerated and did not stultify cultural vitality. The latter insisted: 'The Act dealt primarily with salacious books and those about contraception, it didn't ban ideas. And the law was clearly defined, unlike in Great Britain, where censorship was at the whim of the current Home Secretary – or even worse in the US, at the mercy of the libraries. And the attitude of some of the newspapers at the time reflected their middle-class readership. As soon as their tastes mellowed, so did papers like the clericalist *Independent* change their tune.'

And at least one prominent artist regretted the relaxing of censorship. Surveying a yellowing copy of *The Bell*, Owen Walsh lamented: 'God be with the days when banning would be the making of a book and just one tasty nude would guarantee standing-room only at an exhibition launch. We'll miss the rare joy of reading a magazine like this. And, like the hint of sin – an aphrodisiac unknown to those pagans across the water – the frisson of excitement from displaying *Borstal Boy* or some other banned tome.

'You couldn't match the buzz of that march through the streets from Lampshades to the courts to support Alan Simpson. Nor the battle of Herbert Lane, when the rozzers retreated before Brendan Behan's army of Pike defenders. An artist needs something to fight against, Ireland won't be the same, thanks to these anti-censorship kill-joys!'

Chapter Fourteen

THE PIKE – A LITTLE THEATRE BY THE CANAL

Sorry about your trouble over The Rose Tattoo. *Bastards, bastards, bastards.* – Samuel Beckett

'Curtain up in five minutes', Alan Simpson heard as he rushed out to see the garda who had asked for him.

'Alan Simpson of the Pike Theatre?'

'Yes! And my apologies, if it's a patron's car blocking an entrance. I'll have it moved immediately.'

'Mr. Simpson, we have been informed that your play, *The Rose Tattoo*, contains objectionable passages.'

'Objectionable… passages…? Impossible. No one has complained. The play has been performed around the world, copies are freely available in the bookshops.'

Inspector Ward pulled himself up to full height: 'A member of the public has complained about these passages. Unless they are removed, you must not proceed with this evening's performance.'

'Can you show me the passages?' Alan Simpson asked.

'I do not know which ones,' the garda replied.

Alan Simpson and his actress wife, Carolyn, opened Dublin's most famous little theatre, the Pike, in September, 1953. Alan wrote its manifesto: 'Our policy is to present plays of all countries on all subjects, written from whatever viewpoint, provided they appear to us to be of interest and to be dramatically satisfying. As our theatre is a small, intimate one we intend

to avail of the opportunities afforded to stage productions which, for various reasons, would not be seen on either the larger or smaller commercial stages, and we hope to give theatregoers opportunities to see more of the struggle going on at present in world theatre to introduce new techniques and new subjects in play writing.'

Alan was born in 1921 into an incorruptible Dublin Protestant family. His father, Canon Walter Simpson of St. Bartholomew's, Ballsbridge lost many friends when he staged a service for executed nationalist author, Erskine Childers. Alan wanted to be a drama producer since his engineering student days, but opportunities were limited in post-war Ireland. After a 1945 stint as stage manager with Hilton Edwards and Micheal MacLiammóir, he was forced to emigrate. He endured a south London office by day, while at night he frequented every theatre in the city which regularly staged compatriots Shaw and O'Casey. Observing direction and production in the smaller theatres such as the left-wing Unity, his engineering background enabled him to swiftly assimilate the importance and secrets of stage lighting.

After a year and a half, Alan returned home. He joined the Irish army as an engineer and immediately renewed his drama activities. He directed award-winning rural dramatic groups and founded the Mercury Theatre Company in Limerick with London actress Carolyn Swift, whom he married in 1947. The day job was only a means to the ultimate end of founding his own theatre. Ireland had a reputation for plays and playwriting. But, apart from the basement venues, Dublin boasted only two main theatres. The Irish Literary Revival's Abbey and the less green Gate. As Micheal MacLiammóir observed, the mainstream Abbey showed Ireland to herself, his Gate showed the world to Ireland, with the works of American and continental dramatists.

While seat prices remained almost at pre-war levels, production costs had spiralled. Alan Simpson decided that the only way to retain independence and stage cost-effective productions was to design his own theatre: 'Some Paris mini-theatres and a couple of tiny art theatres in Dublin – the 37 and the Studio, which had been running in Georgian basements – gave me inspiration.' The basement theatres were not, however, suitable for Alan's purposes. The uniform ceiling level allowed no scope for efficient scene changes or effective lighting. Alan and Carolyn searched for over a year before they found an old coach house at 18a Herbert Lane, in the shadow of the canal-side Peppercannister church. On two levels, the premises consisted of a garage, two minute bedrooms, an out-of-order toilet and a partly-roofed yard with double and single doors which led on to the lane.

Despite the renovation work, Carolyn Simpson found time to have her daughter, Grainne in July 1952. As she related in a Radio Éireann talk, it took three friends and themselves a whole year to convert the premises into a theatre: 'My husband designed lay-out and decoration and bought the materials, picking up things cheaply at auctions and begging from friends. I was the unskilled labourer, doing the dreary jobs like removing nails from old boards that could be re-used, as well as being the painter and seamstress. The other three, fortunately, were master-carpenter, plumber and electrician. But, in the heel of the hunt, we all did everything, taking it in turns with pick and shovel to 'rake' the auditorium by digging down nine inches at the front and putting the resultant rubble at the back.'

Alan's army friends supplied additional carpentry expertise. Seating consisted of Dunlopillo upholstered tip-up benches, covered in maroon army hessian which had fallen off the back of a gun-carrier. Electricity was provided by a cable running from the home of the mews owner. The main lights were from London's old Harringay arena, supplemented by floodlights improvised from biscuit tins by actor Charlie Roberts. Under Simpson's direction, these helped to create the illusion of a stage much greater than its restricted twelve feet square.

Alan appreciated the paramountcy of theatre lighting for audience involvement: 'In the Pike, with about twenty lights to play around with on a space no bigger than the average No. 1 dressing-room, I had the opportunity of getting the very most in the way of depth and solidity. In other words, I had achieved something in the nature of a 3-D theatre, making the audience feel they were a part of the play and involving them in its action and atmosphere. This question of atmosphere seems to me to be all-important. Once you can establish the atmosphere, everything else follows. But it does lead to extremes in audience reaction, since no one can sit outside the play and enjoy or criticize it on a purely intellectual basis. They are emotionally involved.'

Theatrical friends including Cyril Cusack provided moral support. Journalist R.M. Fox described the emerging premises as 'the spirit of the theatre personified'. In order to save space, the booking office shared the stable across the lane with Dolly, the piebald pony of local deliveryman and Pike cleaner, Frank Doyle. Advertising and printing costs dictated a pithy title, the Simpsons named their theatre the Pike. Alan explained that: 'Like the pikes of the 1798 insurgents, we wanted our theatre to be a revolutionary

force of small means which, by its ingenuity, would stir up the theatrical lethargy of post-war Ireland.'

Liam Millar's Dolmen Press designed and printed the programmes. Cecil Salkeld was another supporter. His daughter Celia was assistant stage-manager when the 60-seat theatre opened in September 1953 with G.K. Chesterton's *She Sits Smiling*. More than the permitted number jammed the creaking benches, including Lords Killanin and Longford, whose girth severely strained already scarce space. But the night was an instant success. The audience acclaimed the cast and the theatre's founders. Reviewers marvelled at the slickness of the costume and scene changing in such confinement.

In December, the Pike staged Ireland's first satirical show, *The Follies of Herbert Lane*. The theatre quickly established itself as a nursery of Irish acting talent. The revues and subsequent productions featured a Who's Who of future Irish stars, such as Donal Donnelly, T.P. McKenna, Anna Manahan, Maureen Toal, Genevieve Lyons, Milo O'Shea and later *Cosmopolitan* editor, Deirdre McSharry. George Hodnett supplied the piano accompaniment. His frequently intemperate pace led to rows with the breathless cast, including Laurie Morton and dancer and costumes and backdrops designer, Pauline Bewick, who remembered: 'The scuffling noise in the warm theatre lights and chatter of the first night arrivals was like a heart stimulant. The noise of talk in front of that curtain, the smoky excitement of the little Pike made Herbert Lane a centre where the heart beat in Dublin, for us anyway. The audience loved it. It was a success. The party afterwards, a huge buzz of self-love exciting us all.'

Carolyn Simpson had worked as Ernie Gebler's typist, before his *Plymouth Adventure* became a best-selling book and film. In May, 1954, the Pike presented Ernie's psychological thriller, *She Sits Smiling*. Shortly afterwards the Simpsons offered to stage a play by Ernie's friend, Brendan Behan, which had been rejected by the two main theatres. Alan Simpson's first 1946 meeting with Brendan was suitably dramatic. Alan's BSA motorcycle was stolen from outside the Gaiety stage door. When he ran across Grafton Street to the studio of Des MacNamara, another Pike enthusiast and costumier, he was so angry that the alleged hard man, Brendan, retreated in fear. Recalling Behan's apprehension, Carolyn Simpson noted: 'He treated Alan with the greatest respect and a certain amount of caution ever after, always saying, when Alan pressed him for a decision: "I'll talk to your Jewish wife about it!"'

It was Alan who came up with the title for Brendan's play about a condemned prisoner who never appears on stage. *The Quare Fellow* was an immediate success and launched Behan's brilliant if short-lived career. Brendan crowned its November 1954 world premiere with a well-lubricated rendition of Sean O'Casey's *Red Roses for Me*. Extravagant headlines proclaimed that the Pike Theatre and he had arrived. The *Times Literary Supplement* said: 'Mr. Behan's prison play *The Quare Fellow*, produced not at the Abbey but at the Pike Theatre, was the most exciting dramatic experience which Dublin has had for many years.'

Brendan Behan at the Pike with some of The Quare Fellow *cast*

Alan Simpson's production and lighting were also lauded: 'I realised that greater resources and adequate space really matter much less in the theatre than artistry and passionate conviction.'

Alan was soon on the trail of another Dubliner. After hearing about Samuel Beckett's new play, *En Attendant Godot*, he immediately wrote to the author in Paris, asking if would allow him to translate the play into English and produce it at the Pike: 'I got a nice letter back, saying that he had himself translated the play for publication in the US and would send me a typescript as soon as it was ready and that I was very welcome to do it in Dublin.'

Waiting for Godot opened in October 1955 to further glowing reviews for both play and theatre. The title became a much-repeated Dublin catch-cry and added further to the Pike's fame.

'What are yous doing?'
'I'm waiting.'
'Waiting for who?'
'I'm waiting for Godot.'
'Have yous tried the Pike?'

Patrick Kavanagh was so enthralled that he saw the play six times. He enthused in the *Irish Times*: 'It is because of its awareness of the peculiar sickness of society and a possible remedy suggested that I like Beckett's play. The remedy is that Beckett has put despair and futility on the stage for us to laugh at them. And we do laugh.'

Godot won several awards and became the second play in Dublin's history to have 100 consecutive performances. The Pike team was invited to stage it at the much larger Gate in March, 1956. R.M. Fox wrote in the *Evening Mail*: 'The setting, painted by Mira Burgess and constructed by Edmund Kelly, together with the lighting and production by Alan Simpson, represents a triumph for the Pike Theatre. It puts Dublin on the world map of drama.'

Though operating on a shoestring budget, the four-year-old theatre was on the crest of a wave, with membership numbering almost 3,000. Carolyn Simpson celebrated: 'Now at last we felt we were really in the Big Time!' Audience potential far exceeded the capacity of the theatre, which did not allow the Simpsons to stage many of their preferred plays. After looking for some time, they found a city-centre premises in Fownes Street, which they believed was suitable for conversion into a 200-300 seat theatre.

State approval followed the Beckett success; the Pike was included in the programme for Ireland's first International Theatre Festival in 1957. The Simpsons announced that they would stage the European premiere of *The Rose Tattoo* by American playwright Tennessee Williams. Set in a Gulf Coast village, the passionate and devout Sicilian-American, Serafina della Rosa, lived with an idealised memory of her late husband. But the truth about his infidelities was revealed and threatened to destroy her, until Alvaro Mangiacavallo's ebullience restored her zest for life. The Pike Newsletter confidently surmised: 'The play has a theme of religion versus primitive superstition and should appeal particularly to an Irish audience.'

Tennessee Williams at work

The Newsletter's optimism about the play's appeal appeared to be well-founded. During its open-

ing week in May 1957, *The Rose Tattoo* received rave notices. The play looked to become the Festival's showpiece. In her first major role, Anna Manahan played Serafina. Pat Nolan was Alvaro and 19-year-old Kate Binchy played Serafina's daughter Rosa. The Irish stage debut of Serafina's goat guaranteed additional headlines. The *Manchester Guardian*, London *Times* and *Sunday Times* acclaimed Alan Simpson's production, the *Irish Press* concluded: 'Once again, the Pike must be highly recommended for giving Dublin a remarkable piece of theatre.'

The Rose Tattoo headed the list of Dublin theatre attractions in the bulletin of the Department of External Affairs. Delighted with the positive image that the Festival was creating abroad, Bord Fáilte sought additional Pike seats for international critics. The Simpsons unexpectedly found themselves in demand for receptions and at the Festival Theatre Club. Impressed by the play's success, the Gate Theatre agreed to host the company and its production after the Festival's fortnight run. The new enlarged Pike would soon be a reality.

But fifteen minutes before the curtain went up on Tuesday evening of the play's second week, May 21, 1957, Alan Simpson received a rude shock. Carolyn called him: 'There's a garda here who wants to see you.' When he went outside, he found an inspector rather than the expected uniformed garda. Inspector Ward informed him that the evening's performance should not proceed unless 'objectionable passages' were removed. Realising that the show was running late, Carolyn left Alan to deal with the inspector and ordered the curtain to be taken up. 'I will have to consult my solicitor,' Alan stalled the garda. Little did either of the Simpsons realise that the diversion within would be nothing compared to the real-life drama which was about to engulf them and their precious Pike.

Alan used a neighbour's telephone to call his solicitor. Con Lehane arrived quickly and copied the document which the inspector read to him but would not allow him to examine. The following day Lehane contacted the Garda Deputy Commissioner asking him to identify the alleged offensive passages. Alan telephoned Lord Mayor Robert Briscoe to see if he, as chairman of the organising Dublin Tostal Council, could intercede on their behalf with the Department of Justice. Astonishingly, Briscoe, who had not been to the Pike, abused him for staging 'such a play'. Alan's Kafkaesque misgivings further increased when, despite their agreement, Lord Longford informed him that he would not now present the play at the Gate. It might prejudice his own re-licensing negotiations.

Setting for The Rose Tattoo, *Pike Theatre, 1957, by Reginald Gray*

In the dark as to the play's offending passages, Alan could only surmise: 'The spark which ingnited the whole affair was the scene in which the widow Serafina rejects the advances of her lorry driver suitor. When a small packet falls from his pocket, Serafina's deep, almost instinctive religious conviction is so strong that, even though her passions are aroused, her disgust at the suggestion that he is proposing to make use of something basically repugnant to Catholic dogma, overcomes her fiery Southern nature.'

The falling of the packet was mimed, as contraceptives were illegal in Ireland. Carolyn Simpson later recalled: 'The detective could not say that a condom had been dropped but he insisted that it was a condom which had not been dropped!'

With no word from the gardaí and Lord Longford already publishing cancellation advertisements, Alan and Carolyn drafted a media statement on Thursday, May 23, in which they reiterated that there was nothing objectionable in the play. That evening, plainclothes gardaí arrived in force in Herbert Lane. Angry at the presence of photographers, four officers in

regulation trilby hats pushed Carolyn and one of the staff out of the way and bundled Alan into the box office. They read an arrest warrant and sped him immediately to the Bridewell, where he was formally charged with 'presenting for gain an indecent and profane performance'. He was placed in a cell to await a court hearing the following morning. 'Are yous in for showing naked women,' a warder enquired.

Shortly before Alan was due to appear in court, Con Lehane informed him that if he were to give an undertaking that there would be no further performance of the play, the whole matter would be dropped. If not, the state would not only proceed with the indictment but would also oppose bail.

Alan recalled: 'Even after the brainwashing effect of my night in the cell, I was still convinced that the play was worthy of the Festival and in no way offensive. If I gave up now, and took the play off, it would be an affirmation of guilt and no one would ever believe that the show was anything but grossly indecent. "Tell them I will give no such undertaking."'

After a sleepless night away from his wife and three daughters, Alan was relieved to see Carolyn, his elderly father, the entire cast of the play and many sympathisers when he was brought up the following morning. His senior counsel pointed out that the defendant had made every effort to identify the offending passages without success. He therefore had not had the option to remove the alleged grounds for complaint. To take off the play would be unfair to him and the cast. The play had been running for almost a fortnight without a single complaint. No offence was admitted and no undertaking could be given.

Luckily for Alan, District Justice Alfred Rochford was a well-known amateur actor and a member of the Shakespearean Society. Despite the prosecutor's repeated assertions of the play's offensiveness and lewdness, and his strenuous opposition to bail, Justice Rochford released Alan on bail until a hearing in July. After his release, Alan, Carolyn, Canon Simpson and the cast of *The Rose Tattoo* posed for photographers and newsreel cameramen.

Meeting his family and friends soothed Alan's battered nerves, but it was to be a short respite. Having previously appreciated any publicity for his theatre, he soon discovered that not all ventilation was good publicity.

He recalled: 'Walking down O'Connell Street soon afterwards, we purchased the early editions of the evening papers. "Alleged Indecent and Profane Performance Charge – Attorney-General alleges play was lewd, indecent, and offensive." These, in inch-high heavy type, were some of the phrases that stared at me from the page. Each story was accompanied by large and easily

recognizable photographs. I felt people looking curiously at me. . . . I had achieved notoriety overnight.'

Having failed to keep Alan in prison, the gardaí next intimidated the cast of the play. Inspector Scanlan called to the theatre and threatened each member with prosecution. After a meeting, they all agreed to continue the play for the remaining days of its planned run. But the Simpsons would not allow Kate Binchy to continue; she was a minor and the daughter of a Circuit Court Judge.

Anna Manahan, who played the part of Serafina, recalled: 'The Pike was such a vibrant and extraordinary theatre which offered a pulsating truth absent in other theatres. And Alan was an actor's director, he gave you room to fly. We all believed we were in a good play, we believed we had done nothing wrong.'

The affair had its comic aspects. Alan Simpson's arrest warrant had been issued by James Joyce's playwright friend, District Justice Kenneth Reddin, whose daughter Lavinia was a member of the Pike staff. The Clerk of the Court, before whom the Bridewell bail bonds were signed, was Austin Byrne who had acted in the theatre's premiere of *The Quare Fellow*. And, while the Simpsons feared that no one apart from the police would visit the Pike on the night of Alan's court appearance, they returned to find a vociferous crowd thronging both theatre and laneway.

Future Tony Award winner Anna Manahan recalled: 'I could hardly conclude my closing words with the cheering of supporters in the lane, led by Brendan Behan singing "The Ould Triangle" and "The Peeler and the Goat"!'

Dubliners were used to seeing Catholic vigilantes demonstrating outside theatres. But on that evening, Herbert Lane was the scene of a spontaneous demonstration rarely seen in the city. Between two and three hundred well-wishers shouted their support and applauded each member of *The Rose Tattoo* cast as they arrived. The throng put an end to any garda plan for further arrests.

Frank O'Connor was a witness: 'A large group of us were waiting outsides the theatre for the arrest of the cast – a handful of theatre-lovers, some newspaper men and a lawyer or two, came to see fair play. Brendan was delivering a long speech in which he said quite truthfully that the country was being depopulated, and all the Government could do was to prosecute a harmless company of actors. Then he sang 'Se Fath Mo Bhuartha' with real feeling. The goat, which was a principal character in *The Rose Tattoo*, emerged on to the

lane, and he shouted: "Never mind the goat! Bring out the xxx peelers!" He sent up to Mooney's at the bridge for a dozen of stout and distributed them among his audience, saying: "Mind the bottles. They'll come in handy for ammunition!"'

The laneway supporters included theatre owner Barry Cassin, actor Thomas MacAnna, Patrick Kavanagh (who would never normally be seen with Brendan Behan), Seamus Kelly better known as Quidnunc of the *Irish Times*, army colleagues of Alan Simpson and even a District Justice, playwright Donagh MacDonagh. Among those who rallied with financial encouragement were director Jim Fitzgerald, Padraic Colum, Des MacNamara, Denis Johnston, Olivia Roberston, Sean O'Casey, Frank O'Connor, Dr. Noel Browne and Lord Inchiquin. Brendan Behan contributed £100 in dirty notes. Producer Phyllis Ryan, another supporter, determined to vindicate the Simpsons and establish 'not just my own company and space, but a society in the theatre which would protect artistic people from being victimised'. Her Gemini Productions later emerged from the ashes of the Pike.

The British theatrical magazine, *Encore*, opened a Defence Fund. Overseas contributors included Graham Greene, Wolf Mankowitz, John Gielgud, John Osborne, Sir Peter Hall and David Krause. Samuel Beckett commiserated: 'Sorry about all your trouble over *The Rose Tattoo*. Bastards, bastards, bastards.' As well as forwarding a generous cheque, Harold Hobson offered to give evidence in Alan Simpson's defence. He wrote in the *Sunday Times* about 'the artistic integrity and high moral purpose of the Pike Theatre's *The Rose Tattoo*'. Notable absentees from the list were Dublin's main theatres, resentful of the Pike's success and concerned about involvement should Alan Simpson be found guilty – a practical consideration in a country dominated by the Catholic Church and its vigilantes.

But who had caused Alan Simpson to be prosecuted and why? As usual in Dublin, fingers immediately pointed to Archbishop McQuaid. He and his Knights of Columbanus cohorts were engaged in a highly-publicised nationwide campaign against 'evil literature'. It was likely that censorship of the theatre was also on their agenda. But the plot was much more Machievellian. It took almost half a century before the real culprits were revealed, with the publication of State Papers and the book *Spiked* by Gerard Whelan and co-writer Carolyn Swift, the definitive account of *The Rose Tattoo* prosecution.

The original indecency complaint had been made by a Catholic activist, who incorrectly claimed that the play had been banned in American cities.

His TD relayed it to Oscar Traynor, the Minister for Justice. The TD pointed out that, ominously, the activist had copied his complaint to Archbishop McQuaid. It was this which panicked the minister and led to the prosecution of Alan Simpson. An official advised the minister that if there was any delay in prosecuting the case, 'you may be faced with a demand – possibly a demand made in public – from any one or more of several sources, including the archbishop, for action, and that you would then be put in a position of having either to take no action . . . or to give the impression to the public that you acted only at the dictation of the archbishop or of somebody else.'

The Rose Tattoo complaint could not have been made at a worse time for Alan Simpson. Aware of how Ireland's image had been tarnished by the indiscriminate banning of books, the Minister of Justice had finally decided to end the usurpation of censorship control by the zealots who had ruled the Censorship Board since its inception. Ironically, the main supporter, if not instigator, of the minister's reform campaign was none other than Bertie Smyllie's wartime antagonist, Thomas J. Coyne, whom the *Irish Times* editor described as 'one of the shrewdest and subtlest brains in this beloved country of ours'.

Now Secretary to the Department of Justice, Coyne sought to implement more objective government control in place of blanket religious-led censorship. Part of the Catholic Right's reaction to the new ministerial resolve was the carefully orchestrated campaign against so-called evil literature, which Archbishop McQuaid claimed in a special Pastoral Letter was 'flooding' the country. Were the minister to ignore the complaint about the Pike, he would allow McQuaid and his supporters a perfect opportunity to demonstrate that it was they alone, and not the government, who could protect the country from both indecent plays and literature. It was for this reason that the minister sent Gardai to order Alan Simpson to take off his play. Citizens usually yielded to church and state intimidation in those days. The minister never anticipated that Alan would refuse to comply.

A year after his arrest, District Justice Cathal O'Flynn decided in June 1958 that Alan Simpson had no case to answer. In a scathing summary, the judge pointed out that, far from being banned, the book of *The Rose Tattoo* was freely on sale in Ireland. Referring to the ordeal which Alan Simpson had endured, he implied that the prosecution had attempted to commit him for trial on the basis of highly dubious evidence.

He concluded: 'I can only infer that by arresting the accused, the object would be achieved of closing down the play. But surely if that were the

Pike Theatre staff, friends and supporters following the court case over The Rose Tattoo; Alan and Carolyn Simpson are in the centre

object, nothing could be more devastating than to restrain the production before even a hearing is held. It smacks to me of the frontier principle "Shoot first and talk after."'

The judgement marked long-overdue vindication for the Simpsons. Congratulatory telegrams poured in from home and abroad, including Pike graduates Donal Donnelly and Lelia Doolan who were now working in London. The Simpsons celebrated with a party at their theatre, to which the critic Brian Fallon later paid his own tribute: 'Undoubtedly, most of the laurels for the decade belong to the gallant little Pike; for its staging of Behan's masterpiece, for mounting Beckett's *Waiting for Godot* the following year and for its 1957 performance of Tennessee Williams's *The Rose Tattoo.*'

But Cathal O'Flynn's pronouncement arrived too late to save the Pike. Its reputation had been ruined. Its membership plummeted in one year from 3,000 to 300. The media reportage of Alan Simpson's innocence fell far short of the earlier sensational headlines. Though Moore Street traders shouted 'Up *The Rose Tattoo!*' and refused to charge Carolyn for her fruit and vegetables, many uninformed people felt that there had been no smoke without fire. Rumours abounded of the Pike's nude shows and indecent performances. Social ostracisation accompanied bankruptcy. Former friends turned their backs on the Simpsons; they were called names in the street.

The affair also contributed to the breakdown of their marriage. Alan Simpson moved to London, where he produced James McKenna's successful Dublin play, *The Scatterin'*. But he and Carolyn cooperated in a bitter-sweet 1962 restaging of *The Rose Tattoo* at Dublin's Eblana Theatre by Phyllis Ryan's Gemini Productions. This time there was no police presence. Ireland was changing. Anna Manahan stood between Alan and Carolyn on the opening night, as the audience cheered and saluted them with flowers. Phyllis Ryan achieved her mission to vindicate the Simpsons: 'We packed out the theatre for three months.' It was fitting that one of Alan Simpson's final successes was with a play by the man whom the Pike had catapulted to fame. This was Brendan Behan's unfinished work, *Richard's Cork Leg*, which Alan completed and directed during the 1972 Dublin Theatre Festival and at London's Royal Court Theatre.

Alan Simpson died in 1980, without knowing that he had been a pawn in a political power struggle. Carolyn Simpson eventually found work with RTÉ as a scriptwriter and also established herself as an author of popular children's stories. She died in 2002, shortly after completing her book with Gerard Whelan.

Artist Noel Lewis grew up within earshot of the bells of St Bartholomew's Church and knew both its rector and his son: 'Like the fearless John Yeats, Alan inherited his objectivity and strength of character from his broadminded father, Canon Simpson. It's nauseating to think that the fundamendalists of the time could be so het up about alleged indecent literature and theatre, while unfortunate children were being abused in schools and churches up and down the country. Alan, however, would be the first to laugh at any image of him as a Socratic martyr! With his regulation haircut and habitually neat attire, he was no wild Bohemian proferring two fingers to the establishment. But he boasted a spirit of enquiry and rare resilience which, as events proved, strengthened rather than weakened in the face of intimidation. It's thanks to his courage and consistency and a handful of individuals like him, that the shackles were finally lifted from our literature and theatre.'

Chapter Fifteen

BAGGOTONIA'S ARTISTS

High time that Irish art and artists were celebrated in the same way as we have acknowledged our writers. – John Taylor

'ART WAS NEVER RATED HIGHLY IN THIS bloody country,' sculptor James McKenna buttonholed an editor one afternoon in Merrion Row.

'A friend of mine once wondered if we should all have gone into auctioneering or doctoring. The public and the media were always more attuned to writers and literature than to the visual arts.'

'– It's a matter of space,' his victim interrupted.

'Space? If Brendan Behan dropped his trousers in Duke Street, they would know about it in New York within the hour. The only publicity we ever got was at an exhibition opening – if we were lucky. Otherwise, only when we got into a fight or were thrown out of a pub or the Arts Club. Yet, artists always outnumbered writers here...'

'Look, my bus!' the editor sprinted aboard a fortuitous number 10, pursued by a volley of artistic endearments.

Paul Henry and fellow-painter Arthur Power also complained that most of the books on Dublin commemorated poets, playwrights and writers to the exclusion of artists. Yet, as they and McKenna protested, there was an abundance of engaged artists. And, unlike many writers, the painters were more in tune with international movements. From the mid-nineteenth century, a great number of Irish artists studied in France. So many Irish women from Mainie Jellett to May Guinness graduated from Cubist Andre Lhote's Paris studio, that they were referred to as 'Lhote's Daughters'. James Joyce and Samuel Beckett embraced Modernism in France. But infinitely more

women artists, like Jellett, Evie Hone and Norah McGuinness, returned from there to inform a less receptive home audience.

Before them, Edith Somerville, Violet Martin and Sarah Purser had worked in Paris and Brittany with John Lavery, Aloysius O'Kelly and Carlow's Frank O'Meara. Insecurity and loneliness were also regular companions. Two artists never returned. Helen Trevor died of a heart attack in her Montparnasse studio in 1900. Sculptor Nuala O'Donel exhibited with Amadeo Modigliani and George Rouault at the Societe du Salon D'Automne. But she committed suicide in 1911 after a misunderstanding with Auguste Rodin, with whom she had worked for many years: 'He has grown very indifferent, and I feel ill and discouraged.'

Baggotonia was Dublin's art hub, with its galleries and vast population of painters. Baggot Street was the birthplace of the haunted Francis Bacon, who lived in constant fear with his family during the Irish Troubles. Kildare Street's Municipal School of Art was Ireland's oldest academic institution after Trinity College. Lady Morgan from the same street became one of four important nineteenth century art historians, with Margaret Stokes, Anna Brownell Jameson and Sir William Armstrong, biographer of Gainsborough and Sir Joshua Reynolds. The Academy of Christian Art was based in Upper Mount Street. Muriel Gahan's Country Shop on St. Stephen's Green boasted a permanent exhibition of art and handcrafts. The Arts Council dispensed carefully chosen patronage from the south side of Merrion Square, whose railings now boast a regular Sunday display of paintings. The nearby National Gallery provided shelter and sustenance to generations of indigents, including Samuel Beckett. And a grateful George Bernard Shaw, who presented it with the multi-millon pound royalties of *My Fair Lady*: 'I am one of those whose whole life was influenced by the Dublin National Gallery, for I spent many days of my boyhood wandering through it and so learned to care about art.'

Ireland's first public gallery of modern art, the Dublin Municipal Gallery, opened in 1908 in Harcourt Street, to the west of Baggotonia. The gallery was founded by Lady Gregory's 33-year old nephew, Cork-born Hugh Lane, a picture restorer who became an early collector and dealer of Impressionist paintings. Stimulated by George Moore's enthusiasm, Lane hoped that Dublin Corporation would build a gallery to house his gift of works by Degas, Manet, Morisot and Renoir. Sadly, the Corporation declined and he transferred the collection to London's National Gallery. Before sailing to his death in the *Lusitania* in 1915, Lane wrote a codicil to his will, returning the

paintings to Dublin. This was unwitnessed. The result was a battle of words between British and belatedly repentant Irish art authorities, which lasted until 1959 when agreement was reached to rotate the works beween the two countries.

Jack Yeats was Dublin's most successful twentieth century painter and the first Irish artist to hold one-man shows at London's National and Tate Galleries. He followed no fashion or movement but, from pen and ink sketches of provincial scenes and events, he proceeded to thickly painted and melodramatic visions, which captured the imagination of both local and international audiences.

Portrait of Hugh Lane, founder of Dublin's first gallery of modern art, by John Singer Sargent

Patrick Kavanagh wrote: 'His fantastic humour is one of the two million points by which he is to be distinguished from the nest of insects who live in synthetic garrets and who paint the queerest and most depressing nothings. I feel it is blasphemy to mention such lousy creatures in the same breath with a genius like Jack Yeats.'

The artist lived from 1929 until his death in 1957 at 18 Fitzwilliam Square, a few doors from Dr. Robert Collis, who encouraged *My Left Foot* author Christy Brown. Like Gwen John during the lifetime of the formidable Augustus, Jack was also overshadowed by his Nobel Prize-winning brother. But, less aloof than W.B., he became a popular Dublin figure, in his waisted long overcoat and black hat with turned-down brim. His visitors included fellow-painters Sarah Purser, Oscar Kokoschka and Henry Tonks. Frequent caller Samuel Beckett was an early devotee: 'He is with the great of our time, Kandinsky and Klee, Bellmer and Bram van Velde, Rouault and Bracque, because he brings light, as only the great dare bring light, to the issueless predicament of existence.'

Yeats had a special affection for tramps and travellers, whom he regarded as symbolic of the whole human odyssey. Author Terence de Vere White visited him in the Portobello Nursing Home, before he died at the age of 85. The artist told him that he had prepared his last words: 'I have travelled all my life without a ticket: and, therefore, I was never to be seen when inspectors came round because I was under the seats. When we are asked about it all in the end, we who travel without tickets, we can say with that vanity which takes the place of self-confidence: even though we went without tickets we never were commuters.'

Thomas Kinsella lamented his death:

> Standing stone still on the path, with long pale chin
> under a broad-brimmed hat, and aged eyes
> staring down Baggot Street across his stick.
> Jack Yeats. The last.

Cecil ffrench Salkeld boasted a background as colourful as Yeats's palette. Born in Assam in 1904, Cecil claimed: 'My first language was Gaelic, which I learned from our nanny. English was my third, after Hindustani.' Cecil's mother, Blanaid, was a poet and actress, his father worked in the Indian Civil Service. Rabindranath Tagore was a family friend and privately published two volumes of Blanaid's poetry. When her husband died, Blanaid and young Cecil settled in Dublin in 1909. Kate O'Brien, Arland Ussher, Patrick Kavanagh and Brian O'Nolan were regular visitors to their Fitzwilliam Square home.

Cecil was a precocious artist. After studying under Seán Keating at the Metropolitan School of Art, he went to Kassel in Germany, where Samuel Beckett also sojourned and where the brothers Grimm penned their *Fairy Tales*. Influenced by Otto Dix and New Objectivity movement, Cecil displayed his work in Dusseldorf with Fernand Leger and Andre Matisse. Returning to Ireland with his new wife, Irma Taesler, he won the 1926 Taylor Scholarship and exhibited with the New Irish Salon and the radical Dublin Painters' Group. The *Dublin Magazine* wrote of his 'original, sombre palette, intellectually rather than emotionally conceived'.

Cecil, whose daughter Beatrice married Brendan Behan, also wrote poetry and plays. Kate O'Brien described him as 'a man of too many gifts – none of which were sufficiently strong to control him'. He contributed to *The Bell* and wrote on the philosophy of art for Francis Stuart's *To-Morrow*, as well as founding the Gayfield Press which published Austin Clarke and launched

Ewart Milne's poetry career. His Glencree cottage was frequented by Joseph Campbell, Padraic O'Conaire and many fellow artists. Guests occasionally swam nude in the nearby river, where Samuel Beckett lost his watch one night. Cecil, who died in 1969, did not match Jack Yeats's productivity. Like Oblomov, he spent much of his later life in bed, reading or discussing his many artistic projects. Beckett recalled one visit: 'Cecil was vibrating in bed, with triple concerto, full length verse play, from which he read me an extract.'

Flann O'Brien immortalised Cecil in *At-Swim-Two-Birds* as Michael Byrne, painter, poet, composer, pianist, master-printer, tactician, and authority on ballistics:

> 'You're a terrible man for the blankets,' said Kerrigan.
> 'I'm not ashamed to admit that I love my bed,' said Byrne.
> 'She was my first friend, my foster-mother, my dearest comforter...'

Cecil's most famous work is *The Triumph of Bacchus* series of murals in Davy Byrne's pub. Dublin, however, proved too convivial for him. Work was sacrificed to Bacchus and conversation. *Martello's* Maureen Charlton surmised that he must have felt isolated in provincial Dublin, after the hectic communal life and spirit of enquiry of the German schools. Poet Robert Greacen lamented: 'The multi-talented Cecil was an amazingly well-informed man, a playwright and publisher as well as an artist. But, sadly, he preferred the bottle and good company to hard work.'

Ireland's women artists positively embraced hard labour. Prominent among the early Modernists were Mainie Jellett, Evie Hone and Mary Swanzy, who were encouraged by the equally industrious Sarah Purser. Born in 1848, Purser first studied at the Metropolitan School of Art. She blazed a trail to Paris in 1878, ahead of Rose Barton, sculptor John Hughes, Richard Thoman Moynan and the Impressionist Roderic O'Connor, who painted in Brittany with Paul Gauguin.

Paris was then the centre of the art world. Studying at the Academie Julian in Montmartre, Purser met Berthe Morisot, Edgar Degas and Marie Bashkirtseff, who mentioned her in her Journal. Author Elizabeth Coxhead said that, at thirty, Sarah 'was the oldest and most serious of the band, with no time to waste on cerebral love affairs, and agonies of the soul, nor the raging jealousy that Marie felt for superior talent.' Returning to Dublin in 1880, Purser's friendship with the Gore-Booth family led to an embarrassment of

commissions. 'I went through the British aristocracy like a dose of measles,' she commented.

Purser moved in 1887 from her first Leinster Street studio to Harcourt Terrace, beside the Grand Canal. Among those she painted were W.B. and Jack B. Yeats, Douglas Hyde and Sir Roger Casement. Purser encouraged young artists such as Beatrice Elvery and helped to organise Ireland's first exhibition of modern art in 1899. Four years later, she set up An Tur Gloine (the Tower of Glass) studio at 24 Upper Pembroke Street, at the instigation of devout Catholic Edward Martyn. An Tur Gloine revived the art of stained-glass in Ireland and led to the emergence of the innovative Harry Clarke. Valuable commissions stayed at home and ensured employment for such distinguished artists as Wilhelmina Geddes, Ethel Rhind, Michael Healy and Hubert McGoldrick. St. Ann's in Dawson Street, burial place of wit and poetess Felicia Dorothea Hemans, features examples of their work (and more stained glass per square metre than any other city church).

Sarah Purser played a key role in Irish art for seven decades, and painted until her mid-eighties. With Lady Gregory's support, she campaigned for the return of the Lane pictures to Ireland. As well as encouraging the early Cubists, she welcomed the White Stag group from wartime England at the age of 90. Shortly before she died, she went up in a plane with Oliver St. John Gogarty to survey her house and surrounding Baggotonia. Despite her fragility, she expelled a burglar: 'How dare you come into a lady's room?' Her friends believed it was art which killed her in 1943 at the age of 95. She collapsed while telephoning President Douglas Hyde about his badly designed image on a new postage stamp.

Mary Swanzy, who was born in Merrion Square in 1882, was another early Cubist. After studying with John B. Yeats and the Metropolitan School of Art, she went with May Guinness to Paris in 1906. Shortly after another Academie Julian student, the furniture designer Eileen Grey, who spent the rest of her life in France and drove an ambulance in World War I with Oscar Wilde's niece, Dolly. Mary soon became influenced by Braque and Picasso, whose revolutionary work she saw on her visits to Getrude Stein. Forty years later, Mary's work was shown alongside that of Braque and Maurice de Vlaminck at a London exhibition.

Mary was spared the opposition experienced by Violet Martin, whose family feared for her moral welfare when she tried to join her student friend, Edith Somerville: 'It seems I cannot go to Paris without a married grandmother!' A cousin of Maine Jellett and fellow-Paris student, Egerton Coghill,

Edith sketched Louis Pasteur before embarking on newspaper illustrations and landscape painting, which Sir John Lavery commended. Edith, however, remained faithful to her horse and hounds background, she much preferred Stubbs to Mary Swanzy's idols. Describing Evie Hone's teacher, André Lhote, as a 'Cubeast', she regretted the five francs admission fee to an Independents' exhibition. Art's loss was literature's gain, Edith and Violet Martin embarked on a successful writing partnership as Somerville and Ross.

The Left Bank of Paris was a cornucopia of bars, junk shops, art suppliers and small hotels. Artists could be seen painting on the streets. Despite their sometimes indifferent accommodations, the Irish students endorsed the observation of fellow-expatriate, Corkman Robert Gibbings: 'In other countries a man with a beard and a paint-box is an object of suspicion; in France he is a man of rank.' A ferment of ideas with such innovators as Picasso, Rodin and Brancusi, the city provided a liberating experience for the Irish newcomers.

Maximilien Luce's view of the Left Bank of Paris, 1889

Paul Henry, who exhibited at the Salon des Refusés, noted: 'Paris in those years was filled with students from all over the globe, all filled with a high resolve to learn as much as they could and to seize every opportunity to perfect themselves. I often thought that in the free companionship there, and mixing with a large cosmopolitan crowd, I learnt more than could ever be taught by the formal masters in the schools.'

The excitement was not confined to the studios. Famous artists could be seen in the cafes and on the streets. Henry never forgot the day he met James McNeill Whistler in Montparnasse: 'I raised my hat ceremoniously and he, just as ceremoniously, raised his with a kindly smile. I walked home with a strange uplifting of the spirit and I trod among the stars.'

Whistler had shared his first Left Bank lodgings with another Irishman, medical student turned revolutionary, John O'Leary. Whistler's most famous

model was his mistress, Irishwoman Joanna Heffernan, whose luxuriant red hair also turned many a head in Montparnasse, though not that of the artist's disapproving mother. Joanna was the subject of Courbet's erotic *L'origine du Monde* and *La Belle Irlandaise*. She was upholding a national tradition. Marie-Louise O'Morphi, Paris-based daughter of Irish parents and mistress of Louis XV, posed for some of art's most erotic nude studies by the eighteenth century painter, Francois Boucher.

Paris also introduced three Irish artists to their future spouses, and a duel was fought over one student! Constance Gore-Booth, known as 'Velo' because she always travelled by bicycle, met the dashing Ukrainian Pole Count Casimir Markievicz in 1899. The widowed Casimir was a champion cyclist and an accomplished fencer. After a Frenchman apparently insulted Constance, Casimir challenged him to a duel and wounded him in the thigh. Casimir exhibited *Constance in White* at the Grand Palais Great Exhibition of 1900, the year the couple married.

Paul Henry also met his future wife, fellow-artist Emily Grace Mitchell, on the Left bank. Dairin Vanston fell in love with a law student from Costa Rica and married in Paris in 1924, three years before 17-year-old Francis Bacon's pivotal first visit, which propelled him into art. Bacon lodged at the Hotel Corneille, where John Millington Synge and James Joyce had also stayed. Four other Irish artists who knew Montparnasse well were Lady Gregory's son, Robert, who perished in World War I, Dermod O'Brien from Limerick, Waterford's Arthur Power and Cork sculptor Seamus Murphy, who exhibited at the Paris Salon.

Another Irishman who had earlier exhibited at the Salon was Dubliner Aloysius O'Kelly, brother of a Parnellite MP. A skilled engraver with deep sympathy for the dispossessed of Connemara, O'Kelly's *Illustrated London News* studies of Irish evictions and western scenes influenced Vincent van Gogh and increased continental awareness of Ireland's political problems. Like John B. Yeats, O'Kelly emigrated to the US, where he died north of New York in 1936.

Polio victim Evie Hone and Mainie Jellett, fellow-students in London, crossed to Paris in 1920. Friends of Eileen Gray, the pair first studied with Andre Lhote, who was influenced by the pioneering Paul Cezanne. They then enrolled with Albert Gleizes, who had developed a form of non-representational art based on geometric principles. Apart from her Cubist expertise, Evie Hone also established herself in An Tur Gloine as a stained glass virtuoso, in the style of the Expressionist Georges Rouault. Hone's monumen-

tal *Crucifixion and Last Supper* east window in Eton College gained her an international reputation. Albert Gleizes later insisted that Hone and Jellett had helped as much to guide his course as he had theirs. The Irish pair's arrival at a crucial stage of his career had forced him to clarify his Cubist theories. Hone and Jellett were followed to Paris by fellow-Dubliners Hilda Roberts and Stella Steyn, the only Irish artist to study at Germany's Bahaus. Friends with Samuel Beckett and James Joyce, Steyn illustrated *Finnegans Wake* in the literary journal *Transition*.

Mainie Jellett became the best known of the later Paris graduates. Like childhood friend Elizabeth Bowen, who later abandoned the brush for the pen, she was introduced

Mainie Jellett's Decoration

to art by John B. Yeats's daughter Elizabeth. A fan of the Impressionists, she first encountered Cubism in Paris at the age of 24. For the next decade, the persistent Mainie spent several months each year at Gleizes' studio.

Convinced that the apparent depth gained by the use of perspective was the function of sculpture, not painting, she noted: 'My aim was to search into the inner rhythms and constructions of natural forms; to create their patterns; to make a work of art a natural creation complete in itself, based on the eternal laws of balanced harmony and ordered movement. I sought the inner principle and not the outward appearance.'

But the search for the 'Inner Principle', the return to a two-dimensional surface and the lack of a subject, bewildered Irish audiences who had been weaned on traditional art. In 1923, Mainie's abstract *Decoration* caused consternation when it was exhibited at the Society of Dublin Painters show. One journal referred to its origins as 'artistic malaria'. Mainie returned to exhibit in Paris, before teaching art in Cork and Dublin. Countering misunderstanding and prejudice, she wrote and lectured on abstract art, and helped to form a bridge between Irish and continental painting. The gov-

ernment commissioned her to design and decorate the Irish pavilion at the New York World Fair in 1939. A year before her untimely death from cancer in 1944, she co-founded the Irish Exhibition of Living Art as an antidote to the conservative RHA.

Despite the gradual acknowledgement of Mainie Jellett and fellow-artists, Ireland's conversion to Modernism was a slow process. Occasional art critic Brian O'Nolan claimed that most of the pictures in the National Gallery were fakes and that if one scraped away a square inch of a certain 'Goya' one would find a banner from a 1903 Wexford Irish language demonstration. He scolded Dublin Corporation in 1942 for the Municipal Gallery's refusal of Rouault's 'Christ and the Soldier': 'The picture is executed in the modern manner, and could not be expected to please persons whose knowledge of sacred art is derived from the shiny chromo-lithograph bondieuiserie of the Boulvard Saint Sulpice, examples of which are to be found in every decent Irishman's bedroom. The members of the Corporation are elected to discharge somewhat more physical tasks, such as arranging for slum clearance and the disposal of sewerage. Why must the members trespass in other spheres where their intellect equipment cannot be other than inadequate?'

Patrick Kavanagh was another critic. No Modernist, he described Edward Delaney's Dame Street statue of Thomas Davis as one of the ugliest he had ever seen. 'What a comment on the new Ireland when we think of the beautiful equestrian statues that our barbarians blew up. And this is our replacement!'

Unfortunately, he did not survive to admire Oisin Kelly's *Children of Lir* and other public sculptures. The move from Academicism to Modernism was further boosted by the 1939 arrival of the White Stag group. Terence de Vere White remarked: 'Mainie Jellett made some converts among the young and earnest, but shock tactics were needed if Dublin was to wake up, and these the White Stag provided. Uninhibited by Dublin backgrounds, they butted their way into the public consciousness, living witnesses of something if it was not always quite clear what.'

The White Stag members had travelled and painted on the continent. They provided a stimulating link with the outside world and with the Bloomsbury set, with whom they had also been involved. The pacifist group was founded by Kenneth Hall and Basil Rakoczi, each the son of an Irish mother. Though they made frequent trips to the west of Ireland, they settled at 34 Lower Baggot Street. Rakoczi insisted that their 'Subjectivist Art' encouraged

an exploration of psychology and modernist ideas, rather than any particular style. The Dublin middle classes repelled Rakoczi but the watershed of the 1940s gradually opened Irish minds to new ideas. His group influenced many young artists including Patrick Scott, Ralph Cusack, Gerald Dillon and Paul Egerstorff. With borrowed pictures, the group also introduced Dubliners to the works of Raoul Dufy, Juan Gris, Picasso and Rouault.

The deaths of close friends by war and suicide affected both Hall and Rakoczi, who lived under constant fear of deportation. But, encouraged by Mainie Jellett and Arthur Power, they continued to stage exhibitions and events at 6 Lower Baggot Street from 1942 until the end of the war. Their activities also stimulated the foundation of the Irish Exhibition of Living Art in 1943, by a group including Sybil Le Brocquy, Jellett and Norah McGuinness. Good news for the likes of George Campbell, Letetia Mary Hamilton, Colin Middleton and Nano Reid. With Yvonne Jammet an enthusiastic member, group artists enjoyed a discount at a famous Nassau Street restaurant. An unlikely Living Art exhibitor was Edward McGuire, whom critic Brian Fallon regarded as possibly the finest portraitist since John Butler Yeats. Like Yeats, he left an invaluable record of such literary contemporaries as Paul Durcan, Michael Hartnett, Seamus Heaney, Michael Longley and Pearse Hutchinson.

Nevill Johnson was another English visitor. His flowing white mane earned him the title, 'Lion of Leeson Street'. Together with many paintings, he repaid his adopted city with a prize-winning photographic record of shawled women, skipping children, second-hand clothes shops and pawnbrokers. Neville himself was no stranger to indigence. He thought his food necessities were satisfied when a musician friend arrived with a handcart of fire-damaged cans from an auction house on the quays. They opened the first unlabelled tin. It contained rhubarb. They attacked the second can. More rhubarb, as had the third and all the other cans.

The Englishman taught wealthy ladies to subsidise his painting. More serious students included Brian Bourke, who remembered: 'Nevill was the only one who taught the technicalities. Many students could draw but couldn't prepare a canvas.' Despite his work ethic, Neville quickly adapted to Baggotonian ways. He remembered one night playing dice in Kildare Street: 'The Feis Ceoil was in progress and fleet dancing men from Galway had come to town bringing their poteen with them; Seamus Ennis made great use of his tin whistle and Eddie Lindsay-Hogg graced the house, elegant with buttoned turn-ups to the cuffs of his jacket. It was dawn when I made for my room off Hatch Street.'

Nevill cast a lean eye on the business of art, having worked on several paintings in Belfast which John Luke subsequently signed. He visited his neighbour Patrick Swift, where Lucien Freud and Edward McGuire also worked: 'His immortality stood clear before me the first time I entered his studio: there rested on the easel a large virgin canvas signed already "P. Swift." No identity problem there.'

When Nevill left Convent Place, he rediscovered unfinished canvases he had bought from a well-known painter: 'Unfinished, that is, till I too started packing. It may be news to him and others that I finished, signed, and sold two of these before I went on my way.'

John B. Yeats would surely have approved the 1940s letting of his Stephen's Green studio to another portraitist and debater, Sean O'Sullivan. Educated in London and Paris, the flamboyant Corkman enlivened Dublin from 1930 until his death in 1964. Rarely without a silk cravat, he became the youngest artist to be elected a member of the Royal Hibernian Academy at the age of 25. He painted virtually every political personality and eminent churchman.

Portrait of Sean O'Faolain by Sean O'Sullivan

Commissions flooded in from society women, after the makers of Pond's Cold Cream contracted him to supply drawings of Irish beauties. Literary sitters included drinking companions Samuel Beckett, Brendan Behan and Brian O'Nolan, whose *An Beal Bocht* he illustrated. James Joyce, whom he sketched in Paris in 1936, was impressed that Sean could speak French as fluently as Gaelic or English.

Sean was a noted raconteur and fond of quoting poetry when drunk. Literally the voice of art in Dublin, his booming mellifluous tones could be heard on the streets from the depths of such pubs as Neary's and the subterranean Dawson Lounge.

Peter Kavanagh recalled: 'Sean was a very pleasant man. He played an important part in Patrick's development, when he introduced him to John Ryan and ensured that *Envoy* Diary mouthpiece. But he was irascible when drunk. He did a romantic drawing of Patrick, which Patrick didn't waste any time in selling to a collector. Sean was furious!'

The artist's socialising resulted in missed deadlines. Owen Walsh remembered a typical panic: 'One evening I carried Sean home blind drunk. "Will you look after that virgin for me?" he asked, as we fell in the door. My heart and everything else rose at the thought of some ravishing lady he'd hidden in his studio. But it turned out to be a convent commission for a Blessed Virgin which he should have completed that day. I had to work flat-out all night without a wink of sleep. As the Louth nuns hammered on the door, I woke up Sean in time to sign the picture.

'"You have a great way with Virgins," he told me, and filled his first pipe of the morning.'

Owen Walsh was one of Baggot Street's best-known artists from the 1950s onwards. He courted actress Celia Salkeld and was one of her father, Cecil Salkeld's, boon companions: 'Many a time, we took the two sides of Waterloo Road as the Chrysler went on auto-pilot on our way to his place in Morehampton Road.' A colourist influenced by Matisse, Owen was impressed that Cecil had once exhibited with the master. Owen won Ireland's first travelling scholarship at the age of 21 and went on to study and teach in France and Spain. With the true artist's disregard for the material, he pawned a Gold medal he was awarded in Paris. Like Sean O'Sullivan, he was frequently in trouble, as Paul Durcan related:

> At closing time on Saturday nights in winter,
> Off Grafton Street in Dublin in the 1950s,
> He was a young creamy bull stamping his hooves
> On pavements, goring, butting, bellowing, bleeding,
> Straining at the neck and being restrained
> By stringy maidens in waist-length plaits.
> Monday mornings he'd appear in the District Court,
> Eyes closed, lips swollen violet to the cheekbone.
> Thursdays he'd draw a beauty with charcoal
> And with crayon he had the nerve of Degas.
> We watched and waited
> While he chose New York or Paris or Rome.

With the encouragement of Robert Gibbings, the Dolmen Press of Owen's neighbour, Liam Miller, employed some of the best artists of the period. These included Ruth Brandt, Juanita Casey, Leslie MacWeeney, Elizabeth Rivers and Eric Patton. Soon to become collectors' items, the Dolmen editions of old and modern Irish writers were printed in the basement of 23 Upper Mount Street. Close to the former home of Ireland's premier sculptor, John Hogan, this Georgian retreat boasted Dublin's greatest concentration of artists.

Brian Lalor reiterated in *Ink-Stained Hands*, his history of the Graphic Studio Dublin: 'Cultural revolutions and movements tend, as in the bohemian quarters of fin-de-siecle Paris, Weimar Berlin or London's Bloomsbury, to develop from hothouse conditions where artists, writers, musicians and intellectuals living in close proximity, generate a ferment from which a movement can emerge. From Barcelona in the 1890s to New York in the 1940s, most art movements have benefited from a community of feeling, the solidarity of a peer group, and the intimacy of a neighbourhood. Graphic Studio Dublin emerged from just such hothouse conditions of a particular location, Upper Mount Street in the very heart of post World War II bohemian Dublin.'

The street's basements and garrets throbbed with the activity of artists who would go on to achieve national and international recognition. These included Ruth Brandt, Charlie Brady and Elizabeth Hickey. Among their neighbours were Elizabeth Rivers in Herbert Place and Dairin Vanston in Mount Street Crescent, where book designer Jan de Fouw also worked. The White Stag artists exhibited at number 30. Graphic Studio Dublin co-founder Patrick Hickey set up his first etching press at number 21. The later and more

permanent Graphic Studio Gallery was designed by architect Peter Stevens, another habitué of Parsons, which supplied the artists' book needs.

Camille Souter recalled: 'A glasshouse complete with a vine graced the garden of the house I shared with my sculptor husband, Frank Morris.' Most of the artistic colony survived less grandly.

Rarely seen without his dark beret, Patrick Pye recalled his time at 41 Upper Mount Street: 'I paid ten shillings and sixpence a week for one small room. Outside my door was a single gas stove which I shared with the large family who lived in the bigger room opposite. Like a village fountain, the stove was a constant focal point, not good for the concentration! And while you may regard *La Bohème* as distant history, a young woman died of consumption in a ground floor room while I was there. The only distraction was the nearby boarding house for very respectable Protestant girls, but Madame French kept a watchful eye on her young charges.'

Pauline Bewick in the 1980s

One aspiring artist who could not afford a boarding house was Pauline Bewick. She lived with her mother, Harry, in a caravan behind an advertising hoarding off Thomas Street. After Des MacNamara praised her work, the 15-year-old enrolled in the National College of Art in 1950. Pauline's dedication to art was joyous and complete; she adapted as enthusiastically to café life and Bohemian ways. Making friends with Leslie MacWeeney and Barry Laverty, Pauline soon sported sackcloth skirts and brightly dyed dishcloth tops. She remembered: 'As I gained confidence in these new surroundings, I became very eccentric, wearing curtain-rings, and on my feet I painted pretend sandals. I still love walking in bare feet.'

Pauline subsidised her studies by singing for £2 a week in the Clover night club, where she met Alan Simpson and Carolyn Swift of the Pike Theatre. From advertising drawings, she quickly progressed to designs for the Pike, the Dolmen Press and Hayden Murphy's *Broadsheets*. Within seven

years of parking her caravan near the College of Art, Pauline shared space in London's Leicester Gallery with Augustus John and Henry Moore.

The proximity of so many artists meant extra custom for Baggotonia's favourite bookshop, where the indigent were afforded an unofficial instalment system. Aidan Higgins recalled: 'Miss O'Flaherty may have run a bookshop hygienic and orderly as a Catholic convent, she the Rev Mother. On the other hand, I remember her being generous, extending credit to the impecunious young music student, John Beckett and handing over an expensive Skira art book on Paul Klee, to be repaid when he could.'

Another Parsons beneficiary was the artist Joan Hayes, who sketched in the pubs and on the streets where, sadly, she died shortly after the shop closed.

A theft by two Irish students made Irish and international headlines in 1956. The controversy over the un-witnessed codicil to Hugh Lane's will had rumbled on for decades. George Bernard Shaw was among the majority who thought the Lane pictures would never be returned to Ireland. Art student Paul Hogan and UCD's William Fogarty, whose coat pocket was never without a volume of poetry, purloined one of the paintings from London's Tate Gallery to focus attention on Britain's refusal to return the collection. 'Byronic Billy' explained: 'We had studied the gallery for a few days and Berthe Morisot's *Jour d'Eté* was the picture we decided to take. It was my friend, Paul Hogan, who actually removed it, I was merely his bodyguard. I covered his back and was ready to anchor the revolving door should any security man rush after us. The nineteen steps to our waiting taxi were long enough – though we still found time to pose for a photographer we had alerted!'

Paul and William got back safely to Ireland and the painting was returned to the Tate days later via the Irish Embassy. As intended, the action reignited the Lane pictures debate and led to successful talks between the British and Irish art establishments. But the pair's service to Irish art went unrewarded. While champagne toasts were drunk inside, William was refused entry to the official welcome party for the pictures. 'I got into the Tate without an official invitation,' he admonished gallery staff.

Owen Walsh observed: 'Wonderful to see the Lanes back, but after our earlier prevarication do we deserve them at all? When George Russell and W.B. Yeats appealed for public contributions for a presentation portrait of Lane in 1906, they got less than half the money needed. Only for Singer Sargent's generosity, Lane would never have got his picture. And as Nora Lever points out, George Bernard Shaw's royalties enriched the National

Gallery but it still hides his statue in a corner. We're an ungrateful bloody race.'

Like the writers who lacked publishers, Irish artists were frustrated by the shortage of local galleries until the latter half of the twentieth century. Leinster Gallery proprietor Loretto Meagher said: 'All the more reason we should remember the few galleries of the period when it comes to recording Irish art history. Long before my time, the Waddington was Dublin's main artistic outlet. Victor Waddington had many contacts and he put Jack Yeats and Irish art on the international map. I worked in the Oriel Gallery, whose proprietor Oliver Nulty and his son, Mark, publicised Grace and Paul Henry, and were also the first to exhibit the works of George Russell, Percy French and Markey Robinson.'

The Dawson, Ritchie Hendriks and later Taylor Galleries were the city's other main exhibitors. The Hendriks displayed such professionals as Barrie Cooke, Paddy Collins and Seamus O'Colmain, famous for his haunting Dublin street scenes, as well as Dutch World War II hero Koert Delmonte, who had embraced Ireland with compatriots Gerrit van Gelderen and Jan de Fouw. The Dawson's stable included the pioneering Nano Reid and Norah

The pioneering Victor Waddington (left) with Jack B. Yeats

McGuinness, while Edward McGuire was an early Taylor Galleries star. John Taylor, who founded the Taylor Galleries when Leo Smith of the Dawson died, said: 'Artists not only led fairly deprived lives then, but they were also severely restricted in having so few galleries in which to display their work. It's fair to say we played a major role in the careers of artists including Louis le Brocquy, Patrick Scott and Camille Souter.'

Deirdre MacDonagh ran the Contemporary Pictures Gallery in the late 1940s in Baggot Street, where Harper's Coffee Shop also displayed paintings. Muriel Gahan's Country Shop on Stephen's Green exhibited art and crafts and provided inexpensive sustenance for local artists and poets for almost half a century from 1930. Mary Lavin based her 'In a Café' story on the Clog restaurant-cum-gallery in Clarendon Street, which was frequented by artists such as Leslie MacWeeney and featured Pauline Bewick's first solo show in 1957. Paintings hung on the red-distempered walls, a notice over the fireplace proclaimed that more were on view in the studio upstairs. If the proprietor was out, regulars helped themselves to coffee from a pot on the gas-ring.

But important as such informal showcases were, artists needed more professional representation. Victor Waddington was without doubt twentieth century Ireland's most important gallery owner. Son of a Scottish professor of oriental languages, Victor's instinctive aesthetic sense, business acumen and charm made him an ideal gallery proprietor. He became Jack Yeats's agent in the 1940s and exhibited his work in London and Paris. Not only did Waddington's South Anne Street gallery promote Yeats, Nevill Johnson and Colin Middleton, it also introduced Ireland to the work of Michael Ayrton, Jacob Epstein and Oscar Kokoschka.

The galleries extended sales and knowledge of Irish art. Inevitably, auction houses arose to fill the demand by private purchasers and investors. The work of once hungry artists evolved into traded commodities. Veteran auctioneer John de Vere White said: 'It's been a long haul but Dublin now boasts three major art auctioneers, while London auction houses also stage sales of Irish art. Overseas interest in Irish painting continues to increase.'

John Taylor concluded: 'Victor Waddington's unique contribution to Irish art is long overdue commemoration. And so is that of our many painters and sculptors. There are plaques all over the place to novelists and poets. But the artists seem to have been forgotten. It is indeed high time that Irish art and artists were celebrated in the same was as we have acknowledged our writers.'

Chapter Sixteen

A Pint for a Woodcut – Harry Kernoff

No artist need go to Brittany or to Holland to paint pictures; he will find plenty down by the docks. – Harry Kernoff

'HK. Two and sixpence, what the hell is this?' Bar owner John McDaid tapped bar manager Paddy O'Brien on the shoulder as he checked the books one night in Harry Street.

'That's for a Harry Kernoff woodcut, "A Bird Never Flew on One Wing".'

'Another one, God blast that leprechaun artist!' John thumped the accounts book.

'Haven't we a flock of them upstairs already? Next time, he pays for his drink like anyone else – and get rid of those bloody birds first thing tomorrow.'

James Joyce boasted that Dublin could be reconstructed from his books. The same could be said for the work of Harry Kernoff. Few recorded the city's streets and inhabitants as warmly or as comprehensively from the 1930s to the 1970s. The artist painted its backwaters with equal felicitousness and captured the vitality and resourcefulness which enlivened Dublin until its destruction by developers. Restored to life, his myriad characters from market ladies and street musicians to dockers and pub philosophers could repopulate the metropolis Joyce knew.

Small, bespectacled and with a prominent chin, Harry's keen and sparkling eyes missed nothing on his daily city promenade. With his ready wit and fund of stories, he became a Dublin character himself. Like most artists

of the period, however, he lived on a rich diet of hope and fresh air. Mirroring Modigliani, he regularly exchanged a picture for a drink in McDaid's and other pubs.

Insisting that Harry was as Dublin as Leopold Bloom, John Ryan said: 'His portrayal of the urban scene as well as the people who inhabit it, seems to contain the same rare ambience that dwells mysteriously in the work of L.S. Lowry, a painter whom he resembles much in feeling.'

Harry illustrated many Dublin Civic Week handbooks. Among the city characters he drew or painted was the 'Toucher' Doyle, who had put the arm on King Edward VII for a fiver at the Curragh Races. Also the *Ulysses* character Endymion and the English-born Lavender Man, who sold artificial lavender and real French letters. And the ubiquitous Pope O'Mahoney, historian and conservationist who regularly cycled around Dublin in his flying cloak. Like James Joyce, Harry shared a friendship with Wicklow-born publican Davy Byrne. And with his former teacher, Patrick Tuohy, who painted the famous portrait of John Stanislaus Joyce. Harry based many pictures on Byrne's Duke Street pub, which still exhibits his portrait of Joyce.

Though no less a Dubliner than Brendan Behan embraced Harry as 'one of our own', Harry Aaron Kernoff was born in London in 1900. His father was Russian and his mother was a direct descendant of the Spanish Abravanel family, one of whom was Chancellor of the Exchequer under Queen Isabella. Harry was fascinated from an early age by the bustle of Shoreditch and the nearby docks. He also developed a second love: 'Even as a child, I had little difficulty in sketching every member of the family.' The docks were neglected in favour of London's art galleries.

When Harry was 14, his family moved to Dublin, where they launched a furniture business. His parents disparaged his interest in art, his father reprimanded him for painting a picture on the window with a butter-tipped finger. But Harry's time as a cabinet-maker was not wasted. The woodworking skills he acquired fuelled his later fluency in woodcuts. He recalled: 'I got little encouragement when I asked them to substitute the art school for the workshop. So, after business, I trailed off to school. In 1923, I had great satisfaction in racing home to tell them that I had won the Taylor Scholarship with a painting called *The Race* – £50 and a gold medal!'

Business held no appeal for Harry. Encouraged by his Metropolitan School of Art teachers, Sean Keating, Harry Clarke and Patrick Tuohy, he decided to make his career in art. Two years after becoming the first night student to win the Taylor Scholarship in both watercolour and oil painting,

A Pint for a Woodcut – Harry Kernoff

St Michael's Hill, Winetavern Street, Dublin 1940, by Harry Kernoff

Harry exhibited at the Arts and Crafts Society. In 1926, he commenced a unique record of almost half a century of annual exhibitions at the Royal Hibernian Academy.

One of Ireland's most prolific artists, he acknowledged later: 'My work in the factory helped too. It gave me staying power. Without it, I might easily have become a futile dabbler blowing soap-bubbles of art. I know now that nothing worthwhile can be accomplished without concerted effort. The workshop helped to teach me that. And no artist need go to Brittany or to Holland to paint pictures: he will find plenty down by the docks.'

Like Corkman Robert Gibbings, Harry was a master of the woodcut, which first thrived in fifteenth century Europe. As well as composition, the woodcut requires forward planning and a feel for the material. A relief is carved out of a block of wood, which works as a negative. The untouched areas stand out in black on the paper, and the cut-out gaps appear as white areas. Albrecht Durer was the first great exponent of the art. Harry was influenced by Durer's realistic line drawings and the simplification of later German Expressionists

such as Ernst Ludwig Kirchner. Harry's perfectly composed *Dublin Cab* was hailed for its brilliant and dramatic lighting.

His evocative woodcuts included *The Melodeon Player* and newsvendors shouting their wares against a gale under Nelson's Pillar. And the now equally defunct number eleven tram as it crested Leeson Street Bridge, headlamps blazing skywards, while pedestrians scurry home under flying clouds. One of his most famous works, *A Bird Never Flew on One Wing*, featured an indomitable *Ulyssian* duo. With jaunty cap and battered bowler, they saluted the viewer with raised tankards, against a background of the names of all the pubs in Dublin.

Bob O'Cathail, another night student and genre painter like Harry, observed: 'Many described Harry as Dublin's Lowry but his pictures were much more alive and individualistic, in my opinion. Like a convert, he loved the city even more than some of its natives. Its streets, laneways, shops, bridges, pubs and theatres. And being an outsider enabled him to celebrate its characters and their idiosyncracies and plumages better than any local. He transformed the most mundane scene with vigour, sympathy and colour. From flowersellers to the washing flapping on a tenement clothesline - and rarely without his trademark stray dog!'

Harry had no time for the obvious or the stereotype. One of Bob O'Cathail's favourite Kernoffs featured a top-hatted elder surveying the world go by from the shade of a nondescript shop. Once-white lace curtains add faded decency to the first of the redbrick tenement's three floors. A young mother in off-cream top and chequered skirt promenades with a baby past the door. In the foreground, an affluent lady in blue suit and yellow hat walks more purposefully. She holds tightly to the wicker basket under her arm, and with good reason. Keeping their own fortunes equally close to their chests, a school of card sharps, caps askew, survey her from the other side of a flaking railings. Bright sunlight transforms the chimneys into lively shadows on the adjacent slanting roofs. Dublin at play in the rare and welcome sun.

When a student once asked him for the secret of a good painting, Harry replied in verse:

> Draughtsmanship, proportions are paramount.
> Spacing and design, then take full account
> Total harmony, balance of colour.
> Will make your picture richer and fuller.
> Impression of mood, an important fact
> Failures are many if this art is slacked.

An avid reader, Harry liked the company of poets and writers. He numbered Austin Clarke, Lyle Donaghy, Frank O'Connor and actor Michael Mac Liammóir among his close friends. The artist appeared in the foreground of Alan Reeve's famous Palace Bar cartoon, close to Dublin's leading literati and *Irish Times* editor Bertie Smyllie. Unlike many of the bar's habitués, Harry was a dooer rather than a talker. He asked education minister Tom Derrig to fund art students, and suggested that the government should purchase pictures with the object of forming galleries in provincial towns. Spanish Civil War veteran Ewart Milne remembered Harry contributing to a collection for anti-Franco socialists. The artist's left-wing leanings ensured the fellowship of Liam O'Flaherty, Peadar O'Donnell, Sean O'Casey and the journalist and First World War Pacifist prisoner, R.M. Fox. And the latter's wife, former suffragette, Patricia Lynch, who wrote *The Bookshop on the Quays* and other children's classics which Harry illustrated.

Apart from the contribution by such diverse figures as Lady Wilde, Edith Somerville and Constance Markievicz, the role of Irish women in the international Suffragette movement has yet to be fully acknowledged. Described as 'the first Irish martyr for the cause', Marjorie Hasler's 1913 death at the age of 26 resulted from police brutality and her imprisonment in London's Holloway and Dublin's Mountjoy prisons. Marjorie was an early member of the Irish Women's Franchise League, which was founded by Hannah Sheehy Skeffington. A friend of Harry Kernoff's, Hanna played an unlikely role in his painting career, when she invited him to travel with a delegation to the Soviet Union in 1930.

Though Harry shared fellow-visitor Bertrand Russell's scepticism of aspects of the workers' paradise, he embraced the ideals of the Association of Artists of Revolutionary Russia. Particularly its accent on the humble labourer and its notion that artists should be the spokespersons of the people's spiritual life. Though an individualist rather than a dogmatist, Harry's subsequent depiction of everyday life reflected the Association's belief that only working people could create cultural change. His studies of toiling Dubliners, travellers and even the currach men of Connemara and the Blaskets reflected this ideal, as much as the influence of Sean Keating who first encouraged his interest in the west. His work also echoed the segmentation and the brilliance of light and shade associated with Russian Constructionalist art.

Brian Fallon referred in a 1974 *Irish Times* review to the socialist realism which inevitably marked the 1930s, with its unemployment and economic hardship. Reviewing Kernoff's work, he noted: 'Yet, what is surprising look-

ing at it now, is its sunshiny, offhand gaiety, its joie de vivre. Of course, that was the quality of the Dublin he grew up in and represents: Dubliners have generally been more cheerful in poverty and adversity than at times of dismal subtopian affluence like the present. It is remarkable how many of his pictures seem to have been painted in the sun.'

The adopted Dubliner said that his painting owed much to Frank Brangwyn, Augustus John and, to a lesser extent, Sir William Orpen. But, while his contemporaries were content with more agreeable scenes, Harry's paintings of industrial subjects provided a tribute to his fearless versatility, as well as a record of vanished Dublin. Estella Solomons and Hilda Roberts painted Marsh's and Trinity Libraries for the 1930 *Book of Dublin*. Harry invigorated the more challenging Jacob's factory, Guinness's Brewery and the giant and equally unadorned riverside Grain Silo. He similarly enhanced the Dock Milling Company's premises and Harcourt Street station's gravel dump.

Harry Kernoff with his portrait of Flann O'Brien

Harry also managed the miracle of enlivening the brooding Liffeyside gasometer, the city's most obtrusive landmark while, on the quays far below, cranes danced over a waiting stack of beer barrels. He spent months in the docks and boatyards of Ringsend. The engines and grimy boilers of its factories and powerhouses came alive in his watercolours. He did not neglect dockland's inhabitants. *Murphy's Boatyard Ringsend* shows seasalts happily painting their beached boats, while a pair of swans assess a local loafer and two girls playing by the water's edge.

The artist's formidable sister, Lina, saw that he drank sparingly. But his wide-brimmed dark hat and black portfolio as tall as himself were regularly seen disappearing into Dublin's best-known hostelries. Though he lived ten minutes away at 13 Stamer Street, Harry spent most of his time around Stephen's Green and the adjacent pubs and cafes. As well as Davy Byrne's, he

visited Bewley's, McDaid's, the Pearl Bar and the Bailey almost every day, as much in search of sitters as sustenance. His diaries record that on other occasions he choose the Dawson Lounge, O'Neill's, the Arts Club and Neary's, where he drank with Kevin Monahan, Owen Walsh or Brian O'Nolan, who devoted a 1948 *Cruiskeen Lawn* column to his work.

Des MacNamara often wondered when Harry found time to paint or eat: 'I used to meet him as early as half ten in the morning at the top of Grafton Street – and often as late that night! He was very Jewish that way, a man of the streets. He was a close friend of Toto Cogley, who opened the Leprechaun Club off Duke Street. Harry painted the leprechauns, who looked the image of himself, only they were ten feet tall! He was always in good humour – unless you mentioned the destruction of old Dublin or the subject of abstract art. Returning from an exhibition of Abstract and Subjective Art, he combusted in a sixty-line denunciation reminiscent of Joyce's 'Gas from a Burner':

> The titles suggested are anyone's guess,
> They spring from the phoney subconscious mess.
> Not worth the charity of Peter's pence,
> Exhibition of puerile incompetence . . .
> It strikes him an infant could do far better,
> With the tail of a dachshund or red-setter.

Friends with both Patrick Kavanagh and Brendan Behan, Harry regularly swam with the latter at the Forty Foot bathing establishment in the shadow of the Joyce tower. And he once went on a cycling tour of Kerry with Kavanagh and a girlfriend, who had insisted to the ever-optimistic poet, 'No chaperone, no holiday'.

Peter Kavanagh recalled the artist as being one of the few people who could make Patrick laugh: 'Harry often had a witty story for Patrick, when they met in Grafton Street. Like a good car driver, Harry was able to scan a quarter of a mile ahead of him. If he saw someone he didn't want to speak to, he would disappear down a side street. He never had a wallet, always just half a crown in his waistcoat pocket to provide his entrée to a pub.'

Though he was essentially a city man, Harry responded warmly to the Irish countryside. His Kerry and Galways sojourns resulted in many landscapes and studies of boatmen and local personalities, and a haunting woodcut of a Gaeltacht funeral. Emulating John Millington Synge, he also cycled to artistic advantage in the Dublin and Wicklow hills. A prolific portraitist,

he painted Brendan Behan, Ben Kiely and Liam O'Flaherty. Mirroring John B. Yeats's record of the Irish Literary Revival, he captured poets John Jordan, Ewart Milne and Lyle Donaghy, and actors Cyril Cusack, Noel Purcell and Ria Mooney. One of the most popular portraits exhibited in Dublin in the late 1950s was Harry's sparkling study of Brendan Behan's father, Stephen. He had to add a hat, however, to his less than flattering study of Flann O'Brien. Unlike John B. Yeats who continually reworked his pictures, Harry was a rapid painter: 'I prefer doing a portrait in one sitting and retain freshness of vision thereby, and avoid a laboured work.'

Nelson's Pillar, GPO, Dublin, by Harry Kernoff

Harry's interest in the theatre led him to design costumes and paint sets for plays such as Lord Dunsany's *The Glittering Gate* and Sean O'Casey's *Shadow of a Gunman*. Friendly with Jack B. Yeats, he illustrated many books and assisted the Yeats family in producing and illustrating their Cuala Press broadsheets. As well as his annual one-man show in Dublin, he also exhibited in Amsterdam, London, Lugano, Paris, Chicago, Nova Scotia and Toronto. The Royal Hibernian Academy elected him to full membership in 1936, he was also made a life member of the United Arts Club. In 1942 he published the first of three limited edition books of woodcuts, and his woodcut of a Dublin cab filled the opening page of the July 25 *Times Literary Supplement*.

Despite his industry, Harry barely survived on his earnings from art. His 1958 diary recorded a net profit of £7.2.11. Eight years later, sales amounted to £415.14s.8p., expenses £362.4s.6p., a net profit of £53.10s.2p. Harry economised on picture frames, sometimes to the detriment of his work.

Brendan Dunne, one of the last remaining framers from the period, remembered: 'A regular and popular customer of our place in Bishop Street, he'd always have an entertaining story and a new view of some corner of Dublin. He was a hard worker, but like many others at that time he never had any money. We selected the most economical wood and agreed on a price

and Harry would always pay us after a sale or an exhibition. But artists were very much at the mercy of the galleries then. Some galleries would insist on using only their own frames for a show – at triple the price!'

The artist's sister complained after his death: 'Art was all that Harry wanted. But it was a shame that his hard work wasn't better rewarded. He was never a businessman and some galleries exploited him. He had a show just before he died but when I asked about the money, the owner claimed to have already paid Harry, which I doubted very much. Another charlatan offered me a song for his remaining work. Luckily, Tom Ryan of the RHA and some others helped me to organise his things after he died and we got everything properly catalogued.'

Harry was unique in that he was universally well regarded in a small city noted for its backbiting. When Samuel Beckett sought news from Ireland during a 1970 *Sunday Mirror* interview, the first person he asked after was Harry. A journalist recalled that the artist 'in conversation is witty at his own expense. He never talks shop, never makes a really unkind remark on a colleague.' Notwithstanding the hardships, Harry's jaunty nature always manifested itself, as it did in his paintings. When asked once if he was happy, he replied: 'I am like one of the Seven Dwarfs, I am happy in my work, leave it at that!' Shortly before he died, he wrote:

> Slowing down a bit after all these years,
> That is natural, no remorseful tears.
> And still conspicuous, by my absence
> From a public press, atmospheric tense.
> Time will separate the good from the bad . . .

Harry Kernoff died, aged 74, on Christmas Day, 1974. The Irish President, Cearbhall O'Dalaigh, playwright John Molloy and fellow-artists John Behan, Charlie Brady, Muriel Brandt, Gerry Davis and Liam C. Martin were among the many who saw him off to Dolphin's Barn Jewish cemetery. It was not long before interest in Harry's work mushroomed. The limited edition books of his woodcuts which he sold for a few pounds became collector's items. Work most unlike his was attributed to him by an enterprising Dublin gallery. His paintings fetched record prices. Leading picture framer Liam Slattery remarked on one of the ironies of Harry's posthumous success: 'Did you ever see such a contrast between the runaway prices and the modesty of the paintings' original frames?'

*The Red Seat Near Baggot Street Bridge, by Harry Kernoff –
where Patrick Kavanagh composed his most famous canal poem*

Liam concluded: 'Harry was lucky to be able to live in the family home, but his existence was more difficult than most. Unlike some, he never followed any fashion, he never courted fame or publicity. It was only shortly before he died that he made a few shillings from broadcasts and lectures. He would regularly hock a print for a pint. If you go into Peter's Pub, you will see three that changed hands there, including one of Roger Casement. It's recognition, I suppose, that one of his pictures sold in London the other day for over £100,000. But it's bloody awful that someone who didn't paint it got more money for that one work than Harry earned during his lifetime.'

Lina Kernoff enjoyed a happy occasion in 1992, when a long-lost painting by Harry was repatriated from South Africa. Complete with a swan and a passing mongrel, it showed the modest brick and wood seat erected beside the Grand Canal to the memory of artists's wife, Mrs Dermod O'Brien. Lina unveiled *The Red Seat Near Baggot Street Bridge* in Harry's favourite Hugh Lane Municipal Gallery. It was a doubly fortunate event. Like his pictures of old Hugenot houses and the Charitable Musical Society's building in School House Lane, the painting is a rare record of the now demolished seat on which Patrick Kavanagh composed his famous canal poems.

Lina acknowledged: 'Harry always had a bit of an eye for the real things of history.'

Chapter Seventeen

IRELAND'S FORGOTTEN WRITER – ERNIE GEBLER

Ernie's fortunes changed overnight, the bike and shack were replaced by vintage cars and Lake Park mansion beside Lough Dan. – Des MacNamara

THE ISLE OF MAN SEEMED THE PERFECT retreat. J. P. Donleavy worked on *The Ginger Man* in a study above the sea. Guest Ernie Gebler enjoyed a welcome respite from the Irish family who disapproved of his friendship with their young daughter.

A car drew up outside the house. Followed by another. Ernie went outside. Valerie Donleavy saw the first blows strike their target. 'Mike, come quick, they're beating up Ernie,' she shouted to her husband.

Gebler knocked one of the party into the sea before he was overwhelmed by numbers. 'That's it lads, give him one in the goolies,' rose a tribal roar from the slipway.

Donleavy raced out the door. His first sight was of a priest waving a crucifix as his colleagues attacked Gebler. The Irish-American's pugilistic reputation had preceded him. 'It's him. It's Donleavy,' warned a look-out.

Bigotry wilted as the Irish-American administered a dose of their own medicine to the Claremen. They finally retreated, throwing a shoeless companion into one of the cars. 'We'll get ye yet, you filthy fornicator,' shouted another, as the posse accelerated away in a cloud of smoke.

Ernie Who? The winners write the histories. Likewise, the survivors. Author Ernie Gebler has had an indifferent press since his death from Alzhe-

imer's disease in 1998. Had the taciturn Dubliner been Padraig O'Gebler and confined himself to native themes, he would undoubtedly have achieved better coverage. He was even ignored by the otherwise excellent *Encyclopaedia of Ireland*, which included many lesser talents. Perhaps his offence was to write a best-seller?

The Dubliner's sacrifices and achievements have also been overshadowed by the reminiscences of those who suffered his less commendable characteristics. As if anyone is perfect. The dusty urn containing his ashes was retrieved from an outhouse as a finale to a recent television documentary. And - shades of Gogarty and Joyce – Ernie is better known to some, not as an accomplished author, but as the former husband of novelist Edna O'Brien. The couple's 10-year marriage ended bitterly in 1964, amid recriminations over his role in her early success.

Ernie Gebler

Far surpassing the sales of Beckett, Behan, O'Connor and O'Faolain, Ernie Gebler was Ireland's most successful author from the 1940s to the 1960s. His historical novel, *The Plymouth Adventure*, sold five million copies and was made into a film starring Spencer Tracy. His play *Call Me Daddy* was adapted for television and earned him an Academy Award in 1968. Ernie's contemporaries J.P. Donleavy and Des MacNamara retained fond memories of the dedicated Dubliner. The former recalled: 'Gebler was, for all his sometimes dour qualities, one of that rare breed, a consummate gentleman.'

Gebler's success was a far cry from Des MacNamara's earliest memory of him: 'When I first knew Ernie, he was working as a projectionist in the Camden Street cinema. He would race in on his bike from a shack in Ashtown and in between changing reels, would spend all his time writing. Sometimes, he would only change a reel when alerted by the howls from the aficionados below! After many years' research, he published *The Plymouth Adventure*, based on the Mayflower voyagers. It became a bestseller and was made into

a film. Ernie's fortunes changed overnight, the bike and shack were replaced by vintage cars and Lake Park mansion beside Lough Dan.'

Born in Dublin on the last day of December 1914, Gebler was the son of a real Bohemian, Czechoslovak-born musician, Adolph Gebler. Adolph originally lived in London. He settled in Dublin after apparently being snared by a streetwise usherette eight years his senior from the Gaiety Theatre, where he was performing in *The Merry Widow*. Adolph regularly caused gaiety himself when he was appointed First Clarinettist with the Radio Éireann Symphony Orchestra. He disliked the conductor and sought every opportunity to annoy him. When resting during a critical moment in a symphony, he would take out a large white handkerchief, spread it over his knees and proceed to clean his instrument. The audience looked at nothing else.

The arts were in the Gebler blood. Adolph's son, grandson and nephew would all become authors. Largely self-educated, son Ernie Gebler worked backstage at the Gate Theatre in the 1930s, before deciding to concentrate on writing. He read voraciously and acquired an encyclopaedic knowledge of literature, astronomy, chemistry and physiology. According to J.P. Donleavy, he could discourse for hours on any subject. No one showed him how to write. With singular discipline, he commenced an arduous apprenticeship. His first stories were published in the religious *Rosary* and *Messenger* magazines. His earliest unrecorded book was a compilation of *In Memoriam* verses, for which he was paid seven shillings and sixpence each. Parental love and encouragement were in short supply. Ernie's mother derided his efforts. He discovered that a house can only accommodate one artist. Insecure about his own achievements, Adolph likewise belittled Ernie's ambitions and tried to throw his typewriter out the window.

But Ernie persisted, like fellow Northsider Brendan Behan, with whom he shared a passion for swimming and politics. Educated on Marx and Shaw, Ernie met Brendan with Des MacNamara on a political demonstration. Des became one of Ernie's closest friends and later allowed him to use his Grafton Street studio for stage-lighting experimentation. Another mutual friend was pianist George Hodnett, whom they visited when he was imprisoned in Mountjoy on a political charge.

Des MacNamara, recalled: 'Some people have described Ernie as an obsessive, as if that were an entirely negative quality. But without that focus against all the odds, he would have remained backstage at either the Gate or the Camden cinema. He simply wrote and wrote and though publication

Ernie Gebler's friend, Des MacNamara

came comparatively late, at the age of 30, it was achieved through singularly hard graft and not by ingratiation.'

In 1945, after many rejections Ernie published his first novel, *He Had My Heart Scalded*, about a Dublin childhood. Like Brendan Behan's debut book, it was immediately banned in Ireland. His success brought Ernie little money but it enhanced his self-belief as a writer. No more would he swap film reels or act as cinema rat-catcher. The Dubliner packed his dictionary and few possessions and took the night mail boat to London. He embarked on a four-year marathon at the British Museum, researching and writing the hitherto unchronicled story of the Mayflower voyage. He subsisted by selling the odd story to magazines such as *Envoy* and filching early-morning milk from adjacent porches. He was also encouraged and supported by the beautiful Sally Travers. She was the actress niece of Mícheál MacLiammóir who had first shown Alan Simpson the manuscript of *The Quare Fellow* by Ernie's friend, Brendan Behan.

The hard work paid off; *The Plymouth Adventure* was published in 1950. The book became a bestseller in the USA, where it was also made into a film. Ernie's social and financial status changed overnight. He appeared henceforth in cap and tweeds. The Camden Street bicycle was replaced by a sportscar, the Ashtown cottage by a 200-acre estate and big house under the Wicklow hills near Roundwood. Despite the drowning of a previous lady of the house, Ernie adapted to fishing and bathing in Lough Dan, which lapped at the edge of the tree-shaded grounds.

His life was further enriched, temporarily, by a new wife. She was Des MacNamara's former girlfriend, the glamourous Leatrice Gilbert, Trinity College student and daughter of American silent movie star, John Gilbert. The couple married in New York in 1950. The new partnership proved a boon for J.P. Donleavy, from whom Lea bought several paintings. Sadly, Ernie's remote manor and the malevolent Wicklow gales proved no match for Holly-

wood and the Californian sunshine. Lea disappeared two years later, together with their baby son, never to return. Once home, she divorced Ernie.

His wife's departure was a shock from which Ernie took time to recover. Normally abstemious, he sought refuge in classical music and Irish whiskey. He became a recluse and neglected his writing. The only positive was that the affair separated real friends from the fame groupies. His loneliness was alleviated by visits from concerned intimates like Des and Skylla MacNamara and Alan and Carolyn Simpson, whom he allowed to milk his favourite cow. Also, Brendan Behan and J. P. Donleavy, who forgave him for using his larger paintings to plug holes in a fence. A short time later, when Donleavy was missing Ireland in McCarthyite America, Ernie encouraged him to ignore publishers' rejections and to return and seek publication in Europe. He offered to support him while awaiting a publisher for *The Ginger Man*.

The Plymouth Adventure *became a best-seller and was made into a film*

Ernie gradually resumed the only security he had ever known, his writing. Like fellow-Dubliner Sheridan le Fanu, he worked alone through the night in the Gothic silence of his mist-shrouded mansion. Eventually, he resurrected his fur-collared motoring coat and descended from the hills in his MG sports car. His literary fame turned out to be a double-edged sword: it introduced him to a second lady who would subsequently leave him amid much bitterness. She was pharmacy student Edna O'Brien, whom acid-penned Hugh Leonard would later deride as 'country cute'. Sixteen years his junior, she ominously admitted to writing ambitions of her own.

Ernie later advised J.P. Donleavy on the mistakes made by authors who fall into unexpected riches: 'Mike, they buy binoculars, shotguns, sports cars and fishing rods, and a big estate to use them on. And then outfitted in their new life, along with new bathrooms, wallpaper and brands of soap, they

make a fatal mistake and change their women. To schemingly get toasted and roasted on glowing hot emotional coals, and subjected to a whole new set of tricks and treacheries.'

The MacNamaras were among the first to visit Ernie and his new girlfriend. Des liked Ernie and admired his dedication, but he recalled that he was frequently as bad-tempered as Brian O'Nolan: 'He wouldn't have been Ernie if he didn't lecture. Ernie was always eager to tell you what to do and how. He would sip whiskey and insist "what you should do is this!" I was very fond of him but he would have been maddening to live with. It was on a 1953 visit there that we met Edna, who had introduced herself to him in the Pearl Bar. My future wife, Skylla, and myself were surprised, as Edna was so young, around twenty compared to his advanced thirties. She laughed as she told us that she also was writing. We were a bit sceptical at first, but we took her more seriously after seeing her halfpenny school jotters lying around the house. I believe Ernie later claimed that he had written her first book. But it was all unmistakably her own writing, though Ernie had shared his experience and shown her the technical ropes, how to develop characters and think in terms of chapters.'

The romance between their daughter and a divorced older man anguished Edna's parents and friends. In Catholic Ireland of the 1950s, it was easy to raise a posse to intimidate a pagan with a foreign-sounding name in Wicklow. After being interrupted by uninvited visitors, Ernie was rumoured to sleep with a gun at hand in order to defend himself from nocturnal attack. Clergy and gardaí interrogated staff on one visit. The beleaguered couple eventually sought refuge in the Isle of Man, to which J.P. Donleavy had repaired with his new wife. They were soon tracked down and Gebler was badly beaten. According to Donleavy, the bloody fracas 'would make the battle of Clontarf seem like a picnic for a Protestant church choir'.

Ernie Gebler and Edna O'Brien were married in 1954. Ernie introduced Edna to the dashing Iain Hamilton of Hutchinson, who subsequently published her first book, *The Country Girls*. But the second Gebler marriage came to a premature end and the pair were divorced a decade later. The Dubliner resumed his work and published several more books including *A Week in the Country* and *The Love Investigator*. *Hoffmann* was made into a film starring Peter Sellers and Sinead Cusack. Ernie's many plays included *She Sits Smiling*, *The Spaniard in Galway* and *A Cry for Help*. He also wrote screenplays and television dramas such as *Why Aren't You Famous* and *A Little Milk of Human Kindness*. He worked briefly in the US and, though he never

repeated the blockbuster success of the Oscar-winning *The Plymouth Adventure*, he won an American Academy Award for his television drama, *Call Me Daddy*.

Ernie's final and most successful relationship was to last for over a decade, but disaster once more struck when his companion, Jane, collapsed in 1989 with a heart attack while mowing their lawn in Dalkey. The writer went into decline. His lingering death from Alzheimer's disease in 1998 was a particularly ironic end for a man who had trained his mind to accomplish miracles. The controversy over his influence on Edna O'Brien's early work clouded his final years and both their lives. The opinions of those who survived Ernie have been well documented. Not so those of the man himself, who claimed to have recorded them in an unpublished autobiography.

Ernie Gebler featured on the cover of the Saturday Review

Skylla and Des MacNamara visited Ernie in Dalkey before he was overcome by Alzheimers. Tall, high-domed and erect as in his youth, Ernie reminisced about his political escapades with Des and his sudden rise to fame and fortune. Skylla said: 'He recalled the summer day we all went boating in the lake and I dived into the water in my underwear. Ernie still derived great amusement from *The Plymouth Adventure* success. He revealed it had netted him £35,000 from MGM for the film rights, a huge amount back in 1952. But he gave us to understand that his writing career was not finished yet. He said he had completed a memoir which, sadly, we understood was partly a diatribe against his second wife. Though he lived for a few more years, we never heard of the book again.'

Words did not come as easily to Ernie Gebler as to his second wife. Compared to her easy lyricism, he was Jack London's rough-hewn Martin Eden. Few doubted that he resented his wife's easier and swifter success. Nor, equally, that he educated her in the technicalities of writing. Though Ernie hoarded notes and documents, there was no mention of his alleged final manuscript being found among his effects. But he gave his side of the story in a letter to *The Observer*. Claiming to have stayed up late every night rewriting his wife's early efforts, he insisted: 'The marriage did not break up

because I "resented" her "success". She has been peddling that for 20 years. Her first novel, about two girls coming up to the city to work, had a normal first novel sale; nothing like instant success. I have the publisher's accounts in my files. The marriage broke up because that first innocent book went disastrously to her head.'

Ernie also explained to Anne Harris of the *Sunday Independent* how he helped his young wife to organise her material. He displayed a notebook in which she had inscribed: 'Ernie very kind and reassuring about my second novel.' Claiming that his criticism had shaped her first two books, he recalled his advice to her: 'Scrawl it all down. Just practise describing people and what they say in a natural way. Be fluent . . . She would fill the pages, I would rewrite, throw away, put a professional shape on it. Then a marvellous thing happened. As soon as she typed it, it became hers.'

Marriages between writers are notoriously fraught, let alone one between a complex city man and a younger, rural and ambitious woman. Just as there was room for only one artist in the original Gebler home, the presence of two of the ilk in Ernie's household was doomed to breed dissension. Ernie may not have been a model husband or parent, but he did not have a model childhood. Without family support, he achieved international success by unremitting effort and sacrifice. His application inspired many. The time is long overdue to respectfully inter his ashes and, with them, memories of his indifferent family skills. It's time to finally celebrate the sacrifice and exemplary dedication which made Ernie Gebler one of Ireland's most accomplished and professional writers.

Chapter Eighteen

Gainor Stephen Crist – The Original Ginger Man

Arrived Steamer Galway Stop Need Money Most Urgent Stop Christ. – Telegram from Gainor Crist

'I WANT YOU TO TELL ME HOW I CAN GET AWAY from evil in this world,' a distressed Sebastian Dangerfield entreated his girlfriend, Chris. Bruised and breathless, he had just escaped a pub brawl on a bicycle.

'How to put down the sinners and raise the doers of good. I've been through a frightful evening. Indeed my suffering has been acute and more.' Chris comforted the victim of the cowardly random attack.

A newspaper arrived the following morning. MAN AMUCK IN PUBLIC HOUSE. The headline story described how a foreign-looking man threw a bottle of whiskey at the bartender and fought with innocent drinkers before fleeing the scene on a stolen bicycle. Guard Ball described the premises as looking like a battlefield.

'Libel!' Sebastian assured Chris.

Brendan Behan was one of the first to read the manuscript of J.P. Donleavy's *The Ginger Man* in the early 1950s. He assured the Irish-American: 'Mike, this book of yours is going to go around the world and beat the bejasus out of the Bible!' Brendan proved a perceptive critic. Within a few decades, Donleavy's debut novel had become a twentieth century classic. Published in 25 languages including Japanese and Russian, it sold several million copies. It was included in the Modern Library's Best 100 English-Language Novels of the Twentieth century.

The timing was perfect – shortly after the publication of Nikos Kazantzakis' liberating *Zorba the Greek*, and at the start of the Angry Young Men revolution which spawned the likes of Jack Kerouac and playwright John Osborne. Donleavy went on to write over twenty other books and plays. Like fellow-buccaneer Ernie Gebler, he progressed from a smallholding to a lakeside mansion, guarded by two great lions and a pair of bald eagles. Dorothy Parker was among those who hailed his talent. She described *The Ginger Man*, which was immediately banned in Ireland, as 'the picaresque novel to stop them all. Lusty, violent, wildly funny, it is a rigadoon of rascality, a bawled-out comic song of sex.'

> Today a rare sun of spring. And horse carts clanging to the quays down Tara Street and the shoeless white faced kids screaming.

Thus began the adventures of the fictional Ginger Man, the wild Sebastian Balfe Dangerfield, an American studying law at Dublin's Trinity College. He dreamt of wealth and peace but, sadly, both work and social inactivity were anathema to him. Married to an upper-class English woman, he was no ideal husband. He spent more time in pubs than at home. Admired by women, addicted to drink and good company, he was dogged by debt, unpaid landlords and disbelieving in-laws. But his poetic vision, natural dignity and saintly charm never deserted him, as he navigated his riotous way through 1940s Dublin. He saw himself as the victim of a conspiracy, abused by all manner of men. But, as he told his friend, Kenneth O'Keefe: 'There's no bitterness in me. Only love. I want to show them the way and I expect only taunts and jeers.'

In the book's opening scene, Dangerfield has just pawned the electric fire, his home's only source of heat. He shocks O'Keefe by chopping up a blanket with an axe.

'Now Kenneth, watch me. See? Put this round the neck like this, tuck in the ragged edges and presto. I'm now wearing Trinity's rowing blue. Always best to provide a flippant subtlety when using class power. Now we'll see about getting a little credit.'

Dangerfield got his credit and returned in style. Escorted by a shop boy laden down with groceries and a bottle of gin. O'Keeffe enquired the secret of his success.

'It's the blue blood, Kenneth. Now I'll cut off a little piece of this cheese and give it to the little boy.'

Difficult to believe that the disordered Ginger Man was anyone but a figment of the imagination of James Patrick Donleavy, who was born in 1926 in New York to a Galway mother and a Longford father. But Dangerfield was based on a very real person. A US Bill of Rights ex-serviceman, Donleavy arrived in Dublin in 1946 to study at Trinity College, where he soon encountered fellow-American law student, Gainor Stephen Crist. Four years his senior, the quietly spoken but sometimes agitated Gainor would become the model for Sebastian Dangerfield. Gainor stood out from the Pearl Bar throng. Not only for his erect bearing and red hair, but for the fact that he was wearing Donleavy's cherished yellow cashmere sweater and flannels. Donleavy had lent these to his friend Randall Hillis, who in turn had gifted them to Gainor, his brother-in-law, for an interview with a model agency. Donleavy was hardly more startled than the friend who must have anticipated a second coming when he received a telegram from the same Gainor: 'Arrived Steamer Galway Stop Need Money Most Urgent Stop Christ.'

Gainor deflected Donleavy from embarrassing questions about sweaters by showing an inordinate interest in the latter's elaborate watch. And he swiftly introduced him to his belief in the concept of immaterialism and his theory of the true nature of being: 'His notion was based on the possibility of energy emanating from the inertia of absolute nothingness. And such energy being applied to providing a daily existence immune from labour of any kind and where as he would say, while the mind raced, eyeballs froze in stillness and stomachs rested in peace.'

Like writer Natalie Barney, Gainor Stephen Crist was a native of Dayton, Ohio where, as a child, he scrumped apples from the orchard of neighbour and pioneer aviator Orville Wright. Gainor grew up in aristocratic Gatsby-like style. He went to the best schools, met the right people and acquired his

life-long regard for attire, courtesy and the use of language. He invariably clicked his heels when a woman entered a room. His father, Frederick, was a noted physician who had accompanied Admiral Byrd to the South Pole. But the privileged security of the Crist family was shattered when Gainor's mother died at a young age, an event to which he frequently and tearfully alluded in later life.

John Ryan recalled Gainor's arrival in Dublin: 'Then, suddenly, one day, he was all around us – oozing Southern charm from every pore. Slender and shy but infinitely winning, he possessed the credibility of one of those Mississippi paddle-boat gamblers of Hollywood legend. He might have been a defrocked Confederate, antebellum whiskey general, or Leslie Howard's understudy, freshly escaped from the set of *Gone with the Wind*.'

The *Envoy* editor soon discovered that the careless front concealed a coiled spring. John was attacked by a drunk at a party in Des MacNamara's studio: 'Caught off-balance and completely unaware, I would have got a terrible mauling had not Crist's reflexes been so fast that he was able to catch my assailant in a judo hold before his claws had reached my throat. It was like catching a bullet in your teeth in mid-flight, and my attacker was so pole-axed by this abrupt termination of his homicidal intention that he turned lime green and threw up.'

While J.P. Donleavy attempted to make a name for himself in Dublin as an artist – shocking the natives with his nude studies and equally lurid catalogue Introductions – the formal and quietly-spoken Crist effortlessly adapted to the Irish pub scene, much to the detriment of his legal studies. Though rarely in the money, his congenial and sympathetic nature invited confidences and ensured a fruitful social life. Recalling his way of engaging everyone, Donleavy noted: 'That anyone near enough to overhear his mesmerising comments reflecting the state of being, would, alive that moment in that bar, in that place and on that continent, know that there was nothing else to know beyond what he already knew. It was Gainor's entrance to such environs that made everyone there sense his presence and wait for him to speak, which he did then with just the very slightest hint of conspiracy.'

Soon on first-name terms with the city's writers, artists and socialites, few parties would be held without the engaging Gainor. Engaging but uncompromising. He saw resistance as a moral virtue, as in Dangerfield's words: 'Got to fight. Must resist or go down in the pile.' The American improvised a sun clock, pieces of cardboard placed around his room, on which the sun revealed

such critical hours as opening time and the 'holy hour', when pubs closed. His day frequently commenced with a hangover cure at Bewley's Oriental Café. Then it was off to Davy Byrne's or a similar hostelry to plan the real business of the night, with various resting actors, artists, poets, horse trainers, fellow chess-players and other would-be Bohemians. And all the while dreaming of the largesse that would flow his way when his sickly father finally passed on. Sadly, recalling his son's misspending, Frederick allegedly invested his hard-earned cash in an atom bomb-proof mausoleum.

A friend wondered: 'What was it that he had? What charisma was his who never even attempted to do anything, let alone complete it, said nothing memorable, yet whose memory is so much cherished; that caused society to somehow spin about him; that made two women love and marry him, penniless and alcoholic that he was, and a man write a book and a play about him that has caused a near-cult throughout the world?'

Gainor Stephen Crist at side gate of Trinity College Dublin

John Ryan invited Gainor to his wedding. Guests included his sister, Kathleen Ryan and friends from Hollywood, where she was making a name for herself with fellow-immigrants Maureen O'Hara, Maureen O'Sullivan and Barry Fitzgerald. Various mishaps played havoc with Gainor's wedding plumage. Paint from the green door which served as an impromptue ironing board streaked his drying white shirt. A Great Dane puppy breakfasted on his black shoes. The clock ticked on as Gainor frantically improvised. John's wife-to-be, Patricia, was startled to find her Rolls Royce being flagged down by the rushing flat-footed American, the grandeur of whose clawhammer coat and trousers was offset by an olive fatigue shirt and a Trinity tie. Press

camera bulbs flashed as, unabashed in his white canvas sneakers, he helped Patricia to dismount and escorted her into Donnybrook Church.

Des MacNamara was another close friend of Gainor, whom he described as: 'A bit insistent and a rapscallion at times. I remember a beautiful old marbled ledger which I had bought on the quays which he purloined for notes on his rare college attendances. He habitually dressed in a tweed herring-bone jacket and grey flannel trousers and padded along with his hands entwined in front of him.'

The American carried a talisman sculpted by Des. One summer while hitchhiking, Gainor sought respite from the heat in Drogheda's cathedral. He was woken by the laughter of a little girl, whose pennies turned on the light which illuminated the head of Blessed Oliver Plunket. Gainor sent Des a postcard of the relic, on which Brendan Behan later scribbled what was probably his last piece of verse:

> The blessings of Ollie,
> So jovial and jolly
> Be on you dear Crist
> 'Til next we get pissed.

Gainor commissioned a miniature bust of Blessed Oliver from Des, which fitted into a match box which he carried with him on all future adventures. In 1947, he accompanied John Ryan, Tony McInerney and some friends to Paris. Gainor introduced John to another American at the Eiffel Tower before disappearing for a drink. Attempting small talk, John remarked on the uncommonly good view. His new acquaintance grimaced. It was only then that John found Gainor had overlooked telling him that the man was blind.

Apart from the attraction of outpacing his creditors, Gainor was a keen traveller. Before his final voyage to Spain, he journied to London, where he attended the first night of Brendan Behan's *The Quare Fellow*. His lifestyle continued to be as dramatic as anything seen on Joan Littlewood's stage. Staid Londoners were startled by his 'meals on wheels' antics, which Brendan reported to Donleavy. While awaiting a bus, Gainor succumbed to the artistic chalked blandishments of a convenient café. He had just commenced eating his bacon and sausage when the bus arrived. Quickly gathering up his plate and cutlery in the tablecloth, he poured some salt on to a napkin and rushed out to the bus. With a commendable economy of time, he completed his meal just before he arrived at his destination.

In real life as in the book, Gainor moved from Howth to Blackrock, after marrying English fellow student Constance Hillis, whom he called Petra. Unlike Gainor, and despite the distractions of their two young children, Constance persisted with her studies and graduated from Trinity. A friend recalled her complaining to Gainor that he never took her anywhere. She asked him if he would mind her meeting another Trinity man who had asked her out. He said he had no objection and they discussed the date amicably when Constance returned. Gainor was more an understanding friend than a husband; the marriage did not survive.

Gainor himself had many relationships which were seldom platonic. Women could not resist his easy charm and need for mothering. *The Ginger Man* recounts many of his exploits, including the fictional Dangerfield's late evening dalliance with girlfriend, Chris, which resulted in a missed last tram to Howth:

Crist with his first wife, Constance, and J.P. Donleavy outside Trinity

> He kissed her hand as he left. And walked through the night by the canal, counting the locks and bulging waterfalls. The story was, Marion, I missed the last tram. Just going down Nassau Street at a ferocious clip. Couldn't possibly get it. I'm in poor condition for running so I went back to Whittington's rooms in college. Smart bloke that, great help with the law of contract.

It did not take Gainor long to meet the second great love of his life, Pamela O'Malley, from Limerick. Her wealthy wine-importing family was less impressed with the penniless American. Pamela told Patrick Cooney of *The Independent*: 'I first saw him on a ferry going from Fishguard to Rosslare. I noted this person because of his unusual footwear. He was wearing sandals

and bright tartan socks – with a suit. I certainly registered that.' They met later at a friend's party and, as she said, 'that was that'.

The couple moved in 1951 to London but, two years later, fled to Spain when Gainor's first wife informed authorities that he had no work permit. Pamela remembered their start in Madrid: 'He still got into terrible messes and expected you to help him out of them. He was very complicated, found it hard to sustain discipline, but then there was a whole lot of things that went into that – the break-up of his first marriage, he missed the children and he always harked back to his mother's death. He'd go some place and get involved with some woman. I'd get furious and then realise what a humiliating emotion jealousy was. Whenever I left him, something happened. He'd say: "I needed company, I didn't intend that at all." And, of course, I'd have to get him out of it.'

Despite Gainor's unfaithfulness, Pamela insisted that he cared deeply for people. His speed in summoning medical assistance saved the life of John Jordan, who was taken seriously ill in Barcelona on Christmas 1963. An act of kindness the poet celebrated in *Blood and Stations*. Jordan disapproved of *The Ginger Man*: 'That book about you knew nothing of your gentleness, of your courtesy, of your sedate wildness.'

To add to his drinking problems, Gainor contracted tuberculosis. He recovered but the illness impaired his strength. His hunger for adventure impelled him on one last journey. In 1964, at the age of 42, he met a former wartime friend in Madrid. After numerous drinks, his acquaintance invited him to accompany him on an American-bound ship. Further drinking led to Gainor's collapse, the ship diverted to drop him off at Tenerife. This time, Des MacNamara's talisman did not save Gainor. He died there on July 5, 1964. From Spain, Pamela O'Malley organised his funeral to the Cementerio de Santa Lastenia.

Quick thinking by Crist saved the life of his friend John Jordan

No friend or anyone who knew him saw the most sociable of men being laid in the sun-baked ground.

Pamela recalled: 'It seemed unreal. I was a widow at 35, and looked about 25. Being called "a widow". God, I felt so stupid, and I felt so guilty after his death, but a friend saved me. He said: "For God's sake, you kept him alive the last few years."'

Though he was apolitical, Gainor would have been proud of the doughty Pamela. She was imprisoned twice for anti-Franco activities. In later years, her adopted country made amends and awarded her the King Alfonso the Wise medal for services to education.

Bust of J.P. Donleavy by Des MacNamara

The Crists had both enjoyed *The Ginger Man*, and the name Dangerfield, which was was Gainor's nickname for an Englishman. Pamela recalled: 'Most of the key exploits were based on fact. Gainor had a zest and a vitality for people. You'd be sitting in some pub and some nutcase would come, and you would know that person was going to end up at your table. He fixed on people and drew them out, made them talk. People got adopted and stayed with him for a week. He had a fatal attraction.'

Despite J.P. Donleavy regarding her husband as a virtual saint, Pamela was miffed to hear of the author's alleged claim that Sebastian Dangerfield was modelled on himself. She remembered that, despite the story being based on her husband: 'It was very odd when the book was published, because we never got sent a copy. It was only when a friend of ours was asked to write the foreword for the English edition that we received one.'

Donleavy revealed in *The History of the Ginger Man* that it was months after publication that he finally gave Gainor a copy of the book, when the pair met in Paris near the end of 1955. Donleavy recalled: 'I left him in a café in the rue de la Harpe, stopping to look back at him through the window where he sat quietly with his calvados and a cup of coffee, and, with *The Ginger Man* already open, he was absorbed with a grin on his face. However, the sight of him there in the nearly empty café, left me feeling an overwhelming sense of

loneliness. For there he sat, so anonymous, this strange traveller who could utter in a universal primordial tongue.'

While in Madrid, Gainor sent a card to John Ryan, asking him to give his love to 'DDD', Dear Dirty Dublin. John always harboured happy memories of the American: 'He was the subject and not the creator of art, but an indefatigable Bohemian and, of all those friends of mine from that time, he is the one I would most dearly like to summon from the shades, for the specific purpose of renewing one night of his exceptional company in the Dublin he knew so well and, as his card tells us, loved. Happily, for future generations, he was the catalyst that Donleavy needed to commemorate Dublin in those days, and surely nobody has done it better?'

But events in Tenerife might not have spelt the end of Gainor Stephen Crist. Donleavy recalled the evening Gainor advised him in Dublin's old Jury's Hotel: 'Mike, even if one day you hear I'm dead and you await patiently to be advised of further and better particulars, be prepared for later and contradictory news. For on some summer's evening when the lark is everywhere singing in the clear air, and when all but you are gone, I'll be back there in Dublin for Bloomsday. I'll be walking down to the end of Grafton Street. And if you see me thus, tell no one but believe it's me.'

One day, years later, Donleavy may have witnessed the realisation of that prophecy. From the Dame Street side of Grafton Street, the writer saw a familiar figure coming around by Dublin's Trinity College: 'The man had Gainor's stature, Gainor's style, Gainor's gait. "My God! It's him," I thought. I was so thunderstruck that I didn't call out or follow him. I watched until he disappeared around the corner on his private way. And I wondered even more about Gainor and his fate. I heard that the cemetery keeper in Tenerife always broke into a laugh when people went to see Gainor's grave. Gainor had so many problems, so many debts, maybe he had faked his death?'

Chapter Nineteen

THE UNITED ARTS CLUB

If you long for things artistic,
If you revel in the nebulous and mystic,
If your hair's too long
And your tie's all wrong
And your speech is symbolistic:
If your tastes are democratic
And your mode of life's essentially erratic:
If you seek success
From no fixed address
But sleep in someone's attic:
Join the Arts Club, join the Arts Club.
– Susan Mitchell

'THE UNITED ARTS CLUB WOULD CERTAINLY claim to have close alliance with whatever in Dublin is Bohemia,' insisted Stephen Gwynn in his book, *Dublin Old and New*. Launched in the early days of the twentieth century, the Club was the brainchild of Hugh Lane's friend, the art lover and journalist Ellie Duncan. But, while noted for late-night socialising and midnight arguments over commas in *Finnegans Wake*, the Club played an enduring role in Dublin's artistic life. Its members were Nobel Prize-winning writers, artists, actors and professionals with an interest in the arts, hence the adjective 'United'. But members were far from sedentary. They included a champion racing cyclist, a member of the Dutch World War II resistance, a former racing driver and a mountaineer who sailed around the world. Another member fought a duel in Paris. Two members were shot by firing squad. Others perished in the First World War.

The Club's first 1907 home was at 22 Lincoln Place, beside the former premises of George Russell's *The Irish Homestead*. In addition to Ellie and James Duncan, early members included Russell, T.W. Rolleston, artist Dermod O'Brien, grandson of the revolutionary, William Smith O'Brien, and duellist Count Casimir Markievicz and his wife, Constance. Thanks to the influence of the Markievicz's and other Paris returnees, members kept abreast of the continent's latest artistic and literary developments. In 1915, Ellie Duncan organised the country's first exhibition of Post-Impressionist paintings at the Club and introduced Dubliners to the likes of Gauguin, Matisse, Signac and Van Gogh. 'More of interest to the psychologist than the lover of art,' thundered the usually mild-mannered George Russell. His *Irish Times* review undid Mrs Duncan's encouragement, the institution passed on the opportunity to acquire a priceless Van Gogh.

Portrait of early member Constance Markievicz by John Butler Yeats

Padraic Colum, Lady Gregory, George Bernard Shaw, W.B. Yeats and many of Ireland's greatest modern writers joined the Club. Also Walter Starkie, James Stephens, Brian O'Nolan and artists James le Jeune, Sean Keating, William Orpen, Estella Solomons, Patrick Tuohy and Jack B. Yeats. And two who are still going strong, Patrick Pye and Thomas Ryan. Members from the legal and other professions bankrolled events and impecunious artists such as Harry Kernoff. The Club staged exhibitions, debates and dinners for illustrious visitors, and offered a sanctuary where writers and artists could relax or dissertate with fellow-souls.

While some of the men dressed in kilts and exotic tweeds, the institution's ladies complemented the artistic tableau. Lady Gregory wrote of her nephew Hugh Lane's annoyance when Beatrice Elvery disappeared upstairs instead of remaining as 'part of the decoration of the room'. Beatrice, who had sketched

Michael Davitt on his death-bed, was a student of William Orpen, who told fellow-members how the former political prisoner had advised him: 'Take my advice. Don't take any side. Just live and learn and try to understand the beauties of this wonderful world that God has been good enough to give us to live in.'

Within a few years of its foundation, the United Arts Club was virtually the centre of intellectual and social activity in Dublin. W.B. Yeats frequently lectured, new members included Oliver St John Gogarty, Tom Kettle and poet Katherine Tynan. Musician and songwriter Percy French entertained guests. Visitors included G.K. Chesterton and Douglas Goldring, former secretary to Ford Maddox Ford of the influential *English Review*. Artist Beatrice Elvery, now Lady Glenavy, moved in equally salubrious London circles which included D.H. Lawrence, Mark Gertler and Katherine Mansfield, whom Beatrice sometimes brought on holidays to Ireland with John Middleton Murry.

Hugh Lane, John Millington Synge, W.B. Yeats and Lady Gregory, by Sir William Orpen

Club members were far from united politically. The coterie of Anglo-Irish co-existed uneasily with Independence supporters Joseph Plunkett, Darrell Figgis and Erskine Childers. The first world war, the 1916 insurrection and the civil war killed many members. The idealistic Tom Kettle perished on the Somme: 'He died not for king or country, but for the secret scripture of the poor.' The 1916 rebellion and subsequent civil war resulted in the executions of Plunkett and Childers. Oliver St John Gogarty escaped from kidnappers. Constance Markievicz missed two uniformed fellow-Club members at whom she fired in Stephen's Green, but killed at least three other soldiers. Only her sex saved her from execution. Mrs. George Yeats and young poet Thomas MacGreevy survived a Grafton Street crossfire. Mountjoy Prison lacked the

Club's creature comforts. When member Robert Barton escaped, he left a note for the Governer about the unsatisfactory service. In time, peace broke out and Ireland gained independence. Lieutenant Colonel T.B. Gunn took over the Viceregal Lodge from the departing British, a feat he regularly related to Club members over the ensuing years.

In 1920, the Arts Club moved to its present premises at 3 Upper Fitzwilliam Street, opposite the Majestic Hotel. Early visitors included actress Sybil Thorndike, architect Sir Edwin Lutyens, composer Hamilton Harty, and Sir John and Lady Lavery. Liam O'Flaherty and poet Lyle Donaghy became members. Ireland might have gained independence from the British but not from religious zealots. A short story by Lennox Robinson about a young country girl who believed herself to be the Virgin raised the temperature of some Club members. Father Finlay resigned from the committee in protest at the story, and though supported by W.B. Yeats and fellow-poet Thomas MacGreevy, Robinson himself was forced to follow suit.

Not that the behaviour of certain lady members was all that virginal. Treasurer Michael Nolan complained that wild women in search of drink were wrecking the Club through sheer spite and jealousy. He informed President Thomas Bodkin of 'the oscillation from females whose practical concern with sex will have ceased one or more decades previously and whose breaths were redolent of ambrosia. Yesterday morning, I asked Mrs. McCrory how many widows (excluding permanent grass widows) and spinsters are members and the count came to 22 widows and 25 spinsters, which will account for most of our troubles.'

Despite the disagreements and divisions of opinion, harmony invariably returned. Russian exile Luba Kaftannikoff affirmed:

> And some wore spats and some wore kilts
> And some in fancy dress wore quilts
> And, each, as if he walked on stilts
> Looked down upon the others
> But all these people changed their ways
> The poets praised each other's lays
> And interchanged their several bays
> In short, became like brothers.

'Hail to our first Nobel Prizewinner!' One of the Club's highlight's was the awarding of Ireland's earliest Nobel Prize for Literature to W.B. Yeats in November 1923, only a year after the country had gained independence.

Fellow-members packed the special dinner for Yeats and his wife, George, and an ageing Lady Gregory. Towering over his admirers, the poet modestly insisted: 'I consider this honour has come to me less as an individual than as a representative of Irish literature, it is part of Europe's welcome to the Free State.'

Three years later, fellow-member George Bernard Shaw repeated Yeats's Nobel success. There were further celebrations when Club member Cruise O'Brien, godfather to diplomat and *Bell* contributor Conor Cruise O'Brien, became the first Irish yachtsman to circumnavigate the world. Like Yeats, O'Brien was treated to a memorable reception and dinner. The excitement proved too much for one enthusiast, who misappropriated the yachtsman's priceless chart. During the subsequent war, O'Brien joined the Small Vessels Pool and sailed boats across the Atlantic to beleaguered Britain.

One of the Club's longest-serving artists was Arthur Power, who became art critic for the *Irish Times* and was a member from 1924 until his death sixty years later. A World War One veteran, he was much in demand for his memories of shell-pocked Flanders and, particularly, for his Montparnasse recollections of Hemingway, Ezra Pound, Sylvia Beach and James Joyce, who often invited him home. It was Power who arranged for Patrick Tuohy to paint the portrait of the writer's father, John Stanislaus. He also tried unsuccessfully to interest James Joyce in modern artists Matisse and Picasso. But just as Joyce eschewed the Bohemian way of life, he also singularly lacked the visual arts enthusiasm of his contemporaries George Moore, George Russell and W.B. Yeats. The fountain pen was Joyce's brush. Power recorded the writer's response to his questions about the most famous word-painting of Dublin: 'When I was writing *Ulysses*, I tried to give the colour and tone of Dublin with my words; the drab, yet glistening atmosphere of Dublin, its hallucinatory vapours, its tattered confusion, the atmosphere of its bars, its social immobility.'

Power also knew many leading art figures in Paris, including Ossip Zadkine, sculptor Aristide Maillol and the legendary dealer Leopold Zborowski. Arts Club members were moved by his memory of Amadeo Modigliani: 'I climbed up several flights of rickety stairs to his studio, a long narrow room the whole of one side of which was glass, and through it one looked down to a grassed courtyard with young trees in it, caught as yet with the white humid mist of early Spring. He was sitting at his easel working, with a bottle of white wine, and a yellow packet of Elegante cigarettes beside him. He looked emaciated with hollowed cheeks, drawn lips, and eyes unnaturally aglow, and

Amadeo Modigliani

his dark hair was in black touseled ropes like that of a man in fever. His manner was calm but pleasant. But when he went to paint, I noticed his hand was very unsteady, and he controlled its movements with an effort.'

The Club lost one of its cherished founders, another former Paris student, when Constance Markievicz died aged 69 in 1927. Thousands attended the funeral of the Citizen Army lady, who had lavished more affection on Dublin's poor than she had on her daughter, Maeve, or the squaddies she had shot in 1916. Her husband, Count Casimir, who returned to his native Ukraine was also missed by Club friends.

Arthur Power recalled: 'A big, tall man with a jovial face, and eyes with a strong squint, he was at heart a Bohemian. What he really wanted was to make Dublin into a continental city and infuse it with continental thought.'

Despite these losses, the Club continued to thrive, with new members such as artists Sarah Purser and Cecil Salkeld. Its committee played a leading role in national art affairs, including the campaign for a municipal gallery to house the works collected by Hugh Lane, which was finally opened in 1933 in Parnell Square.

Though Ireland was neutral during the second world war, members did not escape its consequences. George Bernard Shaw campaigned against the reciprocal bombing of cities. Club founder Ellie Duncan frequently sojourned in Paris, where her artist daughter-in-law, Belinda, became a favourite of James Joyce. Belinda and her husband Alan were walking with Samuel Beckett when he was stabbed in 1938. The writer survived to celebrate with them the publication of his first novel, *Murphy*. Sadly, Ellie Duncan did not long survive Beckett's triumph. The Arts Club founder passed away early in March 1939, shortly after W.B. Yeats died a few hundred miles south at Roquerbrune. At the outbreak of the conflict, Belinda Duncan escaped to

England but her brother Cecil, who helped the French Resistance, was captured and perished in Buchenwald. Samuel Beckett also campaigned with the Resistance, while Club member Denis Johnston distinguished himself as a war correspondent. One of the first to report the horror of Belsen, Johnston was honoured with a Club reception on his return home. Artist Koert Delmonte, who made passports for the Dutch Resistance, became a member after the war.

'The ideal Mimi and the only Butterfly,' Giacomo Puccini said of soprano Margaret Burke Sheridan, who also made her mark on the continent. She sang for five seasons at Covent Garden, once for no fewer than four kings, and spent eight seasons at La Scala, Milan, whose management struck a medal in her honour. Puccini's friend and one of his best interpreters, she was also a favourite of Toscanini. Margaret launched a school of singing when she returned to Dublin. Her star quality and continental ways, sadly, did not go down well with all the wild women of the Club. They proved more amenable to the traditional music and nocturnal ballad singing of the later Meriman Summer School, which was founded by Con Howard, Ciarán MacMathuna and Seán MacRéamoinn.

'If I had known you were as good as this, I would have had the trousers off you long ago,' red-haired novelist Honor Tracy astonished Sean O'Faolain, her elder by thirteen years. The English writer joined the Club in 1947. By turns bewildered and enamoured of Ireland, Honor put her membership to good use when researching *Mind You I've Said Nothing*, which annoyed many natives with its irreverent and too accurate view of Ireland of the period. Members would have been even more upset, had they known of Honor's affairs with Sean and John Betjeman. It was Honor's turn to be outraged when the *Sunday Times* apologised for her feature on the £9,000 mansion being built for Canon Maurice O'Connell, PP of Doneraile in County Kerry. But, unlike Patrick Kavanagh, Honor had the last laugh. She sued the newspaper for casting aspersions on her journalistic integrity and won £3,000, an enormous sum at the time.

Another member making a name for himself was architect Michael Scott. He designed both the modernistic Busáras and the new Abbey Theatre, which opened in 1966. Tom Kettle and Constance Markievicz were honoured with busts in Stephen's Green (as later was James Joyce), but 1967 saw the biggest public tribute to a former Arts Club member, when Henry Moore's *Knife Edge* tribute to W.B. Yeats was unveiled in the Green. Moore and 74-

year old Mrs George Yeats attended the ceremony; Austin Clarke and rising poets Eavan Boland and Brendan Kennelly read from Yeats's poetry.

After Yeats, Austin Clarke was the Arts Club's most distinguished poet. He returned home after many years in England and, with Robert Farren, he founded the Lyric Theatre Company to continue the Yeats tradition of poetic theatre. More concerned with social issues than Patrick Kavanagh, he maintained his independence by launching his own Bridge Press. Courage and honesty were his hallmark. Unlike the majority of silent Irelanders, he spoke out against clericalism, unemployment and injustice. After witnessing the church's reaction to the Cavan orphanage fire, he wistfully recalled its role in Penal times:

Austin Clarke, after Yeats, the Arts Club's most distinguished poet

> Better the book against the rock,
> The misery of roofless faith,
> Than all this mockery of time,
> Eternalising of mute souls.

Cartoonist Isa MacNie and Tom Casement were typical of the members for whom the Club provided a refuge. Tom was younger brother of executed patriot Sir Roger Casement, who described him as 'an extraordinarily unbusinesslike human being'. Born in 1863, Tom commenced an apprenticeship on a sailing ship trading with Australia at the age of 13. Appointed an officer in his twenties, he lost his official papers on a night out in Melbourne. He jumped ship and became an inspector with the local Metropolitan Board of Works. Tom married in 1892 but his love of adventure soon led him to seek his fortune in South Africa. He served in the Boer War and, after prospecting for mercury, became an inspector of mines in the Transvaal. Like the flamboyant Gordon Bennett, he shocked fellow-members of the exclusive Rand Club by riding his horse up the club's staircase for a bet.

A friend of the Boer General, Jan Smuts, Tom emulated his brother's humanitarianism by joining the movement to abolish Chinese slave labour in South Africa. After an unsuccessful attempt at farming, he ran a mountaineers' hostel and was a member of the first party to climb the previously unscaled Cathkin Peak in 1912. He embarked on another short-lived marriage to an English artist, before seeing out the First World War as a Captain in Tanganyika. After replicating Limerick artist Norman Garstin's diamond prospecting, he returned to Ireland in 1920. His friendship with General Smuts proved fruitful when the latter agreed to act as intermediary between the British Government and Irish nationalists.

Tom Casement in the Coast Life Saving Service, Fleet Street, Dublin, 1923

The returned adventurer embraced the conviviality of the Arts Club. He finally found a regular job in 1920, when his idea for an Irish Lifeguard Service was adopted by fellow-member and Industry Ministry officer Gordon Campbell, husband of Beatrice Elvery. Tall, ungainly and partial to alcohol, Tom's tweedy attire attracted as much attention as his colourful sea-shanties. He was a stalwart of the annual Nine Arts Fancy Dress Ball, usually in exotic outfits designed by Beatrice Elvery. A keen rugby fan, he avoided carrying luggage to cross-channel matches by wearing his pyjamas under his suit. Fellow-member Denis Johnston used him as the basis of a character in his play, *The Moon in the Yellow River*. Seafaring and travelling had enriched Tom's vocabulary; Jack Yeats's paintings of returning sailors and their parrots owed much to his tall tales. While Jack always defended him, more genteel members complained of Tom's language, particularly the artist, Isa MacNie, whose own cartoons also caused disharmony.

Tom was noted for his generosity to down-and-outs and to fellow-imbibers in the Arts Club and the Scotch House. When Beatrice Elvery mentioned that she was interested in models of sailing ships in bottles, he scoured Dublin until she had a collection of them. He gave her a treasured telescope which

she in turn passed on to Samuel Beckett's invalid aunt, Cissie. When Beatrice and Tom were holidaying on Achill Island, they discovered a troupe of London musicians and mummers, distressed and stranded without money. After holding an impromptu raffle, Tom organised a concert in the Mulranny Hotel. There were tears all round as the newly-solvent party played and danced numerous encores before finally departing in style for London.

Elected a Life Member in 1924, Tom's star ascended even further, when he was given the honour of piloting Conor O'Brien's boat, *Saoirse*, at the Dun Laoghaire conclusion of its historic circumnavigation of the world. A feat repeated sixty years later in his ketch *Mary B* by artist Pete Hogan, renowned for his studies of Georgian Dublin. Like other guests at the celebratory Club dinner, Tom was surprised to hear that the historic voyage had been unplanned. A friend of George Mallory, O'Brien's forte was to ascend mountains in his bare feet. He had sailed to New Zealand to join a party of climbers. After finding that he had missed them, he simply decided to continue sailing around the world until he reached Ireland.

Tom was acclaimed by the committee for his redecoration of the Fitzwilliam Street premises. But, shortly afterwards, he smoked out members with an over-enthusiastic fire which caused the evacuation of surrounding buildings. An observer recalled that, while Tom fled to the Scotch House: 'The doctors were being suffocated in their consulting-rooms. The fire brigade was sent for. The police were sent for. The President of the Royal Hibernian Academy was sent for.'

Tom's reputation sank even further when Isa MacNie complained that he had misbehaved at a dinner for the aviator, Sir Alan Cobham, and accused him of 'driving members from the Club by his filthy company'.

His job was not pensionable and when Tom retired, he was virtually penniless. Many who enjoyed his company in better days melted away. He was forced to resign from the Club. Some members led by Beatrice Elvery organised a fund, a cousin accommodated him in Burlington Road. Tom was often observed walking or sitting alone on one of the canalside seats. He always crossed the canal by the Mespil Lockgate: 'those bridges are for landlubbers.' After being ill for a few days in 1939, he went out for a walk one night. He apparently fell from the gate footbridge and the following morning was found floating in the canal in his pyjamas and dressing gown. Bertie Smyllie of the *Irish Times* was among the huge funeral congregation. General Smuts and hundreds of members of the Lifeguard Service contributed to a handsome

Chin Angles, or How the Poets Passed *by Isa MacNie*

nautical monument for his grave, for which Beatrice Elvery modelled a ship in full sail.

Tom's *bete noir*, Isa MacNie, outlived him by two decades. Ireland's first female cartoonist, 'Mac's' career was launched by a chance dinner remark to the *Irish Times* editor that she 'saw people in geometric shapes'. After illustrating what she meant on the menu, the editor encouraged her to concentrate on caricatures. Mac's most famous cartoon, 'Chin Angles', occasioned national merriment. It showed near neighbours George Russell and W.B. Yeats failing to recognise each other on Merrion Square, Yeats as usual gazing skywards, the ruminative AE focused on the pavement.

Like Tom Casement, Mac was a person of many parts. Irish Ladies' Croquet Champion in 1907, she was also an accomplished actress, sketch writer, composer and pianist. She raised funds for the Red Cross and co-organised a nursing pageant to mark the 1913 inaugural conference of the National Council of Trained Nurses of Great Britain and Ireland. During the divisive 1920s, she proposed the Irishwomen's Association of Citizenship: 'Our main objects are to bring together Irishwomen of all politics and all creeds for the study and practice of good citizenship; to promote economical and political knowledge, and to hear and discuss the points of view of others in a friendly and sympathetic spirit . . . furthering social, political and legislative reforms, chiefly those which concern women and children.'

Mac was never shy to speak her mind during her half-century's Club membership. She denounced the committee in 1919 for selling the grand piano towards whose purchase she had contributed a hard-earned £10. She further satirised staid members who had been offended by her caricatures. When W.B. Yeats returned to Ireland in 1922 with his wife, George, Mac persuaded the latter to become the Club's honorary secretary. Dismayed by Mac's bickering with fellow-members, George soon took early retirement, though not before enjoying an inside view of Club preoccupations. In a 1925 letter to Lady Ottoline Morrell, W.B. wrote: 'My wife says that members of the Arts Club have become incredibly candid about their love lives.'

But Mac was one of the Club's mainstays. She devised costumes for special events and organised both the Yeats Nobel Prize celebrations and the Club's 21st birthday dinner. Elected Vice-President in 1945, she initiated functions for novelist Kate O'Brien and other visiting celebrities. Clad in a long black cloak, she became one of Baggotonia's most familiar sights, as she swirled from meetings to receptions and launches. She insisted on high standards for Club applicants and complained about one member who had slipped through the net and who had brought several men to the Nine Arts Ball: 'Dreadful little men in badly fitting dress clothes and none of them was sober towards the end of the evening, while she chased them if they moved away from her, dragging them with her arm around their necks and then kissed them violently – all this in the lounge, before a crowded room.'

Mac tried to block the membership application of French-born nightclub owner and Women's Lib pioneer Toto Cogley: 'She was the most damnable nuisance when she was a member before, always borrowing money and cadging for drink and she has cruellest tongue in Europe.'

Justice Kenneth Deale found himself at the receiving end of an equally sharp tongue when, having promised Mac otherwise, he succumbed to wifely pressure and supported Toto: 'I have never in my life seen any man so abject and completely under the thumb of his wife. No raw recruit on a barrack square, shivering and quivering under the angry command of an irate sergeant, ever showed more desire to do as he was told than our friend Deale.'

Despite her disagreements with fellow-members, the Women Writers' Club celebrated Isa's eightieth birthday in August 1949 with a special dinner at the Hibernian Hotel. Blanaid Salkeld presented her with a bouquet of flowers. Bertie Smyllie and fellow-artist Louis le Brocquy sang her praises, congratulatory telegrams arrived from Padraic Colum and James Stephens,

who were now in the US. The Arts Club, sadly, was as unsupportive of Mac in her old age as it had been of Tom Casement. In 1951, despite all her work, Honorary Secretary Eva Fullerton wrote to her: 'Under existing circumstances, the Committee very much regrets that they are unable to accede to your request for residential accommodation.'

The artist grew frail and had to use crutches after a fall. Barry Cassin found her in her Baggot Street room, wrapped in a shawl in a bed made of old clothes propped up on butter boxes. With only her tabby cat, Billy, to keep her company, she was still making her trademark paper flowers. A freshly dislodged lump of ceiling plaster lay on the floor. 'I knew it was going to fall so I moved the bed,' she laughed.

Mac died on April 29, 1958, a fortnight after the diva, Margaret Burke Sheridan. The *Irish Times* noted that Ireland had lost probably its finest cartoonist: 'No future student of our cultural renascence could afford to neglect Mac's exuberant and trenchant commentary in her inimitable black chunky lines, as effective in their own way as Rouault's. It was surely an achievement for a woman to win distinction in a field exclusively reserved for men. For 'Mac's' cartoons were no gentle feminine drawings. They had none of the delicate subtlety of Beerbohm. They had more the robust humour and power of Forain. One more vital individualist of a great epoch has left us.'

Three larger-than-life Club members played a major role in postwar Irish culture. Christened The Three Musketeers by fellow-member Muriel Allison, they were diplomat Con Howard and broadcasters Ciarán MacMathúna and Seán MacRéamoinn. Fellow-member Peadar MacManus insisted: 'With his scholarship, wit and zest for life, Con Howard could make Socrates smile over breakfast, best Cicero at a discursive lunch, and see Dionysius to bed after a long evening.'

In 1967, Con initiated the Merriman Summer School in honour of fellow-Clare poet Brian Merriman. The School discussed national and cultural issues and. in addition to prominent locals, attracted such

Con Howard, founder of the Merriman Summer School

speakers as US Senators Eugene McCarthy and George McGovern. Reflecting Con's appreciation of wine, women and song, the Merriman also featured a revival of Irish set dancing and well-lubricated refrains, which coalesced with many a dawn chorus.

A man of myriad enthusiasms, Con also founded the St. Brendan and the British-Irish Associations. His Irish-Australia Association led to Sidney Nolan's gift of valuable paintings to Ireland. Some of Con's overseas amorous and drinking escapades allegedly almost caused diplomatic incidents. But, too independent to be ever made an ambassador, the gregarious Clareman did more when serving in London and Boston than any other Irish diplomat. A friend of British Prime Minister Ted Heath and US President John F. Kennedy, he played an important role in popularising Ireland and attracting overseas business. Tip O'Neill, the Speaker of the US House of Representatives observed: 'If Con Howard and I stood for Mayor of Boston tomorrow, Con would win.'

Ciarán MacMathúna, the broadcaster who saved Irish traditional music

Combing Ireland for several decades from 1955 in a station-wagon, Ciarán MacMathúna almost single-handedly saved Irish traditional music. Musicians in remote parts of Kerry and Donegal were so awed by the van's array of recording apparatus that they initially hid their instruments under their coats. But they soon responded to Ciarán's mellow charm and recorded songs, airs, poems and stories which would otherwise have been lost. Ciarán's influence and enthusiasm played a key role in the establishment of Claddagh Records. They recorded Sean O'Riada and the Chieftains, who became ambassadors for Irish music and whose outstanding arrangements were acclaimed worldwide.

Ciarán's own radio shows won national and international awards and embraced every strain of Irish musical expression. From solo *sean-nos* to sessions with accordions, bodhrans, fiddles and pipes. A monument to the unifying power of music, Ciarán was dismayed at the 1970s political violence

which curtailed his northern travel and undid much of his good work. Nobel Laureate Seamus Heaney said at his funeral in 2009: 'Over a lifetime he helped the population of Ireland to realise the beauty, strength and value of their native cultural possessions, above all their musical culture. The musical instrument which Ciarán played to magical effect, and which entranced generations of listeners, was his own voice.'

Ciarán's son, Padraic, was sure his father was in heaven with fellow-broadcaster Sean Mac Reamoinn: 'The first thing I thought was that Sean was going to turn around to Ciarán and say, "You know what, we're missing a great funeral!"'

Broadcaster and journalist Seán MacRéamoinn's boisterous nature countered Ciarán MacMathúna's easy calm. Seán the socialite was immortalised in Pauline Bewick's *Heytesbury Lane Party* painting, which also shows equally sociable singer Luke Kelly. A master of the *bon mot*, when asked one day how he felt, Seán retorted in his trademark throaty tones: 'I'm like a page from a census form. Broken down by age, religion and sex.'

Like his fellow-Musketeers, the multilingual Seán was a fluent Gaelic speaker and shared their involvement in the Merriman School and other cultural projects. Appointed Controller of Programmes for RTÉ Radio in the 1970s, he presented a variety of cultural programmes in both Irish and English during a long radio and television career. He confessed to being 'a card-carrying Catholic' and was one of the founders of the Glenstal Ecumenical Conference. But, no orthodox member, he noted that everything in the Catholic Church was either forbidden or compulsory. He supported the ordination of women and married men and, after reporting on the second 1960s Vatican council, celebrated: 'We have got rid of the prudishness and petty puritanisms that made us think sexuality was a tremendously important thing.' Seán was the first of the Musketeers to die in 2007 at the age of 85. Con Howard and Ciarán MacMathúna followed two years later, aged 84.

Other notable Club members included Irish-speaking poets Michael Hartnett and Sean O'Riordain, historian Maurice Craig and his wife, singer Agnes Bernelle. Later artists ranged from pipe-smoking Arthur Armstrong, John Brobbel, John Coyle, Paul Funge and Carmel Mooney to English visitor Jacqui Stanley, whose husband Campbell Bruce taught in the NCAD. And Gerald Davis who, complete with black bowler, each June 16 reenacted Leopold Bloom's odyssey through Dublin's byways. Many a late night discussion featured such writers as Ben Kiely, Ulick O'Connor, Henry Boylan and his

wife Patricia, who wrote the Club's history, harpist Maureen Hurley and Byron Society founder, Mary Caulfield.

The Club's art convenor, Angel Loughrey, celebrated: 'While artists, writers and fashions came and went, the United Arts Club has survived for over a century and made a unique contribution to Baggotonian and Irish life. Our membership is open to anyone with an interest in the arts.'

Its four floors crammed with paintings, the Fitzwilliam Street institution maintained Elle Duncan's original dream of a Dublin centre for the diffusion of the arts, with regular exhibitions, lectures, recitals and even jazz music by pianist 'Professor' Peter O'Brien. It provided accommodation for visiting painters and an unassuming bar which welcomed most of Ireland's leading artists and writers. Individual members promoted the arts with events such as Peggy Jordan's traditional music sessions in her home.

Later members proved more supportive than the contemporaries of Tom Casement and Isa MacNie, when they turned out in force for the 2009 funeral of another Club stalwart, Muriel Allison. Like Tom and Isa, the Club had been Muriel's second home since incompatability with computers encouraged her early retirement from Trinity College Library. Tall, slim and white-haired, Muriel's suited elegance was noted, as she teetered in her trademark high heels around her beloved Baggot Street and Georgian squares. In an unrelenting pursuit of the arts, like her friend Elizabeth McDowell, she rarely missed a book launch or art opening. Her name appeared in social columns, it was rumoured that no gallery could launch without her presence.

Fragile in appearance, Muriel accepted human frailty but was equally unafraid to fight her corner. Her last campaign was to restore the Club bar stools which had been removed in some political dispute: 'Did you ever hear of a bar counter without stools?' she huffed. The operation took resolve and patience, but the restored seating bore eloquent testimony to a consistent devotee both of the arts and the right thing. Muriel's funeral in the depths of one of Ireland's coldest winters attracted 200 mourners, including former RHA president Tom Ryan, longstanding members Ena Byrne, Lorcan Heron and David Johnson. Trinity College friends and almost the full complement of what she once described as 'Dublin's most civilised establishment'.

Chapter Twenty

HODDY, THE POPE AND OWEN WALSH

I heard Brendan Behan and Sean O'Sullivan lamenting one day that there were no more characters in Dublin. – John Ryan

'CAREFUL WITH THE SHERRY!' STEAM AND FLYING clouds were as general as the snow in Joyce's 'The Dead', as the train carrying John Ryan and The Pope O'Mahoney sped across the plains of central Ireland one morning in February 1950. A fitting atmosphere in which to learn an important point of law and the outcome of the tragic case of Galloping Depravity, the army major who had fallen for a comely hound.

The Pope leaned across the diminishing bottle of Winter's Tale sherry: 'Despite learned counsel's plea for the defence when it was argued that the dog had not only willingly accepted his master's amours, but warmly returned them, Lord Chief Justice Baron Palles was moved to give his celebrated ruling that has since become enshrined in the constitution of many lands: "In the case of bestiality, mutual consent is not a good defence."'

James Joyce's *Ulysses* and Oliver St John Gogarty's *As I was Going Down Sackville Street* are encyclopediae of Dublin characters, such as bowler-hatted Endymion, who travelled by compass. Clad in a tail-coat and white cricket trousers, and bearing a cricket bat and twin sheathed sabres, he walked each morning from Pleasant Street to the Ballast Office, which he ceremoniously saluted after setting his pocket watch by its clock. But, despite the gloomy conclusion of Brendan Behan and Sean O'Sullivan, there was no shortage of later city eccentrics, such as street-artist, Joan Hayes, painter Markey Robinson towing his shopping trolley and Christopher Daybell, proffering an armful of his latest poems.

Jazz musician, critic and former Mountjoy prison librarian, George Desmond Hodnett was one of Baggotonia's best known characters from the 1940s until his death in 1990 at the age of 72. Ironically for a jailbird, he was the son of an army officer who was descended from a prominent Cork legal family. Notoriously short-sighted and universally known as Hoddy, he was a schoolmate of future sculptor Des MacNamara. Progressing to Trinity College, like Gainor Crist, he soon abandoned law for more sociable pursuits. Though never far above the breadline, he established himself as a pianist and composer, and popular music correspondent for the *Irish Times*, for whom he reviewed Bob Dylan's first Irish concert in 1966: '"Baby Blue" has lines that stick in the mind like burrs on a coat; likewise "Desolation Row", if one can discount the unhappy relationship between harmonica and guitar, resulting (to put it simply) from sucking when one should blow.'

George Desmond "Hoddy" Hodnett, Monto composer and Mountjoy prisoner

Hoddy's own blowing got him into trouble during the war. One of his first instruments was a trombone, which his landlady forbade him to practice in the house. He brought the instrument to a party in Dun Laoghaire and, having missed the last bus, he had to walk home in the dark. Crossing Sandymount Strand, he considered it would be a fine place for some practice. But as he blew away, he noticed lights coming on in the houses by the shore. Soon he heard the sound of voices and people running across the sand. He decided to flee but, handicapped by the instrument, was quickly caught. His efforts to escape confirmed his pursuers' suspicions that he was a spy, signalling to some submarine or ship just over the horizon. They held him until Gardai arrived.

The jazz fanatic was the ideal man to score late-night revues for the revolutionary new Pike Theatre, where he sometimes slept. His Pike songs included 'Hogsville, Idaho', a send-up of 'Oklahoma'. And 'Monto', a satire on the booming folk scene. To Hoddy's astonishment, 'Monto' itself became one of Ireland's best-known folk songs, sung by Ronnie Drew and Luke Kelly of The Dubliners. 'Monto' was about Victorian Dublin's red light district, off Talbot Street, an area well known to Joyce and Gogarty, where Prince Albert, later King Edward Vll, was rumoured to have lost his virginity. The British army's withdrawal after independence and a campaign by religious groups closed the area in 1925. But it has been immortalized as Nighttown both in Joyce's *Ulysses* and Hoddy's 'Monto':

> When the Tzar of Russia and the King of Prussia,
> Landed in the Phoenix Park in a big balloon,
> They asked the Police band to play the Wearing of the
> Green,
> But the buggers in the Depot didn't know that tune,
> So they both went up to Monto, Monto, Monto,
> They both went up to Monto, langeroo, to you.

Hoddy was immensely popular with audiences at the Pike, where he was also one of the few people in Ireland to play the zither, recently popularised by Carol Reed's film, *The Third Man*. He wrote most of the revue lyrics. And, with cigarette ash flying and spectacles dancing, he would effortlessly switch from jazz to Irish or Russian music. Like Gainor Crist, the fates regularly conspired against Hoddy's best-laid schedules. He tried, but could never be punctual. He had to be kidnapped for rehearsals.

Carolyn Simpson remembered: 'The best way to ensure we had songs for our revues was to get Hoddy seated at the piano in the theatre, where music would burst from the tips of his fingers in a flow which was then as hard to stop as it had originally been to get started.'

The pianist's intemperate pace caused rows with the theatre's dancers. Carolyn explained: 'The trouble with Hoddy was that he was a jazz man first and last and never came to terms with the strict tempo requirements of dancing, tending to sudden accelerations that left the unfortunate cast frantically chasing their music. This resulted in running battles between Hoddy and the cast, who developed a love-hate relationship with him, which sometimes flared into open warfare in the tiny crowded scene dock.'

Honoured with an appearance on Gay Byrne's debut 'Late Late Show', Hoddy was an early and committed environmentalist. He was shocked by the destruction of the much-loved Theatre Royal, on which Eamonn Mac-Thomais commented: 'What would our fathers thought of us who allowed a good, sound 1935 building to be torn down in 1962, when they moved heaven and earth to raise the Royal after fire had destroyed it on two occasions.'

Exploiting a perception that the city's Georgian buildings were a distasteful colonial legacy, developers bulldozed swathes of terraces to make way for office blocks. Lady Gregory's Coole Park House was demolished for its valuable building stone. In 1965, the semi-state ESB group demolished most of Lower Fitzwilliam Street and destroyed the world's longest continuous parade of Georgian houses. Appalled by the destruction of St Anne's School and Hall in nearby Molesworth Street, where Elizabeth Bowen had dancing classes, Hoddy joined the architectural student demonstrations. His enthusiasm led to a confrontation with security staff. His hands were so severely injured that he had to curtail his piano playing for several weeks.

A Georgian gem – Brian Lalor's drawing of W.B. Yeats' Merrion Square home

The Dubliner was parted from his instrument for a longer stretch, when Gardaí raided his home after he became involved with nationalist extremists. The police seized what they regarded as dangerous weapons, a couple of rapiers and a crossbow, which Des MacNamara had designed as props for the Laurence Olivier film, *Henry V*. Des recalled: 'The bow was as high as a man and it took a foot-stirrup to secure. Nevertheless, they were regarded as offensive weapons and Hoddy was sentenced to six months. I made several efforts to retrieve my bow, but in vain. Ernie Gebler came with me to visit Hoddy in Mountjoy, where governor Kavanagh, a friend of Brendan Behan's, gave us tea. Hoddy worked in the library and he read every book there. Thanks to the prison's sub-standard wattage, he was almost blind when he was released.'

When he was sleeping rough in a friend's garage. Hoddy claimed to have solved the long-standing mystery of the Etruscan language. Short of money, he salvaged from dustbins and market stalls. One day he returned with a Japanese bamboo parasol, which he reduced to thirty or forty thin pieces and then turned into charcoal. After spending all Christmas writing on the wall, he invited his friend to see the result. He said that he had isolated something like 84 words, or roots of words, and could now explain the Etruscan language. Sadly, tiring of holiday idleness, the landlord painted over the wall before anyone had a chance of verifying the great discovery.

From ashes to sackcloth, the open door of Parsons Bookshop proved a magnet for many characters. Most were widowers or spinsters in search of company. Like Fiona Plunkett, sister of one of the executed 1916 insurgents, Joseph Mary Plunkett. And the diminutive fur-coated heiress, Miss Brown, who had to duck the same irregulars' bullets as a child in Upper Mount Street. One of Mary King's favourites was Sir Anthony de Houghton: 'A great card, a Catholic straight out *Brideshead Revisited* – one could almost imagine a teddy-bear in tow!

'He paid little attention to convention and once he appeared wearing only a sack, which disconcerted Miss O'Flaherty. One of quite a few remittance men in Dublin, he was a former RAF pilot who was allegedly cashiered after he bombed his own airbase. Originally from Houghton Towers in Yorkshire, which had Shakespearean associations, it was hardly surprising that he had a great feel for literature. It was rumoured that he was related to William Stanley Houghton, the turn-of-the-century Manchester playwright who, like Joyce, was much influenced by Ibsen.'

Sir Anthony lived for drink, company and conversation. 'He would come in during the afternoon, sit down at the counter and produce a bottle of wine, which he drank using our little weighing scales as a glass. An amusing and entertaining gossip, he seemed to have known everyone in the literary and social world. One could listen to him for hours: in fact he would often remain chatting after the shop closed. Then, around 1970, he suddenly vanished from our lives and we never saw him again. Perhaps he was out of a book?'

Another English-born eccentric was Richard 'Dickie' Wyeman. He once walked for a £10 bet to Caherdaniel in Kerry, where Brendan Behan was helping to restore Daniel O'Connell's house. It was Dickie who launched the Catacombs late-night drinking den and flop-house at 13 Fitzwilliam Place. Six feet tall, handsome and gay, Dickie was a former nightclub manager who had fled to Dublin after his army officer boyfriend was killed in the war. Apart from

making sweets and occasionally selling his blood to the nearby Blood Transfusion Service, he lived by renting out the warren of basement hovels which boasted such titles as The East Wing, The Snug and The Pink Parlour. And from the refunded deposits for the empties left by late-night revellers Brendan Behan, Gainor Crist, John Jordan and assorted intelligentsia.

The Catacombs proprietor in turn paid for the basement by posing for its artist owner, who lived upstairs. Her work turned up in unlikely places. One of Brendan Behan's staunch friends and defenders was *Irish Press* literary editor and novelist, M.J. MacManus. When he died, Brendan went to his funeral with novelist Ben Kiely. 'You'll be watched in the church because you're said to be anti-clerical, so behave yourself,' Ben warned.

Eoin 'The Pope' O'Mahoney, conservationist and crusader against materialism

Brendan was on his best behaviour until the newly-painted Stations of the Cross caught his eye. The style was familiar: they had been painted by Dickie Wyeman's landlady. And the model for Christ had been Dickie himself, who was also known as Cecil. Brendan knew Dickie very well in and out of clothes, they both regularly swam in the twopenny Tara Street baths. Brendan recalled: 'There he was in various "camp" attitudes, as they say in England. Cecil arrested by the Roman soldiers: Cecil cruelly scourged at the pillar: Cecil meeting the pious women: Cecil with his afflicted mother, and last but not least, Cecil nailed to the Cross. I burst out laughing and Kiely jabbed me in the ribs. Quickly I bent my head though my shoulders shook and I had to pretend to be sobbing.'

When Brendan was arrested once in England, the authorities were startled by a telegram which arrived for their prisoner: 'I'm flying to defend you. The Pope.' It was from lawyer Eoin O'Mahoney. Another Dublin character,

the pontiff without portfoloio acquired his title from the Vatican ambitions he expressed at Clongowes Wood College and from his habit of cycling around Dublin in his cloak and full Knights of Malta regalia. Described as a lost Elizabethan, he was also a member of the Royal Stuart Society. Like artist Sean O'Sullivan, the bearded and well-nourished Pope boasted a mellifluous Cork accent. He was a member of the southern O'Mahoney clan, which included David Tynan O' Mahony, better known as comedian Dave Allen.

Artist and writer Brian Lalor remembered the Pope in rhetorical flow: 'With a mingling of the Fenians, the clergy (always bishops, cardinals with the occasional pope thrown in), obscure European royalty, criminals, the wild geese, philately, necromancy and the occult, all in the same sentence.'

Author, genealogist, historian, philosopher and crusader against materialism, the Pope was an early conservationist. Describing himself as 'an aristo-democrat', he joined George Hodnett in campaigning for the Irish Georgian Society. He played a key role in the restoration of the Derrynane home of Catholic Emancipation champion, Daniel O'Connell. A member of both the English and the Irish Bars, he was also well known as a frequent defender of Brendan Behan and other lost causes. Wigged and gowned, he was once seen entering the Four Courts wearing odd shoes. Haste and overwork sometimes scuppered his eloquent pleas. Defending two petty criminals, he discovered that one of them had six children, sure grounds for mitigation. Sadly, he confused the names of the prisoners. The result was that the man without children was let off with a fortnight's imprisonment, while the father of six received a month. Brendan Behan remarked that if the Pope defended him for riding a bicycle without a light, he would probably be hanged.

Despite his enthusiasm for Behan, the Pope was a constitutional patriot whose hero was the Home Rule campaigner John Redmond. The Pope excited the sympathy of Osbert Lancaster when he arrived carrying a large wreath to escort the English artist to the Wexford Opera Festival. 'I'm most dreadfully sorry, who's passed on?' Osbert asked. 'It's for John Redmond,' the Pope explained. 'Were you very close?' Osbert enquired. Ben Kiely often recalled another of the Pope's alarming telegrams, sent to the female caretaker of the religious *Capuchin Annual* office in Capel Street, where he sometimes stayed: 'Annie, arriving tonight, stop. Leave bedroom door open, stop. Pope.' *Annual* editor Fr. Senan framed the telegram.

A friend of the Pope's arrived once at St Lazare station in Paris. He was making his way across the vast square when he saw a familiar figure hunched over one of the many tables. Dipping a pen in an inkbottle was none other

than the Pope. 'I'm writing to General Franco,' the Pope informed him. 'Whatever we may think, he's a Christian gentleman and, as a Knight of Malta, I am requesting him to release the three republican prisoners he is holding in Burgos.' The Pope's influence worked where the government had failed.

John Ryan was one of the best friends of the Pope, who spent his last years in the Irish Studies department of the University of Southern Illinois. The week before he died in 1970 at the age of 66, he sent John an article on Father Conmee for the James Joyce tribute book, *A Bash in the Tunnel*. According to the *Envoy* founder, there could be no more entertaining travel companion. Checking in one snowy February morning for a trip to Galway, he discovered the Pope awaiting the same *Queen Maeve* train. John invested in a bottle of sherry to lubricate their journey. As they pulled out of Kingsbridge station in clouds of steam, the Pope commenced to treat him to a series of potted biographies, epitaphs and elegies, which lasted the length of their journey.

John pointed to a straggling avenue of lime trees which led to the ruin of a big house. The Pope pounced. Rathmogerly Castle, home of the Plunkington-Foreshaws, to which he had once cycled from Clongowes College: 'Lady Sarah was herself one of the Fitzroy-Plantagenets and noted for her fêtes champêtres. It is said that Earl Kitchener of Khartoum was attending one of these functions at the castle when he received the summons to assume the Viceroyship of India, but that he was so overwhelmed by the occasion that he spilt his glass of champagne over the Countess of Cappawhite's muslin tea gown. She was then in her ninety-fifth year and had known Wordsworth as a young girl.'

The Pope warmed to his theme: 'The Foreshaws were a decent Catholic-Protestant, Anglo-Irish family. One of their forebears — a Dolan from Westport (who changed his name by deed-poll) was the midshipman on the *Victory* who translated Nelson's commands to the foretopmen into Irish, because they were all native speakers from Cape Clear island with no English. The Pilkingtons were the natural issue of a liaison between Harry, first Duke of Grafton, the illegitimate son of Charles the Second who fell at the siege of Cork, and an amorous adventure with Charlotte Albion, whose family changed their name to Bryuthon and whose motto was Facile Princeps (Indisputably the First).'

According to John, the rich Cork cadences now matched the exhalations of the rampant *Maeve*, as it vanquished the low-flying snow. Continuing with the Plunkingtons, the genealogist recalled the brother who was to become a Buddhist monk: 'He was said to be the love child of the Earl of Dodder

and his mother, Lady Rathmogerly, when his Lordship was with the heavy Brigade in the Crimea. He had survived the charge of Balaclava, having got among the Russian guns at the end of that fatal sally. Indeed he could display in later years (when master of the Ward Union) the scorch marks from the gunpowder of the same artillery, on the lace cuffs he had been wearing that day with his hunting pinks.'

But it was not all good news. Before the train reached the Shannon, John was acquainted with a spectacular fall from grace. The uncle had been a major with the Twelfth Lancers serving with Churchill at the Battle of Omdurman in 1898: 'His wife Nellie (who was famous for her homemade marmalade – hers was a secret recipe, handed down by her family who were themselves, on the spindle side, direct descendants of the last chaplain to Mary, Queen of Scots) became strangely infatuated with James Elroy Flecker to the extent that the major (Galloping Depravity, as he was known) in a fit of pique, turned his affections to his dogs – ten couples of Basset hounds he kept in his luxurious kennels near George Moore's house in Ely Place.'

Sketch of Eoin 'The Pope' O'Mahoney by Raymond Piper

As the train glided to a halt in Athlone, with half their journey still ahead, the Pope acquainted John with the case which led to the historic legal ruling: 'There was a tragic outcome and an ensuing scandal so severe that it almost toppled Gladstone's second government, when the major was made to stand trial on charges of carnal knowledge of one of the dogs in the back of his landau during the running of the Irish Grand National at Fairyhouse.'

Sculpted by Seamus Murphy, the Pope became a national figure with his 'Meet the Clans' radio programme and his participation in the campaign to restore the Hugh Lane pictures to Ireland. He decided to contest the 1966 Presidential election but the established political parties ensured that he

failed to secure nomination. The Pope's membership of the Zoological Society made him particularly popular with some of the literati. Its Phoenix Park restaurant served drink on Good Friday, when all the city pubs were closed. Patrick Kavanagh contrived to meet him one Good Friday and enjoyed many libations in the member's bar. Typically, the poet soon forgot the kindness. Some time later, tiring of the praise he heard being heaped on the Pope by fellow-drinkers in the George pub in London's Great Portland Street, he interrupted: 'The man's a terrible bore.'

'Oh come now, Paddy,' a BBC type insisted. 'You can't say that. Everyone knows he's a brilliant talker. After all he successfully talks for his dinner.'

'He'd eat a damn sight more if he kept his mouth shut,' the poet replied.

Westport-born Owen Walsh was another of the Pope's acquaintances. For half a century, while Dublin changed around him, the gravel-voiced artist lived, loved, smoked and painted in a first-floor studio at 108 Lower Baggot Street. A magisterial presence with his cravat, bright sports coat and, latterly, a stick, he patrolled the street each day before and after work. Proud to be a Baggotonian, he often quoted Joyce's story, 'A Painful Case': 'James Duffy had been for many years cashier of a private bank in Baggot Street.' When asked about his interests, Owen replied: 'Getting my leg over or under any female offering, drink, wandering around the docks, music and getting down West when possible.'

For Owen, life and art were one. Colour and confusion distinguished his oil and turps-marinated studio, which Professor Jimmy O'Donovan described: 'As coruscant as anything painted by Elizabeth Cope.' Paintings that had escaped the regular fireplace cullings illuminated the fading walls. Rubensque nudes competed with dancing street scenes and

'Neither rank nor wealth impressed Owen...'

mother and child studies created purely by contrasting pigments. Discarded wine bottles flashed multi-hued rays, bookshelves listed under the weight of symphonies and tomes on art and literature. Squashed paint tubes and worn brushes carpeted the wooden floor, tea was served on a richly patinated and rickety table. The morning's *Irish Times* resembled the Book of Kells by six o'clock. A photograph of the artist with Siobhan McKenna graced the piano, on which he had allegedly danced naked with another actress. Silversmith Vincent Meehan related: 'I once called on Owen with a Sadler's Wells ballerina. She wouldn't believe that his studio was anything other than a stage set – almost certainly for *La Boheme!*'

Neither rank nor wealth impressed Owen, nor, particularly, the paintings of Markey Robinson. Regarded by his foes as loud, insufferably opinionated and a tad menacing with drink, he eschewed all schools and cliques. 'Art my royal Irish arse,' he growled for all to hear, as he left a fashionable contemporary's exhibition. But his knee flexed instinctively at the mention of two contrasting heroes, Fra Angelico and Henri Matisse. With Bach, Mahler and Tchaikovsky for encouragement, Owen painted for hours, oblivious to both time and temperature, his epilepsy and the increasing pain of a recalcitrant hip. Though he frequently exhibited at the Royal Hibernian Academy, Oireachtas and Living Art exhibitions, he was one of few to decline an invitation to join the RHA. He valued his independence so highly, that he withdrew from the Independent Artists Group immediately after he co-founded it in 1959: 'I was tired of the fighting and shouting, a terrible waste of my precious time!'

After painting for days, Owen regularly went on a skite with kindred spirits Liam O'Flaherty or James McKenna. More famous as a sculptor, the latter was also a playwright and was commissioned by Brendan Behan to script the film of *The Quare Fellow*. Owen remembered: 'James opened my last Dublin exhibition. A wonderful artist, an uncompromising and consistent man. Liam was immense and never did anything by halves. He spoke fluent Irish like Sean O'Sullivan and myself. Dublin was a lively place in their time. Now, there's nothing only suits, offices and such queues of motorin' cars that the cherry blossoms come out no more in Baggot Street. And sociability has plunged into free-fall.'

By the start of the new millennium, Owen was the sole survivor of Baggot Street's once teeming Bohemian population. Most contemporaries had flown to the suburbs; older friends including Cecil Salkeld and Liam O'Flaherty had died. Instead of opening the curtains beside the piano to Lampshades, the

artist's house was now dwarfed by a financial complex. His beard bristled at the row of plastic office bells which encroached on his 'Owen Walsh, Knock Hard' brass knocker.

A reminder of the transformation brought a flush to Owen's cheeks. A teacup spoon danced as he banged the table: 'These Celtic Tigers are tearing the arse out of our city. You blink and a landmark is gone forever. Developers and bankers with cash on tap and friends in high places have succeeded where the invader failed. They've reduced Dublin to a wasteland. Gated apartment fortresses mock our peerless Georgian heritage. Instant cobblestones and rip-off pubs for tourists in Temple Bar. The quick buck, that's the height of our modern culture. While we wait for the bubble to burst, we can thank the Lord for Bertie Smyllie's *Irish Times*, our only constant.'

Cataclysmic changes marked the latter half of Owen's residency. The banter of his corner shop had succumbed to the babble of supermarket tills. Underneath his windows, a commotion of marketing zealots supplanted the 1950s parade of young priests and dark-habited nuns. They supped on the hoof, gabbled into mobile phones rather than to each other and purchased apartments in Dubai built on slave labour. Satellite dishes and private helicopters proclaimed new religions. The monolithic Catholic Church had plumetted from grace, newspapers which had eulogised the institution now as shamelessly headlined its scandals. The revised litany of saints read Saint Bob, Bono, Van Morrison and Sinead O'Connor.

Pandora's Box was impartial. Spectral addicts importuned on corners where genteel ladies once plucked harp strings. Teenage drunks littered the weekend streets. Soon, almost one fifth of greater Dublin's one million residents would have been born abroad. Suicide Crossroads. A giant chrome needle on the site of Nelson's Pillar was the final spike through the old city's heart. Joyce's intimate town and Baggotonia's prime were history. Brendan Behan had been right: 'It will all change one day again.'

But the constant innovations brought one unexpected delight. Owen explained to a visitor who had interrupted his reading of a new biography of Hugh Lane: 'It's an ill wind. After burying it in one improvement, they've uncovered a mural of mine in Larry Murphys' latest manifestation. Let's toast the fucking thing, before it gets covered for another forty years.'

The artist grabbed his stick which, after only a few months, was now a battered extension of himself. He banged the door. The house shook, a new alarm shrieked. The traffic parted as his raised blackthorn commanded the busy

road. 'Moses!' greeted Christy Little, Baggot street's last newsvendor, who was holding up the corner with monologue and mouthorgan maestro, Reggie.

Having been covered for decades, the mural's green and ochre were as fresh as when they were first applied. Action and anticipation animated the wall. Two rugby players went flying as their outstretched teammates thundered after a soaring ball. Spectators bellowed encouragement from the sidelines. One clutched a dangerously tilted pint, another's cap flew in the air. Christy Little's father yelled advice with a hint of equally eloquent abuse.

'I completed it one Easter holiday,' Owen watched his pint being pulled. 'For some reason, the buggers didn't trust me to finish the job and locked me in for the entire weekend. But I couldn't drink, I'd only get my hundred notes if the wall was completely covered by Monday!'

'An appropriate metaphor for Baggotonians' struggles against the odds,' Owen's companion surveyed the wall action.

'Metaphor my arse,' the artist spluttered.

'You sound like one of those bloody critics foisting their frustrations on another unfortunate bit of canvas. You know what Behan said about the critics? "They're like eunuchs in a harem. They know how it's done, they've seen it done every day, but they're unable to do it themselves."'

Owen Walsh unveiling his self-portrait to future Taoiseach Enda Kenny

'What you see before you is a bunch of fellows enjoying a game of rugger in front of an audience...' Owen's drink resumed its original trajectory, '... who are as appreciative of a good game as I am of my first pint of the day.'

After a lifetime devoted to hard work and the good life, Baggot Street's last artist died in June 2002 at the age of 69. 'Heaven's a more interesting place now!' said schoolfriend Father Michael MacGreil, as Owen was buried in the shadow of his favourite mountain, Croagh Patrick. Bohemian Dublin died with the wild Mayo man. Metaphor or not, his mural is a joyous memorial to the prodigals and geniuses of unmapped Baggotonia. And to its last Bohemian, for whom Paul Durcan inscribed a final tribute:

> Artist knowing what he wants and does not want
> He is as nonchalant as he was
> Fifty-five easel-courting years ago:
> He whom now no trend-editor can identify.
> Leaning on his stick he growls 'Goodbye'
> And steps away to work another year alone.

Bibliography

Algren, Nelson, *Who Lost an American*, Macmillan, New York, 1963.

Andrews, C.S., *Man of No Property*, Mercier Press, Dublin, 1982.

Arnold, Bruce, *Jack Yeats*, Yale University Press, New Haven, CT, 1998.

Bair, Deirdre, *Samuel Beckett: A Biography*, Jonathan Cape, London, 1978.

Bardwell, Leland, *A Restless Life*, Liberties Press, Dublin, 2008.

Beckett, Samuel, *More Pricks than Kicks*, Calder and Boyars, London, 1970.

Behan, Beatrice with Hickey, Des and Smith, Gus, *My Life with Brendan*, Leslie Frewin, London, 1973.

Behan, Brendan, *Borstal Boy*, Corgi Books, London, 1970.

Behan, Brendan, *Hold Your Hour and Have Another*, Hutchinson, London, 1963.

Behan, Brendan, *Confessions of an Irish Rebel*, Hutchinson, London, 1965.

Behan, Brian, *Mother of All the Behans*, Arrow Books, London, 1985.

Bourke, Marcus, *John O'Leary*, Geography Publications, Dublin, 2009.

Bowen, Elizabeth, *Seven Winters: Memories of a Dublin Childhood*, Longmans, Green and Co., London, 1943.

Bowen, Elizabeth, *The Shelbourne*, George G. Harrap, London, 1951.

Boylan, Patricia, *All Cultivated People: A History of the United Arts Club*, Dublin, Colin Smythe, Gerrards Cross, 1988.

Bristow, Roger, *The Last Bohemians. The Two Roberts – Colquhoun and Mac-Bryde*, Sansom & Company, Bristol, 2010.

Brown, Barbara, editor, *Maurice Harmon. Selected Essays*, Irish Academic Press, Dublin, 2006.

de Burca, Seamus, *Brendan Behan: A Memoir*, Proscenium Press, Newark, 1971.

Butler, Patricia, *Three Hundred Years of Irish Watercolours and Drawings*, Weidenfeld and Nicholson, London, 1990.

Campbell, Julian. *Frank O'Meara and His Contemporaries*, Hugh Lane Municipal Gallery, Dublin, 1989.

Campbell, Patrick, *My Life and Easy Times*, Anthony Blond, London, 1967.

Carroll, Joe, *Ireland in the War-Years 1939-1945*, David & Charles, Devon, 1975.

Carlson, Julia, *Banned in Ireland*, University of Georgia Press, Athens, GA, 1990.

Cooney, John, *John Charles McQuaid, Ruler of Catholic Ireland*, O'Brien Press, Dublin, 1999.

Corkery, Tom, *Dublin*, Anvil Books, Dublin, 1980.

Costello, Peter and Van de Kemp, Peter, *Flann O'Brien, An Illustrated Biography*, Bloomsbury, London, 1987.

Costello, Peter, *The Dublin Literary Pub Crawl*, A & A Farmer, Dublin, 1996.

Costello, Peter, *Liam O'Flaherty's Ireland*, Wolfhound Press, Dublin, 1996.

Cowell, John, *Where They Lived in Dublin*, O'Brien Press, Dublin, 1980.

Coxhead, Elizabeth, *Daughters of Erin*, Secker & Warburg, London, 1965.

Craig, Maurice, *Dublin 1660-1860*. Allen Figgis Ltd., Dublin, 1980.

Cronin, Anthony, *Dead as Doornails*, Dolmen Press, Dublin, 1976.

Cronin, Anthony, *No Laughing Matter, The Life and Times of Flann O'Brien*, Grafton Books, London, 1989.

Bibliography

Cronin, Anthony, *Samuel Beckett. The Last Modernist*, Harper Collins, London, 1996.

Cronin, Anthony, *The Life of Reilly*, New Island, Dublin, 2010.

Crookshank, Anne and the Knight of Glin, *Ireland's Painters 1600-1940*, Yale University Press, 2002.

Cullen, Fintan, *The Drawings of John Butler Yeats*, Albany Instiute of History and Art, New York, 1987.

Donleavy, J.P., *The Ginger Man*, Penguin Books, London, 1968.

Donleavy, J.P., *The History of the Ginger Man*, Viking, London, 1994.

Donleavy, J.P., *Ireland in All her Sins and in Some of her Graces*, Michael Joseph, London, 1986.

Donleavy, J.P., *An Author and His Image: The Collected Short Pieces*, Viking, London, 1997.

Durcan, Paul, *Cries of an Irish Caveman*, The Harvill Press, London, 2001.

Durcan, Paul, *Crazy About Women*, National Library, Dublin, 1991.

Egan, Desmond and Niamh Hoare, *James McKenna, A Catalogue*, Goldsmith Press, Newbridge, 2005.

Ellman, Richard, *James Joyce*, Oxford University Press, 1983.

Ellman, Richard, *Oscar Wilde,* Hamish Hamilton, Londonn, 1987.

Ellman, Richard, *Yeats. The Man and the Masks*, Faber, London, 1969.

Fallis, Richard, *The Irish Renaissance*, Gill and Macmillan, Dublin, 1978.

Fallon, Brian, *An Age of Innocence: Irish Culture 1930-1960*, Gill & Macmillan, Dublin, 1998.

Fallon, Brian, *Edward McGuire R. H. A.*, Irish Academic Press, Dublin, 1991.

Fallon, Brian and Murray, Peter, *Patrick Swift. An Artist in Portugal*. Crawford Municipal Gallery, Cork, 2001.

Farson, Daniel, *Sacred Monsters*, Bloomsbury, London, 1988.

Fehsenfeld, Martha Dow and Overbeck, Lois More, *The Letters of Samuel Beckett 1929-1940*, Cambridge University Press, 2009.

Fitzgerald, Barbara, *We Are Besieged*, Somerville Press, Bantry, 2011.

Flanagan, Laurence. *Bottle, Draught and Keg*, Gill and Macmillan, Dubln, 1995.

Flanagan, Thomas, *There You Are: Writings on Irish and American Literature and History*, edited by Christopher Cahill, New York Review Books, 2004.

Flynn, Mannix, *Nothing to Say*, Ward River Press, Dublin, 1983.

Foster, R.F., editor, *The Oxford Illustrated History of Ireland*, Oxford University Press, 1991.

Foster, R.F., *W.B. Yeats: A Life. The Apprentice Mage, 1865-1914*, Oxford University Press, 1997.

Foster, R.F., *W.B. Yeats: A Life. The Arch Poet 1915-1939*, Oxford University Press, 2003.

Frazier, Adrian, *George Moore*, Yale University Press, New Haven, 2000.

Frost, S., *A Tribute to Evie Hone and Manie Jellett*, Browne & Nolan, Dublin, 1957.

Gebler, Carlo, *My Father & I: A Memoir*, Little, Brown, London, 2000.

Glenavy, Beatrice Lady, *Today We Will Only Gossip*, Constable, London 1964.

Gordon, Robert, *John B Yeats and John Sloan: The Records of a Friendship*, Dolmen Press, Dublin, 1978.

Gorman, Herbert, *James Joyce, A Definitive Biography*, John Lane, London, 1941.

Gray, Tony, *Mr Smyllie, Sir*, Gill & Macmillan, Dublin, 1991.

Greacen, Robert, *The Sash My Father Wore*, Mainstream Publishing, Edinburgh and London, 1997.

Greacen, Robert, *Brief Encounters: Literary Dublin and Belfast in the Early 1940s*, Cathair Books, Dublin, 1991.

Greene, David H. and Stephens, Edward M., *J.M. Synge*, New York University Press, 1989.

Guinness, Desmond, *Georgian Dublin*, B.T. Batsford Ltd., London, 1988.

Bibliography

Gwynn, Stephen, *Dublin Old and New*, Harrap, London, 1938.

Haffenden, John, *The Life of John Berryman*, Routledge & Keegan Paul, 1982.

Harmon, Maurice, *Sean O'Faolain, A Life*, Constable, London, 1994.

Harmon, Maurice (editor), *The Dolmen Press: A Celebration*, Lilliput Press, Dublin, 2001.

Hartnett, Michael, *A Book of Strays*, Gallery Books, Loughcrew, 2002.

Hart-Davis, Rupert (editor), *The Letters of Oscar Wilde*, Rupert Hart-Davis, London, 1962.

Healy, Elizabeth, *Literary Tour of Ireland*, Wolfhound Press, Dublin, 1995.

Henry, Paul, *An Irish Portrait*, B.T. Batsford, London, 1988.

Henry Paul, *Further Reminiscences*, Blackstaff Press, Belfast, 1973.

Higgins, Aidan, *Balcony of Europe*, Calder & Boyars, London, 1972.

Hill, Judith, *Lady Gregory: An Irish Life*, Sutton Publishing, Stroud, 2005.

Hogarth, Paul, *Drawing on Life*, David and Charles, Newton Abbott, 1997.

Huddleston, Sisley, *Paris Salons, Cafes, Studios*, Blue Ribbon Books, New York, 1928.

Hughes, Andrew, *Lives Less Ordinary: Dublin's Fitzwilliam Square, 1798-1922*, The Liffey Press, Dublin, 2011.

Igoe, Vivien, *A Literary Guide to Dublin*, Methuen, London, 1994.

Igoe, Vivien, *Dublin Burial Grounds and Graveyards*, Wolfhound Press, Dublin, 2001.

Jackson, John Wyse with Peter Costello, *John Stanislaus Joyce*, Fourth Estate, London, 1997.

Jackson, John Wyse and Bernard McGinley, *James Joyce's Dubliners: An Annotated Edition*, Sinclair-Stevenson, London, 1993.

James, Dermot, *From the Margins to the Centre: A History of the Irish Times*, Woodfield Press, Dublin, 2008.

Jeffs, Rae, *Brendan Behan: Man and Showman*, Hutchinson, London, 1966.

Johnson, Nevill, *Dublin: The People's City*, Academy Press, Dublin, 1981.

Johnson, Nevill, *The Other Side of Six*, Academy Press, Dublin, 1983.

Jordan, John, *Collected Stories*, Poolbeg Press Ltd., Dublin, 1991.

Joyce, James, *A Portrait of the Artist as a Young Man*, Penguin Books, London, 1960.

Kavanagh, Patrick, *The Green Fool*, Martin Brian & O'Keeffe, London, 1971.

Kavanagh, Patrick, *Collected Poems*, edited by Antoinette Quinn, Allen Lane, London, 2004.

Kavanagh, Patrick, *By Night Unstarred*, Goldsmith Press, The Curragh, 1977.

Kavanagh, Patrick, *Lapped Furrows*, The Peter Kavanagh Hand Press, New York, 1969.

Kavanagh, Patrick, *Self-Portrait*, Dolmen Press, Dublin, 1964.

Kavanagh, Peter, *Beyond Affection*, The Peter Kavanagh Hand Press, New York, 1977.

Kavanagh, Peter, *Sacred Keeper*, The Goldsmith Press, The Curragh, 1979.

Kavanagh, Peter, *Patrick Kavanagh: A Life Chronicle*, The Peter Kavanagh Hand Press, New York, 2000.

Kavanagh, Peter (editor), *Patrick Kavanagh. Man and Poet*, The Goldsmith Press, 1987.

Kearney, Colbert, *The Writings of Brendan Behan*, Gill and Macmillan, Dublin, 1977.

Kelly, A.A., *The Letters of Liam O'Flaherty*, Wolfhound Press, Dublin, 1996.

Kennelly, Brendan, *Familiar Strangers: New and Selected Poems 1960–2004*, Bloodaxe Books, Highgreen, 2004.

Kiely, Benedict, *The Waves Behind Us*, Methuen Publishing, London, 1999.

Kinsella, Thomas, *Collected Poems*, Carcanet Press, Manchester, 2001.

Lalor, Brian, *Ink-Stained Hands*, Lilliput Press, Dublin, 2010.

Lalor, Brian, *Ultimate Dublin Guide*, O'Brien Press, Dublin, 1991.

Bibliography

Lalor, Brian (general editor), *The Encyclopedia of Ireland*, Gill and Macmillan, Dublin, 2003.

Lennon, Sean, *Dublin Writers and Their Haunts*, Fingal County Council, 2003.

Levenson, Leah, *The Four Seasons of Mary Lavin*, Marino Books, Dublin, 1998.

Levenson, Samuel, *Maud Gonne*, Cassell, London, 1977.

Lewis, Gifford, *Edith Somerville: A Biography*, Four Courts Press, Dublin, 2005.

Lynch, Brendan, *Parsons Bookshop: At the Heart of Bohemian Dublin 1949-1989*. The Liffey Press, Dublin, 2006.

McCann, Sean, *The World of Brendan Behan*, New English Library, London, 1965.

McCann, Sean (editor), *The Wit of Brendan Behan*, Leslie Frewin, London, 1968.

McConkey, Kenneth, *A Free Spirit, Irish Art 1860-1960*, Antique Collectors' Club, London, 1990.

McCullagh, David, *The Reluctant Taoiseach: A Biography of John A. Costello*, Gill and Macmillan, Dublin, 2010.

McDonald, Frank, *The Destruction of Dublin*, Gill and Macmillan, Dublin, 1985.

McDougall, Richard (translator), *The Very Rich Hours of Adrienne Monnier*, Charles Scribner, New York, 1976.

McFadden, Hugh (editor), *Crystal Clear: The Selected Prose of John Jordan*. The Lilliput Press, Dublin, 2006.

MacLoughlin, Adrian, *Guide to Historic Dublin*, Gill and Macmillan, Dublin, 1979.

MacNamara, Desmond, *The Book of Intrusions*, Dalkey Archive Press, Illinois, 1994.

Marreco, Anne, *The Rebel Countess: The Life and Times of Constance Markievicz*, Chilton Books, Philadelphia, 1967.

Matthews, James, *Voices: A Life of Frank O'Connor*, Gill and Macmillan, Dublin, 1983.

Mikhail, E.H. (editor), *The Letters of Brendan Behan*, Macmillan, London, 1992.

Mikhail, E.H., *The Art of Brendan Behan*, Vision Press, London, 1979.

Mikhail, E.H., *Brendan Behan: Interviews and Recollections*, Gill and Macmillan, Dublin, 1982.

Milner, John, *The Studios of Paris*, Yale University Press, New Haven, 1988.

Mitchell, Geraldine, *Deeds not Words: The Life of Muriel Gahan*, Townhouse, Dublin, 1997.

Mitchell, Susan, *Aids to the Immortality of Certain Persons in Ireland*, Maunsell, Dublin, 1913.

Montague, John, *Selected Poems*, Penguin Books, London, 2001.

Montague, John, *Company: A Chosen Life*, Duckworth, London, 2001.

Montague, John, *The Pear is Ripe: A Memoir*, Liberties Press, Dublin, 2007.

Moore, George, *Hail and Farewell*, Heinemann, London, 1933.

Murphy, Patrick J., *Patrick Tuohy*, Townhouse, Dublin, 2004.

Murphy, Wiliam M, *Prodigal Father: The Life of John Butler Yeats*, Cornell University Press, Ithaca, 1979.

O'Brien, Eoin, *The Beckett Country*, The Black Cat Press/Faber and Faber, Dublin, 1986.

O'Brien, Mark, *The Irish Times: A History*, Four Courts Press, Dublin, 2008.

O'Brien, Flann, *The Dalkey Archive*, Grafton Books, London, 1986.

O'Brien, Flann, *Myles before Myles*, Grafton Books, London, 1988.

O'Brien, Flann, *The Third Policeman*, McGibbon and Kee, London, 1967.

O'Brien, Flann, *The Various Lives of Keats and Chapman*, Thomas Dunne Books, New York, 2005.

O'Byrne, Robert, *Hugh Lane, 1875-1915*, Lilliput Press, Dublin, 2000.

O'Connor, Frank, *My Father's Son*, G.H. Hall, Boston, 1985.

O'Connor, Ulick, *Brendan Behan*, Hamish Hamilton, London, 1970.

Bibliography

O'Connor, Ulick, *Oliver St John Gogarty*, Jonathan Cape, London, 1965.

O'Connor, Ulick, *All the Olympians*, Henry Holt, London, 1984.

O'Dwyer, Frederick, *Lost Dublin*, Gill & Macmillan, Dublin, 1981.

O'Keeffe, Timothy (editor), *Myles: Portraits of Brian O'Nolan*, Martin Brian and O'Keeffe, London, 1973.

O'Nolan, Kevin (editor), *The Best of Myles*, McGibbon and Kee, London, 1968.

Oram, Hugh, *The Newspaper Book: A History of Newspapers in Ireland*, MO Books, Dublin, 1983.

O'Sullivan, Michael, *Brendan Behan: A Life*, Blackwater Press, Dublin, 1997.

O'Sullivan, Niamh, *Aloysius O'Kelly: Art, Nation, Empire*, Field Day Publications, Dublin, 2010.

O'Sullivan, Seamus, *The Rose and Bottle*, Talbot Press, Dublin, 1946.

Peters, Sally, *George Bernard Shaw: The Ascent of the Superman*, Yale University Press, Ithaca, 1996.

Power, Arthur, *From an Old Waterford House*, Carthage, Waterford, 1940.

Pritchett V.S. and Hofer, Evelyn, *Dublin: A Portrait*, The Bodley Head, London, 1967.

Quennell, Peter, ed., *Genius in the Drawing-Room: The Literary Salon in the Nineteenth and Twentieth Centuries*, Weidenfeld & Nicholson, London, 1980.

Quinn, Antoinette, *Patrick Kavanagh: A Biography*, Gill and Macmillan, Dublin, 2001.

Quinn, Antoinette, *Patrick Kavanagh: A Poet's Country*, Lilliput Press, Dublin, 2003.

Richardson, Joanna, *The Bohemians: La Vie de Boheme in Paris 1830-1914*, A. S., Barnes & Co., New York, 1969.

Robertson, Olivia, *Dublin Phoenix*, Jonathan Cape, London, 1957.

Roe, Sue, *Gwen John: A Life*, Vintage, London, 2002.

Ryan, John, *Remembering How We Stood*, Gill and Macmillan, Dublin, 1975.

Ryan, John (editor), *A Bash in the Tunnel*, Clifton Books, London, 1970.

Ryan, Phyllis, *The Company I Kept*, Town House, Dublin, 1996.

Ryan-Smolin, Wanda; Mayes, Elizabeth; Rogers, Jenni, eds., *Irish Women Artists*, National Gallery, Dublin, 1987.

Schloss, Carol Loeb, *Lucia Joyce*, Farrar, Strauss and Giroux, New York, 2003.

Simpson, Alan, *Beckett and Behan*, Routledge and Kegan Paul, London, 1962.

Somerville-Large, Peter, *Dublin*, Hamish Hamilton, London, 1979.

Stephens, James, *The Crock of Gold*, Gill and Macmillan, Dublin, 1980.

Stephens, James, *The Poems of James Stephens*, Colin Smythe, London, 2006.

Swift, Carolyn, *Stage By Stage*, Poolbeg, Dublin, 1985.

Toksvig, Signe, *Irish Diaries, 1926-1937*, Lilliput Press, Dublin, 1994.

Tracy, Honor, *Mind You, I've Said Nothing!* Methuen, London, 1953.

Tuohy, Frank, *Yeats*, Macmillan, London, 1976.

Walker, Dorothy and colleagues, *Irish Women Artists*, National Gallery of Ireland, Dublin, 1987.

Walsh, Caroline, *The Homes of Irish Writers*, Anvil Books, Dublin, 1982.

Walsh, Pat, *Patrick Kavanagh and the Leader*, Mercier Press, Cork, 2010.

Warner, Alan, *Clay is the Word*, Dolmen Press, Dublin, 1973.

Whelan, Gerard and Swift, Carolyn, *Spiked*, New Island, Dublin, 2002.

White, James, *Pauline Bewick: Painting a Life*, Wolfhound Press, Dublin, 1985.

de Vere White, Terence, *A Fretful Midge*, Routledge & Kegan Paul, London, 1957.

de Vere White, Terence, *The Parents of Oscar Wilde*, Hodder and Stoughton, London, 1967.

Wilde, Oscar. *Picture of Dorian Gray*, Wordsworth, London, 1992.

Wills, Clare, *That Neutral Island: A Cultural History of Ireland during the*

Bibliography

Second World War, Faber and Faber, London, 2007.

Yeats, W.B., *Memoirs*, Macmillan, London, 1972.

Yeats, W.B., *The Collected Poems*, Macmillan, London, 1976.

Yeats, John B, *Early Memories*, Irish University Press, Dublin, 1971.

Newspapers and Periodicals

The Irish Independent

The Irish Press

The Irish Times

Southern Star

The Sunday Independent

The Sunday Tribune

The Bell

The Capuchin Annual

Comhar

Dublin Magazine

Envoy

Irish Homestead

Irish Statesman

Irish Writing

Kavanagh's Weekly

Kilkenny Magazine

The Leader

Martello

Index

Abbey Theatre, 26, 36, 48, 71, 104, 107, 131, 141, 149, 156, 161, 184, 187, 190, 192, 195, 257
Academie Julian, 209, 210,
Academy Award, 234, 239
Academy of Christian Art, 206
Addis, Jeremy, 137, 143
Aiken, Conrad, 38
Aiken, Frank, 108
Algren, Nelson, 5, 74, 111, 122, 126, 135
Allen, Dave, 167, 273
Allison, Muriel, 263, 266
Amis, Kingsley, 9
An Beal Bocht, 155, 170, 217
Andrews, Todd, 167
Anna Livia sculpture, 80
Antient Concert Rooms, 82
Apinchapong, Sunny, 124
Arena, 114, 188
Armstrong, Arthur, 265
Armstrong, Sir William, 206
Arts Council, The, 206
As I Was Going Down Sackville Street, 267
Association of Artists of Revolutionary Russia, 227

At-Swim-Two-Birds, 121, 145, 151–53, 155, 158–59, 160, 209
Athenaeum, The, 17
ATS Club, 74
Ayrton, Michael, 222

Bacon, Francis, 2, 9, 10, 206, 212
Baggot Street, 1, 2, 3, 5, 9, 10, 11, 12, 47, 55, 80, 86, 103, 104, 129, 142, 159, 169, 206, 215, 217, 222, 266, 276–79
Baggot Street Bridge, 4, 5, 110, 118, 122, 126, 127, 129, 131, 163, 232
Baggot Street Deserta, 9
Baggot Street Hospital, 10, 53, 64, 113, 214, 263
Bailey, The, 76, 78–9, 115, 148, 229
Balcombe, Florence, 18
Balcony of Europe, 108, 132, 136
Baldwin, James, 45
Banville, John, 2, 14, 110, 138
Bardwell, Leland, 14, 84, 113
Barnacle, Nora, 18, 60
Barton, Robert, 254
Barton, Rose, 209
Bash in the Tunnel, A, 121
Bashkirtseff, Marie, 209
Baudelaire, Charles, 16
BBC, 48, 49, 51

Beach, Sylvia, 38, 129, 130, 139, 146, 190, 255
Beckett, Edward, 10
Beckett, John, 10, 220
Beckett, Samuel, 2, 10, 22–3, 45–8, 66, 73, 77, 81, 85, 88, 96, 106, 108, 117, 119, 121, 136, 152, 156, 169, 176, 177, 181, 185–7, 195, 201, 203, 205–9, 217, 231, 256–57, 259
Behan, Beatrice (Salkeld), 10, 39, 42, 47–56, 57–68, 81, 125, 143, 208
Behan, Blanaid, 55
Behan, Brendan, 1, 8, 9, 10, 12, 39–56, 57–68, 69, 72–5, 79, 80–7, 89–90, 94, 96–7, 99, 108, 113–4, 123, 125–26, 132–4, 139–40, 143, 145, 149, 156, 158, 164, 172, 177, 180, 184, 186–7, 189–90, 194–5, 200, 205, 208, 217, 224, 229–30, 234–7, 241, 246, 267, 270–73, 277–78
Behan, Dominic, 81
Behan, John, 14, 56, 231
Behan, Kathleen (Kearney), 39–40, 59, 66, 81, 123, 125
Behan, Paudge, 66
Behan, Stephen, 39–41, 56, 81, 230
Bell, The, 43, 95, 104–6, 164, 168, 180–83, 190, 208
Berlin, 53
Bernelle, Agnes, 265
Berryman, John, 5, 73, 135
Betjeman, John, 97, 105–6, 140, 257
Bewick, Pauline, 194, 219–20, 222, 265
Bewley's, 86, 229, 245
Binchy, Kate, 197, 200
Binchy, Maeve, 2, 11, 73, 86, 141
Bird Alone, 179
Blackrock College, 131, 150,
Blood and Stations, 248
Bloomsday, 9, 125, 146–48, 158, 250
Bloomsbury Set, 214, 253
Bodkin, Thomas, 254
Boland, Eavan, 115, 188, 258
Bolger, Dermot, 188

Bono, 278
Book of Intrusions, 54, 248
Books Ireland, 137
Borstal Boy, 12, 41, 49, 51–2, 63, 65–7, 72, 186, 189
Boucher, Francois, 212
Bourke, Brian, 85, 215
Bowen, Elizabeth, 13, 27, 71, 118–20, 142, 181, 213
Boydell, Brian, 73, 188
Boylan, Clare, 139
Boylan, Henry, 265
Boylan, Patricia, 265
Brady, Charlie, 85, 218, 231
Brandt, Ruth, 218, 231
Brangwyn, Frank, 228
Brave New World, 176
Brendan Behan's Island, 53
Bridge Press, 258
Briscoe, Ben, 143
Briscoe, Robert, 197
British–Irish Association, 264
British Museum, 236
Brobbel, John, 265
Broderick, John, 111, 134, 139, 177
Broe, Desmond, 74,
Broe, Irene, 74
Brown, Christy, 79, 207
Brown, Miss, 136, 271
Browne, Garech, 10, 73, 114
Browne, Dr. Noel, 141, 170, 201
Bruce, Campbell, 265
Bunting, Edward, 10
Buswell's Hotel, 81
Butler, Hubert, 189
Butt, Isaac, 17, 25, 71
By Night Unstarred, 109
Byrne, Ena, 266
Byrne, Gay, 270
Byron, Alfred Lord, 70
Byron Society, 265

Cagney, James, 83
Caine, Michael, 81

Index

Calder, John, 136
Campbell, George, 215
Campbell, Gordon, 259
Campbell, Joseph, 58, 209
Campbell, Patrick, 163, 166–67
Canal Poems, 112
Capuchin Annual, 183, 273
Carlson, Julia, 179
Carroll, Marie, 86
Carroll, Michael, 143
Cartier-Bresson, Henri, 73, 98
Carty, Ciaran, 188
Casement, Sir Roger, 210, 232, 258
Casement, Tom, 126, 258–62, 266
Casey, Juanita, 218
Cassin, Barry, 15, 201, 263
Catacombs, 44, 74, 188, 271
Caulfield, Mary, 265
Cavan fire, 156-57, 258
censorship, 7, 23, 52, 93, 168, 175–90
Censorship of Publications Act, 176, 190
Chamber Music, 77
Chapman, Eddie, 44
Charlton, Hugh, 78
Charlton, Maureen, 209
Chesterton, G.K., 30, 72, 194, 253
Chieftains, The, 264
Childers, Erskine, 192, 253
Claddagh Records, 10, 114, 264
Clancy, George, 13, 20
Clare Street, 22–3
Clarke, Austin, 8, 23, 73, 75–6, 89, 104, 142, 169, 177, 208, 227, 258
Clarke, Harry, 73, 210, 224,
Clarke, Kenneth, 105
Clog Gallery, The, 222
Clongowes Wood College, 273
Cobham, Sir Alan, 260
Coghill, Egerton, 210
Cogley, Madame Bannard "Toto", 15, 79, 229, 262
Collins, Michael, 20, 40, 72, 76, 127
Collins, Paddy, 10, 73, 78, 221

Collis, Dr. Robert, 207
Colum, Padraic, 19, 34, 73, 102, 122, 130, 201, 252, 262
Come Dance with Kitty Stobling, 106, 110, 113
Comhar, 46, 58, 180,
Comhthrom Feinne, 150–1
Confessions of an Irish Rebel, 42, 55
Conmee, Marie, 79
Connolly, Cyril, 70, 107
Connolly, Joseph, 168
Connolly, Rev. Peter, 187
Connor, Jerome, 75
Conor, William, 171
Contemporary Club, 28–9, 74
Conway, Cardinal, 189
Cooke, Barry, 221
Cooney, John, 171, 178
Cope, Elizabeth, 276
Corkery, Tom, 5, 63
Costello, John A., 89, 92–6, 98, 114, 116, 141
Costello, Peter, 87–8, 138, 141, 190
Country Shop, 5, 206, 222
Courbet, Gustave, 212
Coxhead, Elizabeth, 9, 209
Coyle, John, 265
Coyne, Thomas J., 168, 174, 202
Craig, Maurice, 14, 119, 135–36, 265
Crist, Frederick, 244
Crist, Gainor, 10, 74, 83, 172, 241–50, 268–69, 272
Crock of Gold, The, 13, 21
Cronin, Anthony, 42, 44, 74, 76, 83, 96, 106, 146–48, 155, 182
Cross, Eric, 179
Cruiskeen Lawn, 153–54, 164, 170
Cuala Press, 10, 31, 111, 230
Cuirt an Mhean Oiche, 177
Curran, Con, 73
Cusack, Cyril, 78, 81, 193, 230
Cusack, Ralph, 215
Cusack, Sinead, 238

Dalkey, 239
Dalkey Archive, The, 159–61
Dame Street, 214, 250
Damer Hall, 50
Dark, The, 178
Davis, Gerry, 231, 265
Davitt, Michael, 28, 74, 252
Davy Byrne's, 9, 19, 67, 76–8, 86, 146, 148, 209, 224, 228, 245
Dawe, Gerald, 181
Dawson Gallery, 221, 222
Dawson Lounge, 81, 217, 229
Daybell, Christopher, 267
Day-Lewis, Cecil, 181
Dayton, 243
de Balzac, Honore, 16
de Beauvoir, Simone, 74, 115
de Bremont, Comtess, 17
de Burca, Seamus, 43, 59
de Fouw, Jan, 218, 221
de Houghton, Sir Anthony, 136, 271
de Houghton, William Stanley, 271
de Maurier, George, 7
de Valera, Eamon, 14, 167–68, 189
Deane, John F., 188
Degas, Edgar, 22, 72, 206, 209,
Delaney, Edward, 73, 214
Delaney, Shelagh, 65
Delmonte, Koert, 221
Derrig, Tom, 227
Diarmuid and Grania, 32
Dix, Otto, 208
Doheny and Nesbitt's, 7, 80
Dolly Fawcetts, 74
Dolmen Press, 10, 114, 134, 137, 194. 218–19
Dolphin Hotel, 83
Donaghy, Lyle, 230, 254
Donleavy, J.P., 7, 8, 44, 50, 74, 76, 78, 79, 81, 83, 107, 122, 177, 184–86, 233–34, 236–38, 241–44, 246, 249–50
Donleavy, Valerie, 233
Donnelly, Donal, 194, 203
Doolan, Lelia, 201

Dorgan, Theo, 188
Dowden, Ernest, 26–7
Down All Those Days, 79
Doyle, Jack, 99
Doyle, Lynn, 171
Drama in Muslin, A, 71
Drew, Ronnie, 73, 80, 135, 269
Drogheda, 246
Drums of Father Ned, The, 185
Dublin, 1660–1860, 14, 135
Dublin Magazine, 101, 102, 180, 208
Dublin Old and New, 251
Dublin Opinion, 174
Dublin Painters' Group, 208, 213
Dubliners, 153, 177
Dubliners, The, 80, 269
Duke Street, 76, 148, 205, 224
Duke, The, 81, 86
Duncan, Belinda, 256
Duncan, Cecil, 257
Duncan, Ellie, 251–52, 256, 266
Duncan, Isadora, 25, 38
Dun Emer enterprise, 28, 31
Dunne, Brendan, 230
Dunne, Lee, 177
Dunsany, Lord, 112, 230
Durcan, Paul, 115, 125, 140, 215, 217, 280
Dylan, Bob, 268

Eblana Theatre, 204
Edwards, Hilton, 192
Eliot, T. S., 97, 107
Ellis, Brendan, 135, 142
Ellis, Gerard, 136
Ellmann, Richard, 73
Elvery, Beatrice (Lady Glenavy), 33, 166, 210, 252, 253, 259, 260
Ely Place, 2, 15, 20, 21, 22, 72, 275
Endymion, 224, 267
Ennis, Seamus, 215
Envoy, 8, 44, 78, 83, 107, 109, 163, 180–81, 184–85, 217, 244
Esther Waters, 13, 22

Index

Eton College, 213

Faber Book of Twentieth Century Verse, The, 89
Fallon, Brian, 190, 203, 215, 227
Fallon, Padraic, 75
Farewell to Arms, A, 176
Farmers' Journal, 112, 113, 126
Farrell, Michael, 128
Farren, Robert, 89, 258
Faustus Kelly, 156
Fay, William, 34, 78
Feasta, 180
Felo de Se, 8
Ferguson, Samuel, 71
Figgis, Darrell, 253
Finnegans Wake, 135, 153, 169, 213, 251
Finucane, Brendan "Paddy", 40
Fisher, Archbishop, 141
Fitzgerald, Garret, 131, 141
Fitzgerald, Jim, 10, 87, 201
Fitzgibbon, Constantine, 8
Fitzmaurice, James, 10
Fitzpatrick, Jim, 142
Fitzrovia, 7
Fitzwilliam Square, 4, 21, 207
Fitzwilliam Street, 254, 260, 270, 271
Flanagan, Thomas, 140
Fleming, Lionel, 166–67
Flynn, Mannix, 122
Fogarty, William, 220
Foley, John Henry, 187
Fortnightly Review, 19
Foster, Roy, 31
Fox, R. M., 193, 196, 227
Freud, Lucien, 215
French, Percy, 124, 253
Funge, Paul, 265
Furlong, Rory, 96

GAA, 183, 187
Gahan, Muriel, 206, 222
Gaiety Theatre, 32, 78, 81, 149, 161, 185, 194, 235
Gaj's Café, 86

Ganly, Bridget, 97, 104
Garnett, Edward, 88
Gate Theatre, 156, 185, 190, 192, 196–97, 235
Gauguin, Paul, 209, 252
Gayfield Press, 208
Gebler, Adolph, 235
Gebler, Ernie, 72, 177, 184, 194, 233–40, 242, 270
Geddes, Wilhelmina, 210
Geldof, Bob, 278
Gelderen, Gerrit van, 221
Gemini Productions, 201, 204
George, David Lloyd, 164
George, The, 276
Gertler, Mark, 253
Gibbings, Robert, 211, 218, 224
Gibbon, Monk, 184
Gilbert, Leatrice, 236
Gilligan, Tom, 86
Ginger Man, The, 10, 44, 50, 78, 185, 233, 237, 241–42, 247–49
Girl with Green Eyes, 72
Glasnevin Cemetery, 56, 68, 143, 146
Gleeson, Evelyn, 33
Gleizes, Albert, 212–13
Glencree, 58, 77
Glor, An, 180
Gogarty, Oliver St John, 11, 13, 20–1, 35, 72–3, 75–7, 103, 119, 144, 176, 177, 182, 210, 253, 267, 269
Gogh, Vincent van, 212, 252
Goldring, Douglas, 253
Goldsmith, Oliver, 23, 48, 69, 70, 90, 101, 108, 145, 186
Gonne, Maud, 29, 40
Good Words, 27
Gore-Booth family, 209
Gough memorial, 187
Goulding, Cathal, 66
Grafton Street, 28, 61, 85, 86, 96, 99, 103, 113, 172, 194, 218, 229, 235, 250, 253

Grand Canal, 1, 13, 110, 113, 116–28, 132, 149, 232
Grapes of Wrath, The, 176
Graphic Studio, Dublin, 218, 219
Graves, Robert, 24
Gray, Reginald, 59, 198
Gray, Tony, 161, 165, 172
Greacen, Robert, 112, 181, 209
Great Hunger, The, 105, 111, 178
Green Fool, The, 102
Green Lion, The, 177
Greene, Graham, 152, 176, 201
Gregory, Lady, 2, 30, 34, 71, 206, 210, 212, 252–53, 255, 270
Gregory, Robert, 212
Grey, Eileen, 210, 212
Griffith, Arthur, 130
Grogan's Castle Lounge, 85, 86
Guardian, The, 159, 161, 188, 197
Guinness, May, 205, 210
Gunn, Lt. Col. T.B., 254
Gwynn, Stephen, 251

Hackett, Francis, 177, 189
Haddington Road, 103, 137
Hail and Farewell, 22
Hall, Kenneth, 214
Hall, Sir Peter, 201
Hamilton, Iain, 72, 238
Hamilton, Letetia Mary, 215
Hanlon, Father Jack, 178
Hanly, David, 132
Harbison, Dr. Peter, 135
Harcourt Street, 206
Harcourt Terrace, 9, 123, 210
Harper's Coffee Shop, 222
Harris, Anne, 240
Harris, Richard, 79, 185
Harty, Hamilton, 254
Hartnett, Michael, 85, 87, 189, 215, 265
Harty, Hamilton, 254
Hasler, Marjorie, 227
Hatch Street, 14, 215

Hayes, Joan, 220, 267
Healy, John, 164–65
Healy, Michael, 210
Heaney, Seamus, 2, 15, 116, 138, 140–41, 215, 264
Hearn, Lafcadio, 19
Heath, Lady Mary, 11
Heath, Ted, 264
Heather Field, The, 71
Heatherley's Art School, 27
Heath-Stubbs, John, 81
Heffernan, Joanna, 212
Hemans, Felicia, 70, 210,
Hemingway, Ernest, 139, 154, 176, 255
Hendriks, Ritchie, 221
Henri, Robert, 35, 38
Henry, Grace, 212, 221
Henry, Paul, 10, 205, 211–12, 221
Herbert Lane, 14, 188, 190, 192, 194, 198, 200
Herbert Place, 13, 118, 121, 149, 218
Herbert Street, 12, 47, 52, 60, 62, 67, 115
Heron, Hilary, 184
Heron, Lorcan, 266
Hickey, Elizabeth, 218
Hickey, Patrick, 218
Higgins, Aidan, 8, 108, 132, 136, 220
Higgins, F.R., 171
Hillis, Constance, 247
Hillis, Randall, 243
History of the Ginger Man, The, 249
Hobson, Harold, 48, 51, 201
Hodnett, George Desmond, 10, 79, 194, 235, 268–71, 273
Hogan, Desmond, 73, 188
Hogan, Paul, 220
Hogan, Pete, 88, 134, 144, 260
Hogarth, Paul, 53, 64
Hold Your Hour and Have Another, 46, 62, 114
Holohan, Leo, 116
Holy Door, The, 188
Hone, Evie, 206, 209, 211–13

Index

Hone, Nathaniel, 32
Hoover, Edgar, 185
Hopkins, Gerard Manley, 28
Hostage, The (An Giall), 12, 42, 49–51, 53–4, 56, 63, 65–7
Hotel Corneille, 212
Hoult, Nora, 177
Howard, Con, 138, 257, 263–65
Howth, 27, 61, 247
Huband Bridge, 119, 120, 121, 124, 127
Hugh Lane Municipal Gallery, 206, 214, 232, 256
Hugh Lane pictures, 206, 210, 220, 256, 275
Hughes, John, 209
Hughes, Ted, 78
Hurley, Maureen, 265
Hutchinson, Pearse, 60, 74, 84, 215
Huxley, Aldous, 176
Hyde, Douglas, 28, 30, 34, 71, 210

Ibsen, Henrik, 19
Illustrated London News, 212
Importance of Being Earnest, The, 13
In a Glass Darkly, 16
Independent Artists Group, 277
Informer, The, 13, 180
Inglis, Brian, 90, 167–68, 173
Iniskeen, 100, 113, 116
Ink-Stained Hands, 218
Iremonger, Valentin, 84, 90, 97–8, 184
Irish-Australia Association, 264
Irish Council for Civil Liberties, 183
Irish Exhibition of Living Art, 214, 215, 277
Irish Farmers Journal, 112–3
Irish Homestead, 19, 60, 180, 252
Irish Independent, 47, 78, 177, 190, 247
Irish Lifeguard Service, 258, 260
Irish Literary Revival, 2, 15, 25, 29, 33, 107, 192
Irish Press, 46, 60–2, 106, 272
Irish Times, 9, 32, 46, 48, 49, 75, 78, 92, 94, 102, 104, 121, 127, 131, 139, 153, 154, 157, 159–61, 163–74, 176, 187, 201, 227, 252, 255, 260–1, 263, 268, 277–78
Irish Women's Franchise League, 227
Irish Writing, 180
Irish Women's Liberation Movement, 86
Isle of Man, 233, 238

Jameson, Anna Brownell, 206
Jammet, Yvonne, 83, 215
Jammet's Restaurant, 82–3
Japan, 135
Jeffares, George, 74
Jellett, Mainie, 2, 8, 66, 123, 205–6, 209–10, 212–15
Joad, Professor, 105, 176
John, Augustus, 72, 228,
John O'London, 101
Johnson, David, 266
Johnson, Nevill, 7, 14, 80, 124, 215–16, 222
Johnson, Samuel, 102, 145
Johnston, Denis, 201, 257, 259
Jordan, John, 42, 55–6, 60, 84–5, 88, 91, 107–8, 158, 230, 248, 272
Joyce, James, 2, 8, 11, 12, 18–20, 35, 45–6, 76, 77, 81, 86, 102, 107–8, 115, 117, 120–21, 130, 138, 140, 145, 147, 149–50, 152–4, 157–60, 169, 177, 182, 183, 186–90, 205, 212, 217, 223, 255–7, 267, 269, 271, 274, 276
Joyce, John Stanislaus, 31, 82, 83, 145-46, 224, 255
Joyce, Lucia, 81
Joyce, May, 82
Joyce, Tom, 146
Jury's Hotel, 250

Kaftannikoff, Luba, 254
Kane, Michael, 15, 124, 125

Kavanagh, Patrick, 2, 5, 7–12, 45, 47, 72, 75–6, 78–81, 84–6, 89–98, 99–116, 122, 126, 128, 131–34, 138, 141, 146, 149, 156, 158, 161, 164, 170, 172, 178, 180, 182–84, 187, 196, 201, 207–8, 214, 217, 229, 232, 258, 276
Kavanagh, Peter, 11, 81, 91–2, 97, 101–5, 109, 112, 114, 127–28, 141–42, 183–84, 217, 229
Kavanagh's Weekly, 91–2, 95, 109, 127, 141, 183–84
Kazantzakis, Nicos, 242
Keane, Eamonn, 73, 87
Keane, Senator John, 175
Keane, John B., 56, 73
Keane, Marie, 79
Kearney, Colbert, 63
Keating, Sean, 208, 224, 227, 252
Kehoe's, 81
Kelly, Luke, 265, 269
Kelly, Oisin, 214
Kelly, Seamus (Quidnunc), 167, 201
Kennedy, John F., 188-9, 264
Kennedy's, 81
Kennelly, Brendan, 116, 123, 140, 258
Kenny, Adrian, 141
Kenny, Enda, 279
Keogh, Peter, 69, 79
Kernoff, Harry, 9, 56, 75, 78, 81, 83, 117, 124–25, 156, 158, 183, 223–32, 252
Kernoff, Lina, 228, 231
Kerouac, Jack, 115, 242
Kettle, Tom, 13, 72, 76, 119, 187, 253, 257
Kiely, Ben, 60, 114, 132, 134, 177, 183, 186, 230, 265, 272–73
Kildare Street, 3, 19, 20, 58, 70, 206, 215
Killanin, Lord, 194
Killeavy, Cynthia Moran, 124
Kilroy, Tom, 73
King, Mary, 49, 63, 66–7, 125–26, 129, 133–44, 186, 189, 271

Kinsella, Thomas, 9, 14, 119, 132, 208
Kipling, Rudyard, 71
Kirkwood, Harriet, 35
Knights of Columbanus, 177, 201
Kokoschka, Oscar, 207, 222
Krause, David, 136, 201

La Boheme, 7, 277
La Scala, 257
Lalor, Brian, 138, 218, 273
Lampshades (Phil Ryan's), 10, 57, 69, 79, 190, 277
Landlady, The, 43
Lancaster, Osbert, 105, 273
Lane, Hugh, 34–6, 206–7, 220, 251–53
Langrishe Go Down, 136
Lantern Theatre, 15
Lapped Furrows, 112
Larry Murphy's, 80, 278
Lavery, John, Sir, 206, 254
Lavery, Lady, 254
Laverty, Barry, 219
Laverty, Maura, 143
Lavin, Mary, 2, 5, 73, 80, 86, 122–23, 132, 142, 143, 222
Lawrence, D.H., 253
le Brocquy, Louis, 222, 262
le Brocquy, Sybil, 215
Le Fanu, Joseph Sheridan, 16, 70, 131
le Jeune, James, 10, 252
Leader, The, 84, 89–98, 109
Leahy, Carmel, 129
Lee, Laurie, 5, 136
Leeson Lounge, 87
Leeson Street, 1, 2, 87, 111, 150, 216
Leeson Street Bridge, 119, 126, 226
Lehane, Fr. Aidan, 130-1, 142
Lehane, Con, 197, 199
Leinster Gallery, 221
Leinster Street, 210
Leisure Hour, 27
Lemass, Sean, 188–89
Lenihan, Brian, 189

Index

Lennon, Peter, 188
Leonard, Hugh, 67, 140, 161, 237
Lessing, Doris, 12
Leventhal, Con, 75, 146
Lever, Charles, 2, 71, 81, 118–19
Lever, Nora, 15, 220
Lewis, Noel, 7, 125, 204
Lhote, Andre, 205, 211, 212
Liddy, James, 72, 86, 107, 114, 129, 141, 144, 180
Liddy, Nora, 72
Life of Riley, The, 76, 182
Limerick, 192, 247
Lincoln Inn, The, 60, 81
Lincoln Place, 252
Lindsay-Hogg, Eddie, 215
Little, Christy, 278–79
Littlewood, Joan, 42, 48, 50, 56
London, 1, 26-27, 29, 33, 48–50, 63, 65–6, 76, 88, 107, 110, 113, 115, 119, 153, 181, 192, 201, 204, 216, 218, 220, 222, 224, 227, 230, 232, 246, 248, 253, 260, 264
Longford, Lord, 14, 194, 197–98
Longford, Lady Christine, 86, 182
Longley, Michael, 181, 215
Look Back in Anger, 47
Loughrey, Angel, 266
Lover, Samuel, 70
Lower Mount Street, 15, 119
Lutyens, Sir Edwin, 254
Lynch, Brian, 188
Lynch, Jack, 141
Lynch, Patricia, 73, 143, 227
Lyons, Genevieve, 194
Lyric Theatre Company, 258
Lysaght, Charles, 141

MacAnna, Thomas, 201
MacAonghusa, Proinsias, 188
MacBride, Sean, 108
MacBryde, Robert, 87, 112
McCarthy, Senator Eugene, 263

McCormack, John, 11, 72, 82, 149
McCourt, Frank, 168
McDaid's, 45, 55–6, 83–5, 87, 98–9, 107–8, 112, 158, 172, 223, 229
MacDonagh, Deirdre, 222
McDonagh, Donagh, 170, 201
McDonnell, George, 138
McDonnell, Peter, 112
McDowell, Elizabeth, 266
McEntee, Sean, 56
MacGabhann, Liam, 185
McGahern, John, 101, 108, 122, 177–79, 189
McGoldrick, Hubert, 210
McGovern, Senator George, 263
MacGowran, Jack, 10
MacGreevy, Thomas, 14, 23, 142, 253, 254
MacGreil, Rev. Michael, 280
McGuinness, Frank, 188
McGuinness, Norah, 73, 104, 206, 215, 221
McGuire, Edward, 78, 87, 215–16, 222
MacInerney, Tony, 74, 111, 246
McIntyre, Tom, 122
McKenna, James, 86, 204–5, 277
McKenna, Siobhan, 277
McKenna, T.P., 194
McLaverty, Michael, 182
MacLiammóir, Micheál, 9, 78, 192, 227, 236
McMahon, Dolly, 73
McMahon, John, 188
MacManus, Francis, 183
MacManus, M.J., 272
MacManus, Peadar, 112, 263
McMaster, Anew, 97
MacMathuna, Ciárán, 46, 73, 257, 263–65
MacMathuna, Padraic, 265
MacNamara, Brinsley, 75, 103

301

MacNamara, Des, 2, 8, 10, 43, 46–7, 54, 61, 74, 79, 83, 85, 112–13, 157, 194–95, 201, 219, 229, 234–39, 244, 246, 248–49, 268, 270
MacNamara, Oengus, 85
MacNamara, Skylla, 85, 237–39
MacNeice, Louis, 8, 76, 84
MacNie, Isa, 7, 10, 258, 259–63, 266
McQuaid, Archbishop John Charles, 79, 98, 109, 131, 171, 178–9, 183, 185, 188–89, 201–2
MacRéamoinn, Seán, 257, 263–65
McSharry, Deirdre, 194
MacThomais, Eamonn, 75, 270
MacWeeney, Leslie, 15, 218–19, 222
Macken, Walter, 177
Madrid, 124, 248, 250
Magennis, Senator William, 175–77, 180
Maguire, Eddie, 73
Mahon, Derek, 181
Mailer, Norman, 45, 60
Maillol, Aristide, 255
Mallarmé, Stéphane, 2
Mallory, George, 260
Malone Dies, 136
Manahan, Anna, 197, 200, 204
Manet, Eduard, 2, 22, 72, 206
Mangan, James Clarence, 16, 21, 100
Mannin, Ethel, 8
Mannion, Michael, 87, 142
Mansfield, Katherine, 253
Marcus, David, 141, 181
Markievicz, Constance, 212, 227, 252–53, 256–57
Markievicz Count Casimir, 212, 252, 256
Marsh, Clare, 35, 37
Martello, 209
Martin, Professor Gus, 141–42, 183
Martin, Liam C, 40, 124, 231
Martin, Violet, 206, 210, 211
Martyn, Edward, 2, 20, 22, 30, 71, 210

Matisse, Henri, 217, 252, 255, 277
Matthews, Tom, 138
Maturin, Rev. Charles, 16, 70
May, Freddie, 74
Meagher, Loretta, 221
Meehan, Vincent, 277
Melmoth the Wanderer, 16
Merriman, Brian, 155, 177, 263
Merriman Summer School, 138, 257, 263, 265
Merrion Row, 32, 205
Merrion Square, 4, 15–6, 26, 70, 131, 206, 261
Mespil Road, 60, 124, 127
Messenger, The, 132, 235
Metropolitan School of Art, 28, 208, 209, 210, 224
Meyer, Kuno, 72
Middleton, Colin, 184, 215, 222
Miller, Liam, 10, 73, 79, 137, 194, 218
Millet, Jean-Francois, 32
Milne, Ewart, 209, 227
Mind You I've Said Nothing, 257
Mitchell, Susan, 15, 30, 251
Mitchell's, 86, 100
Modigliani, Amadeo, 142, 206, 224, 255–56
Molesworth Street, 81, 270
Molloy, John, 231
Moloney, Katherine, 86, 113–15
Monaghan, Ken, 177
Monahan, Kevin, 124, 229
Monet, Claude, 22
Montague, John, 1, 12, 42, 45, 73, 82, 91, 116, 119, 122, 141, 180
Montague, Madeleine, 12, 141
Montgomery, Niall, 135, 140
Monto, 269
Mooney, Carmel, 265
Mooney, Eddie, 15
Mooney, Ria, 230
Mooney's, 10, 80–1, 145, 201
Moore, Brian, 71, 177

Index

Moore, George, 2, 21, 22, 28, 33, 66, 71, 72, 102, 107, 119, 121, 177, 206, 255, 275
Moore, Henry, 115, 220, 257
Moore, Thomas, 70, 74, 86, 108
Moran, Francis "Bunch" 12, 124
More Pricks than Kicks, 23
Morgan, Lady Sydney, 2, 70, 206
Morisot, Berthe, 206, 209, 220
Morrell, Lady Ottoline, 262
Morris, Frank, 219
Morris, William, 29
Morrisey, Paddy, 87
Morrow, Larry, 95, 106
Mother and Child Scheme, 171,
Mount Street Bridge, 120
Mountjoy prison, 43, 45, 58, 235, 253, 270
Moynan, Richard Thomas, 209
Moynihan, Rev. Senan, 183, 273
Muggeridge, Malcolm, 48
Mulligan's, 153
Mulranny Hotel, 260
Municipal School of Art, 206
Murger, Henry, 7
Murphy, Aidan, 85
Murphy, Hayden, 15, 85, 188, 219
Murphy, Jay, 122
Murphy, Dr. Patricia, 126
Murphy, Richard, 78, 140
Murphy, Seamus, 212, 275
Murry, John Middleton, 253
My Left Foot, 207
My Life with Brendan, 66

na Gopaleen, Myles, *see* Brian O'Nolan
Nassau Street, 247
National College of Art, 219, 220
National Gallery, 206, 214, 220
National Library, 19, 146
NCAD, 265
Neary's, 81, 86, 160, 217, 229

Nelson's Pillar, 146, 187, 226, 230, 278
Nevin, Donal, 184
New Irish Salon, 208
New Irish Writing, 188
Newman, Alec, 173
New York, 26, 33, 37-8, 51, 54, 63, 65, 81, 112, 205, 212, 214, 218, 236, 243
Nicholson, Harold, 102
Nimbus, 110
Nisbet, Tom, 74, 124
Nobel Prize, 2, 138, 141, 169, 254, 255, 262
Nolan, Michael, 254
Nolan, Sir Sidney, 264
Nonplus, 126, 180
Norris, Senator David, 108
Northwestern University, 115
Nulty, Mark, 221
Nulty, Oliver, 221

O'Brien, Conor, 260
O'Brien, Conor Cruise, 184, 189, 255
O'Brien, Dermod, 128, 212, 252
O'Brien, Mrs Dermod, 232
O'Brien, Edna, 72, 177, 234, 237-40
O'Brien, Flann, 2, 9, 48, 56, 81, 83, 94, 114, 121, 139, 146, 161, 184, 214, 228, 230
O'Brien, Professor George, 141
O'Brien, John, 112
O'Brien, Kate, 112, 142, 177, 208, 262
O'Brien, Paddy, 45, 48, 84-5, 98-9, 114, 158, 223
O'Brien, "Professor" Peter, 266
O'Cadhain, Mairtin, 43, 180
O'Casey, Sean, 23, 41, 47, 55, 103, 136, 155, 169, 177, 180, 185, 192, 195, 201, 227, 230
O'Cathail, Bob, 226
O'Colmain, Seamus, 221
O'Conaire, Padraic, 58, 76, 180, 209
O'Connell, Canon Maurice, 257
O'Connell, Daniel, 4, 271

O'Connor, Frank, 5, 8, 9, 21, 51, 102, 104, 123, 132, 139–41, 153, 177, 179–80, 182, 189, 200, 234
O'Connor, Roderic, 209
O'Connor, Sinead, 278
O'Connor, Ulick, 42, 50, 265
O'Dalaigh, Cearbhall, 231
O'Dea, Jimmy, 81, 160, 161
O'Doherty, Eamonn, 80
O'Donel, Nuala, 206
O'Donnell, Peadar, 43, 106, 181, 182, 189, 227
O'Donoghue's, 80
O'Faolian, Julia, 139
O'Faolain, Nuala, 73, 86
O'Faolain, Sean, 8, 43, 52, 71, 73, 88, 102, 104, 153, 177–83, 185, 189, 216, 234, 257
O'Flaherty, Liam, 2, 8, 10, 23, 52, 58, 80, 112–13, 123, 126, 132, 139–40, 176, 177, 180, 227, 230, 254
O'Flaherty, May, 55, 67, 112, 125, 129–32, 135–45, 161, 220, 271, 277
O'Flanagan, Petronella, 62
O'Flynn, Justice Cathal, 202–3
O'Hegarty, P.S., 165
O'Heithir, Breandan, 180
O'Herlihy, Dan 74
O'Higgins, T.F., 156
O'Keeffe, Timothy, 112, 160-161
O'Kelly, Aloysius, 206, 212
O'Kelly, Sean T., 42
O'Leary, John, 28–9, 32–3, 121, 130, 211
O'Leary, Michael, 141
O'Mahoney, Eoin "The Pope", 97, 224, 267, 272–75
O'Malley, Pamela, 247–49
O'Meara, Frank, 206
O'Morain, Donal, 180
O'Morphi, Marie-Louise, 212
O'Neill, Tip, 264
O'Neill's, 229

O'Nolan, Brian, 45, 82, 87, 104, 108, 121, 132, 139, 145–62, 164, 170, 177, 208–9, 217, 227, 229, 252, *see also* Flann O'Brien
O'Riada, Sean, 87, 142, 181, 264
O'Riordan, Mary, 129
O'Riordan, Sean, 265
O'Shannon, Cathal, 75, 174
O'Shea, Milo, 79, 194
O'Sullivan, Seamus, 19, 76, 130, 171
O'Sullivan, Sean, 25, 70, 75, 81, 83, 87, 103, 148, 158, 160, 171, 216–17, 267, 273, 277
O'Toole, Michael, 66, 143
Observer, The, 48, 239
Old Stand, The, 81, 86
Olivier, Laurence, 105, 270
Olympia Theatre, 190
Oriel Gallery, 124, 221
Orpen, William Sir, 72, 76, 228, 252, 253
Osborne, John, 47, 136, 201, 242
Osborne, Walter, 33, 72, 130
Oscar award, 239
Other Side of Six, The, 80

Paganini, Nicolo, 70
Palace Bar, 70, 75, 103, 158, 171, 227
Paris, 1, 6, 7, 22, 23, 40, 53, 60, 64, 66, 72, 77, 88, 107, 108, 113, 121, 129, 134, 181, 195, 206, 209, 210, 211, 212, 213, 216, 217, 218, 222, 246, 249, 252, 255–256, 273
Parker, Dorothy, 242
Parsons Bookshop, 5, 49, 52, 110, 112, 114, 119, 125–26, 129–44, 184, 218, 220
Pasteur, Louis, 211
Patton, Eric, 218
Pearl Bar, 75, 84, 87, 171, 229, 238
Pembroke Bar, 86
Pembroke Road, 11, 81, 100, 106, 109, 116, 184
Pembroke Street, 86, 210

Index

Peppercanister, *see* St. Stephen's Church
Peter's Pub, 81, 86, 232
Pike Theatre, 10, 15, 46, 58, 79, 124, 189–204, 219, 269
Pinter, Harold, 56
Pisarro, Camille, 22
Plath, Sylvia, 78
Playboy of the Western World, The, 13, 26, 36, 187
Plough, The (London), 112
Plough and the Stars, The, 169
Ploughman and Other Poems, 102
Plunkett, Fiona, 271
Plunkett, Sir Horace, 33, 72
Plunkett, James, 73, 87, 140–41, 180, 182
Plunkett, Joseph, 253, 271
Plymouth Adventure, The, 194, 234, 236–37, 239
Pocket Theatre, 15
Poetry Ireland, 181, 188
Points, 45-6, 108
Poor Mouth, The, 155
Portrait of the Artist as a Young Man, A, 140, 177
Portobello, 117, 119, 121, 123, 126, 208
Pound, Ezra, 38, 255
Power, Arthur, 205, 212, 215, 255–56
Pre-Raphaelites, 17, 27, 32
Pritchett, V. S., 140
Prodigal Father, The, 25
Puccini, Giacomo, 257
Purcell, Noel, 230
Purser, Sarah, 27, 32, 40, 72–3, 123, 206–7, 209–10, 256
Pye, Patrick, 219, 252
Pygmalion, 13

Quare Fellow, The, 10, 12, 43, 46–9, 58, 59, 63, 79, 158, 195, 200, 236, 247, 277
Queen's Theatre, 39, 47

Quinn, John, 33–4, 38, 71
Rakoczi, Basil, 214, 215,
Radio Éireann, 46, 89, 93, 107, 126, 174, 185, 193, 275
Raglan Road, 80, 111
Rann, 180
Red Roses for Me, 195
Red Seat Near Baggot Street Bridge, The, 232
Reddin, District Justice Kenneth, 200
Reddin, Lavinia, 200
Reeves, Alan, 75, 158, 171, 227
Reid, Nano, 184, 215, 221,
Renoir, Pierre-Auguste, 206
RHA, 32, 36, 104, 190, 214, 216, 224, 230, 231, 260, 266, 277
Rhind, Ethel, 210
Richards, Shelagh, 188
Rivers, Elizabeth, 218
Roberts Cafe, 86, 100
Roberts, Charlie, 193
Roberts, Hilda, 213, 228
Robertson, Olivia, 5, 201
Robinson, John, 168
Robinson, Lennox, 254
Robinson, Markey, 221, 267, 277
Robinson, Mary, 189
Rochford, Justice Alfred, 199
Rodin, Auguste, 206
Roethke, Theodore, 73, 84, 135
Rolleston, T. W., 252
Ronan, Patricia, 129, 138, 145
Rooney, Philip, 186
Rose Tattoo, The, 15, 79, 196–204
Rouault, George, 206–7, 212, 214, 215
Royal Hibernian Hotel, 81, 262
RTÉ, 113, 160, 188, 204, 265
Russell, George (AE), 19, 21, 28, 30, 33, 38, 101–12, 180, 220, 252, 255, 261
Russell Street, 12, 40, 46, 56, 67

Ryan, Eoin, 91
Ryan, John, 8, 44, 60, 74, 78–9, 81, 108, 125–26, 128, 142, 146-8, 152, 154, 158, 164, 183–84, 189–90, 217, 224, 244–46, 267, 274
Ryan, Kathleen, 245
Ryan, Patricia, 245
Ryan, Phyllis, 15, 201, 204
Ryan, Thomas, RHA, 231, 252, 266

Saints Go Marching In, The, 161
Salkeld, Blanaid, 208, 262
Salkeld, Cecil ffrench, 9, 12, 24, 47, 58, 67, 77–8, 83, 86–7, 142, 194, 208–9, 256, 277
Salkeld, Celia, 58, 194, 217
Salon des Refuses, 211
Sandymount, 268
Sargent, John Singer, 207, 220
Saroyan, William, 75
Saturday Review, 239
Scarperer, The, 46
Scheidemann, President, 164
Schrodinger, Erwin, 75
Scotch House, 153, 259, 260
Scott, Michael, 1, 135, 147, 257
Scott, Patrick, 215, 222
Scott, Walter, 16
Searson's, 10, 81, 126
Sellers, Peter, 238
Scenes de la Boheme, 7
Self Portrait, 114, 133
Shadow of a Gunman, 230
Shakespeare and Company, 129, 130
Shaw, George Bernard, 2, 14, 22, 29, 40-1, 49, 72, 78, 119, 139, 164, 176, 186, 192, 206, 220, 235, 252, 255, 256
Sheehy Skeffington, Francis, 13, 20, 183
Sheehy Skeffington, Hannah, 227
Sheehy Skeffington, Owen, 189
Shelbourne Hotel, 71-2

Sheridan, Margaret Burke, 74, 257, 263
Sheridan, Niall, 153
Sheridan, Richard Brinsley, 70, 86, 186
Sigerson, George, 149
Sickert, Walter, 72
Simms, Archbishop George, 132, 141
Simpson, Alan, 44, 46–7, 79, 124, 190–204, 219, 237
Simpson, Carolyn, 79, 124, 191–204, 219, 237, 269
Simpson, Canon Walter, 192, 199, 203–04
Sinnott's, 153
Slattery, Liam, 231
Sloan, John, 38
Smith, Leo, 222
Smith, Tommy, 85
Smithson, Annie P., 2
Smuts, Jan General, 258, 260
Smyllie, Bertie, 46, 75, 84, 103–4, 127, 153, 163–74, 202, 227, 260, 262, 278
Solomons, Estella, 228, 252,
Somerville, Edith, 206, 210–11, 227
Soul for Sale, A, 106
Souter, Camille, 2, 219, 222
Southern Star, 159
Spectator, The, 101
Spellman, Cardinal, 185
Spender, Stephen, 84
Spotlight, 187
St. Ann's, 210, 268
St. Brendan Society, 264
St. Stephen's Church, 14, 119, 149, 192
St. Stephen's Green, 3, 5, 6, 19, 24, 28, 33-5, 47, 58, 78, 115, 187, 216, 222, 228, 253, 257
Standard, The, 106, 150
Stanford, Sir Charles Villiers, 12
Stanley, Jacqui, 265
Starkie, Enid, 73
Starkie, Walter, 34, 73, 75, 252

Index

Steadman, Ralph, 155
Stein, Gertrude, 210
Stephens, Edward, 15
Stephens, James, 13, 21, 72, 76, 86, 102, 130, 187, 262
Stevens, Peter, 143, 218
Steyn, Stella, 213
Stoker, Bram, 18, 28
Stokes, Margaret, 206
Stokes, Stephen, 130
Strumpet City, 141
Stuart, Francis, 58, 139, 184, 188, 208
Sunday Independent, 240
Sunday Mirror, 231
Sunday Times, 48, 197, 257
Swanzy, Mary, 35, 66, 209–11
Sweny's chemists, 82
Swift, Patrick, 74, 107, 216
Synge, John Millington, 13, 15, 28, 36–7, 71, 108, 119, 164, 212, 229

Taesler, Irma, 208
Tagore, Rabindranath, 208
Tailor and Ansty, The, 175, 179–80, 189
Tara Street, 104, 272
Tarry Flynn, 93, 96, 106, 113, 182
Tate Gallery, 220
Taylor, John, 221–22
Taylor Galleries, 221–22
Taylor scholarship, 224
Thackeray, William Makepeace, 71
Third Policeman, The, 155, 158, 160
Todhunter, John F., 26, 30
Theatre Royal, 94, 149, 161, 270
Thirty Seven Theatre, 15, 192
Thomas, Dylan, 62, 75
Tierney, Dr. Michael, 98, 132, 177
Time, 51
Times Literary Supplement, 51, 195, 230
Toal, Maureen, 194
Toibín, Colm, 2

To-Morrow, 208
Tonks, Henry, 207
Tracy, Honor, 106, 171, 179, 181, 257
Tracy, Spencer, 234
Transition, 213
Travers, Sally, 236
Traynor, Oscar, 202
Trevor, Helen, 206
Trilby, 7
Trinity College, 22, 26–7, 47, 103, 106, 145, 164, 174, 189, 206, 242, 243, 245, 247, 250, 266, 268
Triumph of Bacchus, The, 9, 78, 209
Trocchi, Alexander, 45
Trollope, Anthony, 118, 131
Tur Gloine, An, 210, 212
Tuohy, Patrick, 224, 252
Turgenev, Ivan, 121
Tur Gloinne, An, 210, 212
Tynan, Katherine, 21, 28, 253

Ulysses, 13, 19, 77, 81, 107, 120, 138, 146–48, 152, 177, 182, 185, 189–90, 224, 255, 267, 269
Uncle Silas, 16
United Arts Club, 9, 229–30, 251–66
University College Dublin, 145, 150, 220
University of Southern Illinois, 274
Upper Mount Street, 14, 111, 206, 218, 219
Ussher, Arland, 73, 208

Vail, Sinbad, 45–6
Vanston, Dairin, 212, 218

Waddell, Helen, 102
Waddington, Victor, 14, 178, 184, 221–22
Waiting for Godot, 10, 13, 47, 195–6, 203
Wall, Mervyn, 73, 158
Walsh, Maurice, 182
Walsh, Caroline, 122, 143

Walsh, Owen, 6, 25, 31–2, 69, 80, 85, 117, 126, 134–35, 139, 143, 190, 217, 220, 229, 276–80
Warrington Place, 121
Waterloo Lounge, 81
Waterloo Road, 47, 60, 125, 217
Watt, 185
Welles, Orson, 83, 185
Westland Row, 81, 82
Wexford Opera Festival, 273
Whelan, Gerard, 201, 204
When We Dead Awaken, 19
Whistler, James McNeill, 121, 211–12
Whitaker, T.K., 188
White, Jack, 188
White, John de Vere, 222
White, Terence de Vere, 14, 208, 214
White, T.H., 84
White Stag group, 83, 84, 210, 214, 218
Whyte's Academy, 86
Wilde, Constance, 18, 60
Wilde, Dolly, 210
Wilde, Isola, 15
Wilde, Lady Jane Francesca, 16–18, 25, 30, 70–1, 187, 227
Wilde, Oscar, 2, 13, 16–18, 30, 46, 49, 60, 66, 133, 145, 177, 186
Wilde, Sir William, 16–18, 26
Williams, Richard Dalton, 108
Williams, Tennessee, 15, 54, 79, 196, 203

Williamson, Bruce, 173
Wilton Place, 123, 126
Women Writers Club, 262
Woods, Macdara, 85, 188
Wright, David, 110, 116
Wright, Orville, 243
Wyeman, Richard, 74, 271–2

Yeats, Anne, 14
Yeats, Elizabeth, 28, 31, 33, 213
Yeats, Mrs. George, 253, 255, 258, 262
Yeats, Jack B., 2, 9, 14, 30, 32, 38, 117, 119, 121–3, 207–8, 210, 221–2, 230, 252, 259
Yeats, John B., 6, 25–38, 71–2, 74, 204, 210, 215, 252
Yeats, Lily, 28, 31, 33, 37
Yeats, Susan, 26–7, 31
Yeats, W.B., 2, 8, 19, 22, 27–9, 32–4, 36–7, 40–1, 71, 102, 107–8, 115, 121, 135, 164, 169–70, 176–7, 179–80, 186, 207, 210, 220, 252–8, 261–2, 270

Zborowski, Leopold, 255
Zola, Emil, 41, 71
Zoological Society, 276
Zurich, 19